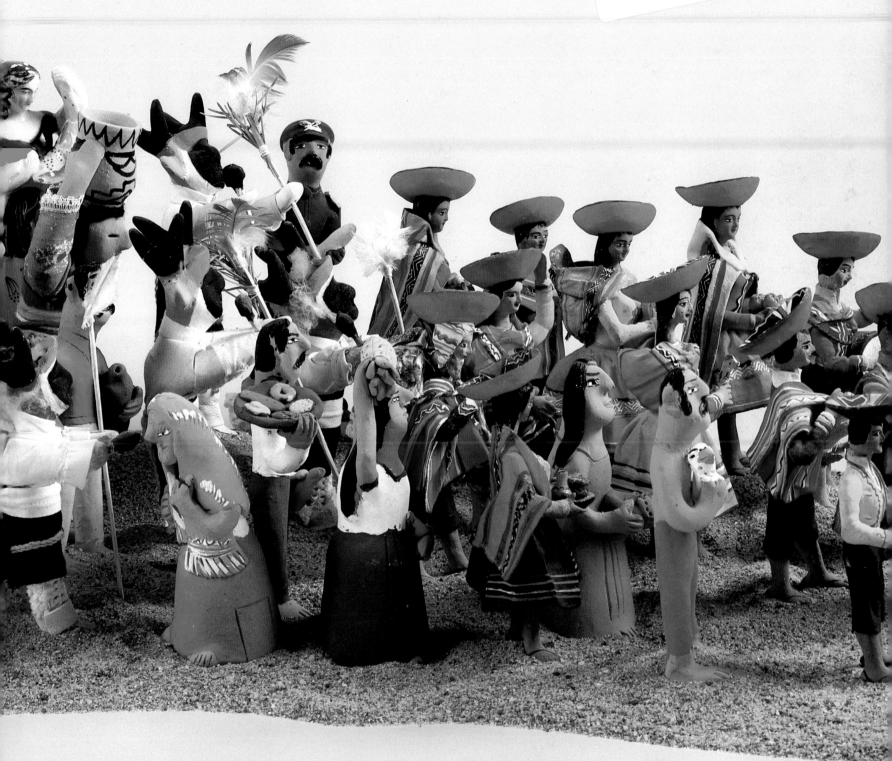

THE SPIRIT OF FOLK ART

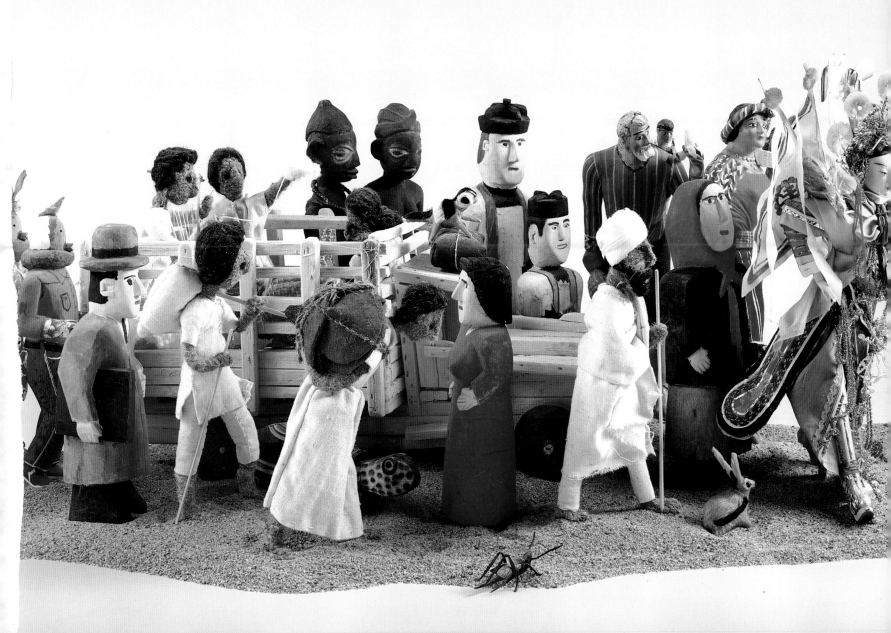

Color photography by Michel Monteaux
Black-and-white photography and
drawings by Henry Glassie

Harry N. Abrams, Inc., Publishers, New York,
in association with
the Museum of New Mexico, Santa Fe

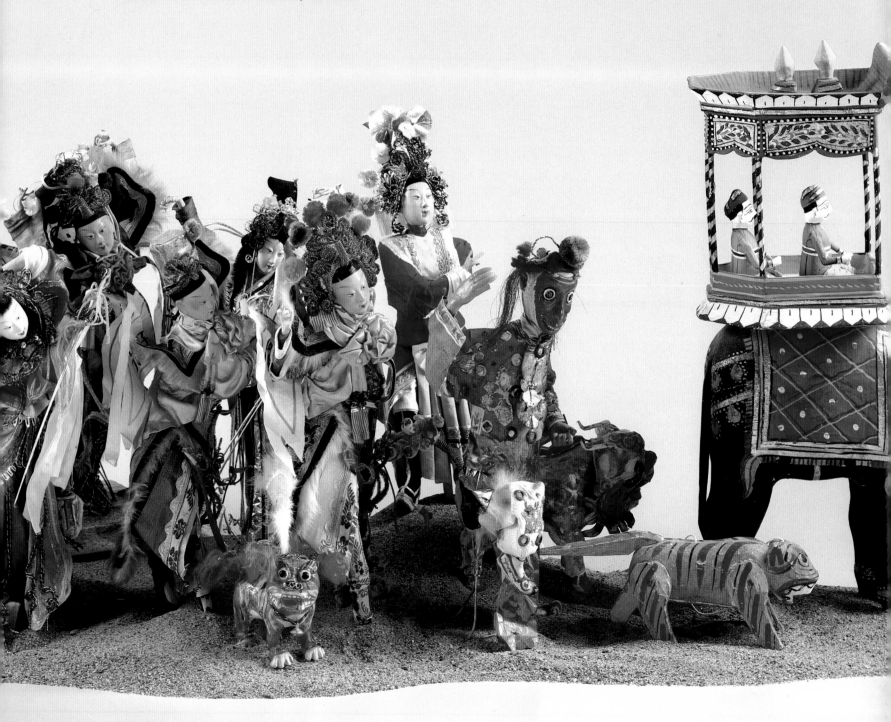

THE SPIRIT OF FOLK ART

THE GIRARD COLLECTION
AT THE MUSEUM OF
INTERNATIONAL FOLK ART

HENRY GLASSIE

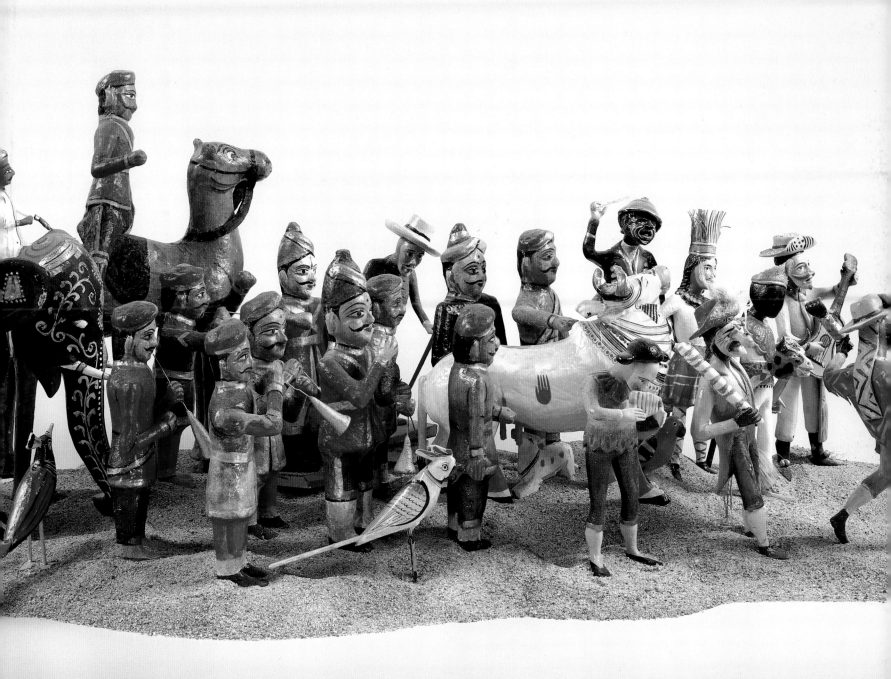

...o the memory of my father, Henry Haywood Glassie, Jr.

Folk art is, indeed, the oldest of the aristocracies of thought,
and because it refuses what is passing and trivial,
the merely clever and pretty, as certainly as the vulgar
and insincere, and because it has gathered into
itself the simplest and most unforgetable thoughts of the
generations, it is the soil where all great art is rooted.
—William Butler Yeats, 1901

For Harry N. Abrams, Inc.:
Editor: Margaret Donovan
Art Director: Samuel N. Antupit
Design Assistants: Doris Leath, Ellen Nygaard Ford

For the Museum of International Folk Art:
Charlene Cerny, Stephen Becker, Karen Duffy,
Deborah Garcia-Ortega

Right: Puppets. Bamana people, Mali. Painted wood with
metal, tallest 43″ high, c. 1960

Library of Congress Cataloging-in-Publication Data
Glassie, Henry H.
 The spirit of folk art: the Girard Collection at the
Museum of International Folk Art/Henry Glassie;
color photography by Michel Monteaux;
black-and-white photography and drawings by
Henry Glassie.
 p. cm.
 Bibliography: p.
 Includes index.
 ISBN 0–8109–2438–2 (Abrams: pbk.)
 ISBN 0–89013–193–7 (Museum of New Mexico: pbk.)
 1. Folk art—Exhibitions. 2. Girard, Alexander—
Art collections—Exhibitions.
3. Museum of International Folk Art (N.M.)—Exhibitions.
I. Monteaux, Michel. II. Museum of International
Folk Art (N.M.) III. Museum of New Mexico. IV. Title.
NK607.G5 1989
745′.074′018956—dc19 88–21854

Printed and bound in Japan

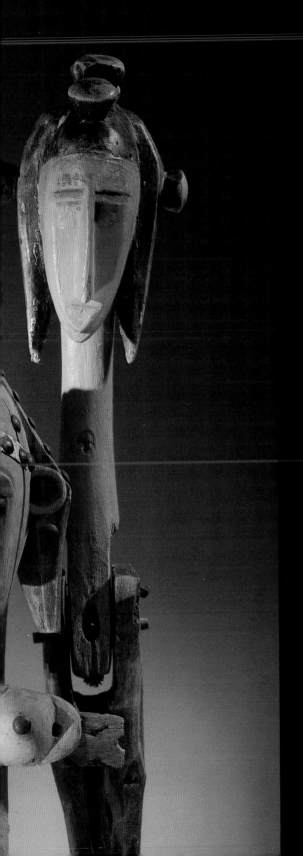

ontents

FOREWORD

At this time, the definition of the term "folk art" remains vexing even to scholars in the field. It is tempting to view recent writings as falling into either of two philosophical camps: one where the sense of "community" (i.e., the "folk") holds sway, the other in which individual creativity (the "art") is heavily emphasized. But this dichotomy has not served folk art study well.

It may be that the discipline of folklore, international in scope and more than two hundred years old, offers the best hope for a balanced view, and for understanding in depth, since the folkloristic position has traditionally embraced both individual aesthetic expression and consideration of collective order. Being neither art history nor anthropology, folklore finds a comfortable niche in the middle ground between its two senior siblings.

In 1988 the American Folklore Society, the professional organization of folklorists in the United States, celebrated the one hundredth anniversary of its founding. It thus seems appropriate indeed that the current president of that group, Dr. Henry Glassie, was invited to be the author of *The Spirit of Folk Art*, a volume that reflects upon the Museum of International Folk Art's Girard Collection, the world's largest cross-cultural collection of folk art, in order to shed light upon the true nature of folk art.

Looking toward a new century, in a world where international telecommunications are instantaneous and foreign travel is measured in hours, we now must ask ourselves: can a more global approach to folk art provide an exit from the definitional maze that has for so long plagued serious inquiry?

If so, there is no doubt that the Girard Collection can lead us there. For in addition to being vast—it numbers some one hundred thousand objects drawn from over one hundred countries—the collection offers depth. Far from championing the single, atypical example from a given tradition, the Girard Collection often offers up dozens or even hundreds of examples. At first this comes as a rude shock, so tied up is our own artistic tradition with the concept of the unique, the one-of-a-kind. But even a brief stay in one of the countries where folk art still flourishes resoundingly in homes and marketplaces convinces the traveler that the vitality of this art in fact lies in its abundance. Firing completed, the kiln reveals scores of miniature clay horses or water jars. Acres of a verdant landscape are covered by row upon row of brightly colored saris drying in the sun. In such countries, one finds uniqueness and rarity subsumed in the aesthetic of an art governed by strict guidelines, where individual creativity surfaces in subtler fashion than we are accustomed to, and where a production mentality is no cause for shame.

The opportunities that I have had to experience other peoples' art in the context of their communities have inspired a kind of reverence in me, have left me a changed person. Florence Dibell Bartlett, an early collector of world folk art, was so profoundly affected by similar experiences that she founded the Museum of International Folk Art, convinced that the appreciation of folk art was one road to international understanding.

Opposite
1. *Baptism. By the Aguilar family. Ocotlán de Morelos, Oaxaca, Mexico. Painted earthenware, c. 1960*

[7]

Alexander Girard, a man of artistic genius in his own right, pays homage to the folk artists whose work he has collected by deflecting the praise offered him as collector. "Thank the artists," he says. This is of course both admirable and appropriate, but the Girard Collection is such an achievement, assembled over some fifty years of dedicated effort by Girard and his wife, Susan, that we must pause to appreciate the vision that infuses such an accomplishment.

As a young boy in Florence, Alexander Girard first took notice of what he would later identify as folk art when he became intrigued with the Nativity scenes that appeared at Christmastime (actually, "intrigued" is perhaps too mild a description—"addicted" is the word he himself has used). It was not until some twenty years later, as a newcomer to New York City, that he first purchased a piece of folk art, a Mexican spatter-painted clay bank in the shape of a horse, which he "simply had to have." To hear Alexander and Susan Girard speak of the subsequent growth of the collection is to realize that at some point it truly began to take on a life of its own—they seem as amazed as the listener by its vast size and scope.

The development of the collection paralleled Girard's own stellar career in the world of design, his growing fame as a preeminent colorist and textile and interior designer. Once the Girards moved to Santa Fe in 1953, and Alexander Girard's work took him on international assignments, the collection grew in leaps and bounds. As a designer, he was one of the first to incorporate folk art into interiors, which meant that it began to reach much wider audiences than previously and to be seen in some of the most beautifully designed interiors of the twentieth century. Girard made folk art accessible to millions, in world expositions, corporate offices, airport lounges, restaurants, and museum exhibitions. He deserves a great deal of credit for his role as catalyst in awakening the public to the value of folk art, particularly that from nations other than our own.

In 1978 the Girards generously agreed to donate their collection to the Museum of International Folk Art, a unit of the state-funded Museum of New Mexico. The gift remarkably increased the folk art museum's existing collections fivefold. Thanks in part to today's art auction prices and government deficits, we are so accustomed to thinking in terms of millions and billions that it is worth contemplating the meaning of a 100,000-object gift, a gift so large that a crew of twenty people working full time would take four years to unpack and catalog it! Imagine what it means to acquire, ship, and care for such a collection as a private individual. Such was the task the Girards took on willingly as their collection grew—and in the process whole traditions were documented and preserved for future generations.

It is the nature of the Girard Collection, and of the Girards' own evocative and eclectic tastes, that much of what they have singlehandedly preserved is precisely what has not been collected by others, particularly museums, in any systematic fashion. Among such works are a broad category of ephemera, from Chinese door gods to European juvenile theaters; figurative ceramics, from Cochiti Pueblo to Calcutta, often deemed "tourist art" by the purists who view tradition as unresponsive to change; and toys, traditionally those objects most ignored by ethnographers. Objects such as these give mute testimony to the vision that marks the Girard Collection.

But perhaps the greatest contribution to be made by the Girard Collection is its breadth, the fact that it encompasses so many of the world's cultures in its reach. Global in scope, it assists us in overcoming the ethnocentricity we may fall prey to when studying the folk art of only one nation or people. In its breadth, it also resists the tendency to force upon

the traditional arts those categories of media such as "painting," "sculpture," and "decorative arts" which may at times be useful in describing Western art, but only hinder analysis when there is no culturally valid reason for using them. Girard collected in quantity what was readily available in a given place; he did not strain to find traditions that simply paralleled our own. As a result, the collection respectfully accords the same attention to great traditions in clay and fiber as to those in painted canvas and carved stone.

When the possibility of a publication on the Girard Collection presented itself, there seemed to me to be only one choice for its author: folklorist Dr. Henry Glassie. A distinguished member of the faculty at Indiana University's Folklore Institute, Dr. Glassie is well known in his field. He has written ten previous books, several already classics in their field. In an era of extreme specialization, he is a rarity in that he has made significant contributions to nearly every subfield of folklore: material culture, verbal traditions, vernacular architecture, methodology, and, especially, folklore theory. He also has wide experience in conducting fieldwork among diverse peoples. He spent ten years in Ireland, producing four important books on the oral traditions of that country; five years in Turkey, researching material culture, particularly weaving; and many years studying the architecture of the Southeastern United States. Most recently, he has acted as a consultant to the government of Bangladesh, where he is training young scholars in the skills of the folklorist.

Dr. Glassie brings to his work a most intimate understanding of the artistic process, coupled with an unrelenting passion for clarity in a field where confusion has all too often reigned. We feel privileged that this publication of the Museum of International Folk Art will bring his important perspective on folk art to a wider audience, far beyond the halls of academe.

I wish to express gratitude to Dr. Glassie for interrupting a busy academic schedule to write this book, for supervising the selection of all the images and determining their sequence, and for providing drawings and black-and-white photographs of artists and their work drawn from his field research. His efforts, which went far beyond what was originally envisioned, are gratefully acknowledged here.

It is my hope, on behalf of the Museum of International Folk Art and of the two individuals whose interest and generosity made this publication possible, Linda and Stanley Marcus, that this book can in some small way begin to repay Alexander and Susan Girard for their contributions to the field of folk art. Not only did the Girards donate their collection to the public, but Alexander Girard also volunteered his time and talents to the monumental task of designing the inaugural installation in the Girard Wing. Selections from this exhibition, *Multiple Visions: A Common Bond*, illustrate the hallmarks of the Girard approach: recreation of an ambience suggesting the culture from which the folk art comes, a focus on events drawn from the lives of the people whose art is represented, visual excitement created by a flamboyant use of color and the sheer mass of material on exhibition, and a perfectionist's attention to detail. For this effort, Girard has earned the gratitude of the more than half a million enthralled visitors who have seen and appreciated the magnitude of this gift. We join with them to express our deep appreciation to him.

Linda and Stanley Marcus must receive credit for recognizing the need for such a book as this. It was their firm belief that the Girard Collection was deserving of a major publication and a new interpretation. They also felt that such a significant gift should be commemorated in an appropriate fashion, in a format that would broaden its accessibility. To

them and the Nonesuch Foundation, we are most grateful. I also wish to thank Mr. Marcus for his assistance in raising needed additional funds. As a result, the following individuals also generously contributed to this project:

Bank of Santa Fe	Joann and Gifford Phillips
Hugh DePree	Dr. and Mrs. Albert G. Simms
Mr. and Mrs. E. E. Fogelson	Louis Slavitz
S. Roger Horchow	The Honorable and Mrs. I. M. Smalley
Issey Miyake	J. I. Staley
Herman Miller	and an anonymous donor

Finally, I am grateful to Mr. Marcus for agreeing to write a brief biographical sketch of Alexander Girard and highlights of his brilliant career. His more personal look at the man behind the collection follows this foreword.

This book could not have taken form without the teamwork of a number of dedicated individuals. Michel Monteaux, photographer, was an essential part of the collaborative effort. His work in color vividly illustrates the aesthetic significance of the Girard Collection holdings. Raised in a home where folk art was no stranger, Mr. Monteaux brings to his subjects an ease and confidence that shine through his photographs. We thank him for both his talent and his dedication to the task.

The curatorial staff of the Museum of International Folk Art must be gratefully credited for providing Dr. Glassie with information concerning the works illustrated. They are: Marsha Bol, Karen Duffy, Nora Fisher, Helen Lucero, Robin Farwell Gavin, and Judy Chiba Smith. Assistant Director Stephen Becker was critical to the success of the project both in its early stages of formulation and in administrative supervision of the gallery preparation, which was implemented by Peter Weiss and Alan Lerner. Deborah Garcia-Ortega supervised preparation of the manuscript. A special debt of gratitude is owed to Karen Duffy, who acted as coordinator for the entire project, approaching it with the necessary zeal and commitment to assure a superior result.

The professionals at Harry N. Abrams, Inc., have proved themselves to be amiable and able colleagues. They are: Paul Gottlieb, Sam Antupit, Margaret Donovan, Suzanne Cohn, and Doris Leath. We thank them for their dedication to our joint effort.

Lastly, there are a number of individuals and organizations without whom this project would never have happened. They are: Yvonne Lange, Ph.D., Director Emeritus of the Museum of International Folk Art, and her former Assistant Director, Paul Winkler, both of whom led negotiations for acquisition of the Girard Collection; the Board of Regents of the Museum of New Mexico; the Legislature of the State of New Mexico, which appropriated funds for the Girard Wing; the National Endowment for the Arts and the International Folk Art Foundation, which provided very generous supplementary funding; the Museum of New Mexico Foundation; Raymond G. Dewey, former President of the Board of Trustees of the International Folk Art Foundation; and Thomas A. Livesay, director of the Museum of New Mexico. To all of these we are grateful for their support as well as for their efforts on behalf of the Girard Collection and the Museum of International Folk Art.

Charlene Cerny
Director, Museum of International Folk Art

ALEXANDER GIRARD: DESIGNER AND COLLECTOR

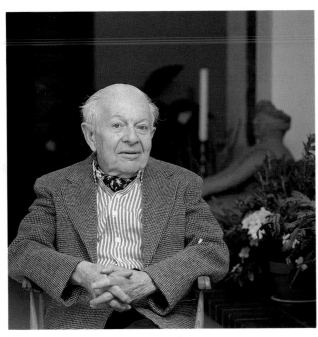

Alexander Girard, 1988

In the 1930s, while visiting Mexico, Alexander and Susan Girard became intrigued by the native folk art. For relatively little money they picked up colorful terra-cotta toys, papier-mâché skeletons made for the celebration of the Day of the Dead, and miniature bandstands, bullfight rings, and festive carts.

Many tourists, of course, have done the same thing, but the Girards recognized the aesthetic value of this art immediately. And they bought it in quantity, a dozen to fifty of each item. Girard claims that he truly didn't know what he was going to do with these objects, but his wholesale purchases lead to the speculation that he harbored the idea to ultimately create vignettes of Mexican life from the material he was gathering. To do this, he recognized he would need quantities of houses, park benches, and trees for his villages, as well as people to populate them.

As the collection grew, his business associates at Herman Miller, Inc., were so enthusiastic about his finds that they decided to open a specialty shop to sell folk art: thus, Textiles and Objects was born. Girard returned to Mexico to buy a stock of textiles and artifacts for the shop and to enlarge his own collection further. These works caused great public attention, for they were the first large group of folk art objects New York buyers had ever had the chance to see and to acquire.

This retail presentation reached the attention of Restaurant Associates, which had embarked on a program of building theme restaurants, such as the Forum of the Twelve Caesars. Their efforts had proved so successful that they decided to draw on Girard's collection of Latin American folk art and commissioned him to design and decorate their second Manhattan cafe, to be named La Fonda del Sol. Girard then made his first visit to South America, to buy folk art in Bolivia, Peru, Argentina, and Brazil. His decor and the

South American menu, so imaginatively developed by food guru Joseph Baum, scored a great hit for the restaurant.

Girard achieved another public triumph in 1968, when he was invited to design an exhibition for the Hemisfair in San Antonio. Thousands of visitors were intrigued by the Girard creation, *El Encanto de un Pueblo (The Magic of a People)*, a recreation of Latin American villages and town plazas assembled from his collection of miniature folk art from Mexico, Bolivia, and Peru. It was the most popular spot in the fair, captivating both young and old, local residents and tourists, world's fair buffs and novices.

Alexander Girard's American mother and Italian father came to New York so that their child would be born in the United States. Shortly after his birth, they returned with him to the parental home in Florence. After secondary education in Italy, Girard went to London to study architecture at the Architectural Association, from which he received his degree. This was in the late 1920s, a period of little opportunity for architectural employment in England. Girard returned to Italy, only to find that similar job conditions existed there. Eager to get involved in any activity related to design, he accepted a position designing and staging an exhibition for the Florentine craftsmen who had been assigned space in the Italian building at the 1929 Barcelona Fair.

The scarcity of architectural work continued to steer Girard toward the fields of exhibitions and interior design. In the 1930s, Sweden was in the forefront of avant-garde architecture, so he went there to absorb the Scandinavian interpretation of contemporary design. One of the great department stores of Europe at that time was Sweden's Nordiska Company, which believed that a great store needed to be more than just a quartermaster to its public, that it should be a creator of merchandise which would elevate its customers' tastes and aspirations. To accomplish this objective, Nordiska, under the leadership of its president, Ragnor Sacks, set up a studio with a staff of artists and designers to develop original textiles, rugs, and furniture. Girard took a job as a member of the design studio, where he was exposed for the first time to the international design movement.

The sluggish economy in Sweden forced his return to Italy in 1931. After several years of creating showroom displays, staging exhibitions for Florentine craftsmen, and designing domestic interiors, Girard emigrated to America in search of architectural work. Arriving in New York in 1937, he again faced the frustrations of the depressed times. "There was no work anywhere," he said, so when he was offered a position with a decorator's studio in Detroit, he jumped at the opportunity. The Detroit company turned out to have stereotyped decorating ideas, and at the outset, its principals showed little comprehension of Girard's contemporary designs. After a year, however, they responded to his fresh concepts and put him in charge of the design of furniture, fabrics, and office interiors.

Aggravated by having to constantly defend his "moderne" designs, Girard went to work for a radio company, Detrola, and redesigned all their cabinets in a contemporary style. One day he returned from lunch to find that someone had placed three or four radio cabinets from a competitor on his desk. Girard had no idea who had put them there, but he was shocked because they looked almost identical to the ones he had designed. Under one of the cabinets he found a note from Charles Eames, explaining that they must be kindred spirits. That was the beginning of a lifelong friendship and collaboration between the two designers.

Girard settled in Grosse Pointe, doing interior design work for the Ford Motor Company's offices and for the homes of several local industrialists and designing fabrics on a free-lance basis. In 1951, Eames induced Girard to become a third member of the Herman Miller furniture company's design team, joining himself and George Nelson, its director. Girard came to be impressed by the designs of the firm, and particularly by the taste standards Nelson had established. While Girard's first assignments for Miller were in display and exhibitions, he soon began designing textiles that proved to be tremendously successful. (Even today, fabric designs he created for Miller in 1952 continue to be popular.)

Girard's fruitful relationship with the Dupree family, the owners of Miller, and with his fellow designers lasted until 1966 and gave him the opportunity for a wide variety of assignments. During his tenure with Miller, he designed all the company's showrooms, organized and executed the Good Design Exhibition at the Chicago Merchandise Mart and the Museum of Modern Art in 1953 and 1954, and conceived the smashing show *Textiles and Ornamental Arts of India* for the Museum of Modern Art in 1955. "This was America's first broad glimpse of Indian design, and Girard's juxtaposition of jewelry, fabrics, and artifacts simply bowled the public over," recalls Ray Eames, Charles' widow and collaborator.

The Girards moved to Santa Fe in 1953, having decided that they would like to live in a less urban setting than Detroit or New York and in a less socially conscious place than Grosse Pointe or Westchester. They chose Santa Fe because it seemed an ideal answer to their needs.

The Girards' folk art collection had grown to the extent that they had to provide warehousing facilities next to their home. These were organized with typical Girard efficiency, making it possible to lay one's hands on any given object in a matter of minutes. Eventually, the Girards came to the conclusion that they needed to find a permanent home for their collection, and they were quite frank in stating that they would consider giving it to any city or institution that would build suitable facilities for it. Fortunately for Santa Fe, the State of New Mexico offered to add a wing to its Museum of International Folk Art to house the collection.

Alexander Girard (Sandro to his close associates) is a multifaceted person. He is a fine designer and brilliant colorist, and he has a superb sense of scale. That he possesses a wry wit is clear from the vignettes that make up his exhibition *Multiple Visions*, which opened in Santa Fe on the evening of December 5, 1982. His greatest skill, it seems to me, is his ability to organize diverse objects—whether they be keys, gloves, bills of lading, hinges, or folk art—into intelligible, artistic, and convincing presentations. This talent is apparent, for example, in his huge montage for Eero Saarinen's John Deere building in Moline, where farm tools, invoices, and old gloves make an appropriate and beautiful eyestopper in the lobby of the corporate offices. No one brings order out of artistic chaos better than Sandro Girard. He is truly the super-organizational man!

This book, funded in part by friends, serves as documentation of the design creativity and imagination of Sandro Girard and of the generosity of the donors Sandro and Susan Girard for the gift of their collection to the Museum of International Folk Art and to the world.

Stanley Marcus

Overleaf

2. *Nativity. By Helen Cordero. Cochiti Pueblo, New Mexico. Slipped and painted earthenware, c. 1964*

[*13*]

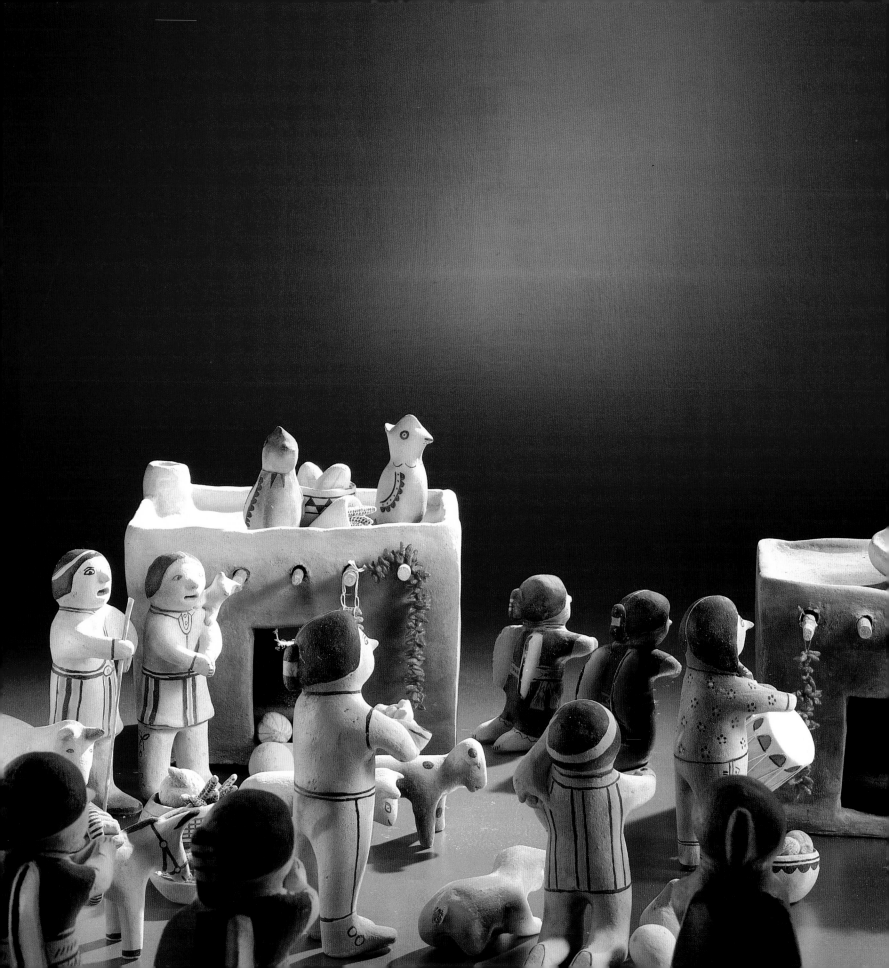

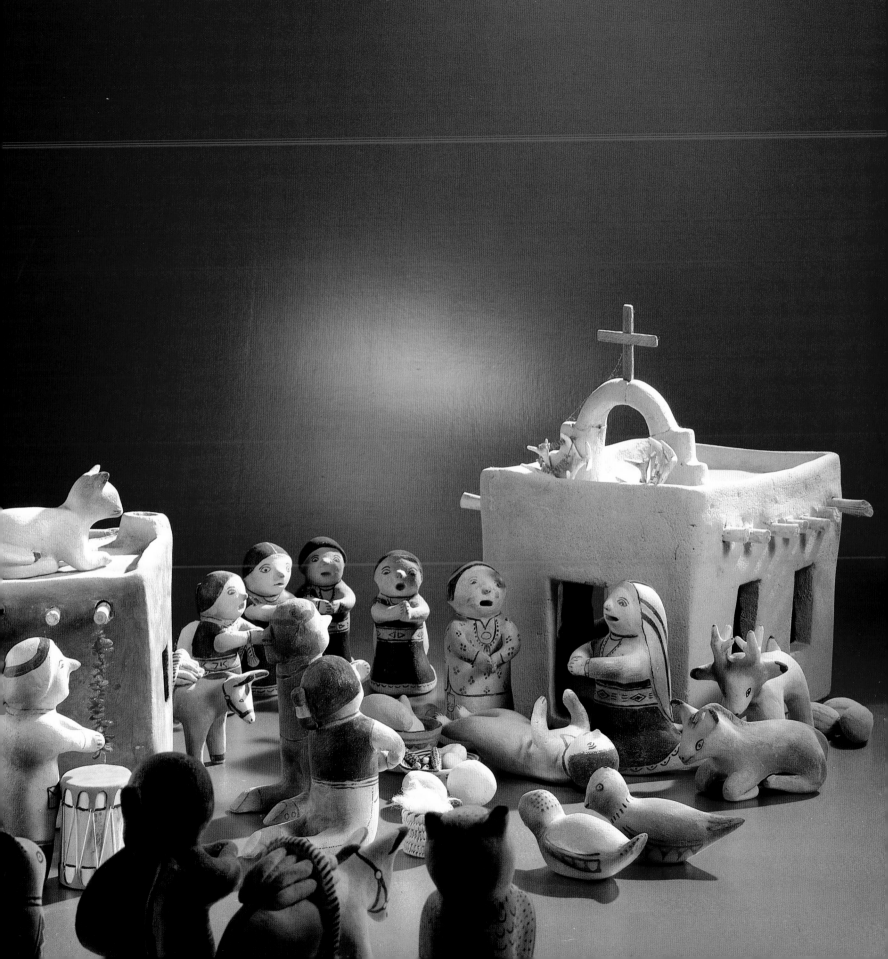

THE SPIRIT OF FOLK ART

THE GIRARD COLLECTION AT THE MUSEUM OF INTERNATIONAL FOLK ART

Folk Art in the Girard Collection

Luxurious with complexity, art requests diverse response. Here is the scene of the Nativity. Brought out at Christmas, unwrapped, it beckons a rush of memory: the scent of pine, the slick feel of ribbon, visions of old smiles, the flickering gloom of Midnight Mass. Little shepherds and angels invite the child to play. Artful small statues carry the adult mind into history: the personal history of Christmases past, the larger history of styles of creation, the deep history of religious belief.

For Alexander Girard, a lifetime of collecting shared with his wife, Susan, began in the experience of a Nativity and led to the creation of a masterwork. Mr. Girard's installation at the Museum of International Folk Art, like a Nativity, like all art of importance, calls people diversely. Children run in wonder, letting their minds follow their eyes on marvelous journeys. Adults upon entering are overwhelmed. Sparkling, flaming, spinning things fly at them from every direction. "Mind-boggling," they say repeatedly before settling into encounters that excite, confuse, and nudge them toward knowledge.

My reactions are many. As a lover and collector of folk art, I discover during every trip through the exhibition new works that trap my attention and perplex my understanding. As one who has worked in museums and fretted over exhibits, I am delighted by Mr. Girard's design, its humorous surface and deep purpose. Treasuring museums as institutions for public education, I feel his brave avoidance of wordy labels and his surprising mixtures of artifacts to be worthy of wide emulation. But my reactions that matter rise from my profession. I am a folklorist, and I find continual convergence between the concerns of my discipline and the ideas Mr. Girard built into his exhibition. This book will unfold from those instants of contact and expand along the lines of my own research to become one folklorist's account of the nature of folk art. A student of exhibition design or a historian of childhood would write a different book. Mine will concentrate on the points at which my study and the Girard Collection touch. They are numerous.

The Girard Collection assembles artifacts from the whole of our globe. It offers us a rich entrance to the world of folk art. In America folk art study has been disturbed by a war over definitions waged by people who should be cooperating. One of the many reasons for their disagreement lies in the nature of folk art in the United States. Concentrating on familiar examples, scholars drift away from the knowable present into a dim past where folk

art becomes confused with antiques, and they frustrate themselves in worry over marginal cases. Like all nations, the United States abounds in folk art, but trying to derive universal concepts from the product of one country, especially one like ours, is passing difficult. It would be like trying to comprehend the whole of industrial civilization from the study of Pakistan—possible but unnecessarily complicated. To know folk art, I have balanced years of study at home with study abroad. Most recently, I have rejoiced in work in Turkey, where folk art is not a memory, nor the struggle of a few elderly people, nor the rebellion of a few small communities. It is a normal part of the life of everyone. In places like Turkey or India or Bolivia, the study of folk art does not drive the mind through painful contortions. Things are rich and clear. Principles of wide validity rise smoothly. I find, then, the international scope of the Girard Collection congenial. Indeed, I find it necessary. It lets us think plainly about the big issues that lead us straight to the heart of folk art.

Eşe Coşgun watching her daughter, Fadime Akdağ, and her granddaughter, Emine, weaving a kilim, Güneydamlar, Manısa, Turkey

Two things thwart our approach to folk art: what we know and what we do not know. Both are addressed in the dominant concept of contemporary folklore scholarship: context.

Context is the source of interpretation, the environment of significance. Outside context there is no understanding. There are only contexts that are appropriate and contexts that are not. Things out of context are in the wrong context. Direct reading is a delusion; texts and objects read directly are but tangled in the wrong web of association, the contexts we spin out of our own experience. The danger is to think we are encountering folk art directly or interpreting it correctly when all we have done is to build a false context around it out of the culture we know best, our own. Our task is to bring our assumptions into awareness so that improper contexts can be dismantled and replaced by proper ones, the contexts within which folk art makes sense in its own terms.

Context is the organizing principle of Alexander Girard's exhibition. Before we began our first trip together through it, Mr. Girard told me that when he sees the things he has collected he is reminded of their original environments, the scenes of their creation, the worlds of their artists. He stated his goal succinctly, "I don't want to line things up in a row like a regiment. I want to provide the background that will enhance the material." When we entered the exhibition hall, he stopped and said, "It is all theatrical." Along the corridor leading to the exhibition he arranged a series of toy theaters. He speaks of his exhibits as sets, of their objects as props, of their figures as actors. All is in dramatic motion. Standing at the beginning, he gestured broadly and said that it should all be part of a joyous spectacle, a dance.

As part of a dance, the mask comes alive. It lives in its own context. Folklorists unify with Alexander Girard in their search for appropriate contexts for artifacts—the contexts through which art breathes and pulses into life. Contexts are of different kinds, and arranging his exhibition, Mr. Girard commented upon their variety. Let us follow him into his own work of art.

He turns right, so the first set in the exhibition portrays an Italian villa located beneath an array of Navajo weavings of American flags. Born in New York, Mr. Girard was raised in Italy and settled in New Mexico. We begin our search for folk art at home. The first

context in which art makes sense is our own. Standing there, Mr. Girard told me that, while most of the things in the collection were folk art, the figures in this first exhibit are not. His brother made them. They stand in isolation. They read. They look at the art on the wall. They are people like us. In this exhibit, folk art is merely decor. It is not central to life but mixes with other things, both fine and ridiculous, to paint the scenes in which we live. Our homes provide odd contexts for folk art.

The exhibit of the Italian villa reaches out to the larger one opposite, which he calls American. Together, they comment on our lives. Both raise the issue of class and social disjunction. In "America" bulky houses stand in a line along the tracks. "The populace lives here," he said, turning to point, "while the very rich live over there, up on the hill." In both exhibits there is a feeling of prosperity, a mood of emptiness, a strange conjunction of artifacts, the beautiful and useful, the shoddy and trite. This is the context out of which our yearning for folk art grows.

To make things clear, the next exhibit on Mr. Girard's itinerary is Mexican. Here color is bright, things are packed and rackety. A grand, fantastic orchestra blares. The contrast between the first and second sets, between the Italian villa and the Mexican band, is the contrast of isolation, silence, and incoherence with crowds, noise, and coherence. Mr. Girard has said that folk artists may live in material squalor, but we live in aesthetic squalor, and at the beginning of his exhibition he has associated our individualistic prosperity with artistic cacophony, while making the noisy crowds of Mexico, where his collecting began in earnest, seem aesthetically reasonable. From the first two exhibits alone we would conclude that the context for folk art is loud, crowded, and culturally coherent.

The question posed is the source of folk artistic coherence. First Mr. Girard provides a false answer. The next exhibit on his counterclockwise journey is Spanish. Leaning in from the right, as though peeping out of the last exhibit, a Mexican figure looks out upon Spain—possibly the source of Mexican artistic vitality. But Spain is small and pale and weak. Simple historical continuity is not the answer.

Mr. Girard's answer lies in the next exhibit, the set on which the entire installation literally turns. Around the corner curls Poland—"the best place in the whole world," says Alexander Girard. Here again we find color and crowds and music. But here there is more. Poland announces the dominant theme of the exhibition. What joins Poland and Mexico? Not history, but a vibrant culture invigorated by religion. The context for understanding folk art is not history. It is religion.

Next on your journey lies Portugal. "I put Portugal and Poland close together," he said, "because there seemed to be a relation between these very separated parts of the world." Both sets feature Nativities, the source of Mr. Girard's love for folk art. As in Poland, little people from Portugal march in festive processions amid holy statues toward a church. The themes are set. The critical context for our appreciation of folk art is the alienation and disharmony of our own world. The physical context for the creation of folk art is the noisy crowd. The conceptual context for the understanding of folk art is religion.

At this point a pair of routes are open to you. Take one, and you will find in Peru and Mexico a repetition of the themes sounded in Poland. Take the other, and you will find artifacts from India and the Pueblos of New Mexico reiterating the vision of crowds in procession and the concept of religion as life's organizing principle. Off center, but lying at the end of either route, you will enter the one enclosed, roofed, and secure section of the

3. *Poland: Procession with Szopka model church. Painted wood figures; foil-on-cardboard church, c. 1960*

4. *India: Rajasthani marionettes milling around holy images. Painted wood and cloth puppets; painted earthenware and soapstone images, c. 1900*

5. *Peru: Procession with churches from Quinua, Ayacucho. Painted earthenware, c. 1958*

6. *Nativity. By Jan Lameski. Poland. Painted wood, c. 1962*

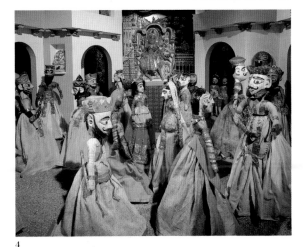

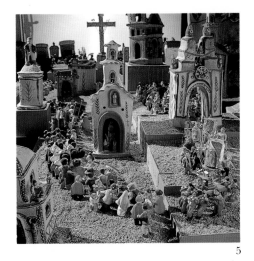

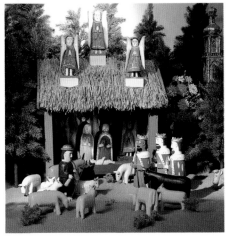

3 4

5 6

exhibition, where Christian images from many cultures cluster in a small chapel. (It echoes across the hall to the children's favorite, the international exhibit of Heaven and Hell.) Here we leave the physical and the conceptual for the universal. Summarizing the lessons built into the displays of individual cultures, the chapel presents a universal idea. The world's people are one in their confrontation with the unknowable, their need for faith.

The world, Mr. Girard knows, for he has traveled its breadth, is one. To drive his message home, he punctuates the exhibition with packed assemblies of objects drawn from many places. They tell us that people are united by faith and by the simple, homely acts of playing, eating, and going to market.

The human universals of happy play and sociable consumption, and most important, the universal encounter with the unknown, underlie the whole exhibition and provide contexts for the exhibits within which universals are clothed in cultural particularity, from Poland, where the exhibition finds its pace, to India, where it ends—if you follow Mr. Girard's own course and attend as he does to the exhibits on your right. Above India, a long procession leads back into the exhibition hall, moving steadily, directly toward the chapel of holy icons like a caravan of kings pulled by the light of a far star.

Alexander Girard presents the world's cultures in two ways. Those with which he is familiar are displayed through figures who turn into their own affairs and ignore us. We watch and gain some sense of their experiential scenes, of crowds roaming their own environments. The key idea is the procession—the public, ritual motion that gathers people, unifies them, and orients them in a single direction toward the sacred. The procession is the visible social manifestation of the cultural order that generates folk art. It leads from the physical context of the crowd to the conceptual context of religion.

When arranging artifacts from cultures he knows less well, Mr. Girard does not turn the figures toward each other but toward you. There is no verisimilitude in their setting. It is abstract, marked often by expanses of gold. He has courteously removed himself and resisted any temptation to depict a scene he does not know. He leaves the artifacts alone to teach their own meanings. He described his decision like this: "Some things have a context attached to them; they make a set, say a Nativity. You put things into a setting when possible. But it is not always possible. Then the way to create context is to use other stuff from the same place." Cautiously, carefully, in these sets, notably those of East Asia, he has placed only things that come from the place in question. The figures and props, the paper of the backdrops—all, he stressed each time he led me through, belong together. Confronting them, we must, like the archaeologist, develop contexts entirely out of objects. Physical and conceptual contexts have vanished, but we can still bring artifacts into association and order them into stylistic contexts within which they make artistic sense.

There is much along the way, among the things he calls fillers, to amuse and disturb us, but deep in his exhibition Mr. Girard teaches gently of the varieties of context we use to make folk art meaningful. There is the universal context of our humanity, of our bodies that want nourishment, our hearts that want play, our minds that want understanding, our souls that want faith. There is the stylistic context within which alien works become beautiful as part of a culture's formal system. There is the conceptual context of culture, composed of the values that drench art with power. There is the physical context of experience, the vital scenes within which culture is enacted. There is the critical context of the observer, within which our search begins.

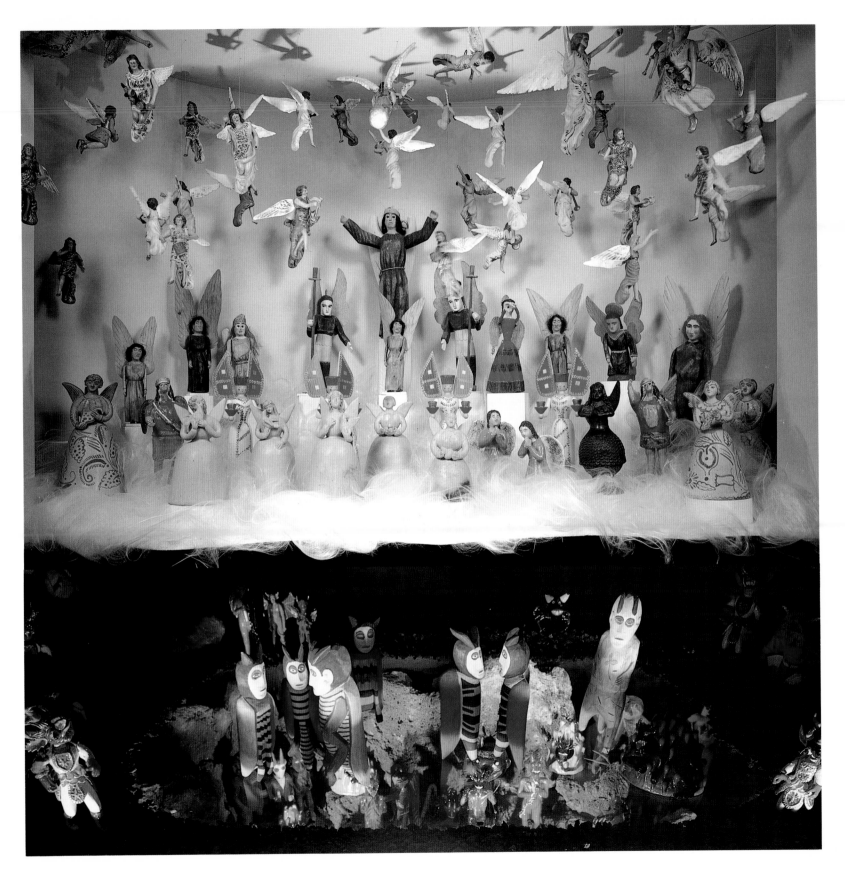

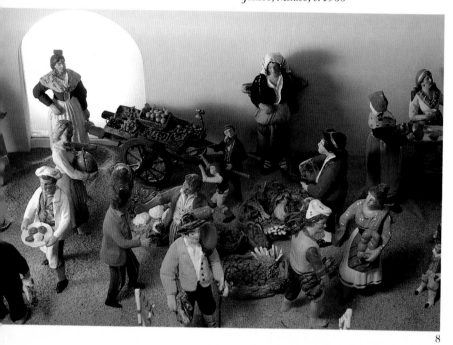

8. *Market Scene: Ceramic figures from Italy and France, c. 1950*

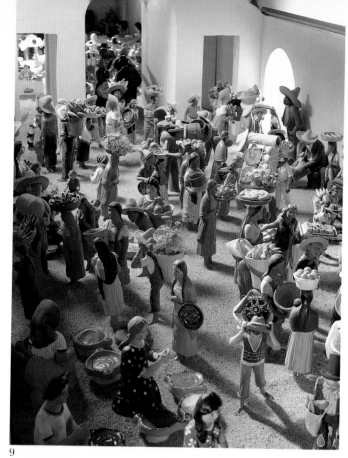

9. *Market Scene: Ceramic figures mostly from San Pedro Tlaquepaque, Jalisco, Mexico, c. 1960*

8 9

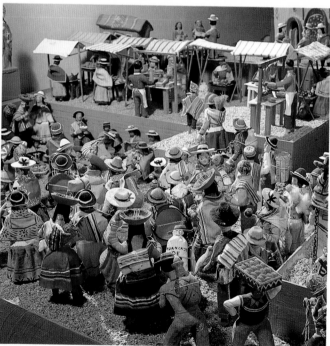

10

10. *Market Scene: Painted cactus-wood figures from Azapampa, Huancayo, Junín, Peru, c. 1958*

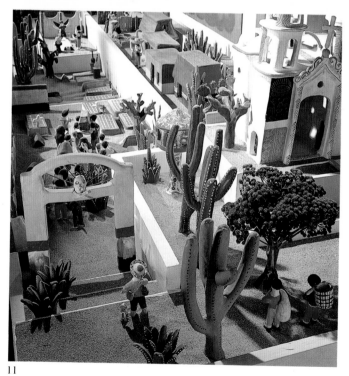

11

11. *Village Scene. By the workshop of Herón Martínez. Acatlán de Osorio, Puebla, Mexico. Painted earthenware, c. 1960*

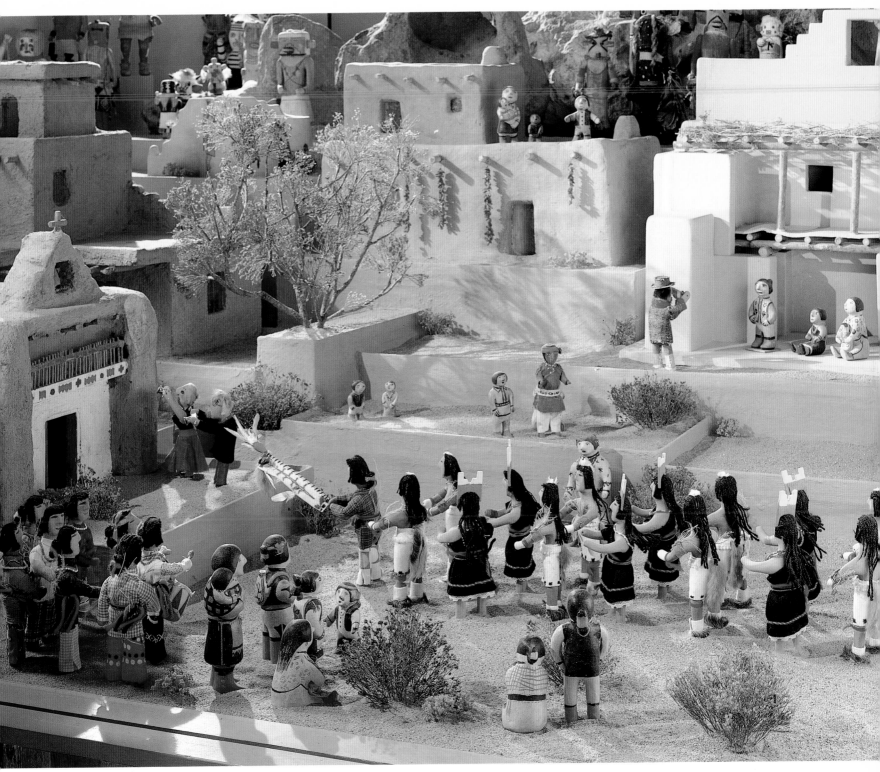

12. *Pueblo Scene: Corn dancers and church. New Mexico. Painted earthenware dancers by the Vigil family, Tesuque Pueblo, New Mexico, c. 1960*

Folk art embraces all these varieties of context. To understand folk art, we must clarify our understanding of ourselves, bringing it into such order that we can hold it aside when meeting others in contexts of their own. We must eliminate the familiar to become familiar with the alien. That is my task for the rest of this book, to circle as Mr. Girard did, simultaneously examining our world and the world of the folk artist, so that we can refine what we know and learn what we do not.

We begin our search for the spirit of folk art by considering the words we use to separate folk art out of the world.

"Folk" and "Art"

Nonchalantly saying "folk art," we bring into collision a pair of short words heavily freighted with meaning. It could be that your intentions are modest, your meanings clear to yourself. Old debates may not interest you. But if you choose these words and link them, you will be dragged into history. Each word reaches back into time and pulls into the mind vast babbles of association. Out of the explosion ignited by the casual conjunction of "folk" with "art," smoke enough lifts to confuse any line of argument and obscure any object we chance to admire.

Much art is imagined, made, and loved without words. It feels good to enter the meaningful silence of works of art, to drift with them unburdened by concept. But it is our duty, our genetic fate, to speak aloud of what we know, naming the beasts of paradise, advancing civilization through reasoned discourse. Accepting the commandment to teach, we might still try to circumvent old words in search of synonyms. Doing so, we but slip willy-nilly and witless into other historical entanglements. Worse still, skirting the words "folk" and "art," or using them thoughtlessly, or dismissing the matter of definitions as a dry academical exercise, we shy away from the hard, serious questions those words bring into awareness. Definitions of folk art have been hard to derive, I believe, mostly because people in the act of definition have glimpsed challenges, not only to their notions of folk art, but to their very way of life, and have abandoned the effort in discomfort and fear.

No, the thing to do is face the words history has chosen for us, rooting into them in quest of their logic. To begin, let us consider the terms separately.

Folk

"Folklore," though coined as recently as 1846, is the old word, the parental concept to the adjective "folk." Customarily folklorists refer to the host of published definitions, add their own, then get on with their work, leaving the impression that definitions of folklore are as numberless as insects. But all the definitions bring into dynamic association the ideas of individual creativity and collective order. In response to different problems, to suit different traditions of thought and exposition, writers have spoken of the relation of creativity to order in ways so various that reconciliation seems impossible. Yet, out of their words, three coherent definitions can be constructed. All of them are subsumed by the master philosophy of romanticism. Not too pleased with my words, but knowing names to be necessary, I will call them the nationalistic, the radical, the existential.

In the nationalistic conception, creativity and order merge when the individual

Left
13. *Devil Mask. Aymará people, Andean region, Bolivia. Painted plaster, 13¹/₂" high, c. 1960.* The Diablada *dance, dedicated to the Virgin of the Cave, portrays the defeat of the devils by the Archangel Michael.*

Below
14. *Devil Dancer. Aymará people, Andean region, Bolivia. Painted plaster, 17¹/₈" high, c. 1960*

enacts the collective will. The collective shapes and perpetuates itself through the creations of the individual. The individual develops a personal style in accord with the needs of the collective. At once and completely, the creation is mine and ours—as the poems of Robert Burns are simultaneously his and Scotland's.

The problem surrounding the nationalistic definition of folklore is the survival of the authentic nation, the group assembled naturally by tradition rather than artificially by law. Today we would be apt to say culture or ethnic group. "Nation," though, was the word in the eighteenth century when the concept was developed in the context, say, of the failure of the last Scottish movement for independence, and it continues to gather force across the globe whenever a people bound by blood, custom, and desire lack political autonomy. Before victory, the nation lives through rare heroic performances. If it fails to perfect itself in a native government, its life will lie less in political institutions, often imposed from without, than in cultural expressions, such as architecture and poetry, that expose the national

Robert Burns, a late nineteenth-century Staffordshire figure

character and preserve its integrity. The heroes are artists. And if a nation's elite is converted to a foreign culture, then national life depends on humble and rooted people who continue to create out of the collective resource. The heroes are the common folk.

When the last battle was lost, Robert Burns stood forth to claim the name of national poet. He not only harkened to the Scots muse, collecting folksongs, crediting the people with his compositions, taking theirs for his own, mixing his singular talent with the common voice, he felt obliged to maintain the role of man at the plow.

In the nationalistic frame, culture's creator is the workaday artist. Folklore is defined as the individual's expression of the national tradition. The "folk" is the authentic conjunction of individual creativity and collective order. It is the result of a people shaping their destiny through the reformulation of their heritage, often in the face of a colonial threat.

The nationalistic definition responds to external threats. The radical definition responds to internal threats. Characteristically, the radical definition appeals to us when our worries are less about political order than they are about the decay that inevitably accompanies progress. It arises in self-criticism as a complaint about modern life.

Folklore, in the radical definition, is a positive projection from a negative evaluation of modernity. If the modern world is too individualistic, full of freedom but broken by greed and alienation, then folklore is defined as collective, communal, unifying. If the modern world is too materialistic, comfortable but shallow, folklore is spiritual, deep. If the modern world is progressive unto decay, a place of disorienting change and vacuous fashion, then folklore is conservative, constant, profound. If the modern world is ripped by competition among great states, characterized by oppression and fouled by industrial waste, folklore is local—regional or ethnic—and preindustrial, cooperative, and participatory.

Envisioned as communal, spiritual, conservative, local, and participatory, folklore stands in opposition to the powers that demand cultural surrender. The state appropriates the collective identity. Industrial labor obliterates the cooperative, voluntary urge. Folklore counters with a tradition that invites individual involvement and builds order out of fluid, intricate social arrangements. In contrast to the restless changes that drive the economy of

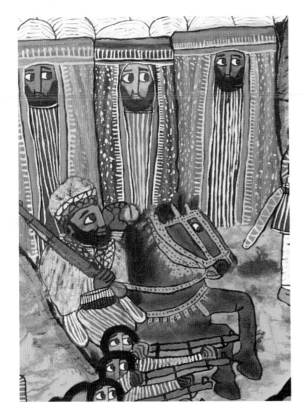

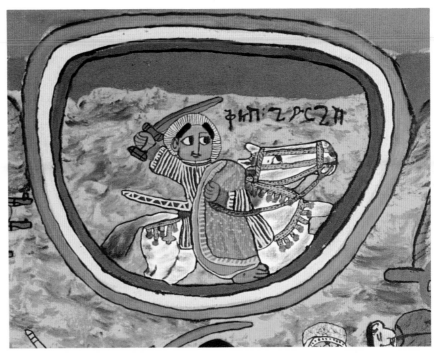

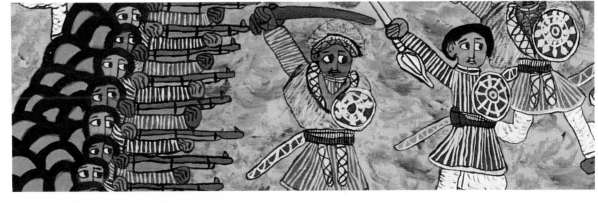

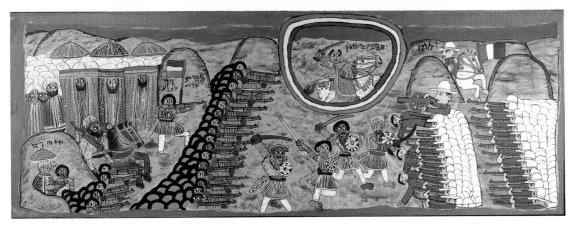

15. *The Battle of Adwa (entire work at left; details above). Central Ethiopia. Painted cloth on wood, 31¹/₂ x 87³/₈", c. 1965. Saint George leads the Ethiopian troops in victory over the Italian invaders in 1896.*

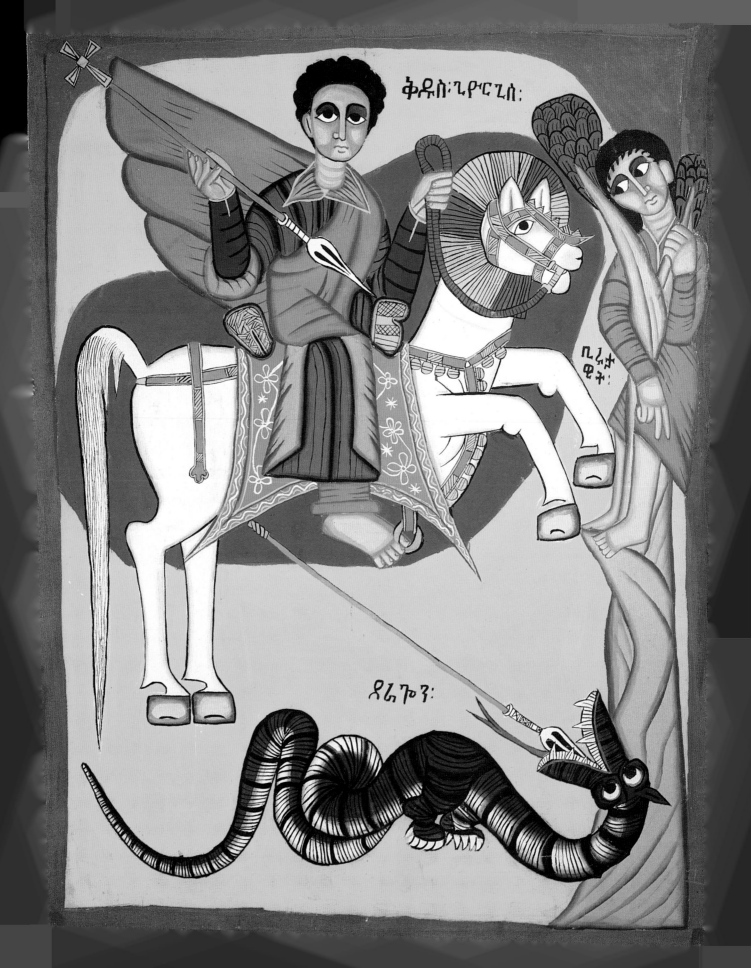

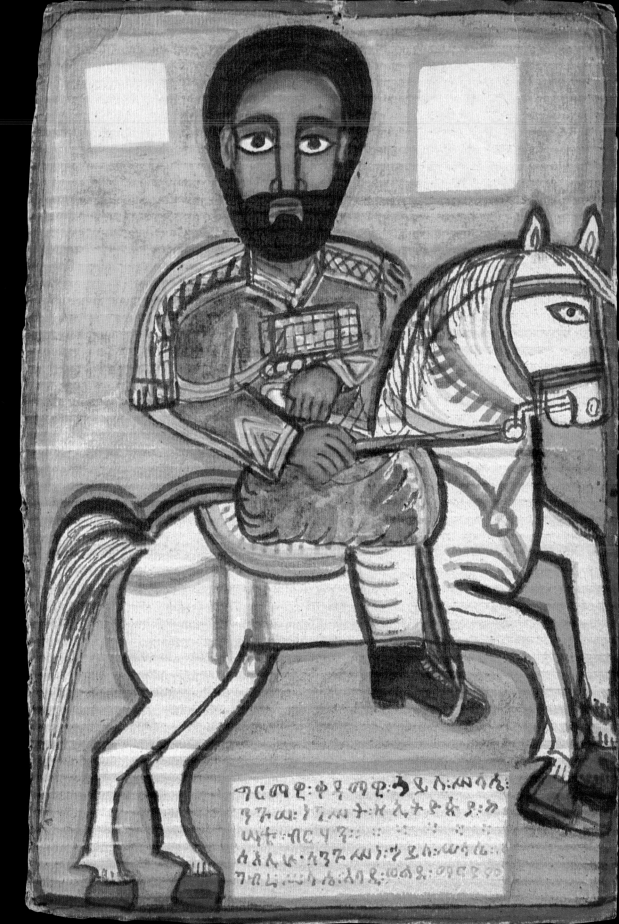

ግርማዊ፡ ቀዳማዊ፡ ኃይለ፡ ሥላሴ፡
ንጉሠ፡ ነገሥት፡ ዘኢትዮጵያ፡
ሃይማኖር፡...
ስነ፡ ... ሄ፡ ...
ግብረ፡... እ...

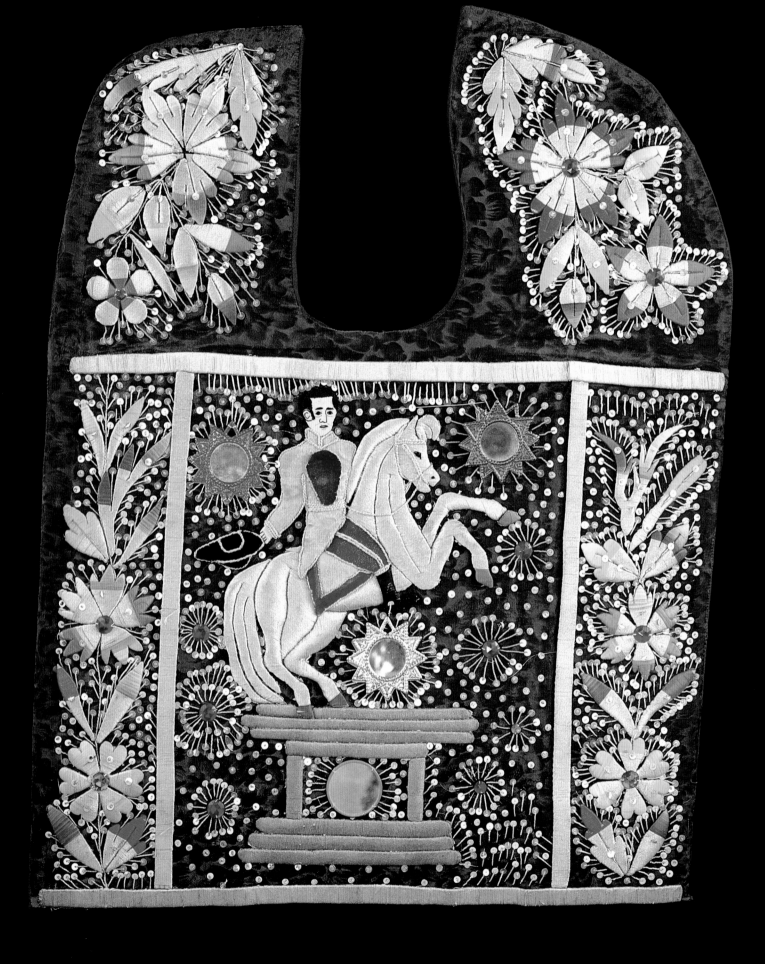

capitalism and eradicate local allegiance, folklore holds steady upon native virtues and maintains itself over time. In contrast to systems of management that reduce men to tools and numbers, folklore requires constant willful intervention and so varies naturally with differences among personalities and social occasions.

Folklore is traditional. Its center holds. Changes are slow and steady. Folklore is variable. The tradition remains wholly within the control of its practitioners. It is theirs to remember, change, or forget. Answering the needs of the collective for continuity and of the individual for active participation, folklore (in the radical definition) is that which is at once traditional and variable.

The test for authenticity drawn out of the radical definition sets the thing at question, this song or that pot, within an array of closely comparable things. If folk, it will belong to a set that can be arranged into a series to demonstrate a pattern of continuity over time and that, taken as a whole, will illustrate a particular culture's style. Finding our song or pot to be an emblem of a culture's continuing search for its own soul (and not the product of trivial, fickle fashion), we name it traditional. At the same time, though fitting its set, every song or pot worthy of the qualifier "folk" will be precisely like no other. It will have gathered into itself something of its creator's freedom. It will have met the second criterion of variability.

Neither tradition nor variability alone makes folklore. The key is their simultaneity, their interdependence. Some things persist over time but exhibit no variability—the texts, for example, of a poem identically reprinted in edition after edition. Some things flame with variability, but lack continuity, such as the fantastical eccentricities of the mildly mad. Whatever these are, they are not folk. I belabor the point because the idea, though a century old, continues to govern the reactions of many folklorists, and because the concept is not simple. In our days it seems paradoxical to require a unity of tradition and variability, of restraint and freedom. Is not freedom the release from restraint? But that is exactly the point. For it was in frank opposition to such modern ideas that the radical definition was formulated. Folklore celebrates and symbolizes the willing submission of individuals to their own cultures.

Persuaded by crude theories of the psyche, we might imagine individual creativity and collective order to exist in an antagonistic relation. We make heroes out of artists like James Joyce, who denied his mother's religion, escaped the nets of his native land, and ended up in Paris speaking Italian to his children and writing a book that defies understanding. From the beginning, folklorists have committed themselves to the opposite kind of excellence, believing that individuals can realize themselves fully in the terms set by their traditions. The product of their self-realization is the work that displays at once personal variability and historical continuity.

The songs and stories that we folklorists study do not provide us with the best evidence to refine our ideas. We have been forced to pull inferences from geographical distributions to suggest historical continuities. As we have shifted focus, only recently in the United States, to material manifestations of culture, to architecture and art, we have found things to study that survive literally from the past. Some things like gravestones and samplers are even dated, so they provide us with clear instances of temporal continuity, while varying so as to bring us messages from real people long dead. A collection of folk art will display insistently, convincingly, the unity of variability and tradition.

Destructive forces from beyond set the problem for the nationalistic definition. Rot

Preceding pages
16. *Saint George. Central Ethiopia. Painted cloth, 47¼ x 36", c. 1965*
17. *Haile Selassie, Lion of Judah, Emperor of Ethiopia, 1930–74. Central Ethiopia. Painted cardboard, 18 x 12", c. 1965*

Opposite
18. *Dance Cape: Monument to Simón Bolívar. By Santa Cruz Capacyachi. Huayuachi, Junín, Peru. Embroidered fabric, metallic yarns, 29½ x 23½", c. 1958*

[*31*]

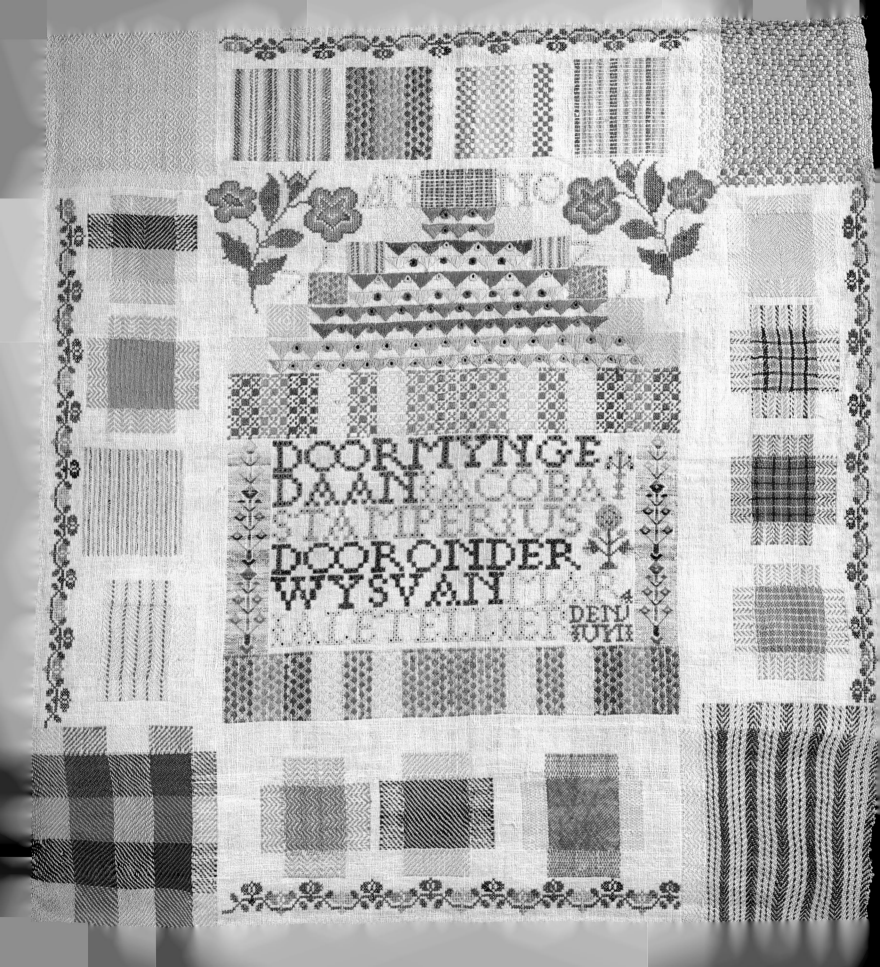

20

21

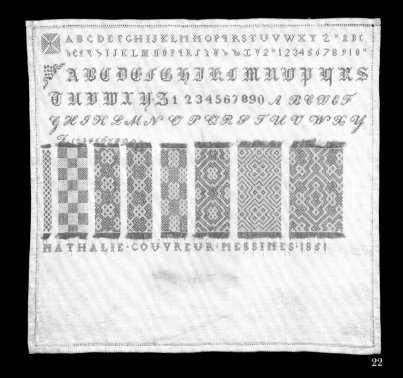

22

from within engendered the radical definition. Then the radical definition, distorted in the name of science, set a new problem for folklorists. When folklore is imagined to consist of things that exhibit simultaneously the traits of temporal continuity and formal variability, it seems possible to develop explanations without reference to human agency. Wishing to be scientific, folklorists began to formulate laws. Tradition ceased being a people's willing construction of culture. It began to look like a mechanical, godlike force that used people as the tools with which it created its continuity. Variability ceased being a sign of freedom. It became a pattern of accident, unknown to people, through which things disintegrated or evolved. Human beings were forgotten while magical forces shuffled objects through time and space according to abstract laws.

What looked scientific early in our century looked anything but scientific in the bright light cast upon human affairs by the realistic philosophy of existentialism. In the past two decades, professional folklorists, my friends and colleagues, have worked to replace abstractions with intelligent people. Our existential definition snaps attention back to real individuals in real situations. It clears away the preposterous structures of false science, recenters on the idea of responsible freedom lying at the heart of the radical definition, and then reformulates it in words suitable to our age. Today we think of folklore not as a kind of material but as a kind of action. It is artistic communication in small groups.

That formulation answers our needs today: artistic communication in small groups. The suggestive word "artistic" gestures broadly. Think of it as the relocation of the impulses to tradition and variability within the intending consciousness of an actor. The artistic act mobilizes the creator, pleases the body and mind, and emerges as comprehensible, because it incorporates shared notions of propriety. If "artistic," the act cannot be coerced. It must involve the creator's will. If it is a "communication," the artistic act cannot be autoerotic or mad. It must reach out to make connections between people. Not everyone is called by the artistic act. It gathers the "small group," those for whom the act is a communication. During communication, in the interplay of coherent intention and coherent response, creator and group become a unity shaped by the creative act. Folklore, existentially, is the unification of the creative individual with the collective through mutual action.

Folklore's three definitions are historical products, expressions of different periods. The nationalistic definition dominated between 1740 and 1860, the radical definition prevailed between 1860 and 1965, the existential holds sway today. But all remain vital, rising into utility as thinkers focus on different problems. The nationalistic definition continues to serve folklorists who feel their national tradition to be threatened by international political and commercial interests. The radical definition serves cultural critics within big nations. The existential definition serves scholars struggling to free themselves from scientific simplifications.

All the definitions can be used to divide things that are folk from things that are not. But that is not their important use. Their value lies in giving definition to research. They are less important for their ability to clarify the margins, doomed for all time to fuzziness, than they are for their ability to orient study toward central problems.

Consider a single artistic tradition. By all definitions, the pottery made today by the people of Acoma, New Mexico, is folk. But scholars guided by different definitions would emphasize different of its aspects.

The nationalistic definition would lead us to stress pottery as an emblem of the

Preceding pages
19. Darning Sampler. The Netherlands. Embroidered silk on cotton, 18 x 17", dated 1771. Darning samplers, with which girls learned to mend fabrics, were especially common on the Continent from 1750 to 1850.

20. Sampler. The Netherlands. Embroidered silk on linen, 11 x 25³/4", c. 1750. Most of the samplers in the Girard Collection were gathered by Marshall Cutler, Alexander Girard's grandfather. This piece, which he bought in Amsterdam, resembles dated examples from the late seventeenth century and could be older than his estimate.

21. Sampler. Germany. Embroidered cotton on cotton, 43¹/8 x 15³/4", dated 1714

22. Darning Sampler. By Nathalie Couvreur Messines. West Flanders, Belgium. Embroidered silk on cotton, 11³/4 x 13", dated 1851

community's identity. Our heroes would be the artists who shape that identity. We would name Lucy M. Lewis and Marie Z. Chino, who reformed their tradition in splendid models that continue to inspire their children and neighbors. We would name Frances Torivio, who felt her tradition weakening and accepted the task of instructing younger potters, so that her daughters, Ruth Paisano, Lillian Salvador, and Wanda Aragon, and their contemporaries like Evelyn Ortiz, have been able to refine the old style into works that signal to all the world the distinct nobility of their community, works that gather after them younger artists in whose hands the collective concept continues to flourish.

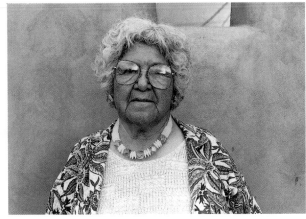

*Frances Torivio,
Acoma, New Mexico*

The radical definition would lead us to link contemporary pottery to a tradition a millennium old. During the nineteenth century, the tradition became recognizably the forerunner to modern work. During the twentieth century, the traditional style has been shaped into a pair of substyles—one tight and geometric, the other looser, more figurative and colorful—that have continued to the present, merging, diverging, absorbing influences, and allowing artists to find space within them for personal expressive needs. As a result, the pottery of Acoma exhibits both great historical continuity and the variable genius of real individuals.

The existential definition would lead us to observe potters as they reshape their heritage, answering inner artistic urges while making connections. Gathering clay and rocks and plant stuff from their locality and using them to make pots and paint and brushes, they connect to the world that embraces them. They connect to their past, Wanda Aragon told me, as they gather old potsherds and grind them for temper. Their pots contain the pots of their ancestors, whose pots, in turn, contained the pots of theirs. Sherds are recycled, consumed into an artifactual sequence that parallels the coursing of blood through the generations. The new pot also joins old ones, Mrs. Aragon said, as it is shaped in its early stages in the rounded, supportive bottom of a broken old pot. Then it goes forth on its own, like a child leaving its mother. The ancient sherds they find, the treasured works surviving from their mothers and grandmothers, the examples preserved in museums, all provide inspiration, further connecting new work to old. Marvis Aragon, Wanda's husband, whose grandmother was a potter, says he enjoys being part of the continuity that pottery represents. "Pottery," he says, "is a history book for

Acoma, New Mexico

the Indian." Connecting to the past, the artists connect to the present. Their pots are used during religious ceremonials through which the community unifies in ritual reaffirmation. They are "thrown," presented from the rooftops to their neighbors on the feast days of Catholic saints. They are used to christen babies. They are given to children, to friends and fellow potters. At last they are sold to outsiders who may then disappear, but who may—through the pot—form a lasting friendship with the artist. The pot gathers into itself the world, the tradition, the artist. Then it gathers for the artist her own small group.

Responding to different problems, the definitions of folklore guide us toward different understanding. We must choose among them carefully.

Art

The idea of art rises persistently but vaguely within all definitions of folklore. Press at the definitions and it will seem as though "folklore" were almost another way to say "art"—to say art while emphasizing its social dimensions. Folklorists, most of them, have been attracted to art and trained in literature. In their nationalistic definition, they made artists into political heroes. In their radical definition, they rebuked industrialists who used people basely, snuffing their creative spirit in numbing labor, and they rebuked artists who withdrew arrogantly into isolation by applauding artists who remained at one with their tradition. And in their existential definition, folklorists directed their discipline's attention to art as communication.

Out of our brief consideration of folklore's definitions, we might come to think of folk art as human creativity in social context. That is not a bad beginning. For clarity, though, we should turn to consider art independently.

Definitions of art unify in their wish to pull art from artifacts. They divide by ambition. The more they attempt to encompass, the more they strive for universal validity, the more subtle and complex they become.

So long as we restrict our scope trimly to a single culture, simple ideas may let us segregate art from other things. In our culture, one tendency is to identify art by medium. A definition of a sort emerges as we list the media we consider to be art. Paintings are art. Sculpture is art. Pottery is not. A bad painting would be bad art (as opposed to nonart), and a pot would remain craft, no matter how excellent.

The easy identification of art by medium contains an important idea and a swarm of problems. The important idea is this. As cultures shape their distinct styles, they often come to emphasize certain media, as pottery has been emphasized at Acoma. Particular forms and performances fill with power. They attract the society's most gifted individuals, and then, absorbing talent and spirit, they spiral out of the commonplace, gathering significance, whirling with energy and beauty. We can call these dense and robust centers of culture "art." It is important for us to recognize them so that we can engage with cultures on their own terms, entering them appropriately. Painting has been for several centuries a special concern for academic artists in Europe. If we concentrate on paintings, we will be led far into the artists' culture. From paintings we learn more than a sequence of pictorial styles. We watch the ascent of individualism, the demise of religion, the reorganization of political power.

Through much of Africa, sculpture has been the prime medium. Since sculpture is also a major academic medium for Europeans, African art has proved accessible to artists in need of fresh inspiration, to collectors of adventuresome taste, to art historians in search of intriguing topics. Once engaged by the inbuilt strength of African sculpture, we are drawn smoothly into some understanding of African cultural diversity and history, into some feel for African social, political, and religious systems. Because it is culturally central, packed with power, African sculpture affords an entry to understanding.

At a more intimate level, I have found that every community I have come to study has had its special media. People had invested certain forms and acts with such a richness of meaning that, once I had located them, I could collaborate with the community's native scholars in the study of their culture by concentrating with them on the exegesis of key works. It takes time. I had lived eight months in a small community on the damp green hills

Opposite
23. Jar. Acoma Pueblo, New Mexico. Slipped and painted earthenware, 14½" diameter, c. 1920

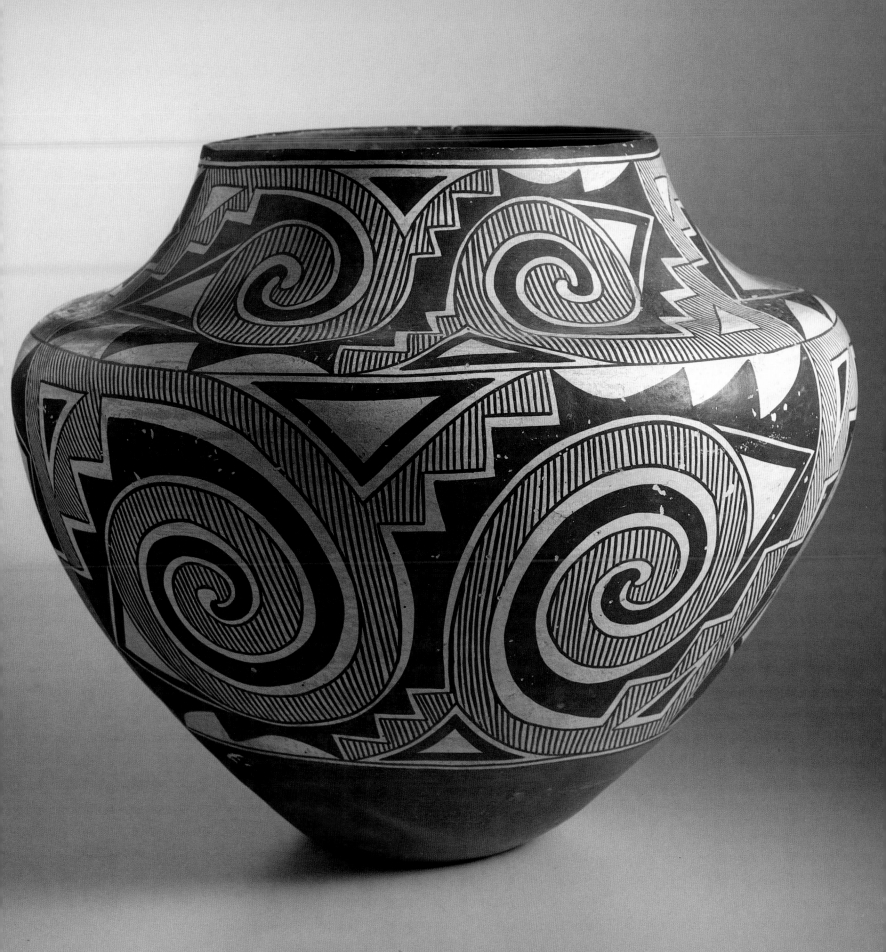

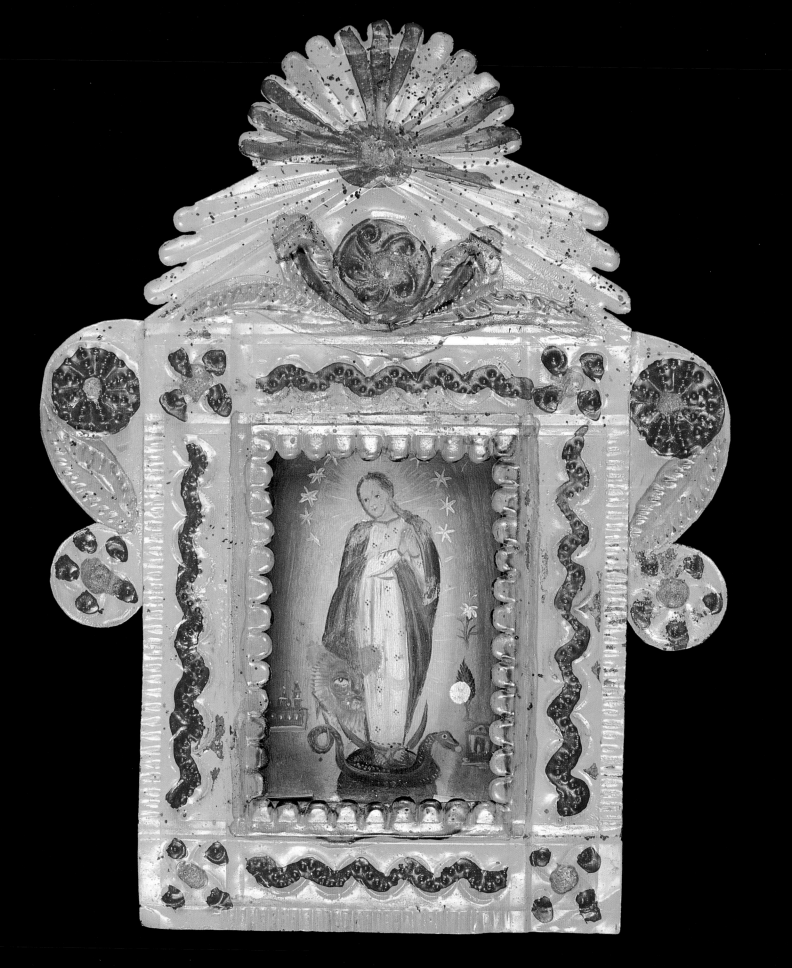

of Ireland. I had walked every lane and bog, knew the people in every neat white house. I had consumed an ocean of creamy tea, had recorded hours and hours of tape, and blackened a heap of fat notebooks with all that passed my eye. I could have written a little ethnography, filling chapters with facts on social organization and economic practice. But I had no real grip on the culture. Then I thought again and relaxed, letting my teachers guide me into chat about historical narratives. Once the gracefully told stories of saints, warriors, and witty farmers became my focus, the culture began to reveal some of its depth to me, and my study was sustained for a full decade more. Historical stories became a lens through which to view, naturally and courteously, the little place its people call Ballymenone.

Saint Brannock's, Braunton, Devon, England

Later, in the village of Braunton in the west of England, I wasted time searching for similar stories, but at last I was led gently up into the ringing chamber in the thick Norman tower of the parish church. There men gathered, and gripping the ropes that controlled the great bells above, they followed the call of their leader to ring out a circling pattern through which all the men changed places until each one had filled every role and the original sequence had been established again. "Call-change ringing" in the tower of Saint Brannock's provided me the entry I wanted into the village's values.

When time allows now, I sit calmly by the weavers at the loom in the villages among the rocks that lift out of the Aegean in northwestern Anatolia, confident that their rugs will carry me into their concept of beauty and along the paths they follow as they construct their connections with the earth, their friends and family, and God.

At the far limits of my experience, in Bangladesh, I stood astounded by the diversity and vitality of the pottery tradition. Around me tiny elephants and horses, enormous rotund vessels, beautiful images of deities, mock fruit wrought in cunning realism, festive jars, and painted tondos rose out of the smooth, cool clay of the vast delta. My fieldwork at home in the United States would yield a widening range of key media—instrumental music in the Southern Mountains, gravestones from early New England, cuisine among Philadelphians of Italian heritage.

The point, though, is clear. People living in intense communication will orient to certain modes of performance and suffuse them so with emotion and meaning that they roll the collective soul open for contemplation. Art is what is best, deepest, richest in every culture. Saying that, we gain an operational definition, good enough to guide study, though standing in need of clarification.

If we define art as a fecund projection of culture, and accept any medium for art, if we dive through things straight into mind, we might have missed something. The problem is not easy to grasp.

In our tradition we have become accustomed to crediting victories to generals and buildings to architects, while forgetting the men who marched or placed stone upon stone. Even more abstractly, we will attribute both battle and building to some monarch who knew nothing of war or masonry. Theorists today sometimes compartmentalize the individual as we once did societies, rendering all praise to the king in the head. As more and more of the body's tasks are assumed by machines that we tend to forget, or by poor people we try to

Opposite
24. *The Virgin "Tota Pulchra." Mexico. Painted tin, with cut, stamped, and painted tin frame, 10 x 7³/₄", mid-nineteenth century. In this specialized depiction of Our Lady of the Immaculate Conception, allegories of her purity surround her.*

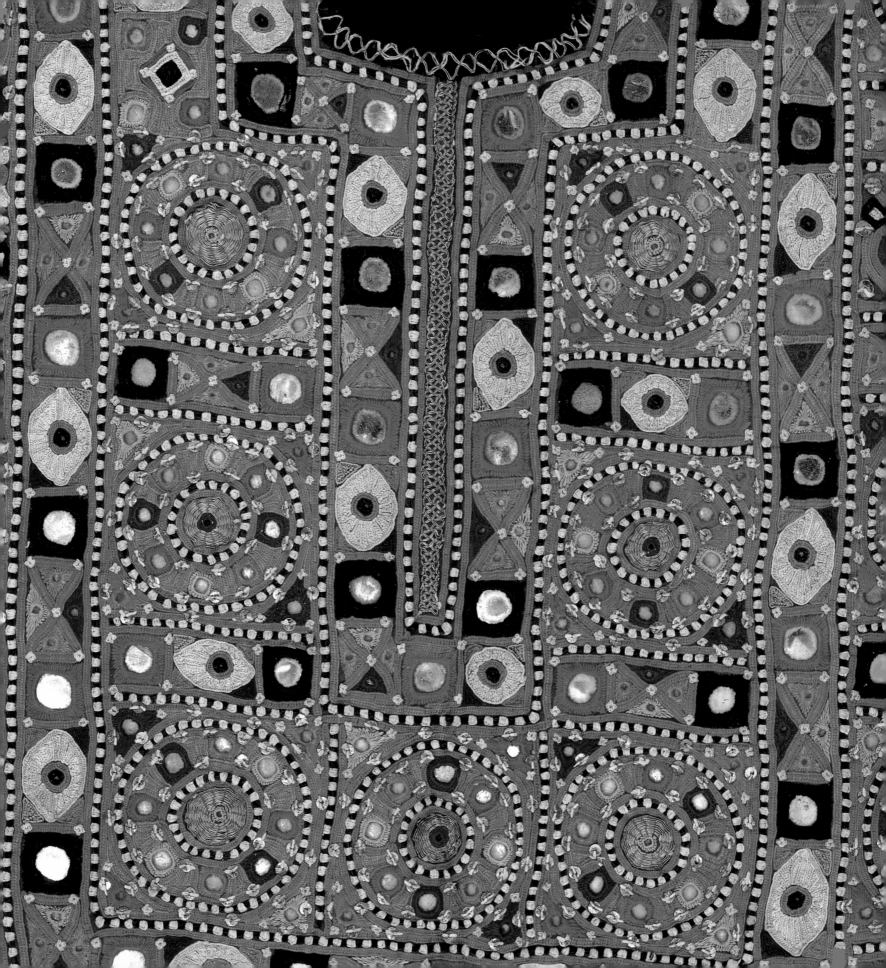

forget, it becomes natural to define people immaterially as thinkers and to focus attention on elegant minds floating free of material concerns. Speech becomes the expression of grammar, objects the expression of design, art the expression of culture. Like grammar and design, culture is an abstract conceptual system. Art is surely an individual's expression of a concept, but that is not all it is.

William Butler Yeats, son of a painter, brother of a painter, trained as a painter, said anyone can envision a great picture. It is easy to form art in the mind. The hard part is realizing it in materials. Art is thinking and it is doing. It comes out of plans and it comes out of thousands of decisions and reactions made as things unfold out of plans in unanticipated and accidental ways. Irreducible to concept, art is culture and it is action. Recently linguists have struggled to get speakers, their heads bloated with intricate grammars, back into social intercourse. Sociolinguistics is a victory for realism. If we remain attentive to the peculiarities of media and the details of material processes, we can get artists back into interaction with the world of sun and shadow, storm and stone.

Sometimes I have found amusing those museum labels that solemnly list substances: oil paint and canvas; plywood, copper wire, and styrofoam; oak and raffia. But there is wisdom in labeling things to connect them to the environments out of which they were hewn. We are reminded not to mistake their authors for angels who occupy a place unlike that we tread.

It is good to remember that art comes from the earth as well as the mind, but when we speak of songs as artistic communication, or describe a graceful move on the basketball court as artistic, we have not lost the old meaning of the word "art." Joined with others that share its root, art becomes the means by which artisans make artifacts. In ancient India and medieval Europe art was skill, at once all skill and the specific skills of craftsmanship: it was that which mastered nature through artificiality. In the last century "art" and "manufacture" were still used synonymously to indicate something handmade. Meanings superadded in recent times complicate our job, but if we hold them aside momentarily to see the older meanings they have obscured but not obliterated, we can think of art as skill in any endeavor, or we can restrict it to skill in material media. I feel the original and broadest meaning to be best, and I believe our study should lead us to understanding cultural excellence, however exhibited. Still, I also see virtue in closing art down around the handmade. So narrowed, the concept forces us to take hands as well as heads into account, and it prevents the rightful power of the makers of things from being stolen away by mere designers or consumers or collectors. It is not the collector's eye that should be complimented or appreciated, but the artist's hands.

We had nearly completed a stroll through his exhibition when a woman came up to Mr. Girard and thanked him. "Thank you so much," she repeated, pumping his hand. Alexander Girard, professional designer, relentless collector, replied, "Don't thank me. Thank the artists of all these countries." He smiled. "Thank the artists of the world," he said.

"Material culture" is an unlovely term, cursed with conflicting meaning. But if we use it to mean the extension of culture into materials, letting it embrace the whole of the handmade world, then "art" would designate its noblest province, and we would be ready to reclaim elder wisdom. Ralph Waldo Emerson said art was a blending of nature and will. Following our old philosopher, we will not be tempted to see art as the fey manifestation of mind, but as the work of a human being at grapple with nature. Reminded that art is work, we can recapture the truth of William Morris' definition of art as that which makes work pleasurable.

[41]

Opposite
25. *Wedding Blouse: Gaj (detail). Possibly the Lohana people, Thano Bula Khan area, Hyderabad district, Sind, Pakistan. Embroidered silk and cotton, sequins, mirrors, 20½ x 42", early twentieth century.*

Work upon the earth, the earth altered, art is blessed with the special property of endurance. All that we can learn directly about the past lies in artifacts, in books and letters, fields and houses, broken pots, knapped flint, split bone. History depends on artifacts. As William Morris taught, all we will ever know about the people of some civilizations is that they thought this thing we hold in our hands was beautiful. But that is much, for every object erupted out of human engagement with the world. The workings of the mind and the touch of the hand live eternally in artifacts.

There is no need for a pat solution. Raising the problem is enough. If we set aside concern about media to meet and compare cultures in terms of their richness, we will be following a sound program of research. Art is such an exalted term among us that calling the best in every culture "art" makes rhetorical sense. At the same time, following the general practice of folk art study and conceiving of art as a special domain of material culture makes sense too. What is important is to hold the word close to its root so that we will not drift into forgetting the true makers of things during our quest for abstract formulations. Artists must remain part of the world, at work on problems of importance with their feet on the ground, their hands in clay.

Thinking of art as any medium through which a culture reaches for perfection, or limiting art to a culture's achievements in materials—either way we face the first of the problems that engage us here. Basically, "art" means making. We can use it to mean all making or restrict it to the making of artifacts. A second problem looms up if we try to narrow the concept yet further to specific material media. It seems easy when scanning the range of our own material culture to identify art with painting and sculpture. But if we let familiar assumptions freeze into a definition, and then venture out to understand other people, our ideas will confuse us and betray them.

One route out of the trap we set for ourselves might be to generalize our thought by means of excited analogy, making sculpture into all objects in the round—chairs, plows, temples, statues—and paintings all things flat. Such a stretch, in which material culture is bisected from the angle of perception, gains us little, and it surrenders both the lofty aspiration in the notion of art and the essence of painting and sculpture: representation. Pictures and statues are things that portray other things.

Our century's greatest artists have freed us to think of representation as more than the effort to capture images of the things of the world. They have enabled us to encounter a piece of West African *kente* cloth or a worn farm tool (like the wooden hayfork that was moved from the Farmers' Museum into Fenimore House to commence the great folk art collection at Cooperstown, New York) in terms of line and form and color—as abstract art. The artists of the Blue Rider associated their revolutionary canvases with Egyptian shadow puppets and Bavarian paintings on glass, with African masks and Gothic sculpture, with folk art, medieval art, and children's art. They called for an approach to art liberated from jaded bias, for a synesthetic demolition of categories. "Tear down the walls between the arts," cried Kandinsky. Duchamp offered a snow shovel for exhibition and signed a bottle rack. The conventional generic structures of art blew up in our faces. But the exhilarated, liberal vision of our artists has been hard to assimilate.

Writers in our days have enjoyed locating visual parallels between Western abstract art and primitive sculpture, folk painting, and oriental carpets. Carefully selected and spotlit, rugs have been made into paintings. Weapons from the war between men and ghosts

Opposite
26. Kente *Cloth (detail).*
Asante people, Ghana.
Strip-woven plain weave
with supplementary weft,
cotton and rayon,
11'2" x 6'10", c. 1960.
Traditionally woven by men
on narrow treadle looms,
the strips of kente *cloth*
were sewn into togas worn
by men of power.
27. Kente *Cloth (detail).*
Ewe people, Ghana or
Togo. Strip-woven plain
weave with supplementary
weft, cotton and nylon,
74¹/₂ x 46¹/₄", c. 1950

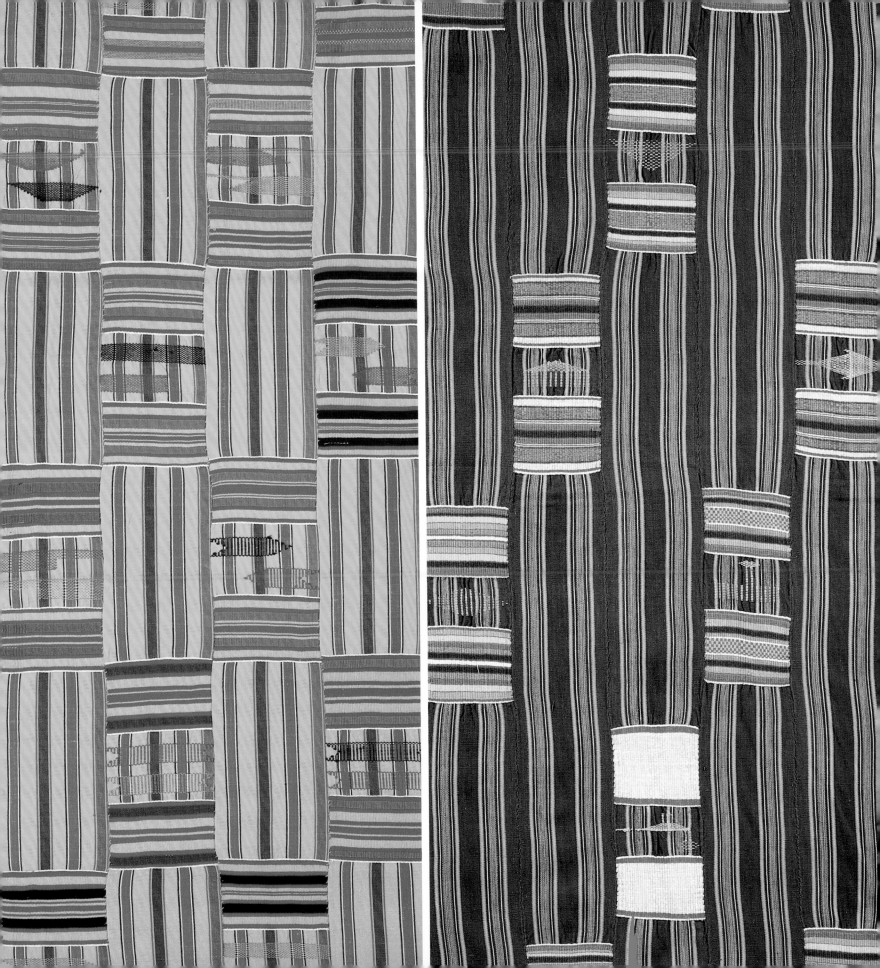

28 29

28. *Jar. Colombia.*
Painted earthenware,
9¹/2" high, c. 1958

29. *Jar. Shipibo people,*
Selvas region, Peru.
Slipped and painted
earthenware, 5¹/2" high,
c. 1960

30. *Opera Singer. Cochiti*
Pueblo, New Mexico.
Slipped and painted
earthenware, 16¹/2" high,
c. 1900. Cochiti men
visiting New York attended
the opera; this figure
records their impressions.

31. *Man. By Felipa*
Trujillo. Cochiti Pueblo,
New Mexico. Slipped and
painted earthenware,
10³/4" high, c. 1960

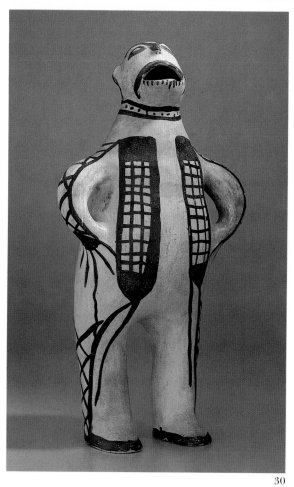

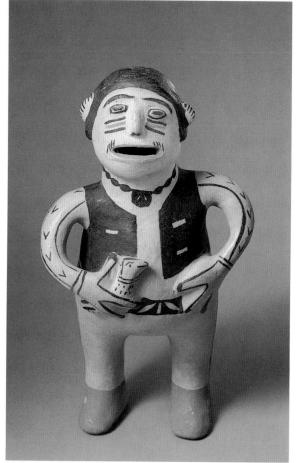

30 31

have been made into sculpture. In response, weavers have rendered paintings in wool. Carvers have created ornaments for the mantel in the shapes of amulets, fetishes, and demons. Intelligently reacting to their new clients—ourselves—artists from other traditions have raised the pictorial quotient in their works.

You would think our century of abstraction would have turned us into devotees of the infinite geometry of Islam. The old woodwork of Morocco and the antique kilims of Turkey have won their admirers. But in Iran weavers are adding more and more cute beasts to their sumaks. In Egypt and Pakistan children directed by commercially minded elders must battle with intransigent textile techniques to create pictures out of them.

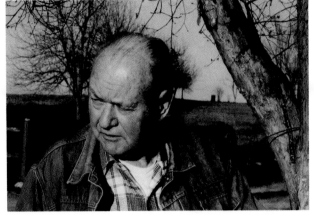

Burlon Craig,
Vale, North Carolina

Burlon Craig is an old-time potter who learned his trade from a man whose house stands within sight of Mr. Craig's kiln in western North Carolina. Despite changes, Mr. Craig keeps at it, for he has, he told me, the potter's mud under his nails. Once he made jugs, jars, and flowerpots for his neighbors. In the old days he made, too, the occasional "ugly jug." He has learned from the scholars and dealers who are his customers now that the form, a jug with a face on it, grew out of the Afro-American tradition. More to the point, he has learned such jugs sell well. That is what they want nowadays. So every kiln he burns is heavily populated with human figures. Mr. Craig's friend, Lanier Meaders, learned to make jugs with faces from his father, Cheever, in northern Georgia. Today he not only makes more of them to meet the market, he has altered his father's model, making his jugs less like jugs, more like heads, turning what was stark and haunting into something fleshier and more lifelike.

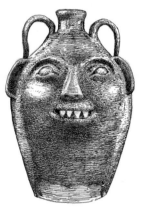

Jug by Burlon Craig,
Vale, North Carolina

There is pattern in the reaction. When the tradition is figurative, it becomes more naturalistic upon contact. That is one trend in contemporary African sculpture, paralleled in the changes in Lanier Meaders' ugly jugs and in the kachinas of the Hopi carvers. When the tradition lacks figures, they are added. It is fortunate that about 1950, shortly after the first visits from collectors, a potter among the Shipibo in the forests of eastern Peru was inspired to model faces upon useful jars that had been decorated geometrically. Her innovation was copied widely, for pots with faces, analogous to the Southern ugly jugs, proved commercially successful. When a tradition's figurative dimension is slight, it is expanded. That is what Burlon Craig did, and the Pueblo pottery of New Mexico offers another instance.

Though the great Pueblo tradition has been dominated (as at Acoma) by useful vessels decorated with geometric designs, it has contained since ancient days a figurative theme. Evidence for the continuity of figurative work is slight between 1500 and 1875, but in the last century it has flourished, especially at Cochiti, in caricatures of outsiders and images of mothers singing to children.

When Helen Cordero of Cochiti turned to pottery late in life, she found her talent in shaping figures of clay. One of the first times she exhibited her work, Alexander Girard

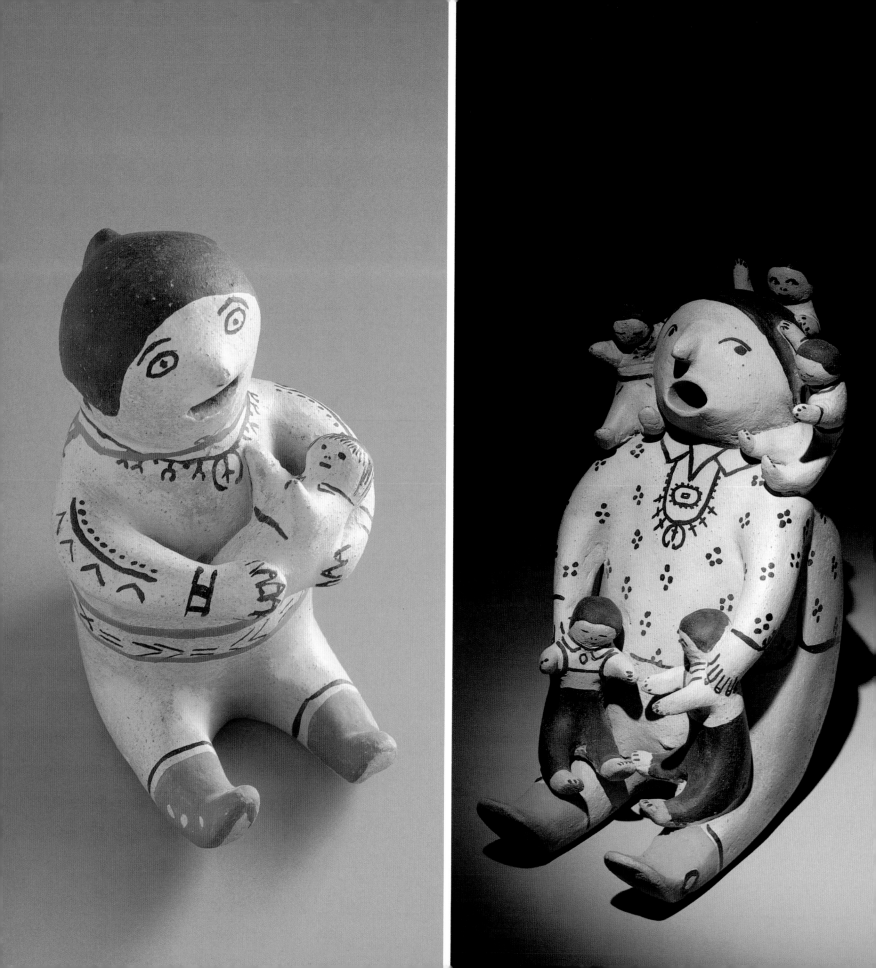

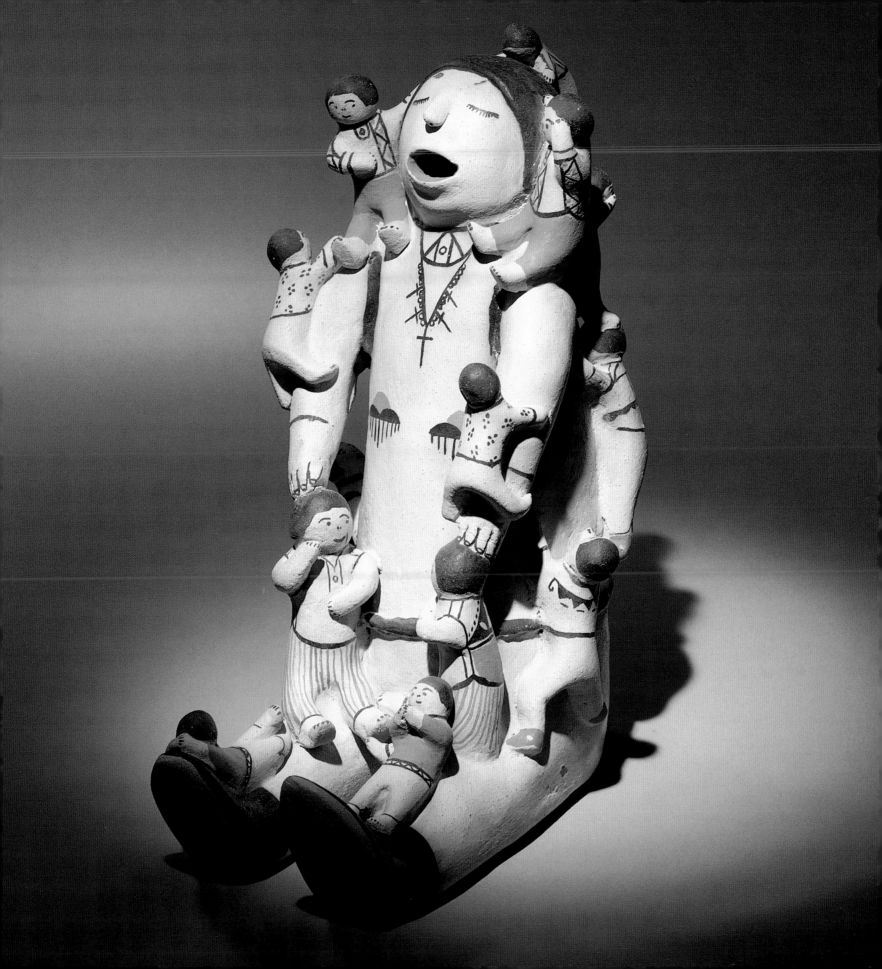

Preceding pages

32. *Singing Mother. By Helen Cordero. Cochiti Pueblo, New Mexico. Slipped and painted earthenware, 5³/8" high, c. 1958–63.* This early work by Helen Cordero is a forerunner of the storyteller.

33. *Storyteller. By Helen Cordero. Cochiti Pueblo, New Mexico. Slipped and painted earthenware, 8¹/4" high, 1964.* This is the first storyteller, made for Alexander Girard in 1964. It is a portrait of Helen Cordero's grandfather, and since she is one of the children, it is a self-portrait as well.

34. *Storyteller. By Helen Cordero. Cochiti Pueblo, New Mexico. Slipped and painted earthenware, 14" high, c. 1965–67.* Through the market, the storyteller connects Indian artists and white patrons. Helen Cordero's grandfather was an important anthropological informant, so his image is an appropriate personification of communication between Indians and white people.

This page

35. *Bank. San Pedro Tlaquepaque, Jalisco, Mexico. Painted earthenware, 7" high, c. 1960*

36. *Head. Acoma Pueblo, New Mexico. Slipped and painted earthenware, 4⁵/8" high, c. 1960.* Frances Torivio at Acoma said such heads represent ritual clowns.

37. *Female Figure. By Anita Lowden. Acoma Pueblo, New Mexico. Slipped and painted earthenware, 7³/8" high, c. 1960*

38. *Mermaid Jar. By Laurencita Herrera. Cochiti Pueblo, New Mexico. Slipped and painted earthenware, 7¹/4" high, c. 1960*

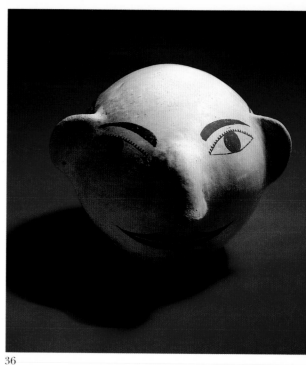

35 36

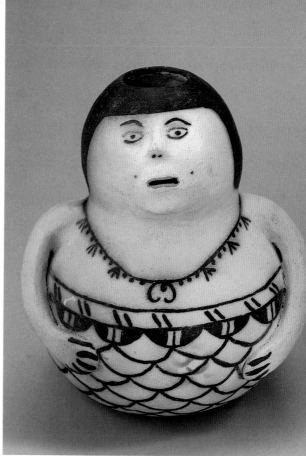

37 38

[*48*]

bought all she had made. He commissioned an enormous Nativity, and he asked her to make a larger singing mother with a greater number of children. She thought about her grandfather, a famed storyteller and anthropological informant, and she shaped an image of him telling a tale to his five grandchildren. Her figure was the first storyteller.

That was 1964. Today as many as three hundred potters in thirteen pueblos have created storytellers. The form has elaborated in many directions: men, women, mudheads, koshares, mermaids, bears, turtles, coyotes, owls, children numbering past one hundred. Every exhibit of Indian arts contains storytellers in abundance. There are storyteller Christmas tree ornaments, storyteller T-shirts, a gallery called The Storyteller in Santa Fe. It has become, says Mr. Girard, "a regular storyteller industry." Storytellers bear a real relation to elder tradition, they are fun for the potters to make, they are shaped in accordance with the distinct styles of different pueblos. And they are commercially apt. Their excellence relies on the integrity of individual artists like Helen Cordero of Cochiti, Ethel Shields of Acoma, Mary E. Toya of Jemez. Their extreme popularity depends on customers trained to think of art as representation.

Storytellers by Frances Torivio of Acoma, for sale at Indian Market, Santa Fe, New Mexico

Whatever our reaction to the storyteller industry, to pictorial rugs or stony ugly jugs that break into fleshy smiles, or to kachina dolls that lean out of static frontality to assume poses of suspended motion, they mirror our thought. In the actions of foreign artists striving to learn our taste, whether to follow us into the future or profit from us now, we encounter ourselves. Our artists exhibit shovels, package hillsides, shoot themselves, and we continue to think of art as mimetic painting and sculpture.

The most abstract work becomes representational. The critic turns the arrangement of colors into a portrait of the artist, naming it a Stella or a Rothko, and then makes it an illustration of an art historical principle, a depiction of its moment or movement. The anthropologist or folklorist comparably reads the abstract work as a diagram of a culture. Modern painting enhances our appreciation of that piece of *kente* cloth, but it becomes meaningful to us as a historical fact—a motif out of the epic telling of Mande influence on West Africa and African influence on the New World. It is an incarnation of a rhythmic structuring of consciousness. It represents a culture.

Put it this way. In our world it is the task of art to represent, whether the tortured psyche of the artist, the evolution of art, the inner dynamic of a particular culture, or the glorious sky of the wilderness at twilight. It is the duty of media free from other responsibilities—painting and sculpture—to perform that task.

Our tradition teaches us, when we look for art, to concentrate upon painting and sculpture, material media that share the task of representation. If our attention does not wander, no troubles arise. Look back upon the United States in the nineteenth century. Focus upon the paintings of Cole and Church, Homer and Eakins, and you will be led far into the spirit of the age. But if you press backward, past Copley, and continue to identify art with painting, you will distort the reality of a society more concerned with furniture than pictures. Or, if you remain in the nineteenth century, but press beyond the small, internationally oriented, Northern, urban culture of the academic painters—say, up into the deep coves of the Southern Appalachian realm—your notion of art will fail you. It is not that the

mountain people were void of the impulse to art. Their creative genius thrives as the basis of a variety of popular music that girdles the globe: listen to country-and-western bands from Ireland or Australia, to bluegrass pickers in Germany or Japan. But the mountain people were not painters and sculptors.

Back into the eighteenth century, up into the mountains—these are but baby steps. Take a real stride, and you must pause to strip away conventional wisdom. In a truly foreign scene, I repeat, it takes time to learn what art is. If we think its art must resemble ours, we may miss what is best and distort the culture by overemphasizing media that may be of marginal import. Ottoman miniatures are vibrant in color and magnificently designed, but if we were to use miniatures to represent Ottoman civilization because they are a kind of picture, we would miss the cultural center. The gleaming ceramics of Iznik, the smoldering stately velvets of Bursa and Istanbul lie closer. At dead center rises the monumental, mountainous architecture of Sinan and the calligraphic masterpieces of Şeyh Hamdullah and Ahmet Karahisari. Like the Renaissance painting of the same time, Ottoman calligraphy formed in schools around great masters whose lives are well known, whose works survive to influence the revered artists of our day, Mahmut Öncü, Hasan Çelebi, Emin Barın.

Assuming the search for art must lead to pictures and statues, we distort distant cultures. Distorting them, we subsume them in a conceptual variety of colonialism. Choosing to stress the pictures of cultures that do not stress pictures, we implicitly compare other cultures with our own and come out looking best. No matter how lavishly we laud Ottoman miniatures, we know they do not really measure up to the pictures we claim as ours, those painted at the same time by Raphael and Michelangelo. A Turkish art historian similarly disposed might perform a cross-cultural comparison of calligraphy to demonstrate the superiority of his culture.

The colonial impulse (hidden in our definition of art in terms of the media in which we chance to excel) rises close to the surface upon contact with the product of societies less "developed" than our own. Appreciating whimsical figurines from impoverished nations or the "naive" paintings of poor preachers, elevating souvenirs or hobbies to art, is less mean than dismissing them from serious consideration. But our praise pushes them into comparison with the great works of our culture. They will not stand it. Ask, do we praise humble things, in fact, to praise our own liberality? Does our enthusiasm only solidify our own superiority?

The art of the other must challenge us. Foreign cultures, that of imperial Istanbul or that of the lost mountain cove, should be approached cautiously, fearfully, reverentially. Our simple assumptions about life and art should be upset on contact.

Our tradition, like them all, has grown strangely. It is the result of millions of accidents and cannot serve as a measure for humankind. We can learn that from studying our century's great philosophy—anthropology—or from wandering attentively through a truly international collection of art. The vast halls of The Metropolitan Museum of Art in New York are filled with humbling experiences for the haughty modern man. Alexander Girard's installation in Santa Fe teaches the lesson most economically. Try as we might to assert our dominance by writing world history from our provincial perspective and by assembling collections of art that feature paintings, other artists will resist us through the creation of excellence hard to fit into our schemes.

If we had to define art by particular media, it would be best to forget all about the

Opposite
39. Bank. Tonalá, Jalisco, Mexico. Painted earthenware, 6" high, c. 1960

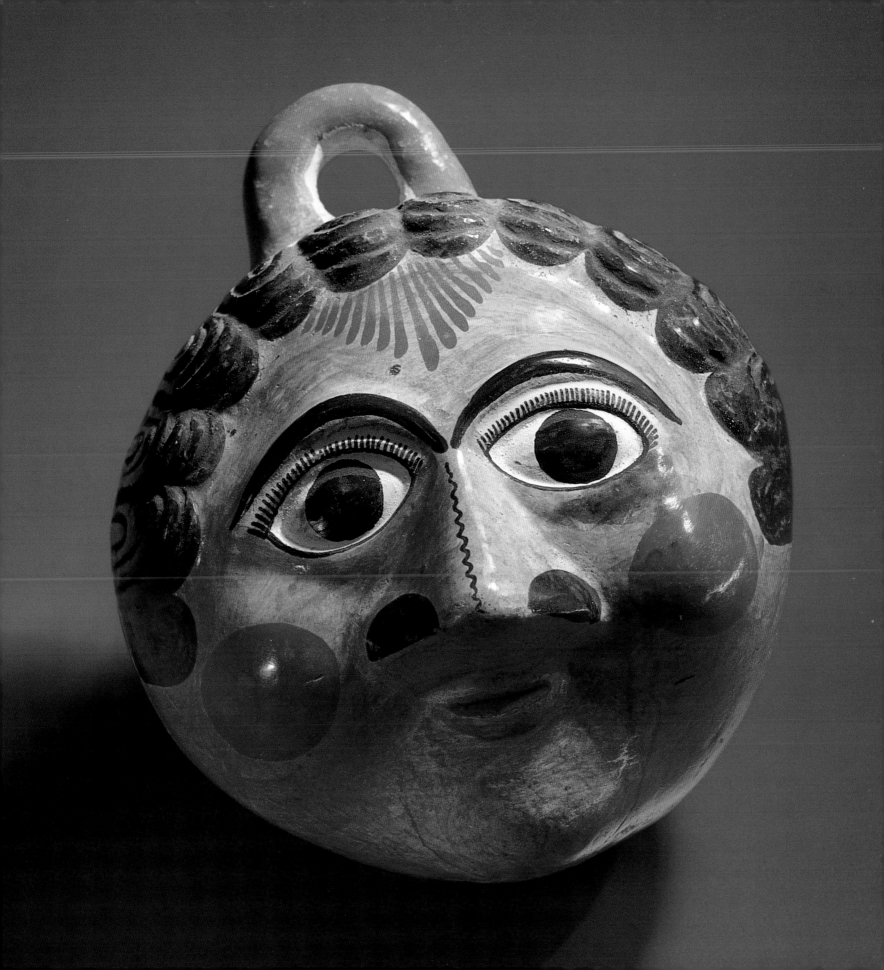

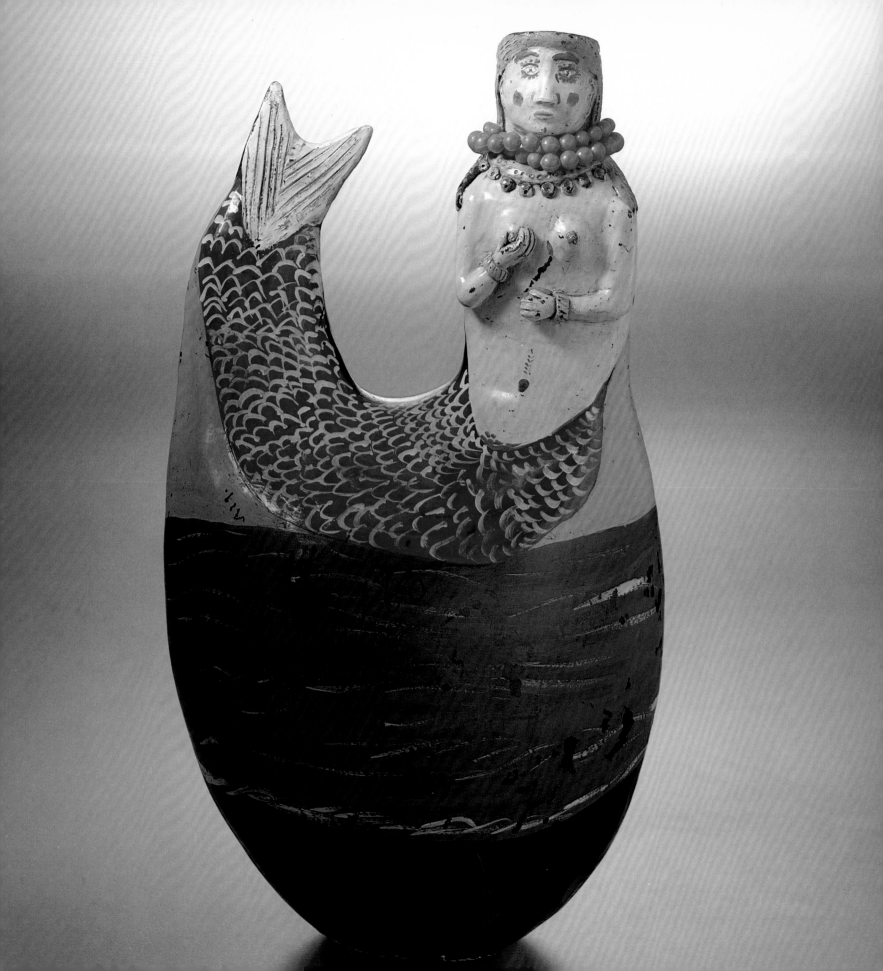

rare, late tradition of easel painting—an accident of our development—and focus instead on architecture, textiles, and ceramics, for they approach nearer to universality. We might not fare so well, for our love of pictures has deflected our attention from media of wider importance. The modern West can offer no building to compare with Hagia Sophia, no weaving to compare with the classical carpets of Iran, no pottery to compare with Chinese porcelain. But we are not obliged to identify art or compare cultures in terms of certain media. To compare more adequately, we shift from medium to function.

Thinking about function, we split the world of material culture, dividing artifacts into those that serve some utilitarian end and those that do not. If art is that which is not utilitarian, then art must be ornament. We conclude that art consists of objects decorative in intent, and craft of useful things. Then our simple conclusion drops us into a thicket of confusion. Two problems rise immediately. First, the word "art" has been invested with more power than can be contained by the idea of decoration. Second, no object is purely utilitarian or purely decorative.

Why decoration? Rummaging through artifacts to find art among them, we look for signs of excellence. The unadorned object can seem like a fragment of nature, the outgrowth of forces and counterforces at play. We want proof that people are not overwhelmed by base necessity, that they are capable of rising into joyous control of their conditions. An artist must have the time and energy, the freedom and talent and desire, to make things better. Art does more than satisfy. It aspires. Decoration—the unnecessary embellishment of form—is the most conspicuous index to aspiration. Forming a pitcher, the potter must make it hold liquid, may add a handle and spout to ease the act of pouring, but when he spins a stripe of slip around its belly or splashes a flower onto its side, he urges his work beyond utility and calls us to consider his presence. Layers of thin cloth stitched together keep sleepers warm, but when the quilter's stitches transcribe a floral outline, or the top layer spreads, patch by patch, into a colorful mosaic, she has communicated her wish for excellence. Concentrating upon the decoration of a thing, we are moved toward some comprehension of the maker's intent. We feel the worker in the work and begin to think of it as art.

It is easy to see why curators call folk art those pieces of furniture carved or painted with inessential flowers. They pull us into confrontation with a human being in the midst of pleasure. There are traditional cultures, notably in Northern, Central, and Eastern Europe, in which ornamental elaboration identifies works of art. But decoration is only one of the ways artists communicate excellence through material media. It is the most obvious, and so collections abound with ornamented things. Our excitement around decoration, however, at last bespeaks the sad distance that lies between us and them. If we step more imaginatively into the artist's world, we will discover other vehicles for excellence. Most profoundly, form itself.

Pitcher by Cheever Meaders, Mossy Creek, Georgia

William Morris, craftsman and designer, spoke the truth when he said that "everything made by man's hands has a form, which must be either beautiful or ugly." The simplest form, though we see in it only utility, always bears the potential for perfection. Averting our eyes from things so familiar that we can no longer see them, and looking upon forms that others comparably take for granted, we will learn, say, that there are thousands of ways to

Opposite
40. *Mermaid Jar. San Bartolo Coyotepec, Oaxaca, Mexico. Painted earthenware, 20″ high, c. 1935*

[53]

41

41, 42. *Bag (both sides, with details). Otomí people, Toluca, Mexico, Mexico. Double-weave cotton, 8¹/₂ x 9¹/₄", c. 1930. Artistic play with the word* recuerdo *(remembrance) makes this bag a special memento.*

43. Bag. Nez Perce people, Plateau area, Washington or Idaho. Weft twining, cornhusk or bear grass and wool on cotton warp, 18³/₄ x 14¹/₄", c. 1920

44. Basket. Aleut people, Aleutian Islands, Alaska. Woven grass and silk thread, 7¹/₄" high, c. 1920

45. Basket. Nagapattinam, Tamil Nadu, India. Woven palm leaf with foil, 6¹/₂" high, c. 1965. Muslim merchants market the baskets woven by the Muslim women of Nagapattinam throughout India and Southeast Asia. As the market has grown, Hindu women have joined in the elaboration of the distinct local style.

44

43

45

shape a vessel that will hold and release liquid. Pitchers may be squat or lean, with long necks or short, wide mouths or narrow; they may lack the globular shape, the flattened base, the handle or spout we think essential to the idea of a pitcher. Each of them, while attributed to utility, will embody a people's ideas of proper form.

Cross-cultural experience should teach what modern designers, inspired by Morris, tried to teach: pure form perhaps most purely embodies beauty. The gaudy, tawdry painted chest clamors for attention. The plain and perfectly proportioned chest waits serenely to stun the subtler eye with its radiance and coherence. If we add basic form to applied ornament, we still have not exhausted our catalog of the ways that artifacts incarnate excellence.

Seemingly lost in form and ornament, yet alive with the power to pull us into engagement with an object's quality, is craftsmanship: the gleaming liquid surface of Japanese lacquer, the slim, impeccable coils of an Eskimo basket, the repetitive marks of the mason's chisel floating on stone. Artisans from widely different cultures with whom I have talked have stressed technical virtuosity—more than form or ornament—as the key to their effort.

Technical skill brings into control the wildness that surrounds us, spreading away toward the unknown, and the wildness that rises within to divide the mind from the body. It makes sense that people living close to chaos, engaged daily in contests with nature, would locate art in technology, appreciating the straight furrow, the whitewashed wall of neatly placed stone, the symmetrically shaped and well-fired urn. If art is reduced to form, technical skill is merely the way ideas are translated into materials. If art is reduced to feeling, technical skill may get in the way of the expressive spirit. Such reductions befit settled, contemplative scenes. But for those in action upon the world, for the hunters and farmers who win life directly out of nature, who exist in a state of wonderful war with forces from beyond, it is reasonable that nature's reordering would be central to their idea of art, that they would evaluate objects on the basis of skill, that their works would feature repetition and symmetry as signs of control, that they would have no word for artist in addition to the word that designates the person of perfected skill: master.

Sabri Yaşar, Soğuk Kuyu, Bursa, Turkey

In the dusty shop, the true master is often admired most by his co-workers for speed. It is the perfect demonstration of control over mind and body, tools and materials. The skill is athletic. When Sabri Yaşar in the pottery of the Cold Well near Bursa, in Turkey, centers a great lump of mud on his kick wheel and pulls the clay rapidly through his dancing fingers into a perfect pitcher, his colleagues are distracted from their work and watch in silent admiration. They call him master.

Dan Garner of the Teague Pottery in North Carolina said it best when he contrasted his work with that of "art potters." They have time to fret over every piece. He must work swiftly. To him it is not the individual piece that is important but the general quality of all the pieces in a particular kiln. The best hitter in baseball fails more often than not. His average, and not any particular performance, marks him as great. So it is with the hardworking artisan. A high average makes him an artist. The athletic folk artist beats the conditions set by life in works that are good and quick.

Speed is the worker's own prime criterion of excellence. It does not register in arti-

facts. But technical mastery can achieve permanence in size. The potter of utilitarian ware secures his status by turning giants that dwarf the efforts of lesser men, that stand in the gaze of the knowledgeable as exhibits of personal quality. At the other end of the scale, craftsmen test themselves by making useful things too small to use. While modifying utilitarian forms in no way at all, tradesmen follow the route of miniaturization into the creation of sculpture. Hugh Patrick MacManus' wee basket the size of your fist is a three-dimensional, superrealistic representation of the willow creels he makes his neighbors in Ireland so they can lug turf up the hill from the bog.

Daniel Garner, Teague Pottery, Robbins, North Carolina

By the unwritten rules that rise repetitively and independently among the workers at useful trades, the tiny thing must rise out of conventional technology; the same tools must be applied to the same materials. The turner will create a dainty bowl the breadth of his thumbnail on the lathe to which he daily goes to work. The rough old potter will center a dollop of clay and turn on his wobbly wheel a pitcher fit for the queen of the mice.

Become enormous or minute, the useful form calls attention to the skill required in every act of manufacture. Ordinarily, care is displayed at normal scale in the midst of common work. The tiny, even stitches of the master quilter, the invisible joints of the master cabinetmaker, the steady, smooth lines of the engraver—these are the artists' own marks of excellence. When they reach beyond their circle of adepts to convince others of their skill, they will exaggerate technical perfection, weaving their rugs with smaller and smaller knots, building their pots with thinner and thinner walls.

Moving in the company of things and attempting to discriminate among them, we learn that their excellence, their aspiration toward art, may lie in ornament or form or technology. Similarly, looking for things to call folk, we find objects that may answer our definition in their decoration or their shape or their mode of manufacture. Trying to get at the rationale for the interest in decoration, we have adopted an analytic approach. We have broken things down, but artifacts fight our efforts in blends of art and craft, of the folk and the nonfolk. They unify what we sunder.

Separated out of nature, artifacts must claim the integrity of form. The act of separation leaves on things the marks of the hand. To color or leave natural an object's surface is a decorative decision. Lifting the work toward excellence, the maker may emphasize one or the other of these features of all artifacts, covering the object with intricate ornament, shaping its form toward the harmonic perfection of an angelic chord, building into it insistent signs of deft fingers in motion. We engage with these distinct signals to recognize art, but the artifact remains a unity effected by the fourth dimension of all things: use.

Think of a house. It is a matter of form, of the sculptural arrangement of masses and voids. It is decorated. Its walls display the colors of stone or wood or earth, whitewash or paint; it may be enlivened with fretwork, encrusted with rows of brackets or swirling suns. The house contains its technology; all over it the touch of the tool will reveal the care of the hand. Its parts fuse in use. Seen, the house is used as an emblem for its occupants. Entered, it is used as a stage for the social drama, as shelter from the storm.

Let us say that things used to meet practical ends are tools, while things used decora-

Opposite

46. *Bowl. Takamatsu, Kagawa, Japan. Turned, lacquered wood, 5⅞" high, c. 1935. Like the glaze on a pot, lacquer on wood simultaneously makes it more useful—impervious to water—and more beautiful.*

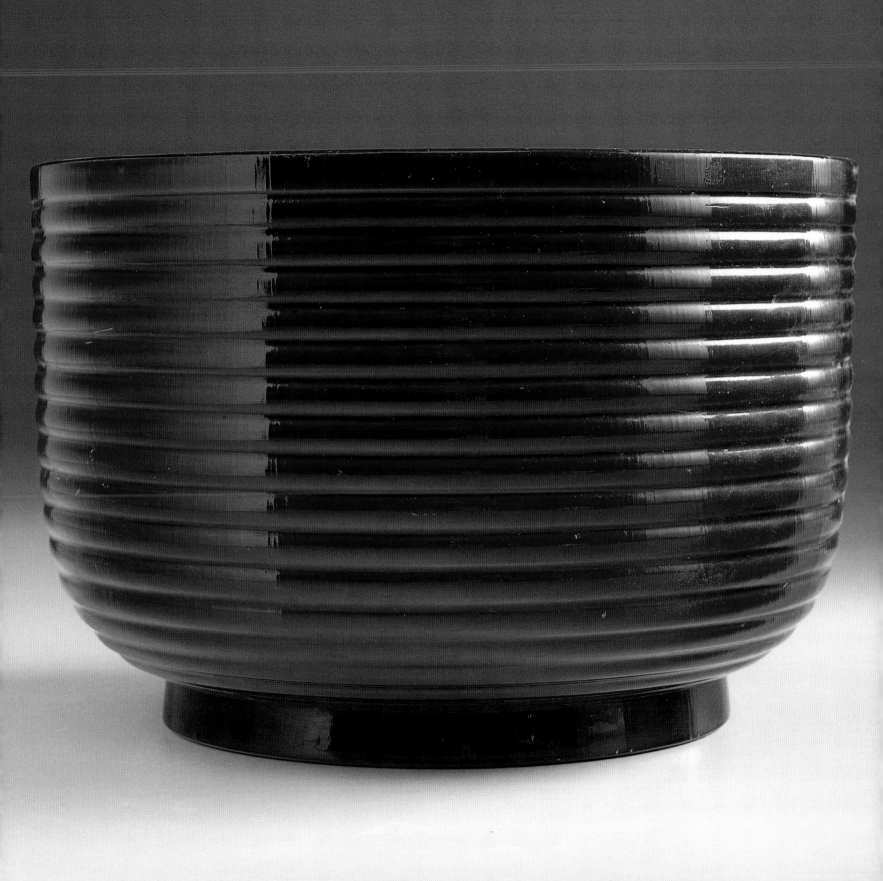

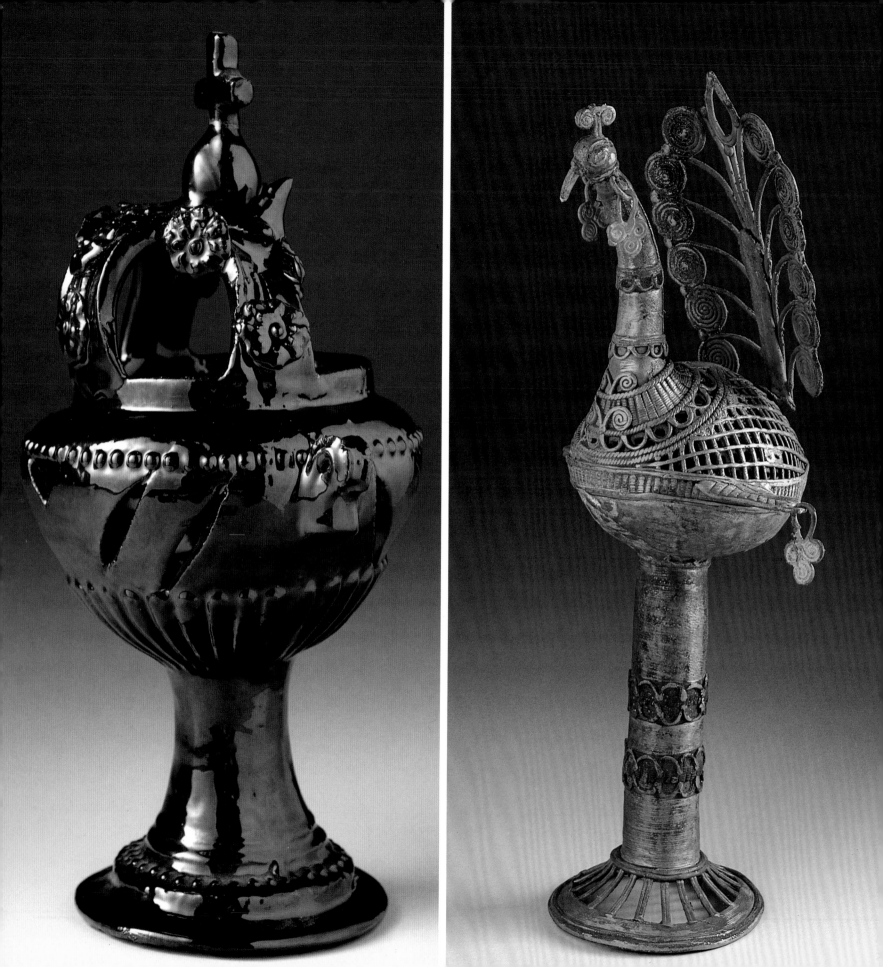

tively are art. Among our conventional categories there is an old one that betrays our discomfort with such simplicity: decorative art. Ironically, the class of art we call decorative consists of useful things: silverware and furniture, textiles and ceramics. Classifying something as decorative art, we remove it from the sphere of tools and increase its value, but its multifunctional reality remains. The antique silver teapot posed in the gallery invites consideration of its sculptural qualities. And it dares you to lift it, to feel it warm with liquid, to tip it, and restore it to useful service.

The ease with which we shift things from place to place bespeaks their complexity. The traveler to Africa buys a shield made for war, carries it home in bubblewrap, and hangs it on the wall. It becomes an ornament. The Kurdish shepherd walking the highway finds a dazzling, chromium, moonlike gas tank cover. He pockets it so that it can become the centerpiece of a hanging in his tent. Such acts, during which tools permute into decor, do not so much move objects from one category into another as they rearrange the functional hierarchies implicit in objects. They amount to witty recognition of the artfulness that lies in tools. They parallel the designation of an armchair or a teapot as decorative art.

Looking upon a teapot as though it were sculpture or a shield as though it were a picture, we erect a class of mixed object located at the midpoint of the continuum that runs between the utilitarian and the decorative. Then, attempting to clarify our thought by discovering an example of a purely decorative object, we find that function leads more smoothly than medium into our fascination with paintings and sculpture. They embody inutility. Framing the picture and lifting the statue onto a pedestal, we effect a separation between the world of tools and the world of art. We divide material culture as we do society. Over there stand things and people that labor. Over here reside the things and people of leisure. In our effort to free things from dirty conditions, we have created an artifactual aristocracy of idle objects. Our thought has thrown a wall around an exalted sphere of irresponsibility in which things exist for themselves, the domain of art for art's sake.

Isolated from work, art is isolated from participation in life. Its separation is clarified by touch. Tools are to be handled. Art is not. Irish country people arrange useable plates on a dresser and call them "delph." Ellen Cutler defined delph precisely as "not for using," and she associated the plates agleam in neat rows on her dresser with the other "ornaments" that beautified her kitchen. She had plates to use stacked away in the pantry. Hungarian peasants once carved and painted tools so lavishly that they could no longer be used. They became items to display in proud homes. For us—though I would wager you have in your home things that could be used but that, instead of using, you exhibit—for us, it is pictures. We place them carefully out of touch on the wall. There they become decoration. But, as decoration, they become part of a building that serves the humble, mundane function of shelter.

Ellen Cutler's dresser, Ballymenone, County Fermanagh, Northern Ireland

The media we cherish most were once architectural ornament. Then paintings ripped free of the building's walls and drew frames around themselves. Statues stepped out of architectural compositions into independence. They became transportable, saleable, and we learned to isolate them in our imagination as things without settings, as bits of pure decoration. In reality, they are always elements in some larger, multifunctional object.

Opposite
47. *Incense Burner. San Juan Metepec, Mexico, Mexico. Glazed earthenware, 11 1/2" high, c. 1960*
48. *Incense Burner. Bastar District, Madhya Pradesh, India. Cast brass, 13 1/4" high, c. 1950*

[61]

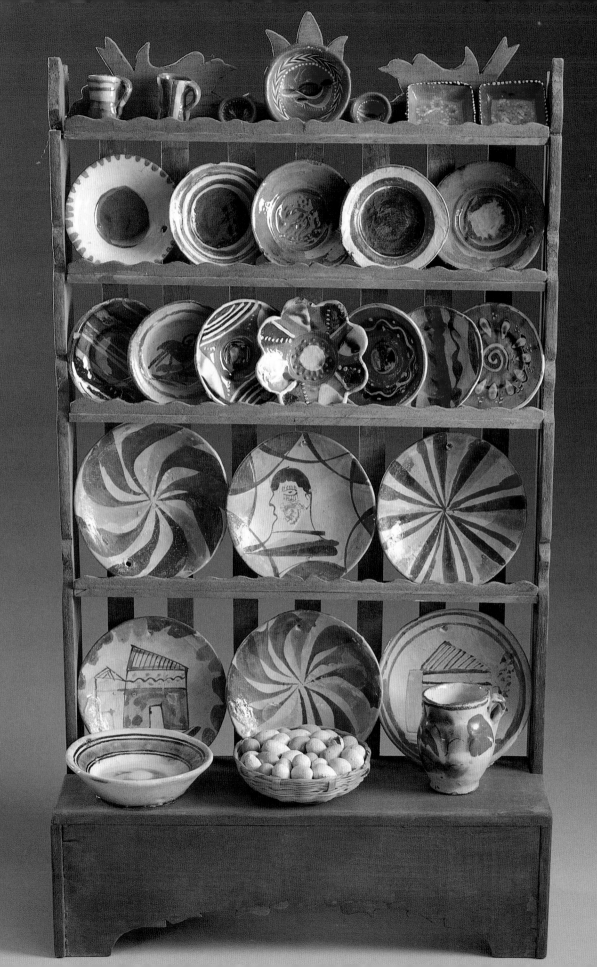

The museum seems a supernaturally neutral space, but museums serve the practical end of preserving artworks from harm in environments controlled for humidity, light, and temperature and making them available to devotees willing to pay for their upkeep. Abandoned to nature, artifacts crackle, wither, fade, and die. In museums or temples or homes, they exist within systems on which they depend for life.

Uselessness fails us as a definition of art because the decorative object is always part of a larger useful object. A painting is to a building as embroidery is to a coat, as carving is to a wagon, as a flower garden is to a farm. Take the painting from the wall and move it. Move it again, but it will always come to rest as part of some larger physical context.

More important, it will always exist in a conceptual context within which its decorative purity will be proved false. The delph on the Irish dresser is more than ornament. It arrived as a series of gifts, and it works to solidify social associations in the mind. The lavishly useless Hungarian tool is part of the ceremonial life through which the community is constructed. Hung in a museum, the picture is not only a small part of the grand sociopolitical scheme through which rulers maintain their power, it is a major element in the system through which painters, dealers, curators, and critics make a living. Through the efforts of those to whom it brings profit, it is made as much a part of history as a painting in a church is part of religion.

Chapel in the Papago country, Arizona

If you take the picture away from the church, you may be able to strip it of religious purpose. James Joyce was capable of watching a High Mass as though it were a handsome dramatic spectacle. But removed from one context, the picture will merely fall into another. No longer religious, it becomes historical. It begins serving new masters and assembling new associations through which serious scholars work to locate it again in its original scene of richest significance where it was enmeshed in a dense web of need, bringing material reward to its maker, calling the faithful into orthodoxy, aggrandizing temporal power, effecting social order—where its utility was plain to see.

Try as we might to confine art to the realm of decorative uselessness, it will punch through simple schemes and reassert its reality. Simultaneously through physical and conceptual contexts, art reaches out to contact the real world in all its sordid, delightful complexity.

We have done what we could with decoration. It carried us into art, but it could not encompass art. Art is bigger than decoration. In pursuit of more expansive terms, let us declare that art can be decorative, but it must be aesthetic.

The word "aesthetic" troubles us. It means too much and it means too little, and it feels like one of those words fancy folk use to keep meaning from us. But we use "anesthetic" easily in the common language to mean that which deadens the nerves. The aesthetic is the opposite. It enlivens the nerves. When the nerves are thrilled, when the senses seek their own pleasure, action is aesthetic. It has met the first requirement of art.

The idea of the aesthetic puts us on the high road to art. Then we lose what we have gained and find ourselves at a dead end by reducing the aesthetic to a variety of reaction. It suits a consumerist mentality to call aesthetic the things that stir us—an opalescent shell found on the sand, a delicate watercolor found at a garage sale. But using the word to name a

Opposite
49. *Miniature Dresser. Mexico. Wood, earthenware, basketry, 13¹/₂" high, c. 1950. This is an assembled representation of the object that, mixing art and utility, symbolizes hospitality and domesticity in traditional homes throughout the West.*

wholly personal experience, we stumble in our search for art.

I recall once showing a brand-new jug to a friend, a highly trained art historian, and using it to support my contention that folk art was alive in America. He said the pot was not art; it did not move him, he had no wish to own it. A momentary wave of noncomprehension numbed my mind and tongue. As I drifted back into conversation, I thought, what possible difference does his opinion make? I am talking about art, not commerce. In that moment I had defined art wholly in terms of the maker's expressive intent. My friend's definition took into account only the reaction of the perceiver. We were both wrong.

The aesthetic is a matter both of intention and reaction. It is taken as well as found; it is expressed as well as received. Pure intention and pure response drift apart and coil into the sleep of solipsism. In art, intention and response embrace aesthetically.

Saying an object is aesthetic and meaning you like it might help you assemble a collection of things to illustrate your own taste, but it does not advance serious study. Study advances in the careful matching of intention to response, in their union in things. Being aesthetic, an object is a communication about feeling.

In work the artist finds pleasure. The fingers run boldly, voluptuously among materials. The mind directs the completion of plans and relaxes with satisfaction. Released to stand on its own, the object preserves and projects the artist's delight. It comes upon observers as a subjective entity, a human thing, a witness to creation. Agitated into attention, observers discover the artist's pleasure in the object and repeat it within themselves. The aesthetic mission of the object is complete. It has communicated feeling.

The first way to undermine the idea of the aesthetic is to reduce it to reaction. The second way is to specify one sensation too quickly when speaking of feeling. Let us proceed directly. The aesthetic is the pleasure of the senses. Pleasure is fun. Fun is the feeling of release from toil into a free state of play. The artifact of play is the toy. It is instructive that the Girard Collection could be assembled around the idea of the toy and end up overlapping significantly with folk art.

All day at the wheel, the potter feels pain. His sense of delight can become dulled by the repetitious production of useful jugs. So he pleases himself by playing with their decoration. Then, choosing a practical pot on the basis of its ornament, his customer joins in his game and plays with the potter. Together they dance to the same soundless tune. In this closure of intention and response, in this communication about joy, lies the emotional rationale, the real reason for the importance of ornament, as William Morris stated so clearly a century ago: "To give people pleasure in the things they must perforce *use*, that is the one great office of decoration; to give people pleasure in the things they must perforce *make*, that is the other use of it."

Decoration is the toylike aspect of the useful thing, its conspicuous gesture toward joy. Delight appears amid daily work, just as decoration appears on tools. But sometimes the potter takes a break. During the change that is as good as a rest for the worker, he answers his inner need to play, purifying the pleasurable dimensions of his craft in whimsical creations. Since he is not alone in the world, he intends the things into which he has released his playfulness to be used by others in their play. He makes toys. He shapes a little horse upon a wheeled platform for a child to pull into fantasy. He spins into elaboration a merry jug for his co-workers to use in rambunctious sport. Toys materialize the spirit of fun. Not all toys, of course. The child may be thrilled by something knocked off or stamped out that brought no

51. *Horse Toy. Celaya,*
Guanajuato, Mexico.
Painted papier-mâché,
14³/₄″ high, c. 1960

52. *Carousel Toy.*
Guatemala. Painted wood,
8³/₈″ high, c. 1958

53. *Horse Toy. Portugal.*
Painted papier-mâché,
6¹/₄″ high, c. 1960

54. *Horse Toy. Costa Rica.*
Painted wood,
9¹/₂″ high, c. 1960

52

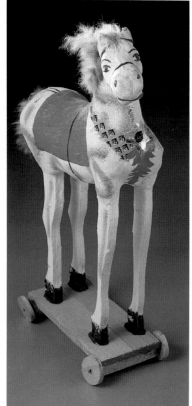

51

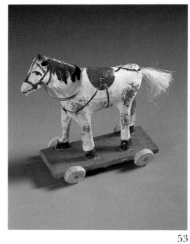

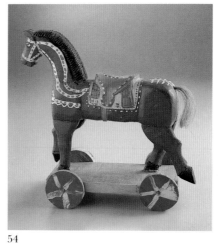

53 54

joy to its maker. But the clay miniatures of the Indian subcontinent or the greater Iberian world, and the puzzle-jugs of the old British potter, capture the artisan's wish to give and take happiness with his skill.

The skills harnessed to delight in the creation of the artful toy were developed through pain to meet practical ends. So the artisan's whimsies gently touch serious purpose. In India the master potter makes little horses for children to gallop into fragments in a world in which the horse is a potent symbol. Mexican children play with skeletons on the Day of the Dead, with figures out of Nativities on Christmas. At play with little gods, angels, devils, and saints, with models of temples and ritual apparatus, at play with little adults, with mothers and soldiers and servants, at play with baby dolls and miniature tools, with little plates and plows and guns and beds and cars, children casually acclimatize themselves to big people's schemes.

Pottery brings the potter his cash, and it follows that the form he elaborates most often for children is a bank. There is probably a lesson in that, just as there probably is in this: in Europe at least, from Turkey to Sweden and Wales, the potter's toy for adults is a vessel for drinking. Most often it is a vessel—a puzzle-jug—with which people make fools of themselves while playing with alcohol. Toys for children nudge them toward sobriety. Toys for adults contain criticism of the very idea of play. Enjoying his skill and his joke, the potter chides the hands that stray from work, just as alcohol tomorrow will berate the head that fails to note the limits tonight.

Puzzle-jug, dated 1889, Yorkshire, England

The little messages in banks and puzzle-jugs do not destroy the feeling of fun at the heart of the toy. Hints of seriousness intensify play by subtly recalling the limits without which fun could not exist. Pleasure depends on the regular pattern that holds it securely. The child in the midst of pure fun, whirling out of control, knows joy because the whirling will stop. The artist blessed with a free moment plays harder because the moment will end. Exploring his moment, in the ambit of fun, he reverses norms, making the plain thing fancy, turning the useful into the playful. The tool is miniaturized or elaborated into a toy. It is a sign of the artisan's sophistication that the forms he makes to turn the world on its ear recall its normal order—the order that will reclaim him soon enough.

We control so little of the world with our own hands that, for us, freedom means escape from circumstance. Searching abroad for freedom, we are drawn to carnival, to festivities in which norms are overturned and license rules. Similarly we are drawn to folk art in its instants of hilarity. But festivals in the traditional world often perfect rather than reverse things. They work to bring conditions under control and insure continuity. And folk artists often achieve their freest forms, not during moments of escape, but at times when things are gathered into total control. They free themselves to have fun during work by being masters of their trade.

Artists must be free. Their greatest freedom is not found, nor stolen, nor granted. It is won. Their freedom comes from their being in such command of their métier that its practice brings them pleasure while they work toward important ends.

The most elaborate folk artistic works do not upset norms. They create them. The artist packages fun as a gift. The bank most aflutter with silly birds, the puzzle-jug pierced

most intricately, the spoon most carved, the towel most embroidered, is transferred between people, between parents and children, between husbands and wives, between co-workers, between subjects and rulers, to do the crucial work of building and securing social associations so that the terrors of life need not be faced alone. The happy, expansive gift is serious business.

Released from the grip of conditions through escape or mastery, finding ourselves at play, we know the feeling of fun. Though underrated in solemn formulations, fun is essential to art. Writers about art may not know, but artists do. Fun is basic to aesthetic action. It is not, though, the only feeling that gives rise to art. Toys begin but hardly complete a lifetime's search for art. In our tradition the aesthetic is bound most commonly to beauty.

It was a fantasy of the brave rational mind of eighteenth-century Europe that absolute canons of beauty could be discovered empirically and formulated scientifically. In these late days, we have become comfortable with the liberal notions that every society will develop its own idea of beauty and that only against a culture's peculiar vision can its product be judged. Beauty is the creation or perception of things in relation to a set of conventions. The conventions do not flow out of nature. They arise out of a historical interaction with nature, during which concepts are projected into nature, and nature is disassembled and rearranged in accordance with the human need to understand and communicate. The resultant conventions differ from culture to culture. They are not merely a part of culture, they are a culture's own energy, at once its mode of apprehension and its force for self-realization. Without conventions to overturn, distort, or perfect—without culture to frame it—art could be neither created nor appreciated.

Aesthetic action entails conventions. Folklorists struggling to separate folk from other art on the basis of communal standards misapprehend the idea of art. There may be things created beyond the reach of communal standards. They are not folk. More important, they are not art. The outrageously original novel *Finnegans Wake* and the comical old folksong "Finnegan's Wake" both depend, as all works of art do, on shared standards, on conventions without which they would not be recognizable as things designed to move us into reaction.

The endless experiences that coalesce into expectations, into conventions against which things scratch and bump to enliven our nerves, enable us to know our own art. The arts of others, shaped against different experiences, embodying different conventions, may lie so far from us that they arouse in us no feelings at all. Or they may spark the wrong feelings. They may alienate us into disgust or tickle us inappropriately.

Humor provides a familiar example. People persist in telling us jokes we do not find funny. Or we may laugh, as we say, at the wrong time. To get the joke properly we need to share the jokester's sense of humor; in folkloristic parlance, we need to be part of the same small group. Every joke has its small group. Every work of art is the same. It gathers out of the world those who understand its intentions.

To understand is not merely to be able to react. Reactions can be strong and wrong. I was with a friend of mine who chances to be a Turkish peasant when for the first time he saw Michelangelo's *David*. I have been taught how to respond to this monument of our patrimony. He had not and he thought it was funny. The statue was evidently of a man, yet in pose and in the pronounced curve of its buttocks, it looked like a woman to him, and this sexual confusion provoked him to laughter.

Encountering objects that incorporate foreign conventions of beauty, scholars work

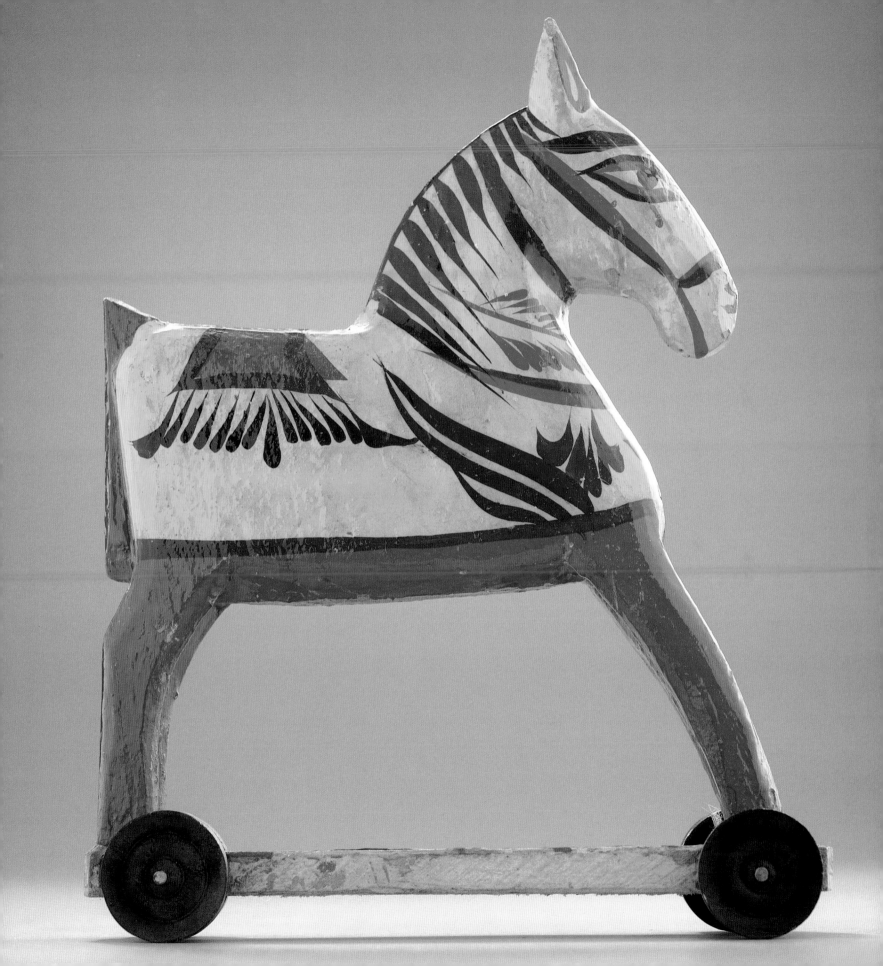

Right
56. *Doll. Eastern United States. Embroidered, stuffed cotton, 18³/₄″ high, early twentieth century*

Opposite
57. *Doll. Burma. Painted papier-mâché, 10″ high, c. 1960*

to overcome alienation and avoid inappropriate appreciation by saturating themselves in the collective experience out of which art always grows. They introduce themselves to as many things as possible. Reaction sophisticates as encounters multiply. That is why we need quantities to do our job. It is a glory of the Girard Collection that instead of offering us a few masterpieces, standing in isolation to shock or appall us, it provides multiple examples from which we can begin to feel familiar with the foreign.

Meeting a lone wanderer from a distant clime, a mask, say, from Mexico, you might walk on by in noncomprehension. Or you might fall in love at first sight. So exotic, so charming, so utterly original—the mask, absorbed by the wrong conventions, becomes lost in vanity. Only after close contact with many masks made by the same people do you begin to love for the right reasons. Deepening affection through disciplined study, we set things within their own range of variation, locating them in their own traditions, making them instances of a style. Within a style, as an epitome of convention, a particular work teases us toward understanding. We begin to see how and why it can arouse the tempered senses. The critic may make much of personal reaction, but the scholar's goal is to refine the match of reaction and intention, to recreate the original communication about feeling that stirred the work to life.

Now say that beauty is an engagement with style that moves the senses, a relation between actual things and deep conventions, between the real and ideal. Then beauty can appear in technology or decoration. Within a group of workers, whether of rural weavers or academic painters, styles of materialization and embellishment exist in a constant state of emergence in terms of which individuals create objects that are competent or excellent or inept. Judged by the local standard, the weave or the brushstrokes are smooth and tight or loose and erratic, the colors harmonize or disintegrate into discord.

Of all an artifact's aspects, form pushes beauty most insistently into the mind. That is because, though it rises, like technology and ornament, out of convention, form can be related most easily to things beyond.

Moving between this object and other things in our experience, comparing them closely, we locate the ideals contained in the object. The artifact is torn out of nature and composed into a distinct, integral form. Returning it into association with the world, we follow the course of the artifact's effort to improve upon nature through its incorporation of convention. This is easiest when the artifact is representational. A classical Greek statue differs from living people in order to incarnate an ideal that clarifies in our minds as we measure the work against bodies exposed on the beach. Relations between forehead, nose, and chin, between shoulders and waist, torso and legs, all isolate aspects of the programmatic attempt to do better than nature. It is the same for the classical sculpture of the Yoruba people of West Africa. There is some similarity. The eyes are large for the head, the head is large for the body, parts articulate smoothly. But at last the canons are distinct. The ideal is different but equally coherent. It has not come of imitating or simplifying nature, but of asserting conventions that rally a culture into unity.

Interacting with nature and material culture, matching innate impulses toward order with such order as they find in things, artists create new objects that by their containment of ideals, by their difference from reality, startle senses accustomed to nature's imperfections. The process is easiest to see in representations, in the human beings of Greek or Yoruba sculpture, in horses painted by Stubbs or modeled by the potters of India, in flowers stitched

Opposite
58. *Jaguar Mask. Mexico. Painted wood, 9 1/2" high, c. 1960. The ancient arts of Mexico abounded with images of the jaguar,* el tigre, *and today the jaguar impersonator appears in dances in several parts of Mexico, especially Chiapas, Guerrero, Oaxaca, and Puebla.*

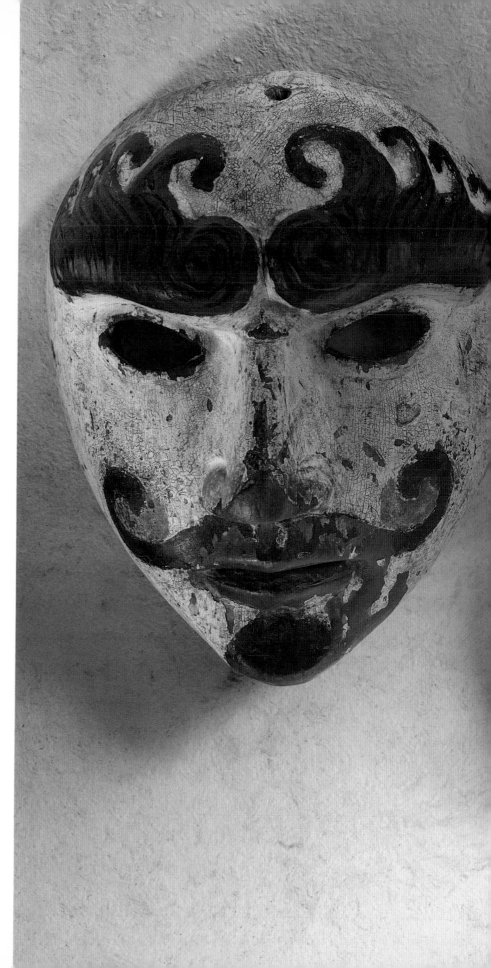

60. Left: *Mask.*
Department of Guatemala,
Guatemala. Painted wood,
6⅝″ high, early twentieth
century. Right: *Mask.*
Department of Guatemala,
Guatemala. Painted
wood, 6¾″ high, early
twentieth century

59. *Pascola Mask. Yaqui*
people, State of Sonora,
Mexico. Painted wood,
horsehair, 14″ high
(with beard), c. 1960

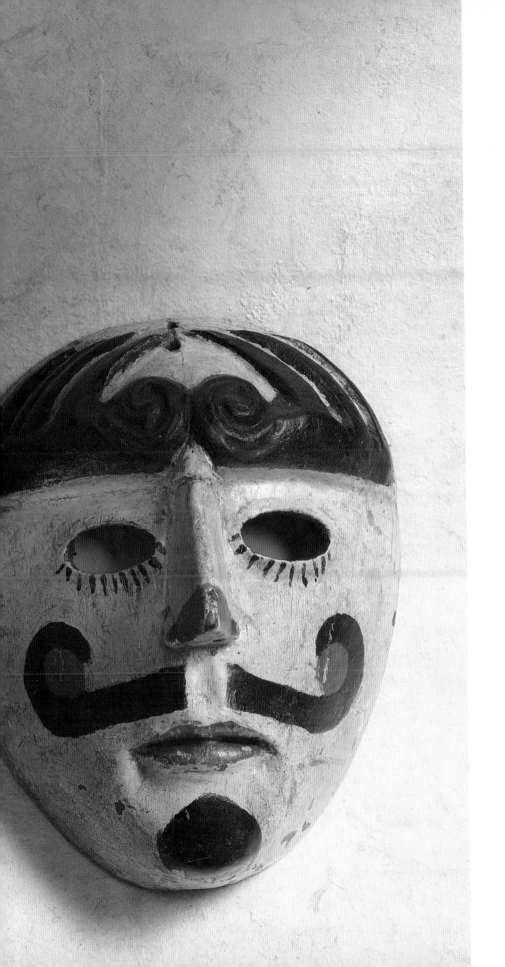

61. *Mask. Probably
Tarascan people, Cherán,
Michoacán, Mexico.
Painted wood, 8³/₄" high,
c. 1960*

into Chinese silk or carved into English oak. The process is driven farther in nonrepresentational art, in ideal compositions that are like nature in process rather than look. The tendency to symmetry that diffuses through the world of appearances is brought to perfection in the bits of wood interlocking on the door of a mosque or in the scraps of cloth snipped and stitched into the top of a quilt.

Door to the avlu *of the* Süleymaniye, *Istanbul, Turkey*

For the tool, the objective correlative is not the flower or the flower's implicit symmetry, but the needs the tool meets. Against requirements demanding it to hold, transport, and spill liquid in an orderly manner, within the wide limits imposed by use, the pitcher rises like a statue of an athlete to body forth ideas of correct proportion.

Embracing the world, its objects and the principles in its objects, accepting the objective task it sets, then aspiring despite the world toward perfection, forms abstractly embody the dynamic that identifies cultures and locates among a culture's products those that are best. Deep in forms abides the power by which culture knows, claims, shapes, and conquers the world.

When cultures collide, their peculiar dynamics erupt into visibility. Odd thinking can cause us to miss the point. If one of our artists borrows a foreign idea and adapts it, we are apt to proclaim the act creative and view the work as a sign of cultural power. If a foreign artist takes an idea from us and reworks it, we are apt to read the act as a surrender of integrity and the work as a sad sign of cultural decay. Now, cultural borrowing can bring on failure if the acceptance of the new is confused, and if it is accompanied by the utter rejection of the old. That happens, but not commonly. Normally, the adoption of a new idea involves the expansion of the old culture, followed by a synthetic recentering. That is how cultures change, how history happens. If we look plain upon historical events, we will find in the act of recentering, during which borrowed ideas are reconstructed, clear examples of cultural dynamics.

The painter of Mexican retablos, exposed to a baroque depiction of a saint, recreates it: the head expands, the body contracts, shapes simplify, action stops. His changes do not come of misunderstanding. They arise out of a heroic attempt to spiritualize the image, to reintegrate religious subjects with religious style. As the Greek sculptor improves the body, the Mexican santero improves the baroque model. He rescues it from the realm of realism, within which Saint James could be mistaken for a soldier riding on a horse, and relocates it in a world within which Saint James appears as the momentary flash of divine fire.

When in the Southern United States the black quilter reorganizes traditional designs, disassembling symmetries and forcing colors to clash, she has not failed to copy the quilt of her white neighbor. She has improved it, reconstructed it (as the jazz musician reconstructs linear melodies) to express cultural ideals of spontaneity and rhythmic energy derived from African sources.

Rearranging nature and altering the arts of other people, artists accomplish forms that express their culture. The ideals built into one form then reach into other forms, ignoring the limitations of media, joining the ideals in technology and ornament to coalesce into an essence of rightness that guides all of a culture's struggles toward excellence. It is the task of art to reveal these essences to the people walking upon the earth. Better than anyone,

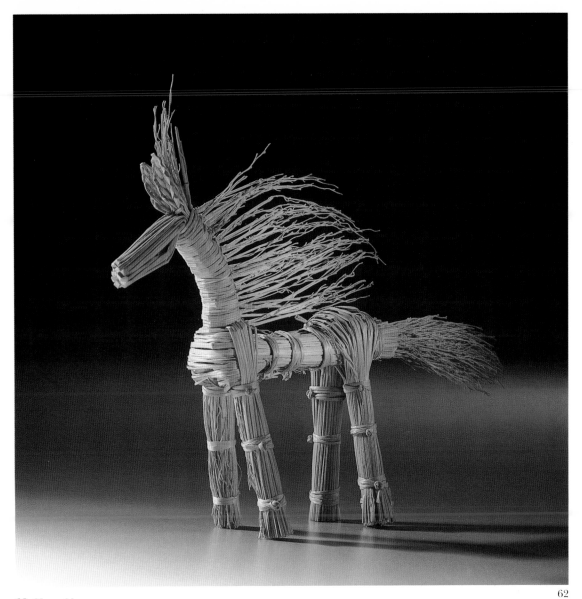

63. *Horse. Bankura District, West Bengal, India. Earthenware, 9" high, c. 1960. This is a hand-modeled version of the votive horses for which this district of Bengal is famed.*

64. *Horse. San Pedro Tlaquepaque, Jalisco, Mexico. Painted earthenware, 9¹/₂" high, c. 1934. From the creative ceramic center of Tlaquepaque comes this bank, one of Alexander Girard's first acquisitions, bought in New York.*

65. *Horse. Cecca Pupuja, Puno, Peru. Slipped and painted earthenware, 13⁵/₈" high, c. 1958*

62

63

62. *Horse. Nagano, Nagano, Japan. Wrapped fiber, 7³/₈" high, c. 1960. Once believed to carry the deity Doso-jin to and from Heaven, straw horses were used as votive offerings, but are now good luck charms. This type is associated with the Kirihara Shrine in Nagano.*

64 65

66

67

66. *The Sacred Heart:* Sagrada Corazón de Jesús. *Mexico. Painted tin, 5 x 3¹/₂", mid-nineteenth century*

67. *Saint Isidore:* San Ysidro Labrador, *the patron saint of farmers. Mexico. Painted tin, with cut and painted tin and painted glass frame, 13 x 9¹/₂", mid-nineteenth century*

68. *The Holy Burial of Christ:* Santo Entierro. *Mexico. Painted tin, 10¹/₄ x 14¹/₄", early nineteenth century. A picture of a statue of Christ in the Sepulchre that is carried in procession during Holy Week, this is an icon of an icon.*

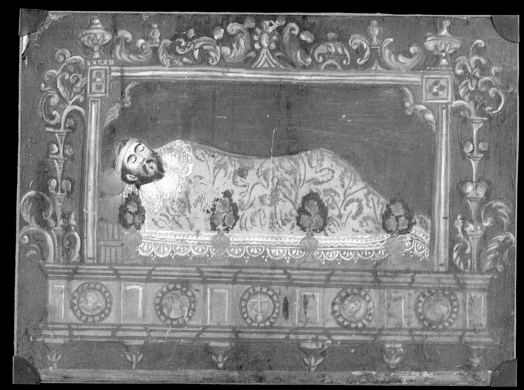

68

69

69. *The Christ Child of Atocha:* Santo Niño de Atocha. *Mexico. Painted tin, with cut, stamped, and painted tin frame, 12⁷/₈ x 8⁷/₈", late nineteenth century. Santo Niño de Atocha, patron saint of pilgrims, is associated with a major shrine in Fresnillo, near Zacatecas, Mexico, and with the Santuario de Chimayó in New Mexico.*

70. *The Infant God Enthroned:* El Niño Dios Entronizado. *Mexico. Painted plaster, glass and tin niche, figure 6" high, late nineteenth century. This and other images, including the Holy Infant of Prague in Europe, Santo Niño de Atocha in Mexico, and Santo Niño de Cebu in the Philippines, all manifest the devotion to the Holy Childhood that arose during the Renaissance.*

70

71

71. *Crucifix:* El Señor de Esquipulas *(detail).* Guatemala or Mexico. *Painted wood, tin halo, 9³/₈" high, early twentieth century*

72. *Crucifix:* El Señor de Esquipulas. *Guatemala or Mexico. Painted wood, tin halo, 11¹/₂" high, early twentieth century. With its characteristic green cross, black Christ, and radiating nimbus, this image repeats a crucifix made in the seventeenth century by Spanish missionaries at Esquipulas, Guatemala, a pilgrimage site associated with healing earth. The image of the image at Esquipulas spread with the cult of healing earth from Guatemala through Mexico into New Mexico.*

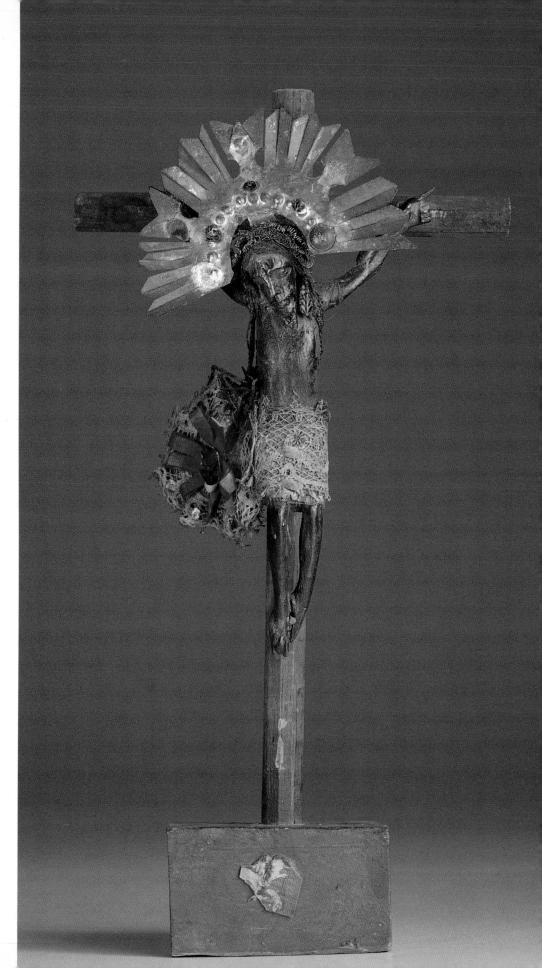

Robert Plant Armstrong, anthropologist and man of perfect taste, taught us these lessons. Before death took him too quickly, too terribly from us, Bob Armstrong gave us three wonderfully difficult and serious books. I do not do their nobility justice as I sketch his project for you.

Robert Plant Armstrong lived within a magnificent collection of Yoruba sculpture. Contemplating the beings in wood that shared his house, comparing them with people as they are, and as they are represented in the radically different art of Indonesia, he learned that all these sculptural works—figures of twins, of Shango and Eshu, Egungun and Gelede masks—contained a powerful essence that made them both great art and inalienably Yoruba. Then he recognized that essence, which he called intensive continuity, to be present, not only in sculpture, but in all the Yoruba did that was profound, in dance and sport and narrative as well as painting and sculpture. Ultimately he identified this formal essence with a kind of energy, a dynamic of consciousness, which he called syndesis and refined in opposition to the synthetic mode dominant in the Western academies. As syndesis shapes forms that embody intensive continuity, as they emerge as fundamentally Yoruba, they jar both the Yoruba and the sensitive scholar into awareness of the presence of excellence in the world.

Every culture shapes around deep essences that rise imperfectly through its works to arouse the senses. We can call this force that grips us into engagement beauty.

The cultural essences that form through conventions into works are the key to the idea of the aesthetic. Calling them beauty, however, stretches the word beyond its limits in our common language. Beauty might be the word for Greek sculpture. But the word for Yoruba sculpture, if we follow Robert Plant Armstrong, is power. Then turn south to a Kongo statue, blackened, crusted with mud and shell, bristling with nails. Does terror name the emotion? Now look upon Christ, God made man, nailed to a tree, face and fingers contorted in agony, red blood streaming. Is the Rood in a shadowy old church described by the word beauty, or trapped by any one emotion? Awe, pity, sorrow, grief, guilt, fear, rapture, love…And what of bright, wheeled horses, canvases painted black, pornographic dancing skeletons, rubbery two-headed chickens pickled in glass jars, or jugs called "ugly"; what of joy, lust, anger, disgust, melancholy, nostalgia, amusement?

The aesthetic is a communication about feeling, not one feeling but all feeling. The senses, being diverse, seek their pleasures diversely. It might seem there is nothing to say in general about feeling. But thinking about fun, we found the release from conditions. Thinking about beauty, we found the reworking of conditions. Aesthetic action will involve some interconnection between feelings of freedom and feelings of connection, some sense of excited engagement with the world that inevitably contains us. To go toward art, however, we must be ready to admit any feeling as a subject for aesthetic communication.

You will recall our course. To get beyond the identification of art with certain media, which leaves many people without art and others with only bad art, we focused on function. The simplest functional definition is negative: art is something that is not a tool. But our examination of the isolation of art from utility, which leaves the world's workers without important art, only brought us back into connection with usefulness. So we abandoned the dream of idle decoration. We traded negative for positive criteria in search of a way to find among artifacts, whether tools or not, those that are art. The first requirement of art is that it be a communication about feeling.

But feeling is not enough.

Our comfortable old notions about art befuddle us, muddying our prose, blinkering and blocking our vision. They make the definition of art a laborious task; they sadly undermine the worker's self-esteem and dangerously mislead our artists into antisocial behavior. As a consequence I have found it refreshing to study beyond the reach of our confusions among the proud workers and responsible artists of Turkey.

The Turks have a word for art: *sanat*. It has nothing to do with medium. Any medium can be a vehicle for art. Potters turn it, weavers weave it, carpenters build it, calligraphers write it. All artifacts, however, are not art. Works of art contain and express *zevk*. "Taste" is a weak translation. *Zevk* is propriety, a pattern of deep choice that characterizes individuals and draws people together, shaping, we might say, small groups.

Ömer Bilge with a rahle, *a stand for reading the Koran, that he carved, Konya, Turkey*

But art is not the product of taste. It is the product of love. Potters and weavers, describing the feeling that engenders art, do not use the word for positive reaction, for approval: *beğenmek*. Nor is their word the usual one for affection: *sevmek*. It is *aşk*: passion, the passion of lovers separated and pining for reunion, the passion of the faithful flowing into mystical union with God. *Aşk* gathers and commits the whole person. It is the passion of the senses feeling, the heart yearning, the mind learning, the soul aspiring. Love is the wish to give all that can be given. When an artifact receives love—when it represents the passionate union of the person with materials—it is art.

The Turkish carpet or panel of painted tiles that is *hakiki sanat*, "true art," contains the wholeness of human commitment. I envy the clarity of the concept. We are accustomed to more fragmentary thinking. We divide the body from the mind, feeling from thought, in a way that Turkish artists do not, so we must specify that art is feeling, and it is more. It is a thing of mind as well as nerve.

To keep us on track, I summarize brutally. Art functions aesthetically. It provides fun to the hands, beauty to the eye. But human beings consist of more than bodies, and art, to be art, must be more than aesthetic. It must touch the body—and make an offering to the mind.

Opposite
73. Kantha *(detail). Bangladesh. Embroidered cotton on cotton, 77⁵/₈ x 53¹/₈", late nineteenth century. Hindu temple cars flank the central lotus.*

Consider the gifts to the mind lying in one kind of art, the quilted *kantha* of Bangladesh. Meaning lies in its technology. Seamless cloth is a symbol of the universe, so traditional Hindu dress is not cut and fitted. It is composed of lengths of unbroken cloth, wrapped and folded. When clothing becomes frayed, it is reused in quilts. Simple quilts are patched of fragments. The *kantha* is built up of layers of worn cloth, stitched together and embroidered. Reassembling cloth, the quilter reassembles the universe. Her art parallels the mythological acts of reconstruction that follow destruction to mark a cyclical sense of time within an enfolding oneness. Ganesha's head is cut off and replaced with that of an elephant. A patched new unity arises. Things roll on. Muslim workers in Bangladesh enact the theme of recycling when they gather broken plates and old bottles, break them into bits, and then reassemble them into the gorgeous mosaics that sheathe their mosques. Making new unities out of fragments of old unities, the quilters of *kantha* participate in the cyclical reconstruction of the universe.

Stitching cloth together, the women of Jessore, Mymensingh, and Faridpur stitch

74

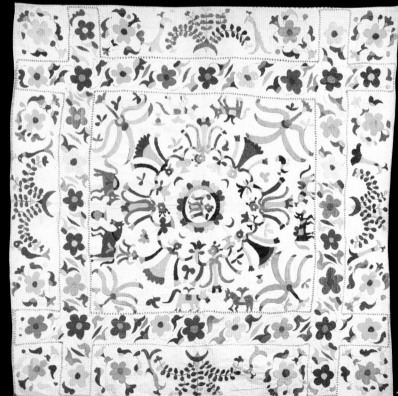

75

their families together. The *kanthas* they make out of their old worn saris they make into gifts. They give them to daughters when they leave home in marriage. They give them to sons and husbands so when they are off and alone, they can roll themselves up in cloth worn soft from washing and touching the skin of the beloved woman. Embraced by the *kantha*, the man is comforted, connected—and protected. Rags are offered in prayer at roadside shrines and used as defense against the evil eye. The *kantha*, a collection of rags, defends the vulnerable sleeper. Babies are wrapped in *kanthas*. When the new nation of Bangladesh was founded, its constitution was wrapped in an old *kantha*.

At the center of the *kantha* expands a lotus. The lotus is the symbol of Lakshmi, goddess of bounty, daughter of the great goddess Durga, prime deity of Bengal. The lotus is also the divine seat, the place on earth awaiting the visit of the holy guest. It is the spot in the breast of the faithful upon which the deity lights. Being her symbol and the sign of her coming into the breast of the devotee, the lotus completes the goddess, providing a conduit for communication between deities and people. It is a picture of prayer. It is a picture of power. The lotus is the flower of the water. In the delta country of Bangladesh, water gives and takes life, causing rice to rise in the fields, bringing destruction and famine in floods. Rising out of the water, the lotus is the flower of power. Rising through the lotus, the goddess is power itself. The lotus floats on the water as creation floats upon the surface of primeval chaos. The lotus symbolizes creative force.

At each corner of the *kantha*, stretching from the edge toward the lotus at the center, rises a tree of life, often reduced to a leaflike, flamelike *kalka*, familiar to us from the shawls of Kashmir. Both symbolize the growth of life out of moisture, and in the blended Hindu and Muslim culture of Bangladesh, the tree of life is a symbol for the growth of the soul toward God. Tree or leaf also marks the four directions that point toward the center, making the *kantha*, a unit of fragments, into an image of cosmic order.

Inside the symmetrical pattern established by the lotus and the trees of life, inside this diagram of a universe ordered by exchanges between faith and power, the quilter ranges free. She stitches pictures of the common artifacts of her life, the jewelry, kitchen utensils, and toilet articles necessary to happy existence within the universal structure shaped by her orientation to the lotus within. She stitches religious images, Hindu temple cars and Muslim amulets. Often she portrays two grand animals, the elephant and the horse. The elephant symbolizes water. Moving on the earth like a great gray cloud of rain, the elephant is like water, beneficial and destructive, tame and wild. The horse is rare in normal life; bullocks and buffalo work in traction. The horse is an emblem of nobility and mortality: it carries the militant hero and the secular master; it bears the rider over the land as the body bears the soul through life.

So dense are the meanings in the *kantha*, so rich is its evocative energy, that one poem, written a generation ago by Jasim Uddin, made it a national symbol. The poet describes the *kantha* as the sad narrative of one woman's life. Every *kantha* tells that tale, the story of one woman alone with her imagination, her rags and needle, and it tells of the art and hope and sorrow of the women of Bengal, and it tells the epic of cosmic power. My sketch of the *kantha* hardly touches its depths, but it should be enough to serve us as an example of the intellectual dimensions of art. Like all art, the *kantha* stimulates the senses—its rippled surface invites the fingers, its delicate colors and stylized forms charm the eye—and it is troubling to the mind. Meditating upon the *kantha*, we are tugged toward an understanding of the universe and our place in it.

74. Kantha. *Bangladesh. Embroidered cotton on cotton, 38³/₄ x 35", late nineteenth century.* Kalkas *at the four corners point toward the lotus at the center.*

75. Rumal. *Chamba District, Himachal Pradesh, India. Embroidered silk on cotton, 32 x 31⁷/₈", early twentieth century. The* Rasamandala, *Krishna's circular dance with the* gopis (milkmaids), *is a popular motif on the Chamba* rumal. The rumal *is used as a covering for offerings made on ritual occasions.*

We declare that art is moving and important, a thing of the senses and the mind. Arriving at that conclusion, we can lose its power by turning to concentrate on mind exclusively and coming to think of the work of art as a kind of philosophical treatise. In traditional societies, art does the work of philosophy, opening enduring problems to contemplation, posing solutions and countersolutions, arguing over the nature of the universe. But the philosophical dimensions of art do not seal themselves off into a separate sphere of cogitation and discourse. They remain bound to feeling.

Within aesthetic action, in the midst of fun, questing for beauty, feelings drift toward knowledge of being in the world. Pleasurable creation teaches that things can be improved, but there are limits. Existence balances freedom with constraint. As we work and ponder works, feelings transform into wisdom. Art pulls us toward integration. It does so naturally, easily in some societies but fitfully in our own, where it must battle with rationalist economies to overcome the division of feeling from thought. The crabbed matter of art reveals our culture. As a distinct category, art varies with cultural integration. The more integrated the culture, the more that creativity is a part of daily life and daily life is a philosophical process, the less is the need to define art as a separate entity—precisely because it is art's job to fuse feeling and thought. If feeling and thought are not separated to begin with, art flows with life and does not loom as an issue for disagreement and argument.

The idea is difficult enough to bear repetition. Art is at once sensual and intellectual, a matter of the senses and the mind, perception and cognition. Implicitly it falsifies the mind-body duality. The mind is one with the body, as the body is one with the environment. So art as a topic, as a thing to define and do, is confusing precisely to the extent that a culture adopts a commitment to the duality of mind and body, which art refutes in its unification of feeling and thought.

Gracefully or tempestuously, art brings together the searches of the senses and the mind. Raising gifts to the intellect through feeling, art is the aesthetic ordering of an important concept. Ideas beautifully clothed, that is what Emerson said. And William Morris defined art a century ago well enough to have spared us much trouble as that which is at once useful to the body and useful to the mind.

Here is the functional conclusion. For its makers and its perceivers, art moves the senses to open the mind.

Attending to function, we have defined art. But if we try to apply our understanding to the job of classifying real objects, we will be struck anew by the complicated truth that all artifacts have more than one function. We might solve our problem by judging which intents are dominant. If an object exists primarily to please the senses and stir the mind, it is art. If a utilitarian or merely decorative purpose dominates—if the artifact serves the body but not the mind—it is craft. Medium has ceased bearing the weight of the distinction between art and craft. Many exquisite paintings, lacking deep significance, are craft. Many pots rise to the status of art. By dividing material culture in this manner, we become able to break books into chapters and arrange galleries more neatly. At great cost. What we have really done is wreck the artifact, replacing its rich reality, its manifold vitality, with a simple scheme.

Contrasts among things have been exaggerated by our customary ways of speaking. The painting we use to exemplify the idea of art for art's sake was sold to bring cash, was exhibited to bring prestige to the artist who calls it a work. It is utilitarian. The pot we call craft brought pleasure to its maker, thrilling the fingers with whirling clay, delighting the

mind with completion, and it stands, molded earth, as a silent essay upon the powers of the universe. It is art.

Artistic and utilitarian functions seem clear, but they always mix in real artifacts. So functional thinking urges us away from the classification of objects into the process of their creation.

At work people rearrange the world to conquer practical problems while groping toward the ideas of right form through which their cultures channel hints about existence. In all creative acts, the artistic and the utilitarian move toward fusion. Every artifact bears witness, dimly or radiantly, to human realities, to the mind planning, to the body shifting among alien substances. So the search for art is not a matter of isolating objects by medium or function, but of following a persistent tendency that courses through creative action to spin into the world things in every medium, useful to every end, that contain a redundancy of essence capable of dragging the mind back through the process of creation into confrontation with a particular individual's version of a particular culture's shaping of the universal. At last we do not classify things. We describe a process that governs the creation, selection, and treatment of artifacts.

Monoranjan Pal, called "Bhambul," at work engraving brass vessels, Dhamrai, Bangladesh

Shifting from function to process, we describe things to understand their creators—those who make things and those who remake them through appreciation and use. When the creator is pleased during work and pulls out of work significance, the result is art, even if the creation exists in the world (as it always does) intimately coupled to a useful goal, even if (as it generally does) the goal deflects attention from the object's existence as art.

The process is a common one, known to every cook and carpenter. It is a matter of reorganizing materials. As more and more that matters is pulled into the process, as it gathers more into itself and so gains the strength to reach out more broadly, it becomes more and more the process of art. The result is an artifact of which art is a part, a great part or a small one.

The complexity of the artifact seems to set different tasks for the scholar. Students of craft concentrate on the process of materialization: on technology, tools, techniques, arrangements among workers, the useful nature of things. The goal is a description of the transformation of the material world. Students of art concentrate on the process of conceptualization. They extract from objects theories of design and taste. The goal is the reconstruction of aesthetic philosophies. In this division of tasks, a beginning is made in the study of material culture, but as materialization and conceptualization become jobs for different scholars in different disciplines, the real and ideal separate unnaturally and resist reintegration. What is lost is the truth that all art is craft. It must be made as well as thought. What is lost is the truth that all craft contains the potential to rise toward art. Its making is directed by concept. What we lose is the process that puts real artifacts into the world.

Architecture provides a plain model. The great architects defy scholastic dichotomies. The builders of Chartres were masons and theologians. Sinan was an engineer and a sculptor. Frank Lloyd Wright worried about both social functions and aesthetic effects. And every building forces itself upon us as a thing to see, a thing to ponder, a thing to use.

Like buildings, paintings and pots mesh the artistic and the useful. Though scholars will divide their effort, studying things now as craft, now as art, we would be wise to let art itself guide us into a theory of wholeness. The world that supplies materials and problems, the culture that supplies conventions, the feelings that want delight, the mind alive with wonder—all blend in the process that yields art.

Folk Art

Now let the words come together. Saying "folk art," we bring into association some sense of the commonplace and some sense of the exalted. It is humbling and exhilarating to recognize that something so marvelous as art can be produced by people so plain as to be called folk. We are shocked as well to feel the conservatism written into the idea of the "folk" touch and embrace the creativity implied by the word "art."

It is one message of folk art that creativity is not the special right of the rare individual. It is the common property of the human race. It is another message of folk art that creativity need not lead to the destruction of norms. It can be dedicated to the perfection of things as they stand.

Deepening our consideration, we remember that art is the result of the merger of people and materials. It records the interaction of human beings with their physical environments. When we qualify that interaction as folk, we stress its social dimensions. The person creating out of substances won from nature is guided by collective wisdom. Dead hands aid live ones. And the artist acts so as to connect again to social reality. Saying "folk art," we emphasize the cultural aspects of every artistic endeavor.

If you want to go farther, if you want to define folk art in order to refine the feelings that the term stimulates, all you have to do is choose from among three different definitions of "folk" (the nationalistic, the radical, or the existential), then from among three different definitions of "art" (by medium, function, or process), and combine them. All of the possible combinations have been used. And many people have not bothered with definitions at all, preferring to label folk art things that look like the things that other people call folk art. The result has been a state of confusion out of which has risen more argument than progress in the study of folk art.

We do not all have to use the same definition, but incomplete definitions baffle us. Some define "folk" carefully, but "art" sloppily. Others do the reverse. If you select from among complete definitions of "folk" and of "art," then combine them to meet your own ends, conversation among us should become easy. I would like to direct things further only by pointing out that some combinations are more logical than others.

The existential definition is processual. It joins comfortably with a processual idea of art. Thinking of folklore as a kind of action (artistic communication in small groups) and art as a kind of action (the synthesis of materialization and conceptualization), the contemporary folklorist might define folk art as the unification of the individual and the collective through a communication that enlivens the feelings while urging the mind toward truth.

The radical definition of folklore joins easily to a functional definition of art because both focus upon particular characteristics of objects. Folklore is that which is traditional and variable. Art is that which is sensual and intellectual. Put them together and folk art becomes

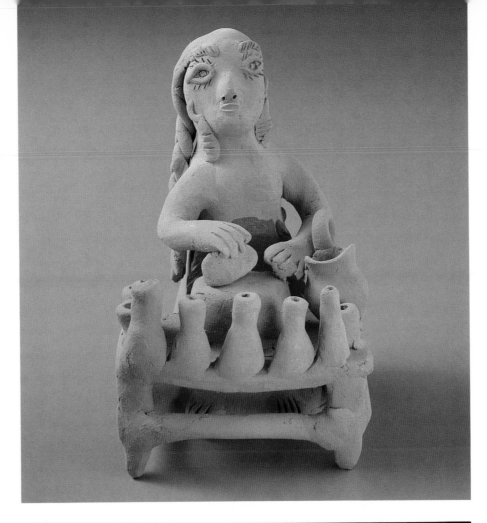

76. *Potter. By Teodora Blanco. Santa María Atzompa, Oaxaca, Mexico. Earthenware, 5³/₈″ high, c. 1965*

77. *Potter. By Teodora Blanco. Santa María Atzompa, Oaxaca, Mexico. Earthenware, 5⁵/₈″ high, c. 1965*

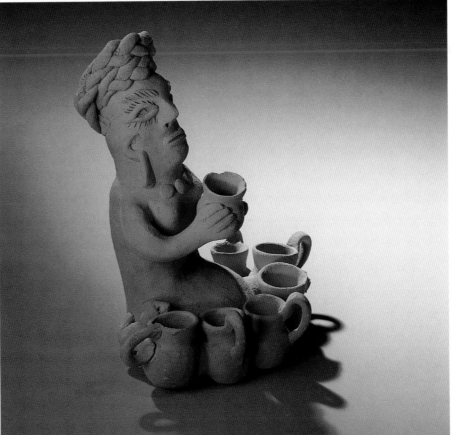

78. *Shadow Puppet.*
Central Java, Indonesia.
Cut, painted leather,
31¹/₂" high, c. 1950.
Kumbakarna, the
mountain-big giant
depicted in this wayang
kulit *figure, is a character*
out of the Mahabharata.

79. *Shadow Puppet.*
China. Cut, painted leather,
20¹/₄" high, nineteenth
century. The leather piying
puppets are technically and
formally related to Chinese
papercuts; both rely
on the effects of lighting
from behind.

Opposite

80. *Shadow Puppet. State*
of Andhra Pradesh, India.
Cut, painted leather, 35¹/₂"
high, nineteenth century.
This tholubommalatta—
"shadow dance"—figure
likely represents Arjuna,
hero from the epic
Mahabharata.

the totality of objects that vary at the pleasure of their creators while holding steady over time to preserve and express a culture's deepest ideas.

The nationalistic definition of folklore would meet a definition of art by medium to make folk art the paintings and sculpture of the common people. More than the others, these definitions were developed within the peculiar frame of Western culture. To expand their validity, and secure the utility of their conjunction, let me remind you of their intentions.

The nationalistic definition of folklore featured the common people on the assumption that the poorer rural people held the native culture most completely, while wealthier urbanites were off whoring after foreign fashion. That might have been true in eighteenth-century England or nineteenth-century Hungary, and it may be true today in parts of India or Peru. In our world, however, poor people often gain access to alien ideas through the mass media. Justly angry about their estate, they abandon the old culture, while wealthier people who have reason to maintain the status quo, and reason to fear the international orientation of the lower orders, become the caretakers of tradition.

The definition of art by medium rose out of limited experience. Treasuring paintings and sculpture, poetry and novels, scholars of another day came to stress their parallels among the poorer people who they assumed would be imitating them. They concentrated naturally upon carved and painted decorative objects and upon the ballad poetry and novel-like prose narratives of other cultures. As study has expanded across the globe, as our artists have struggled to eradicate simple generic distinctions, blending sculpture with painting and dance to recapture the mysterious effects of folk rituals, merging poetry with prose to recapture the power of oral literature, our ideas of art have widened and deepened.

The intention in the definition of art by medium was to isolate the special genres through which culture was expressed most richly. The intention in the nationalistic definition was to celebrate those who maintained the native culture. So if we recast the combination for use in our days, folk art would consist of the most important expressive forms of a group bound by a sense of identity.

I have set before you three reasonable definitions of folk art. Take your pick, or return to the grid of definitions, the pair of triads I labored to explain, and construct a new one. Either way it would seem that we have ordered things enough to know what folk art is. That is not quite the case. Our ideas about folk art are conditioned simultaneously by what folk art is and what we think it is not.

Folk Art and Fine Art

All definitions of folk art presuppose alternatives. For there to be folk art there must be art that is not folk.

Folk art, it seems, is not "fine art." They are displayed in different galleries because they do not look good together. They are taught in different courses in the university, for their appreciation apparently requires different skills. Folk and fine art have been driven apart by scholarly custom, but their separation must bespeak more than class prejudice and academic inertia. So let us consider the issues usually raised during efforts to sharpen the contrast between folk art and fine art. Since their sundering has been largely the work of professors like myself who have become, at great financial and psychic cost, educated, I will

begin our investigation with the issue of education.

Peter Flanagan is a great musician, a master of the violin, flute, and tin whistle. He was not taught. He learned. The small house on the green Irish hills into which he was born was alive with music. His mother was a singer. His father, Phil, a natty wee man with a grand moustache, was famed afar as a great musician. When Peter was a lad with a head full of

music, he took his father's fiddle to a snug spot beneath a hedge, so the crazy sounds of his childish struggle might be mistaken for the weird music the fairies make. Trying to teach himself, twisting and twisting the pegs, he broke all the fiddle's strings. The strings cost money and money was scarce in the house, but his father did not chastise him. That piece of patience, better than any lesson, directed Peter to follow the talent that drove him from within.

As he grew, Peter filled the moments when he was not needed in the fields with obsessive practice. He joined his community's fife and drum band, receiving from the band's leader instruction on reading music by crotchets, and soon he marched as the band's youngest and best fluter. Wherever the old musicians gathered, Peter came to listen and then to play. Recordings of the Sligo master, Michael Coleman, expanded his idea of what a fiddler could do, and Peter, after playing for numberless dances, became famed as a musician. He likes all music, he says, but the old Irish music is best. Its melodic complexity teaches your left hand to hop. His left hand dances, but it is his right hand, driving the bow, that carries his distinction. An intricate sense of rhythm, a war with meter that makes music like waterfalls and skyrockets, marks the highly personal style he developed within the embracing style of what he calls "the old national music."

Ballymenone,
County Fermanagh,
Northern Ireland

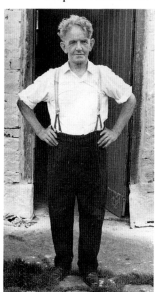

Peter Flanagan,
Ballymenone,
County Fermanagh,
Northern Ireland

When I met Peter Flanagan, he was a poor farm laborer, a courtly gentleman, a wildly youthful old man, who still claimed a central place in the musical scenes in the public houses along the border of County Fermanagh. He had attracted to the smoky hearth of his small house on the hilltop a few young men wishing to learn. He taught them as the old men taught him, by example rather than precept. With only occasional hints from the master, they learned to follow him as he followed others, listening and watching, imitating, practicing, pushing to achieve a satisfactory sound. One of them, Cathal McConnell, is now an internationally renowned master of the flute.

Ask Peter Flanagan how he learned, and in one mood he will tell you he always knew, for his home was made of music. In a more serious mood he will tell you that he was born with the gift of music. It flowed in blood through his parents from God. In his own mind, Mr. Flanagan is but a transitory, faulty vehicle for an eternal and perfect idea of music. Having been blessed and burdened, gifted, he was obliged to work with the spirit that rose inside him, improving it through learning and practice, and now he is obliged to give it back, playing for the lesser men who demand his talent to enliven their revelry or relieve their boredom. He gives reluctantly, inwardly despising those with no ear, but he gives because it is his duty to pull people out of perilous solitude and set them, he

says, on the right road through life, in active engagement with their neighbors. And he gives beautifully because it is his delight, his personal test, his obligation to his God-given gift.

Peter Flanagan learned as thousands of folk artists have learned. He grew, surrounded by examples of art so diverse and yet consistent that repetitive acts of imitation led him naturally into a personal version of a collective style. There was no one point when he learned, no method for instruction beyond the driving, encompassing, synthesizing grip of his gifted will.

Again and again I have flicked on the tape recorder and asked weavers in Turkey when they learned. The hesitancy and misdirection in their answers show the question to be wrong. As babies they crawled around the loom, listening to the soft sounds of the weft being pounded, watching designs rise wondrously on the warp, playing with scraps of brightly colored wool. As little girls they sat by their mothers, attending casually between fits of play in the sunshine. As bigger girls their curiosity increased and before they were twelve they were seated to the left of a master, their mother or an older sister, expertly doing their part, copying, repeating, receiving random hints about how to better their performance, until at last they had so mastered the art that they could control the progress of the rug, while guiding the younger weaver seated at the left.

That is how Nezihe Özkan became a great weaver in the village of Ahmetler. In essence it is how Peter Flanagan became a great musician in Ballymenone. Some who learn thus through experience, through trial and error, call themselves self-taught, while others associate themselves with a particular teacher. The process of learning can be described to seem more or less formal. William Houck, basketmaker from upstate New York, did not remember being taught. His father was a basketmaker, but Mr. Houck said, "I just figured it out by myself." Watching others at work, looking at examples he admired, Bill Houck taught himself to fit into the old Adirondack style. John O. Livingston, basketmaker from Pennsylvania, credited his grandfather as his teacher. His baskets resemble his grandfather's, but Mr. Livingston improvised, altering and sophisticating his instructions to make his craft fit his maturing sense of quality. In the final analysis, they all learned the same way. They were born into environments that supplied them with models that they copied, botched, copied and improved. Eventually they had so mastered the style implied by their models that they developed a personal version of a tradition that had embraced them from birth.

William Houck,
Vernon Center, New York

In England I met an elderly basketmaker, Stanley Lamprey, working alone in a small shop by his house at the edge of his village, Braunton. I expected him to tell the tale I had heard so often from American craftsmen, of learning in childhood from an elderly relative, of abandoning the craft in mid-life when economic needs pressed hard, of returning in old age to a remembered skill as a way to keep the hands busy and the mind awake. The United States had taught me to think of the folk artist as a solitary worker, alone responsible for the maintenance of tradition, managing the entire craft process, gathering materials, processing them, selling the result. That is how I found Mr. Lamprey. But his nostalgia was not for childhood. His story was different.

Wistfully, Stan Lamprey recalled the good old days at the basket factory. There he

had gone as a youth, ascending through set stages under the watchful eye of a master, to become a master himself. Alone now, he misses the comradeship of the factory, where they

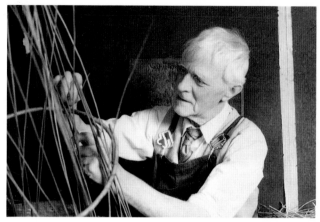

Stanley Lamprey, Braunton, Devon, England

chatted and joked while they worked. He misses the help of the boys who did the dull labor, leaving him with the board on his lap to perform the interesting, challenging work. The need for baskets declined, the factory in Braunton closed, and Mr. Lamprey was left like the American craftsmen I know, managing the whole job, surrounded by a silence within which he bore down on his work, weaving beautiful baskets of willow, because it is the best an old man can do.

Stan Lamprey's mode of learning differed from that I had come to think of as normal in America. A factory—the word is Mr. Lamprey's—might suggest a late stage in the development of craft, but Stan Lamprey taught me first that the self-sufficient worker often represents a factory in decay. Just as the solitary farm unit we take for normal in the United States is largely the result of the destruction and scattering of compact agricultural villages like Stan Lamprey's Braunton, so the solitary worker may but recall the destruction of ancient guilds. What we are accustomed to reading in the American scene as signs of the original human spirit, self-sufficient and combative, may be only evidence of the struggle to endure amid the wreckage of former order. As I traveled east and came to understand the vast stretches of the world where farmers continue to live in tight villages, I came to realize that Stan Lamprey's way to learn, as much as Peter Flanagan's, is natural to the folk artist. It is the system of the atelier.

The little atelier is a family operation. Within it, the kind of learning that happened at the hearth of Phil Flanagan's house is narrowed and directed. It is directed by explicit instruction, but what is more important, it is constrained by a reduction in the range of models available for imitation. The result is a more restricted style, which, sturdily compressed and reinforced by blood, can survive on its own without support from the wider community, through which Peter Flanagan wandered to add tricks and tunes to the music that circled the hearth of his boyhood.

In the mountains of northern New Mexico, in the village of Córdova, José Dolores López developed an original style of carving that thrives today among his great-grandchil-

George López with his carving of San Pascual, Córdova, New Mexico

dren. He died in 1937 and lies beneath a cross and a stone to the right of the entrance to the church at Córdova. His blood flows on. His son George gathered the old man's energy, made it his own, and scattered it into a profusion of crosses, stark saints, and trees full of animals that stand like fragments of a single shattered spirit. George López's eyes have nearly failed him, but the old power pulses. Studying his work and the treasures surviving from his father, remembering the lessons of childhood, the next generation has kept the family's art surging with life. They have found room for themselves within the tradition of the old men. Sabinita López Ortiz has quickened the style, streamlining it toward expressive essences. Gloria López Córdova has made it a vehicle for exquisite workmanship, while refining and expanding the repertory of forms. Their

82

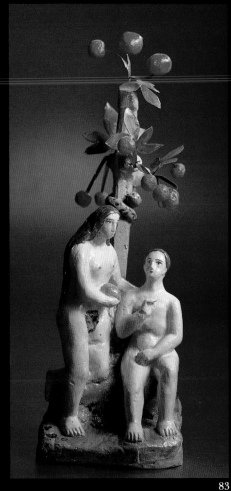

83

84

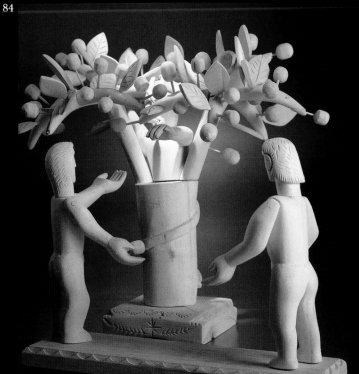

85

82. Sampler (detail).
Germany. Embroidered silk
on cotton, 20³/4 x 14³/8",
dated 1785. Many of the
motifs spread across this
sampler display the same
bilaterally symmetrical, yet
tripartite, structure; note
Adam and Eve, the
architectural facade, the
vases of flowers.

83. Adam and Eve.
Lima, Peru. Painted plaster,
12³/4" high, c. 1958

84. Adam and Eve. By
George López. Córdova,
New Mexico. Wood, 14"
high, c. 1950. José Dolores
López first carved Adam
and Eve in the Garden
about 1932.

85. Adam and Eve.
San Juan Metepec,
Mexico, Mexico.
Painted earthenware,
5" high, c. 1970

86. *Saint Michael:* San
Miguel Arcángel. *By
George López. Córdova,
New Mexico. Wood,
33" high, c. 1960.
Mr. López's image of
San Miguel follows the
model struck by his father.*

87. *Our Lady of the
Immaculate Conception:*
Nuestra Señora de la
Purísima Concepción.
*By George López. Córdova,
New Mexico. Wood,
20¼" high, c. 1960*

88. *Saint Joseph:* San
José. *By José Mondragón.
Córdova, New Mexico.
Wood, 12¼" high, c. 1965*

86

87

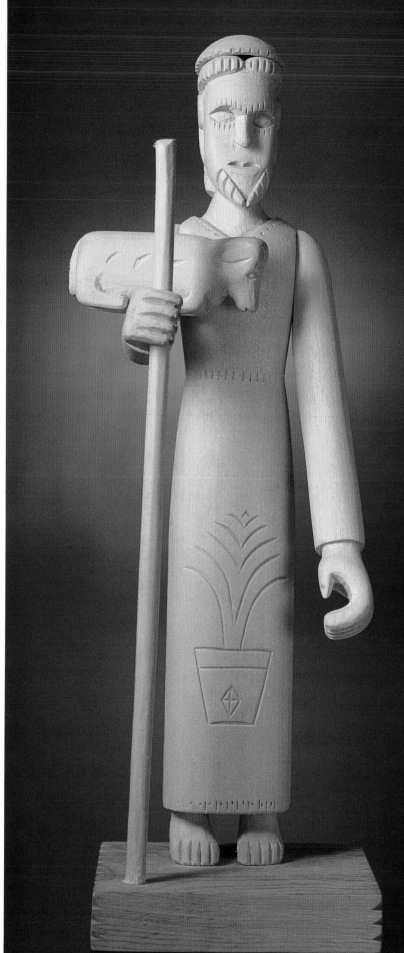

88

carvings and the carvings of their children interlock into a neat unity that is the spirit of old José Dolores alive in the world.

The rare genius of José Dolores López shaped out of the wide tradition of Hispanic wood sculpture a certain style. Neither the taste of his customers, busy about the development of a special ambience for Santa Fe, nor his carpenter's inclination to decorate with the knife rather than the paintbrush fully explains things. Unpainted, integrated by the pale tones of smooth-grained wood, stilled into haunting symmetry, the López saints locate the center of ancient spirituality. That spirituality might have dissolved into the market for antiques had it not been for the dynamic of the little atelier that joins artistic continuity to genealogical continuity, that uses divisions in the family unit to suggest divisions in the work force. The old teach, the young do the simple work. Different skills are blended. George López carved the figures. His sprightly, delightful wife, Silvianita, decorated them and carved the little animals. The husbands of Sabinita and Gloria help by gathering and preparing materials, and they do the selling.

Left
Sabinita López Ortiz with a photograph of her grandfather, José Dolores López, Córdova, New Mexico

Right
Gloria López Córdova with her carving of San José, Córdova, New Mexico

The López style has drifted beyond the family. A few others, notably José Mondragón of Córdova, became accomplished in its practice. But the tradition depends for vitality on connections sealed with blood. The clear identity of a style with a family might seem to make the carvers of Córdova a rare case, but families the world over divide the tasks, share the work, and pass the skills from generation to generation.

In the big atelier, the division of work elaborates. The educational processes that insure continuity may intensify and increase in formality. The big atelier stretches wider, welcoming novices from beyond the bonds of kin.

Ahmet Şahin was born in Kütahya, a lovely small city in the mountains of western Anatolia. For half a millennium, Kütahya has been a robust center for the manufacture of ceramics. We would call it pottery, but for the Turkish artisan pottery is earthenware, and *çini* is the name for ceramics with complex composite bodies, decorated by underglaze painting. Ahmet Şahin was not born into a family with a ceramic tradition; he was born into a city in which *çini* provided the traditional outlet for the artistic spirit. As surely as Peter Flanagan, Mr. Şahin was born with the soul of an artist, but his environment was not made of music. Fountains and mosques glowed with *çini*, and the shadowy ateliers rumbled with art being made.

Kütahya, Turkey

At the age of ten, Ahmet Şahin began spending his vacations from school in the atelier of Çinici Hafız Mehmet Emin. Then as now the boys did the master's bidding. He did not have to speak twice or even once. A nod, and knowing the atelier's rhythms, the boys hauled and mixed the mud, swept the floor, ran for coffee. When he was fourteen, Mr. Şahin was formally apprenticed. For two years he learned by helping with all the atelier's tasks, while his deep talent rose to notice and he began formal study with Ressam Hasan, learning to prepare the designs used to paint the plates and tiles. At eighteen he was

named headmaster of an atelier, charged with the control of a process of manufacture that was broken between a dozen or more people. He had to know the clay and how to mix its many elements. He had to know how to shape it and burn it, how to decorate and glaze and burn it again. But his will was to design.

Many enter the atelier to learn a trade and make a living. Others ascend. In 1927, when he was twenty, Ahmet Şahin formed a partnership with Hakkı Çinicioğlu—Hakkı, Son of the Maker of *Çini*—that marked the greatest peak of achievement in the Kütahya tradition between the 1890s and our days, when once again young masters have taken responsibility for their ancient tradition and urged it toward perfection.

Ahmet Şahin,
Kütahya, Turkey

Ahmet Şahin is the hero of the young masters. He is *tam usta*, the complete master, the great designer of Kütahya. As a youth he copied old work. As a mature man he copied no more. He had opened himself to all influences and blended them perfectly within. As accomplished speakers create out of themselves without reference to the rules of grammar or rhetoric, Mr. Şahin created out of himself seven big chests packed with designs drawn impeccably on white paper. He continues to experiment with better mixtures for the ceramic body; he draws new designs and executes new works with precision. He is one old man, hard at work, but his spirit has scattered through the streets to become the possession of the whole city.

There are twenty-three big ateliers and hosts of little ones in Kütahya. Three quarters of their designs are Ahmet Şahin's. The young masters orient their works toward him, using his works as guides to quality. From him flows the energy of a familial atelier. One son, Zafer, is the master. Zafer's wife, his son Ahmet Hürriyet Şahin, and Ahmet Hürriyet's wife, Nurten, continue in old Ahmet's line, experimenting and painting beautifully. And Ahmet Şahin's beloved son Faruk has become subtly the chief embodiment of the city's tradition, its innovator of new designs, its perfect painter, its ironic critic. In excitement the young masters exhibit their work before him, then stand back, hoping for approval.

Faruk Şahin knows the old Kütahya tradition and performs superbly within it. He is also a scholar, an expert on the world's ceramics, the author of important books and articles. Faruk teaches in the intimate style of the old masters, and he is, like me, an instructor in an institution of higher learning.

Schools like Faruk's and mine represent a third level of educational formality. Classes in schools make formal the educational interactions of ateliers, which in turn make formal the educational interactions of life. You can learn as Peter Flanagan did or as Ahmet Şahin did or as I did. All of us during our learning were provided with models to imitate. The imitations were corrected through hints from our betters and improved through comparison of our results with our models. We kept at it until we had devised ways to create that met our needs. Into our actions the rules of our traditions have been so thoroughly absorbed that our works can be read as personal or cultural. Peter Flanagan's music, Ahmet Şahin's plates, and the book in your hands simultaneously express one man's earnest efforts at perfection and the dreadful limitations of a particular culture.

As modes of training increase in formality, they can embrace greater diversity. They can reach farther. Peter Flanagan circled his parents' hearth, learning as he wished, and

launched himself into a state of excellence that brought him recognition as the best musician in a community devoted to music. Ahmet Şahin was drawn into an atelier and pushed through a series of grades to become the incarnation of the artistic spirit of his hometown. Schools can reach into diverse populations. They can draw from great distances. So schools can bring about violent disruptions in community values. Entering school, an American Indian girl might be stripped down and rebuilt in a foreign image. A university framed on an English model and dropped upon India might breed in its students hatred for their culture of nurture.

I remember Reverend Kirkpatrick, sitting in a glittering chamber buried in the national Capitol, dressed in the dungaree uniform of the warriors of the civil rights movement, defining folklore as the self he was educated out of being. The sense of loss is terrible.

But schools do not materialize out of the air. They grow, like the houses on the Irish hills, like the ateliers in Turkish towns, out of culture. For a person like myself, born into a house full of books, inspired by a scholarly father, there is nothing unnatural in schooling. It is a matter of choice, of course. It always is. Peter Flanagan did not become a tailor like his father. He became like him a musician. He heard every kind of music, but he cast around himself an environment of influence within which he became an especially excellent, particularly Irish, musician.

The potential for cultural disruption makes formal schooling emblematic of all that is not folk. Folk art is the result and cause and symbol of cultural connectivity. Yet, consider a lecture in a university on its own terms. A good one will use rhetoric to stir the senses so the mind will stretch for engagement with issues of importance. If that is accomplished, then surely a lecture is an artistic communication in a small group. The lecture will employ conventions without which it could not be understood as a lecture, and it will vary in accord with the personality of the teacher. Both traditional and variable, the lecture, like the scholarly paper, is a key medium of the community of intellectuals, willfully bound into an institution to preserve their culture in the face of threats from beyond. We will have to abandon all of our definitions if we want to think that lectures in universities cannot be folklore.

We might return to the idea of cultural disruption and note that not all who sit in a lecture belong to the teacher's small group. Everyone who hears Peter Flanagan play or who buys a plate from Ahmet Şahin is not a member of his group either. There is a difference. Most of those in Mr. Flanagan's audiences are like him farmers from Fermanagh. Most of Mr. Şahin's customers, being Turks and Muslims, understand something about his work. But both men know, and they lament the fact, that the groups they really reach are tiny, and they are composed mostly of artists like themselves.

Community is not a static thing, given out of eternity. It exists in a fluid state of creation that depends upon the actions of individuals. Rising out of a personal recreation of the collective tradition, the work—the fiddle tune or lecture, the painting or political speech —at once consolidates community and offers an invitation to participation. Out of the heterogeneous audience, the lecture pulls in those few for whom lecturing is an appealing expressive mode. Extending the invitation broadly, gathering a diverse assembly, schools increase the formality of their procedures so as to create the kind of coherence that grows naturally among the more homogeneous groupings seated at the hearth or laboring in the atelier.

It is not necessary to cite unusual instances in order to see the school as a situation in which folk artists learn. Sometimes traditional communities build schools to perpetuate their arts. Sometimes people trained at the hearth are invited to teach in big schools where they may encounter people capable of receiving their message and making it their own. But during normal operations, confined by the narrow culture of the intellectual, people for whom schooling is the natural fulfillment of their desire draw together to learn the skills necessary to advancement and self-realization.

If all modes of training can make people into folk artists, we have discovered one reason why the attempt to identify folk artists through their education will not do. But suppose we suspend the logic built by history into our definitions, and employing the judicial technique of the King of Hearts, simply declare that people trained in school cannot be folk artists. Though academic art fits the definition of folk art, let us assert, by decree of whimsical authority, that what is academic is not folk. Then folk artists would be people who learned as Peter Flanagan and Ahmet Şahin did. Saying that, we come upon the second problem.

Some of the artists we call fine artists were trained as I was, Thomas Eakins, for instance. And in our century it has become increasingly the case that, feeling the urge to paint and having displayed early signs of talent, people come into schools where they are sent through exercises, where they emulate their teachers while continuing to widen their minds by visits to galleries and encounters with books full of pictures, historical summary, and theoretical formulation. At last they shape a personal version of the big tradition built by the ongoing interaction of creators and critics. Outside of that tradition they might be mistaken, on the one hand, for mere craftsmen or illustrators or, on the other, for mere people, so they shape their works within the tradition, so that they can be called artists. They internalize ideas about medium and form and conduct in order to belong.

Now for the problems. Teaching academies date only to the mid-sixteenth century in Italy, the mid-seventeenth century in France, the mid-eighteenth century in England. The great heroes of the art historical epic include many—Giotto, Leonardo, Rembrandt—who were trained as Ahmet Şahin was. They ground paint as lads and filled in the backgrounds before they rose to the rank of master. The Peales and Wyeths are products of little ateliers like that of the López family in Córdova. And among the greats of fine art are some who, like Peter Flanagan, received encouragement at home and then wandered, absorbing bits of formal instruction, interacting and collaborating with colleagues, attending to various influences—following their personal star through thick cultural experience so relentlessly that they cannot be said to have been taught. John Singleton Copley is a shining instance, and you could add Winslow Homer and Paul Gauguin. If education is the key, Copley and Giotto are folk artists.

Weaving, teaching, and learning in the atelier of Firoza Begum, Rupsi, Bangladesh

We can divide the educational process by levels of formality, and we might generalize that folk artists learn informally; that is to say, they rise to maturity in homogeneous scenes in which a redundancy of model and message obviates the need for formal instruction. By contrast we might generalize that fine artists learn in heterogeneous scenes that depend on formal instruction for coherence. But reference to any definition of folk art, or contemplation of our customary division of art into folk and fine, will deprive us of the ability to

89. *History Professor.*
Izúcar de Matamoros,
Puebla, Mexico. Painted
plaster, 7³/₄″ high, c. 1960

90. *Cow with Man's Body.*
Celaya, Guanajuato,
Mexico. Painted papier-
mâché, 6³/₈″ high, c. 1960

89 90

identify folk artists by mode of education, especially since a single system—the atelier—seems to have produced the best of the fine artists and the best of the folk artists.

My point is not that the manner of learning is unimportant to understanding folk art. There must be a way, formal or informal, for the universal, innately human creative capacity to become trained and directed, contained and inspired, so that it can fulfill the spirit of a culture. In terms of the culture expressed by its grand exponents, whether Ahmet Şahin or Thomas Eakins, we come to be able to judge and understand art.

In Ballymenone, where Peter Flanagan represents music at its best, there are others who play. There are some with talent who did not practice, whose tunes alternate between the fine and the messy. There are others who worked hard but were not gifted. Their tunes are competent. As they say in Ballymenone, such people take their turn, providing the master with a moment of rest, but they do not play to please you.

It is a great virtue of tradition that people who surrender to it completely can perform despite a lack of gift. In the Turkish village only a few women are great weavers, but every woman weaves. Receiving help from her sisters at difficult points, adhering closely to techniques and designs into which have been built the collective experience of a vast population, any woman can create a passable rug. Similarly, not every member of a Victorian sketching club was talented. But reading Ruskin and following the guidance in manuals while receiving assistance from their friends, all could accomplish a reasonable landscape in watercolor.

Though marked by instants of near perfection, traditions are made mostly of competent performances through which the average practitioner melts into the collective style. That is as true for academic painting as it is for country fiddling. We may lose that understanding by representing one tradition with a selection of extraordinary examples, while

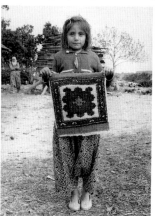

Sabriye Taşkın, age 8, with the first weaving she completed by herself, Karagömlek, Çanakkale, Turkey

representing another by the run of the mill. Taken as a whole, Impressionist landscapes exhibit about as much variety as Irish reels or New Mexican santos.

Within traditions that embrace both the excellent and the average, there are also immature works. It is amazing how quickly children learning within the confines of a sturdy tradition can accomplish works of quality. The girls who stitched samplers in the past and the girls who weave rugs in Turkey today challenge our notions of childhood. Maturity can come early to artists, but before it does, immaturity will be expressed in lesser little things.

The child fiddler's struggles die into thin air. But the wobbly first efforts of the child artist are often saved by tolerant parents. The finger-painted ducky is taped to the refrigerator, then stored in a drawer. Ahmet Şahin's great-grandson's first tentative tile stands on display in Zafer's living room. There is a corner of Gloria López Córdova's shop given over to her children's early carvings, labeled "Not for Sale." Their new and more secure works mingle with hers on another table with prices attached.

The childish effort preserved by the loving parent seems to confuse curators of folk art. There is children's folk art. Like children's folklore, it is learned from other children and used by children during their work, which, looking enviously in from the outside, we call play. But children's struggles toward adult models are neither folk nor fine art. They are

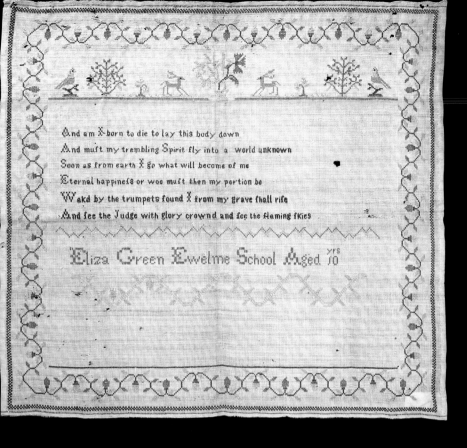

And am X born to die to lay this body down
And muft my trembling Spirit fly into a world unknown
Soon as from earth X go what will become of me
Eternal happinefs or woe muft then my portion be
Wakd by the trumpets found X from my grave fhall rife
And fee the Judge with glory crownd and fee the flaming fkies

Eliza Green Ewelme School Aged 10 yrs

91. *Sampler. By Eliza Green. Ewelme, Oxfordshire, England. Embroidered silk on wool, 13 1/4 x 14 7/8", c. 1815. Eliza stitched this verse on death when she was ten years old.*

92. Servilleta. *Zacapoaxtla, Puebla, Mexico. Embroidered cotton on cotton, 22 3/8 x 25 1/2", c. 1900. Though resembling a sampler, the* servilleta *was used as a carrying cloth. At the center spreads the Mexican eagle.*

evidence of the developmental stages through which people pass valiantly to achieve the art we call folk or fine.

Immaturity is one cause for the existence of things that can be called naive—a word raised constantly during talk about folk art. The immature work is less than competent. It is an incomplete accomplishment that often offers useful hints to scholars laboring to reconstruct the process of learning in order to understand mature work. The idea of the naive is used diversely in the literature on folk art.

The idea is fallaciously used when one tradition is judged by the standards of another. By the standards of the Royal Academy, the *fraktur* art of the Pennsylvania German schoolmaster looks naive. The assumption is that the painter in rural Pennsylvania was trying to accomplish what Sir Joshua Reynolds accomplished. He was not, of course. It would be equally reasonable to fault Sir Joshua for his failure to achieve the effects of his contemporary in Pennsylvania. Each of them matured through different experiences. They learned differently and at last were able to express excellently their distinct traditions. Evaluating traditions by alien standards is, well—the kindest word is ignorant. An African mask judged as though it wanted to be a French portrait, or a French portrait judged as though it wanted to be an African mask, becomes lost to understanding.

Art is made by people who direct their inner spirit to achieve excellence in terms of the tradition within which their product is to be judged. Immature strivings inside a tradition may justly be called naive. That should cause no confusion. Complications arise in the idea of the naive when distinct traditions slip into contact.

When Modigliani borrows an African mask for use in a painting, his work might look naive from an African point of view, just as an African use of a European concept might appear naive to a Western connoisseur. From within the tradition, thus expanded and recentered, such acts seem like enrichment, signs of energy and sophistication. If a borrower were able to shake completely free of native tradition, of all learning since birth, and set to work in an alien style, the result might be naive: an incompetent performance within an incompletely understood tradition. But owing to the power of the unconscious, ·shaped profoundly in childhood, such things are rare. What appears on the surface as naive appropriation is usually more deeply the product of the native tradition. Outsiders who try to copy folk art, like people who fake antiques, generally fail because ideas out of their own culture will rise through actions they cannot bring entirely into awareness. Somehow their efforts to repeat the fearful sacred images of another culture end up looking like the cute dolls and comic book heroes of their youth and the sickly pictures off greeting cards. Comparably, folk artists' attempts at portraiture resemble the timeless spiritual beings that populated the environments of their first consciousness. That is how things usually are. Learning hits early, drives deep. Culture is not a bag of tools and tricks that can be thrown off. It is the way the mind is molded through interaction with the world.

The problem concerning us now, that of the recreation of foreign models, is addressed most often in studies of provincial styles and understood most completely with furniture as the example. A new form arises in an urban center. The place is London, the form is the Chippendale chair. Thomas Chippendale copied, collected, and consolidated, more than he created. The bookish render him credit, for he was the author of a big book, but he was more clever than original. His form was, like all forms, derivative. Novelties that appear suddenly in one sequence of style have usually risen gradually in other sequences;

they are matters of borrowing and modification more than invention. What seemed new in England would have looked provincial from the angles of France or China. Ignoring all that, we proclaim the Chippendale chair a new thing, for so it was if we hold our attention tight upon London. Then turning to the countryside, we note a range of reactions materialized in chairs that depart from Chippendale's model. Looking out from London, the location adopted to call the form new, we dismiss these country chairs as poor copies. If that is all they were, the failures of rural woodworkers, they would display endless, patternless variety, being the mesh of a new form with the multitudes of discrete personalities and talents floundering on the fringe. Instead, what we find in the chairs (or the houses around them or the paintings on the walls) is local varieties, provincial types that blend the glamorous new idea with tough old traditions to create syntheses newer than new. Country Chippendale chairs in Wales or the Connecticut Valley resemble each other. Both are plainer than the urban model, but they are not the same. In materials, details, and proportions, each fits its place, distinctly, consistently representing its region.

The provincial artifact combines the new and alien with the old and familiar. Nineteenth-century folklorists realized that if provincial work were seen as only a version of the urban model, then rural culture could be described as a broken-down, incompetent imitation of urban life. So they stressed the survival of ancient ideas in modern situations, focusing upon the pagan elements in Christian contexts and the archaic dimensions of provincial creations. Their fascination with survivals may strike us as odd—and their explanations were odd indeed—but their concern was politically and historically apt, for it drew attention to continuities that could not be dismissed as bad imitations, and it is echoed today when black scholars refuse to see Afro-American culture as simply a reaction to European culture. Correctly, they seek connections with Africa so their culture can claim the power of its own history. Afro-American art, like provincial European art, is more than a reaction; it is a creative mesh of the native with the strange.

Provincial art results from cultural synthesis. New and old, alien and familiar, blend usefully. Today folklorists do not call this process provincialization, but creolization. The idea has not changed, is not new, but the new word properly relocates creative force in the hands of the maker. The country Chippendale chair or the Afro-American quilt is creole: a foreign concept improved in accordance with elder taste to fit the local situation.

Much folk art is provincial. It is not a docile acceptance of foreign models, nor their inept replication, but a rebellious recasting of novelties that makes them work in strange new ways and forces them to submit to the dominance of the local tradition. One result is coherent regional patterns within a large geographic whole. A story can be told of ideas arising in centers of influence and diffusing outward to become reshaped in distinct localities. The historian's tale elaborates but holds its shape: a great tradition flows on, leaping with innovation, calming to classic perfection, disassembling in baroque excitement, all the while interacting with the small traditions running alongside at their own pace, now bumping toward fusion, now pulling away to relocate their own integrity. Provincial art is assimilated with difficulty, but it can be made to fit. The provincial or creole, however, does not contain the whole of the folk art story, and the historian's tale as a result remains incomplete, false.

Folk art is provincial, and it is parochial. We generally use neither of those words positively. That is because we imagine ourselves to live in the places to which other places play the provincial and parochial roles. Irish thinkers have had to face the provincial reality. For

To The
Memory
Of
Richard Green
Died June 1st 1863
Age 47 Years

To The
Memory
Of
Thomas W. Green
Born May 5th 1858
Died August 15th 1864
In the service of his Country
Age 56 Years 3 Months

93

ABCDEFGHIKLMNOPQRSTUVWXYZ &. .

94

eight hundred years, Irish culture has seemed to waver at the edge of absorption. England's colonial expansion began on Irish soil, and armed foreigners still stalk the Irish streets. Irish virtue has been ignored or appropriated: where would "English" literature be in the twentieth century without its best novelist, Joyce, its best poet, Yeats, its best playwright, Beckett— Irishmen all? Irish writers have had to contemplate, to embrace or shun, provincial status. In the nineteenth century, William Carleton came out of the countryside, mastered the style of the English novel, and produced provincial works, at once Irish and English. Fitfully, painfully provincial, Carleton praised the parochial, the pure Irish tradition of art that droned and danced at the country hearth, that carried on without connection to Britain. In our century, the poet Patrick Kavanagh, similarly raised in poverty within the rich Irish tradition, raged at his own provinciality. It was better than sliding into the sleazy accommodation of the West Britons, but it was at last less fine that the parochialism of his agricultural youth that Carleton alerted him to, the sublime parochialism of the peasant for whom chat among the neighbors, the light dripping in the hedge, and the mutable color of a stone in the corner of a field were enough.

Some folk art is provincial, some is parochial. While some Irish chairmakers copied London designs precisely, so precisely that they can be sold at auction today for English, others blended English models with local taste to create provincial works. And still others, at the same time and in the same places, framed chairs that owed nothing to foreign notions but stated afresh the local tradition. The parochial pushes forward in energetic ignorance of the things out of which historians contrive their narrow tale.

All art from some perspective is provincial or parochial, a barbarous blending or a dogged persistence. From the outside, the provincial and parochial may seem naive, but from the inside they manifest a tradition's own creative power, its sophistication. Then what is naive? The genuinely naive might issue from a faulty grip on a foreign style, following the successful overthrow of the native tradition, especially in the context of violent conquest, when slaves struggle to do a new master's bidding. In settled times, the naive is the product of people who attempt to create within native traditions they have not mastered. Children provide the easy example. But sometimes adults act without having submitted to the discipline of the tradition. Let us imagine a person raised with magazines full of photographs and occasional pictures of things labeled art, who turns then to making some of that art by getting a piece of cardboard and painting on it some flowers in a vase.

We have drowned ourselves so thoroughly in our own tradition that we casually mistake its intricate artifice for natural process. We tend to forget that genres like portrait, landscape, and still life are not inevitable. They were won out of centuries of hard work, and a person does not turn to them, or even to the idea of drawing a colored picture on a flat surface, except as an actor in a cultural frame.

There are outsiders, people who abandon society to live alone in the cracks, but they mumble to themselves in their native tongue. If they set out to create things, they have no option but to engage with some tradition through which they tumble into connection with other people. Their works may excite us with their originality. They might contain such spirit that they attract a group of imitators who build around them a new tradition. Until then, no matter how enthusiastically we excuse or sentimentalize them, what they are, at last, is incompetent. Their authors may be elderly, but it is apt that such works strike us as childlike, for that is precisely what they are: immature. To call them naive is correct. To call them folk is

93. *Memorial to Richard and Thomas W. Green. United States. Cut paper, 14¹/4 x 20³/4", c. 1864. The dates of death in this dual memorial call up the grief of the Civil War.*

94. *Sampler. Possibly England. Embroidered silk on cotton, 13¹/8 x 18⁷/8", c. 1810. The willow and urn were the major neoclassical emblems of death in mourning pictures and on gravestones in England and the northeastern United States in the early nineteenth century.*

not. They are imperfect expressions of a tradition. Ancient fiddle tunes are often played ineptly. Much that is authentically folk is, as Alexander Girard said, junk. But I will recall the example of our painter of flowers on cardboard and assert—crudely but correctly—that what serious people mean by naive art is normally immature fine art.

Art is to be understood by reference to the models from which the operative idea of art was derived. Art never comes from innocent apprehension of the world. That could happen only if a person were raised entirely outside of the kingdom of material culture. All people are born into material culture, into environments that have been artificially shaped to enhance comprehension, to effect communication, to narrow the mind and drive it in certain directions. The person raised amid illustrated children's books and prints of old masters, amid billboards and magazines and films, will naturally construct from that experience (and not from an experience of George López's saints or Ahmet Şahin's plates) an idea of art. Out of the landscapes of Constable, the portraits of David, the genre scenes of Mount, the still lifes of Van Gogh, perhaps viciously channeled through commercial art, ideas flow to naive painters. In such company, they blot up cardboard.

The issue of education is not hard. All arts are supported by customary ways of learning. Some are formal, some informal, but all lead to competent performances that contrast with incompetent performances. If we arbitrarily divide competent performances into academic and nonacademic, and then (ignoring the anachronism in calling academic those works of art created before there were academies as well as abandoning the logic in definitions of folk art) if we call these fine art and folk art, we could also divide incompetent efforts into fine and folk. Easy, but the problem is that examples of incompetent fine art and competent folk art are sometimes lumped together because they happen to resemble certain instances of twentieth-century fine art. The taste of modern consumers gathers in disparate things and makes them costly. Dealers want to make money. Collectors want objects suitable to modern homes. Nothing wrong with that, but there is no reason why meeting the needs of the contemporary art market should require distortion of historical fact. Folk and fine art are both products of coherent educational systems.

Education is not the problem, but the issue of the naive is not yet clear because it entails, subtly but consistently, the idea of illusion. Allow me to begin simply. Imagine a spectrum of images running from the purely abstract to the purely illusionistic. Folk art by any definition runs the full gamut, from the pristine geometry of Islam all the way to radical realism. In Mexico and on the Indian subcontinent, folk potters play by making banks in the shapes of fruit, painted to trick the eye. At a *mela*, a country market held at the tomb of a saint at the end of a long earthen road in Bangladesh, I walked past piles of mangoes and melons searching for pieces of pottery and missing entirely those stacked before me. When I awoke to my mistake and recognized the fruit as ceramic, I felt a shock of bemusement like the one I feel when I enter a room inhabited by Duane Hanson's plastic people. The arts we call fine swing equally wide, from canvases striped with bold bands of color to photorealism. Still, it is not wrong to generalize that the most characteristic folk arts and the most characteristic fine arts cluster separately on this spectrum.

The great works of the Early Renaissance blended the abstract and the realistic. Giotto and Chaucer created people who at once resembled those around us and represented concepts. In the Arena Chapel and *The Canterbury Tales*, in scenes sketched out of nature, human beings interact with types. Before them in European history lay works that were

fundamentally typological, paintings of ideas in human form set against pure gold, plays in which people representing vices and virtues enacted the drama of consciousness. After them in the High Renaissance of Michelangelo and Shakespeare, the typological impulse was submerged in the effort to describe, but it was not lost. Appreciating Adam's anatomy or Hamlet's psychology, we still do not mistake the works that contain them (not to mention *The Last Judgment* or *King Lear*) for attempts to ape nature.

It is in this period, as art heaves, reversing the priority of the typological and the descriptive, that folk art and fine art separate. As fine art pushes through Caravaggio and Defoe toward greater descriptive accuracy, folk art stabilizes upon the typological.

Folk literature orients to the abstract. Its plots are repetitive geometric figures through which people who are not people but types move to push moral concepts into awareness. In folktale after folktale, a little boy, who is not a real lad but the personification of immaturity, leaves home, breaking the bonds that join him to his mother and his childish estate. He ventures into the big world to encounter giants. Some are emblems of evil, often the children and agents of wicked women. Others are emblems of benign authority, humble but wise elders, great kings. Discriminating correctly, binding himself to the service of authority, he gains tools to aid in his struggle, beheads the ogre, and secures a new contract with a new woman, through whom he is bound to adult male power. Receiving in marriage the daughter of the king, the folktale hero settles down to live happily. Life continues in the ballad. The type of the adult, intended or betrothed, perhaps married with children, breaks the new contract by venturing into the world again and receives the wages of sin.

The master narrative of the European tradition, composed by the enjambment of story and ballad, does not relate the biography of an individual as an eighteenth-century novel might. It exhibits the abstract pattern of life by plucking a person out of one home, forcing him to know good and evil, then providing him with a new home, there to practice quiescent wisdom or to relapse into childishness, which brings on the death of the mature person.

The characters of classic folk literature are not people but abstractions. Their minds are not entered, their bodies are left undescribed. They are pared down to the representational minimum. It is enough in a folktale to make the hero a little boy, enough in a ballad to call a lady fair. Offering no scenic settings, no account of appearance or motivation, folk literature reduces itself to a moral geometry. What people look like, how they think, and more important, what issues they imply—all that is left to the audience.

Folk literature works because the narrator and the audience share experiences and values that enable them to construct, separately and inwardly, the proper images and messages. Authors who do not know their audiences, who do not face them directly across the hearth, must pack into their tales more psychological, physical, and environmental description, and more guides to reaction. Stories lengthen, elaborate, and become realistic (just as educational procedures become more formal) in relation to the heterogeneity of the audience. The less we know and trust the people we are trying to reach, the more detail we put in the stories and pictures, the textbooks, cookbooks, and blueprints we give them. Compensating for the complexity of its scene, for the real distance that lies between author and reader, the descriptive work incorporates more of the real world so as to bring to the surface all the richness that lies hidden in the minds of the folktale's audience. The novel must make explicit what the folktale can leave implicit.

Opposite

96. Cicim *(detail). Turkey. Supplementary-weft woven wool, 78¹/₂ x 18³/₄", c. 1930. Both the design and technique are employed widely in Anatolia, though the colors suggest the region of Konya.*

Pages 114–17

97. *The Holy Family. Portugal. Painted wood, 12¹/₄" high, early twentieth century*

98. *The Holy Family. By Domingos Goncalves Lima, called "Misterio." Barcelos, Braga, Portugal. Painted earthenware, 8¹/₂" high, c. 1960*

99. *The Holy Family. By Jan Lameski. Poland. Painted wood, 13" high, c. 1960*

100. *The Holy Family. Sicily. Reverse painting on glass, 14⁵/₈ x 12⁷/₈", early twentieth century*

101. *The Holy Family. State of Oaxaca, Mexico. Painted wood, 14⁷/₈" high, c. 1960*

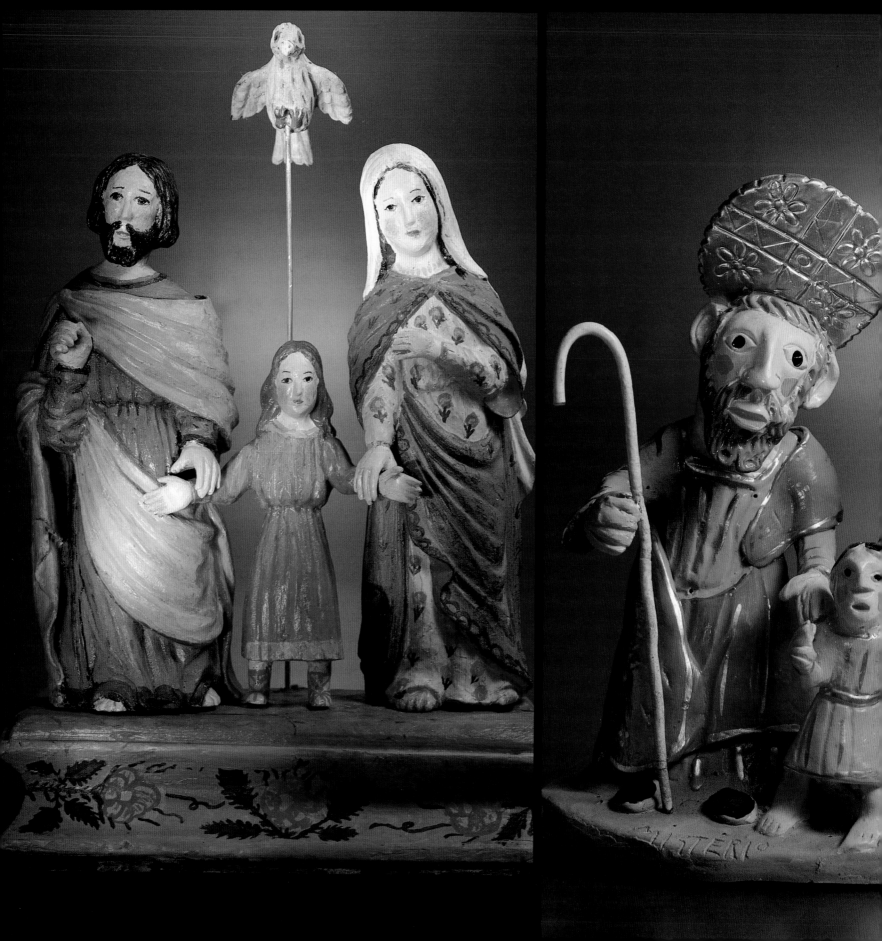

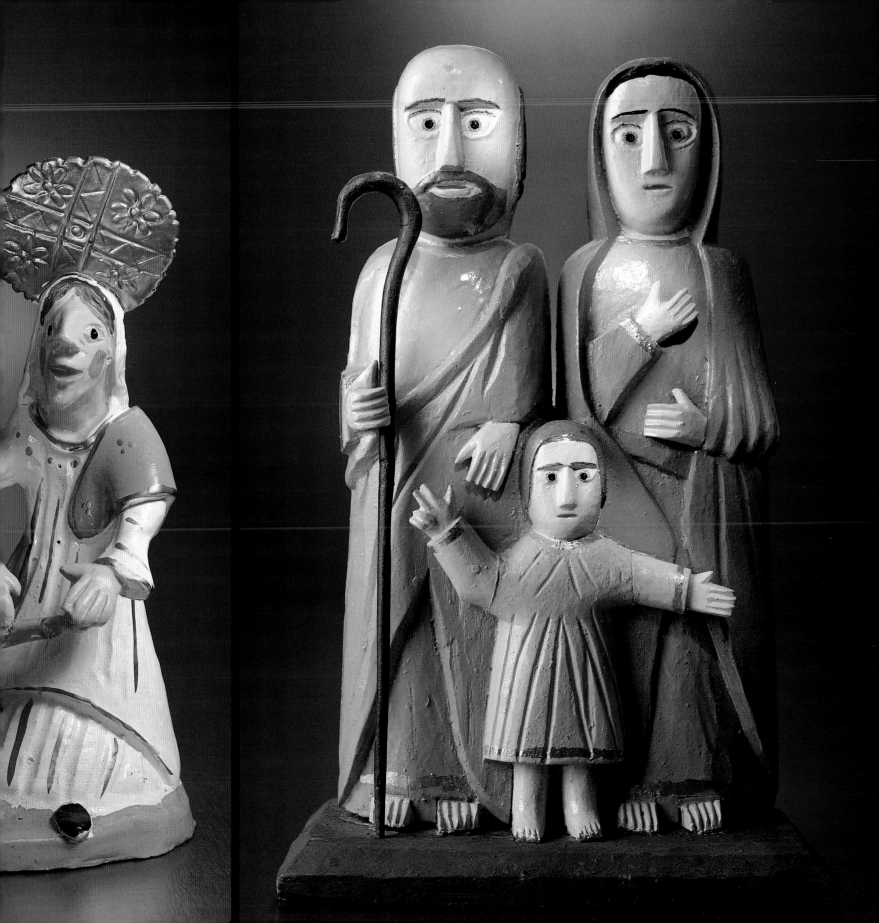

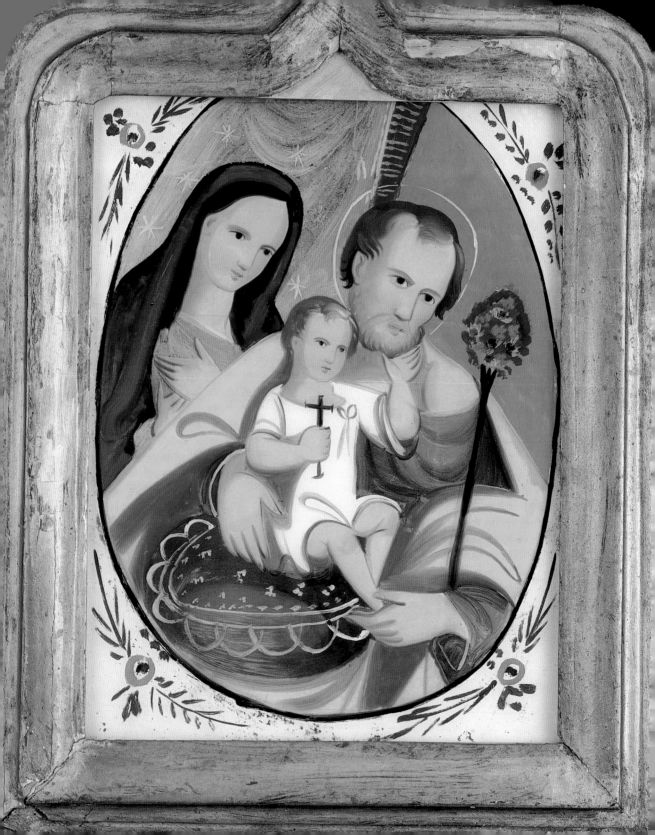

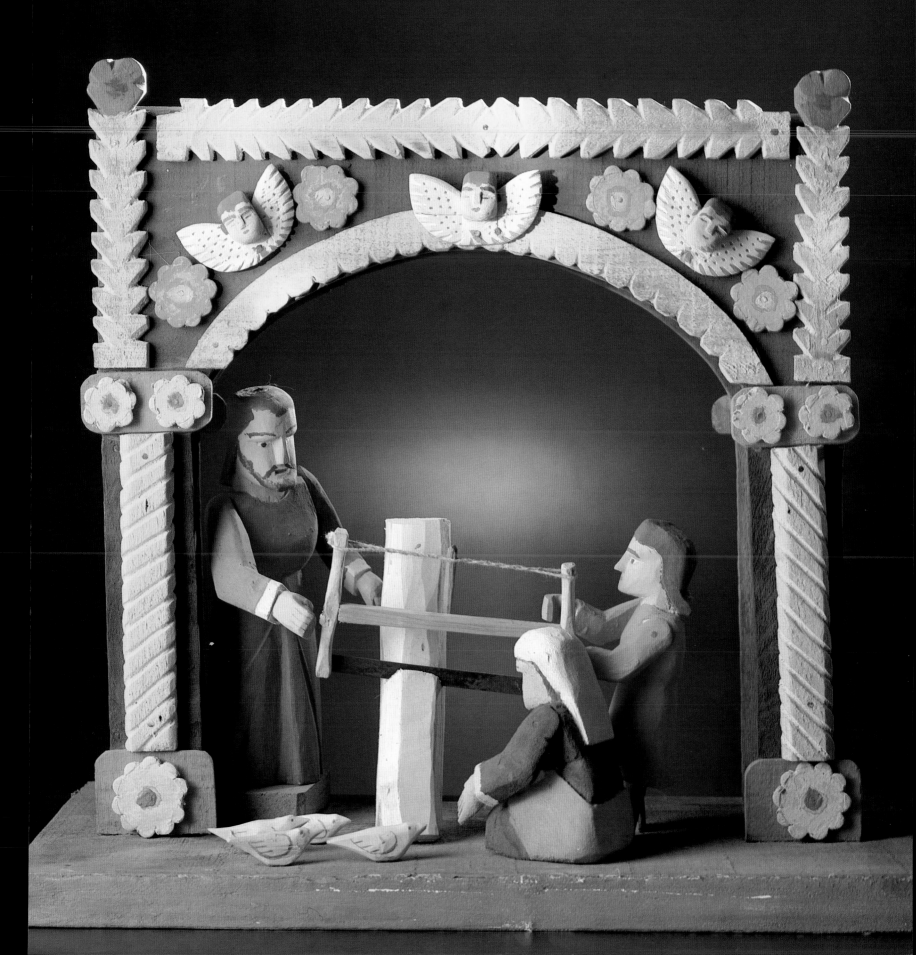

102. Sampler. Germany.
Embroidered silk on cotton,
5¹/₂ x 6⁵/₈", dated 1770.
Purchased in Munich and
presumably German,
this sampler was never
quite finished.

103. Sampler. The
Netherlands. Embroidered,
pattern darning, cotton
and silk on cotton,
11¹/₂ x 12¹/₈", dated 1810

Folk painting and sculpture come from the same mind. They embody the same principles as folk literature. It follows that in folk art, as in early medieval art, settings would be held to a minimum. There would be no descriptive elaboration of landscape into perspective. Central would be repetitive images, simplified so their surface detail would not detract from the deeper ideas they contain.

Wandering once through an exhibit of medieval art, I was struck and struck again by a single image. Carved or cast, detailed or streamlined, it consisted of a youthful man and a youthful woman turned to the viewer and holding hands. Equal in size and beauty, bound securely into a unit of design, they began to represent to me more than marriage. They recalled depictions of couples from later European folk art and the famous *Arnolfini Wedding*, and they recalled the great narrative verse of the Middle Ages, the romances of fidelity. Echoing back and forth across the exhibition, they came to suggest all sacred contracts, that of master and man, of man and God, as well as that of husband and wife. These couples may have been real people, but stylized away from particularity, made abstract, they became an emblem for a concept, the very idea of proper union. They made visual the moral message in the master folk narrative of Europe.

Folk images in paint or stone or clay resemble those in the folktale. As in medieval art, they represent types more than people, ideas more than things. They need to be realized only enough to specify their identity in the mind of the viewer. Deep in the mind, they are enriched with detail and saturated with significance. The man with the key is Peter. The man with the book and sword is Paul. Once we know this man, this woman, this child to be the Holy Family, the image will release narratives into the mind, emotions into the heart.

I have begun in Europe because it is only within the European tradition that the idea of the naive relates to the idea of illusion, but the typological impulse is general. In any coherent culture, slight suggestions can set trains of thought in motion. An Indian statue of Ganesha might grant him all his attributes: four arms, soft belly, the head of an elephant with one tusk, a rat to ride on, a pair of women to serve him. But a sphere with a thing like an elephant's trunk mounted upon a cylinder is enough to call the Lord of Obstacles into the mind, along with the myth of his origin and the host of powers he enjoys as Guardian of Beginnings. Among the Tlingit, the face beneath the dorsal fin is Killer Whale. Among the Yoruba, the face beneath the knife blade is Eshu rising in power. Detail can proliferate, but it need not. Once identified, however minimally, the image plunges into the mind that is properly prepared and sets about building elaborate castles of association. The image—the couple carved in ivory, the god cast in bronze—can gather the real world into itself at the pleasure of its maker, but it is enough for it to represent its idea clearly, to establish unequivocally its typological existence.

As European time drove into the modern era, folk artists held to the typological and became increasingly separated from fine artists, who fastened themselves to the other side of Renaissance greatness and strove to purify it in realism. In the nineteenth century, while science completed the conquest of nature, artists tested themselves by their ability to capture nature, to describe the look of the world in their works. To be skilled was to create cunning illusion. Against this fascination with appearance, the great moderns mounted their rebellion.

Sick of surfaces, weary with what Marcel Duchamp called the retinal, the reproduction of images mechanically registered upon the eye, the great moderns demanded the

Pages 120–23

104. *The Family of Krishna. Northern India. Painted paper, 9¼ x 7¾", late nineteenth century. The infant god Krishna sits on the lap of his stepmother, Yashoda. Nanda, his stepfather, holds Balarama, his brother and companion. An episode from his later life appears in the lower section of the work.*

105. *Ganesha. Madhubani, Bihar, India. Watercolor painting with block-printed borders, 24 x 25⅞", c. 1950*

106. *Ganesha. Saurashtra area, Gujarat, India. Embroidered mirrorwork, silk on cotton, 24¼ x 23", early twentieth century. This hanging (sthapana) bears two inscriptions, one honoring Ganesha, the Lord of Success; the other is probably a signature.*

107. *Ganesha. Saurashtra area, Gujarat, India. Embroidered mirrorwork, silk on cotton, 22½ x 15", twentieth century. The sthapana is a ceremonial hanging used at weddings; its shape repeats the gabled form of a shrine.*

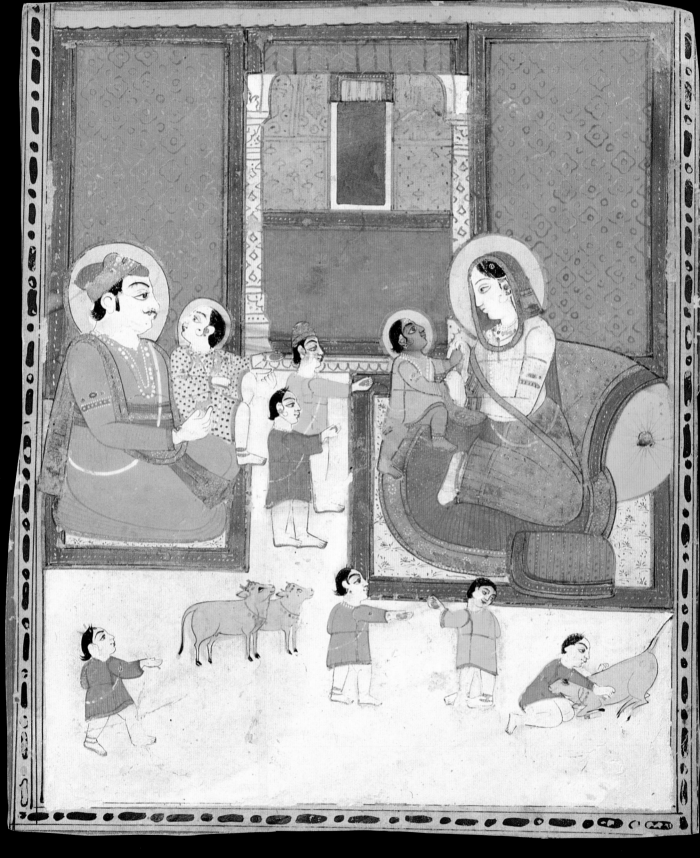

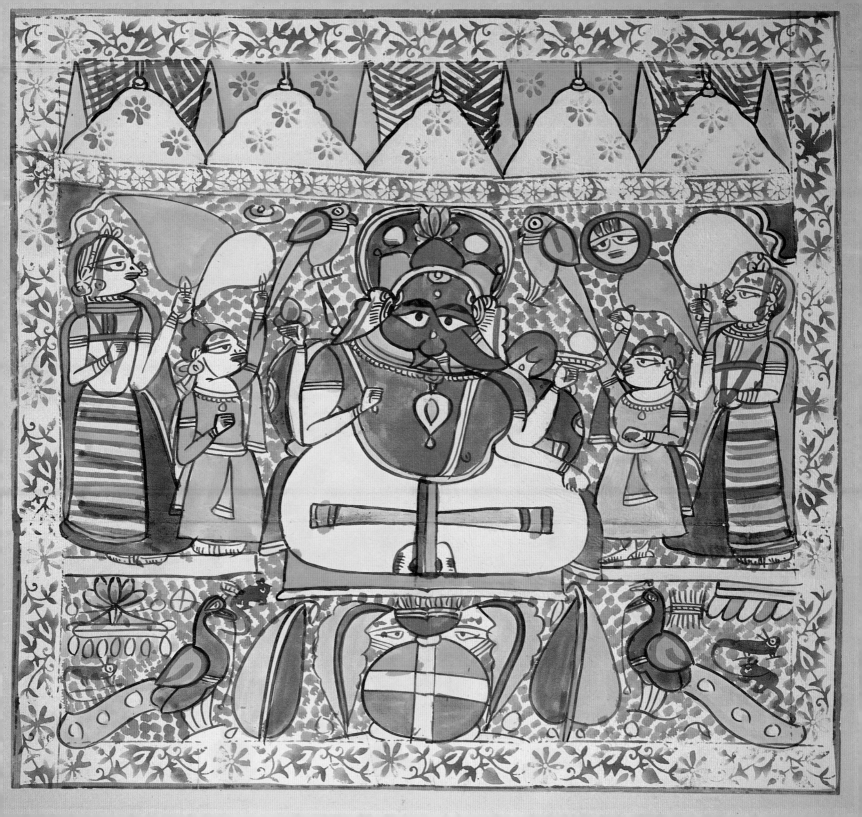

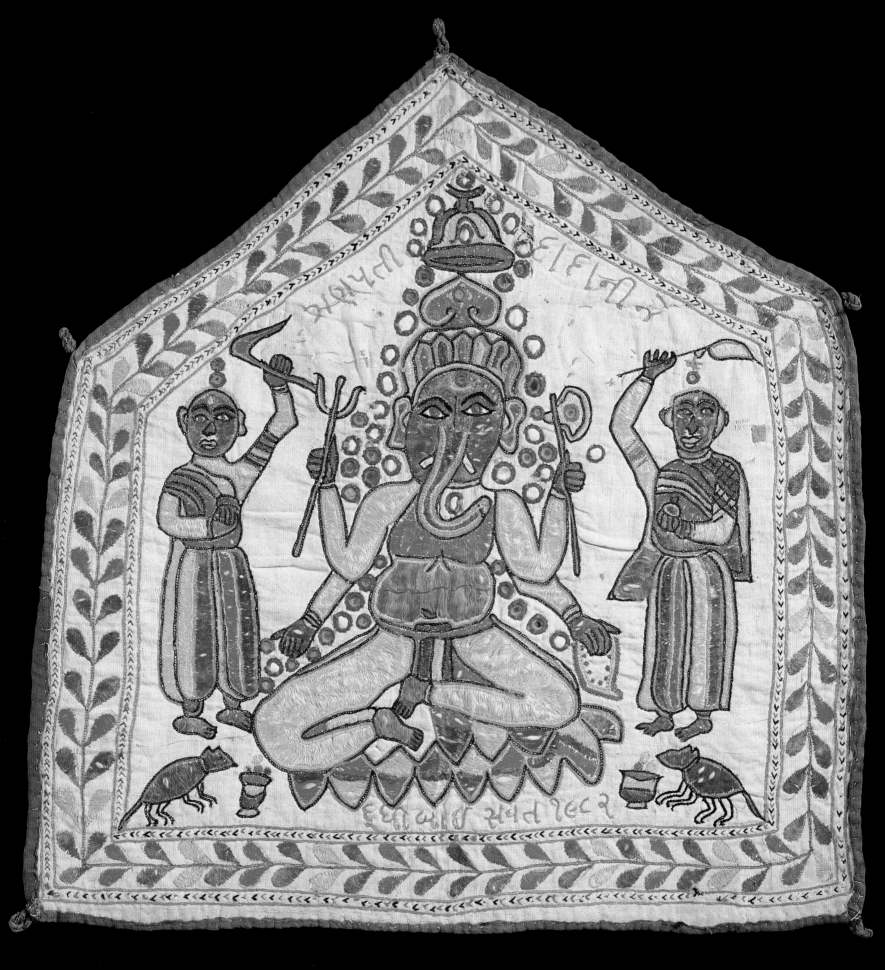

108

109

108. *Ganesha. State of Bihar, India. Cast brass, 5" high, c. 1950*

109. *Ganesha. Benares, Uttar Pradesh, India. Painted, varnished wood, 5³/₄" high, c. 1960. Ganesha is the special protector of Benares, holiest of Hindu cities. Fifty-six monumental images of him surround Benares' sacred center, and small images, like this one, fill the city's markets for sale to pilgrims.*

110. *Saint Augustine and Saint Gregory. Paraguay. Painted wood, Saint Gregory 5¹/₈" high, c. 1960. San Gregorio holds the Book, San Augustín the Church.*

111. *Saint Joseph:* San José con El Niño. *Mexico. Painted wood, 19³/₄" high, late eighteenth century. This statue exemplifies the provincial baroque style of* Latin America; the glass eyes and gold are especially characteristic.

112. *Cross of Souls:* Cruz de Animas. *Mexico. Painted tin, 7 x 5¹/₈", nineteenth century. God the Father, the sun and moon, Christ, and the instruments of the Passion normally appear on the* Cruz de Animas. *On this one, souls in Purgatory are identified* personally: at left, "Juan Ramires"; at right, "Dorotea Olgin."

113. *Cross of Souls:* Cruz de Animas. *Mexico. Painted wood, 15³/₄" high, nineteenth century. Souls in Purgatory licked by expiatory flames appear on the base of the Cruz de Animas; images of Death and the Garden of Eden may also be included, as here.*

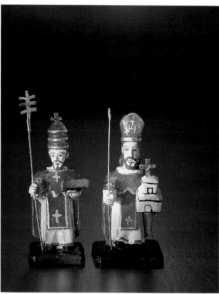

110 112

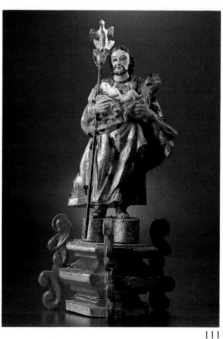

111 113

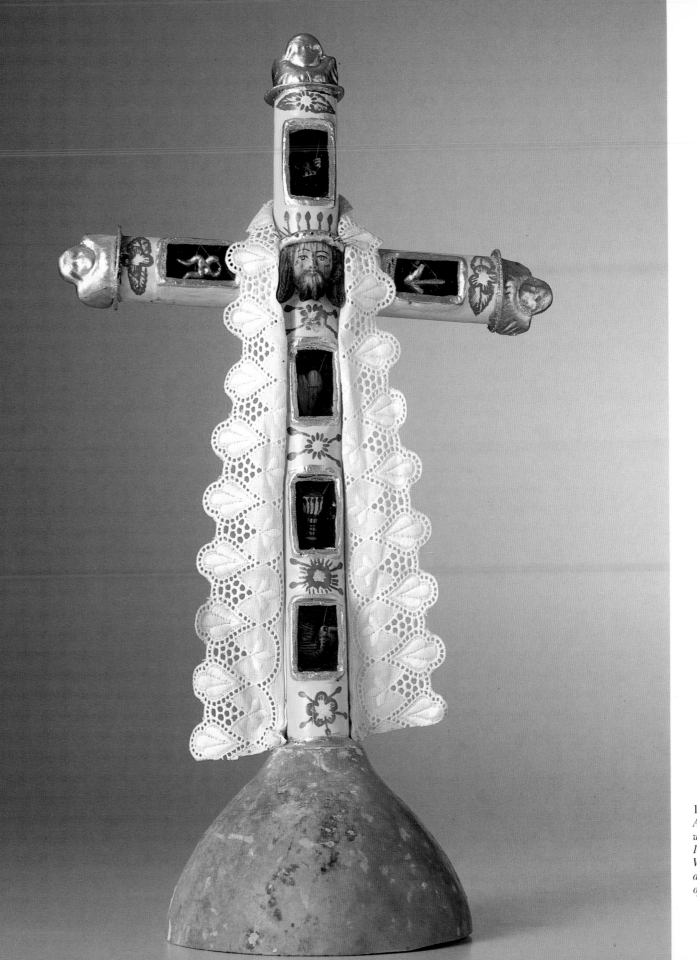

114. *Crucifix. Ayacucho, Ayacucho, Peru. Painted wood, lace, gourd, glass, 16³/₄" high, c. 1958. Within each of the six niches are suspended instruments of the Passion.*

return of the mind into art. With the grand projects of James Joyce providing us clear examples of the course of their action, the moderns worked to create for a new age a blend of the sensual and the intellectual like that which typified the Renaissance. Advancing historically, they returned conceptually to a point where the typological could gain strength and infuse description with significance.

In the days of Duchamp and Joyce, Wassily Kandinsky drove the quest farther. His love for art began in pure color squeezed from the tube. New paintings from France thrilled him early. As author of the first nonobjective paintings, he is a hero of art history. But mere artistic revolution was not his goal. He wrote of building new art out of old, of the inevitability of tradition, and insistently he spoke of art as the search not for the new but for the spiritual. Working as a professional ethnologist, Kandinsky walked into a richly decorated peasant home and felt as though he had entered a painting. That experience, repeated in visits to churches, guided his work. Its recreation became a motive for his art, but his deeper motive was to pull art away from the atheistic nightmare of materialism and place it in service to the divine. The true source of Kandinsky's art, his wife wrote, lay in the old religious art of Russia. Unabashedly, Kandinsky called for an art integrated as religious art had been, an art sprung mystically from the soul, an art rising toward Heaven. The purpose of art, he wrote, is to increase spirituality in the world. For Wassily Kandinsky, collector of folk art and master among the moderns, the search was not for mind but spirit.

The search for mind recoils from mere illusion and brings the descriptive and the typological into union. The search for spirit goes farther. Coming upon the blending of idea and image—a man nailed to a cross—it keeps pressing until the idea rises into clear dominance, and the image, become abstract, can lead the mind away from the details of the surface into the significance roiling below—away from the historical facts of the Crucifixion into confrontation with the essence of Christ's Passion. Then the search for spirit drives farther until the abstraction becomes a symbol, a bare cross that can suggest through lines intersecting at right angles the whole of the Christian tradition. Not stopping, the search pushes onward until a perfect geometry appears that is not an abstraction from the world's objects but a depiction of the process by which the world exists. Even then the search is not complete. It continues until art becomes irrelevant and things vanish into the pure and perfect whiteness that is no color and all color. Enlightened then, the maker of art returns to the world through the stages of geometry, symbol, abstraction, typological description, realism—with each step spirit attenuates until it dies in illusionism. It was spirit that had disappeared from late nineteenth-century art, when art through illusion and science had become, like so much else, thrall to materialism and vulnerable to revolution.

The nineteenth century had its transcendental artists, like Frederic Church and the Pre-Raphaelites, who tried to preserve the spiritual by declaring that their meticulous pictures of nature were portraits of God, but things swept past them into the retinal. Their style, despite them, was materialistic. Perfecting it and using it with admirable facility, even in images of the Holy Family, they only contributed to the destruction of their own values. The spiritual lay behind them, just as they said, in Raphael's day and beyond, when images were stylistically as well as topically spiritual.

With the complaint and vision of the great moderns behind us, we are ready for a more forceful summary. The spectrum running from the abstract to the illusionistic is but the manifestation in art of the spectrum of life experience running from the spiritual to the materialistic.

Opposite
115. *Crow Mother. Hopi people, Arizona. Coiled, dyed yucca leaf and grass, 12 1/2" diameter, c. 1960*

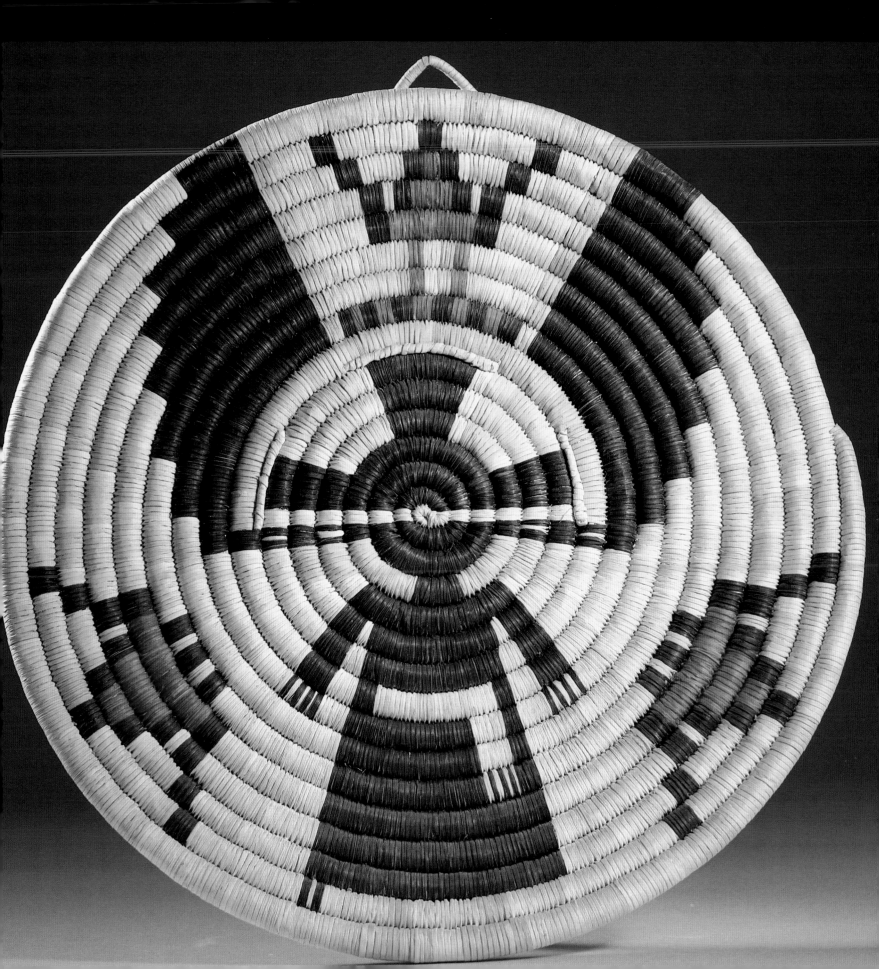

A pause is due. I remind you that I am no longer defining folk art. We have done that. Our task now is to refine our understanding of folk art through contrast. Folk art by definition can arise anywhere along the continuum stretching from the abstract to the illusionistic. But by contrast to fine art, folk art displays certain tendencies. It is relatively abstract. The words used to arrive at that small conclusion are not satisfactory. The usual synonyms—nonobjective and objective—are no better. It is not wrong to assert that folk art is relatively abstract or relatively nonobjective, but these terms belong to a domain of art dominated by the concepts of illusion and objectivity. To think of abstraction as the negation of realism is to accept the preeminence of illusionism. It is instructive that critics in an age of abstraction continue to use words appropriate to an age of realism. To avoid definitions by negation, I substituted the ideas of typology and description. Both are positive forces. Art is not typological because it is not descriptive (as art can be said to be abstract because it is not illusionistic). No, folk art is not descriptive because it is typological. It seeks a different power.

Concluding that folk art is more typological than descriptive, we come into alignment with another contrastive pair. All art, to be art, serves the mind and the body. It is conceptual and sensual. Folk art stresses the conceptual over the sensual. Fine art does the reverse, as is revealed by the emphasis on the aesthetic, the sensual side of art. That is obvious when fine art concentrates upon appearances, but even the abstract work, despite the efforts of the early modern masters, is apt to be discussed in sensual rather than intellectual terms. By contrast, scholars of folk art, like scholars of medieval art, stress philosophical issues. That division in scholarship matches emphases in the art itself. Continuing in this simple mode, we might say that the richness of folk art lies in its entailment of philosophy, while the richness of fine art lies in its incorporation of the sensate world, whether through the depiction of light fluttering among the leaves or the apposition of blocks of color. Folk art is relatively intellectual.

Yet more significantly, the contrast of the conceptual and the sensual aligns with that of the spiritual and the material. To emphasize the sensual is to emphasize experience of the world, its feel and sound and look. Folk art, by contrast, withdraws from the world toward spirituality.

I simplify further during our quest for the spirit of folk art when I raise anew a widely accepted generalization. Folk art is the expression of traditional societies. Within the small group of the artist, all art is traditional. It embodies shared principles of propriety. But all artists do not exist in traditional societies, groupings within which life unfolds like art out of willful compliance. Among people who gather and control themselves by traditions that grow from within (as opposed to laws imposed from without), the ultimate authority is normally not government. It is religion. Being the product of traditional societies, folk art is the product of religious societies. Fine art is the product of secular societies. It rises in scenes of institutional division. Politicians govern, philosophers philosophize, priests busy themselves with religion, and artists in their coveys define their task by contrast and concentrate on communicating feeling. Folk art lifts out of more integrated scenes in which philosophers are priests, where the power of priests counterbalances that of princes, and a tradition founded upon sacred principles simultaneously governs conduct, informs thought, and inspires the creation of art.

The product of religious societies, folk art is typological, conceptual, spiritual. The

product of secular societies, fine art is descriptive, sensual, materialistic. That contrast is too severe, too clear, but its essential validity will gain support from consideration of art that mixes the key traits of folk art and fine art.

When creative action drives into dynamic tension the typological and the descriptive, when the spiritual and the material swell with equal force and counterforce, the result is the art we react to as greatest. It is the expression of societies attracted equally to the sacred and the secular, societies that are battlegrounds for tradition and law, on which priests and princes contend for control. The moment is the Renaissance: Florence in 1500, London in 1600, Dublin in 1900. As temporal power succeeds, and societies become increasingly secular, their art seeks illusion. At the same time, others clarify their difference by honoring the sacred contracts that bind people together before God and by holding to an art that expresses their commitment through spiritual abstraction.

Secure within the fortress of secularity we have built around us, we gaze out on the wider world. Looking backward, espying art in its great instant of impurity, we naturally see most clearly what is easiest for us to assimilate. We stress Michelangelo's great descriptive powers at the expense of his terrible religiosity. We admire Yeats as a poet of personal feeling and find his spiritual experiments embarrassing. Then, catching a glimpse of the art of societies governed by religious tradition, we mistake it for an inept attempt at illusionism, as naive, when it is the expression through objects of the sacred power that drives life.

Folk art is the flower of religious society. That is why in Europe it appears to be a survival from the Middle Ages. It exists in these times because, while some societies have achieved secular order, others living hard by, often occupying the same geographical space, organize themselves traditionally through the sacred. Folk art is not a bundle of expressive conventions that has tumbled by queer accident into an age in which it is anachronistic. It is the emblem of a way of life that endures through exertion. People in traditional communities, the makers of folk art, hold to the virtues of the past, but they are not looking backward, nor are they lost in the present. Their orientation is to the future; their tradition directs them clearly toward the life to come.

Return now to the Museum of International Folk Art, where works from far-flung cultures have been gathered to facilitate comparison. Around us congregate representatives from many societies. In their midst, Alexander Girard says he has gathered them from all the world over to teach us that the world is one. We are standing next to a hosting of works from Peru, and he gestures carefully toward the comparable sets of statues from Portugal and Poland. The small people of clay and wood assembled in these separate exhibits do resemble each other. They incorporate traits of artistic action too general to be confined by nation or culture.

Art works something like metaphor. To figure out why a man is like a lion or a raven is like a writing desk, we release the wholeness of things and isolate their traits, concentrating on those that organize things productively in our minds. Reducing, focusing, and comparing, we come to an understanding that is richer than the undifferentiated gestalt with which we began. The work of art is like half of a metaphor, like a riddle. What it is like is up to you. Your work is joining the object to that which makes it make sense. Art begins your job by incorporating conventions that display patterns of reduction and concentration.

The reductive, concentrating power in folk art follows a particular course to bring forth people with big eyes and big heads. Big in the organs for gathering and processing

information, the little statues from Poland, Portugal, and Peru are especially human. There they stand and stare ahead without expression, each in its own world. Though cajoled in the exhibit into interaction, taken individually they want no physical context. They spring out of time's flow, away from the world into a timeless, placeless isolation, and begin to seem like eternal presences, as though they were not images of people, but images of human spirits, of souls. That reaction strengthens when we notice that ordinary people are portrayed the same way saints and angels are. Certain attributes separate them, but the people are more like angels than they are different. They are of the same stuff, less flesh than spirit. Less people than types, they are less types than souls. It is no accident that the countries from which these souls were gathered share a hearty Catholicism. To make the point clear, Mr. Girard has arranged the folk from Poland, Portugal, and Peru into religious processions and placed churches prominently among them.

Alexander Girard's exhibition is his conceptual artwork, and these are among the hints he provides to pull us toward understanding: souls in motion around churches. But Catholicism is not the key to his idea of oneness. The exhibit opens or closes, depending on your route, with India. Hinduism and Catholicism differ in much, but they are alike in possessing the idea that unifies Mr. Girard's concept and points to the center of folk art. In both, divine power floods into human form. Christ is God made man. Angels bearing God's messages to humankind appear in bodies like ours. The saints are people who contain sparks of divine fire that they display in miracles. Mere mortals are molded in the image of God and bear within them angelic essence. In Hinduism, perfect and infinite power surges through millions of deities who take on the shapes of people; it pulses within saints searching for union with pure spirit. Krishna, like Christ, came as a god and as a man among the earth's people. It is natural for Catholics and Hindus to stress the body as an incarnation of spirit, to place bodily images in a mediating role between people and divinity. It follows that their art would abound with human images that seem less like people than like human essences aswim in eternity. The center of Mr. Girard's exhibition is claimed by a certain kind of religious society, the kind that creates through human embodiments of spirit a vision of a world unified by sacred power.

The world of Alexander Girard's exhibit is not the whole world. It is not even the whole world of folk art. Yet, for Westerners, for people accustomed to thinking of art in relation to representation, it offers an excellent entry into folk art. Swinging wider, gathering in the arts of certain cultures in Africa and East Asia, we would but strengthen the right granted to Catholicism and Hinduism to lead us straight to the heart of folk art.

Here folk art gathers its power and consolidates its opposition to fine art by proclaiming through abstract form the superiority of the spirit.

Were spirit all, folk art would not exist. The wordless prayer of the enraptured heart, leaving no earthly sign, would be its sole human expression. It is by contrast to fine art that folk art is spiritual. Following religious traditions that allow spirit to appear in human form, we find folk art to lie, not at the end of the spectrum, opposite to materialism, but somewhere to the spiritual side of the position occupied by the art of the Early Renaissance.

Out of its own place, folk art reaches in both directions at once and pulls into itself both spiritual essence and worldly appearance, then arranges them so that spirit dominates but the world forms an exciting counterforce. Loving God, the medieval European sculptor loved, too, the tender flowers of the riverside, the fleshy forms of men and women at work in

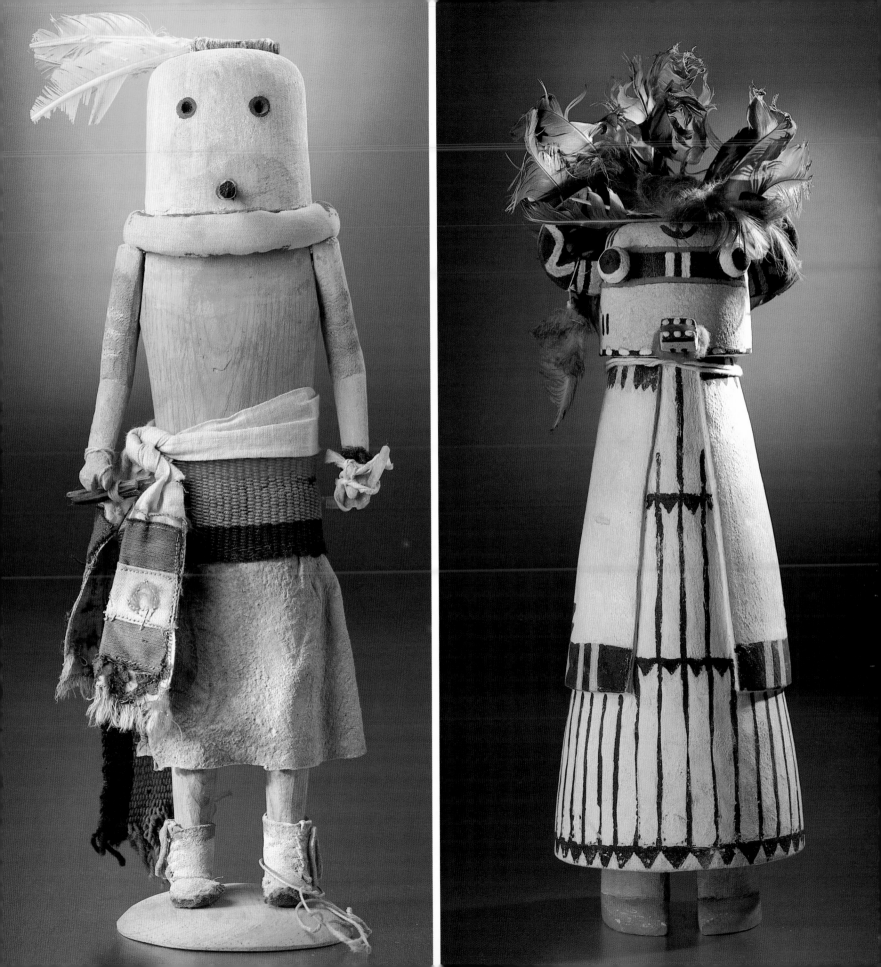

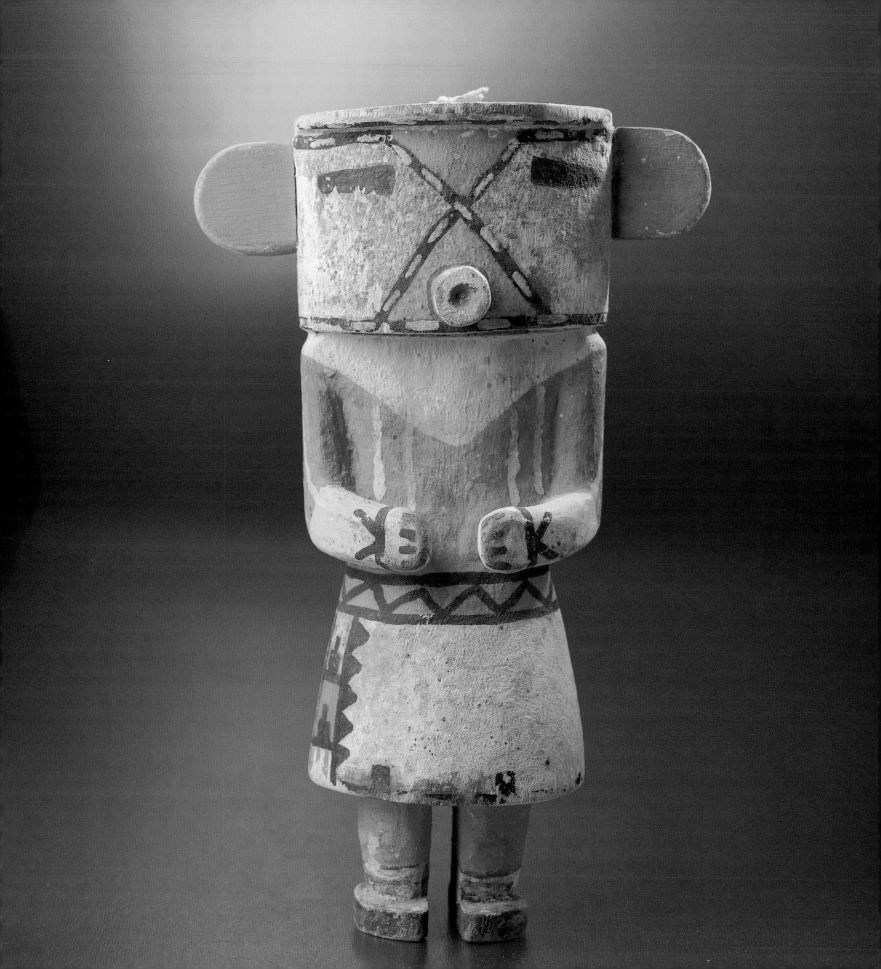

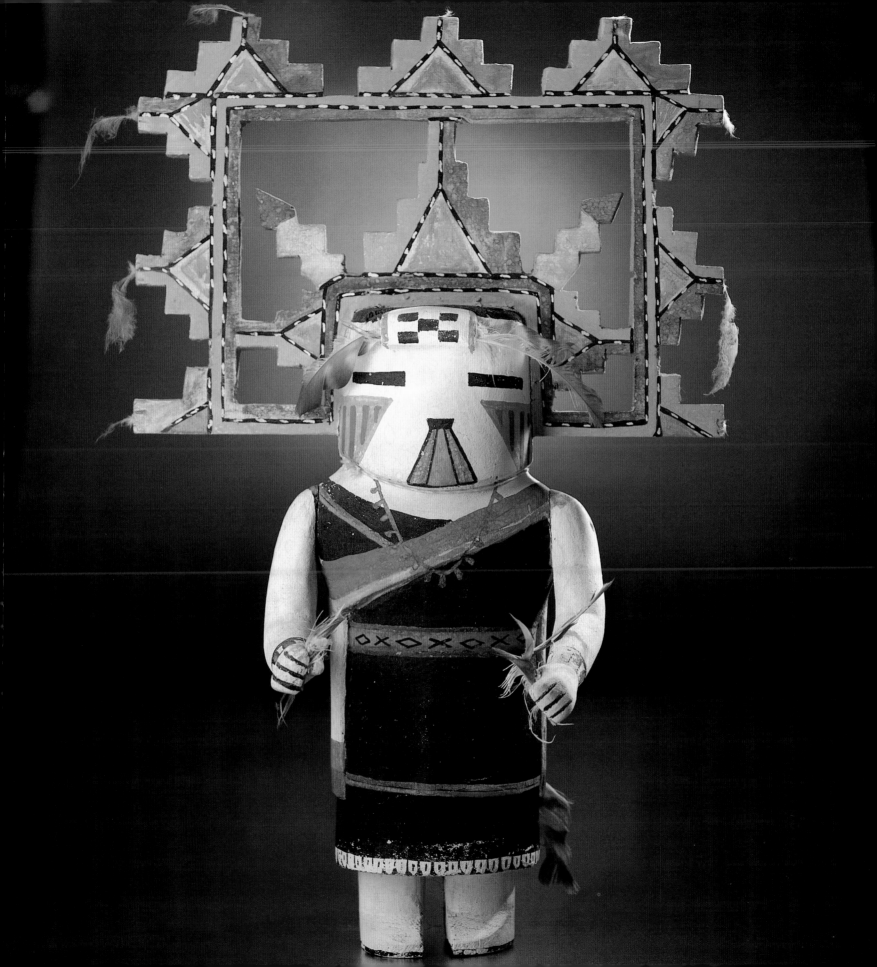

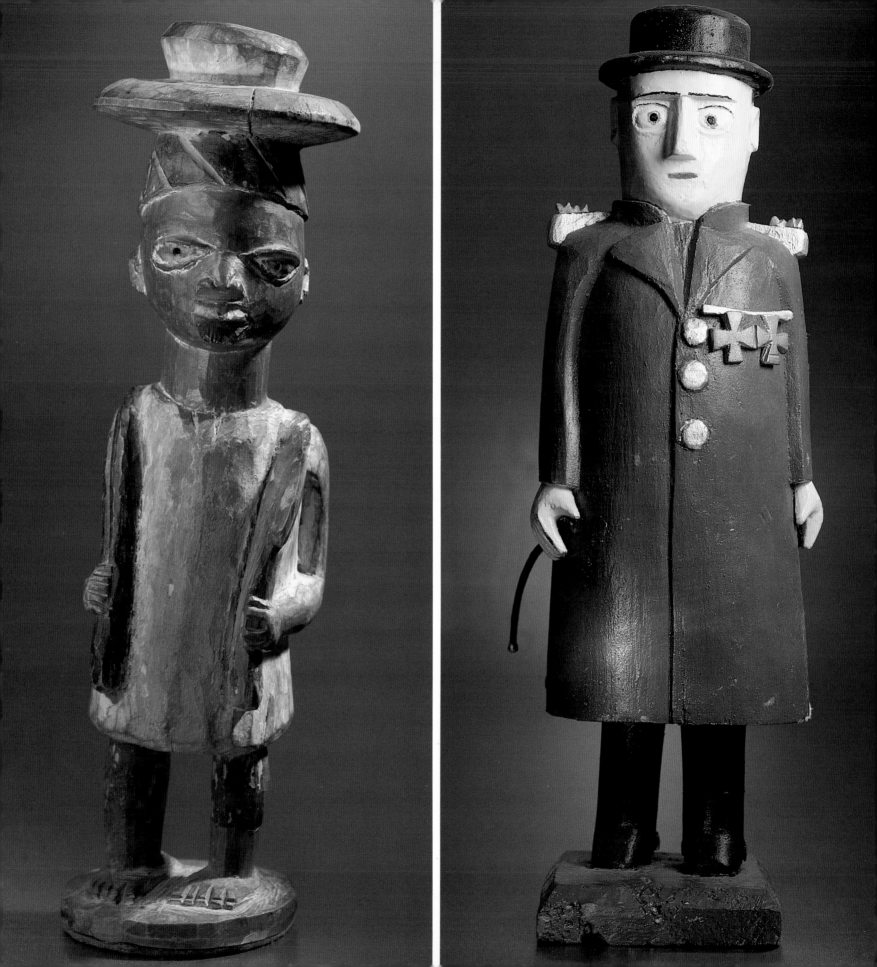

Left to right

120. *Man. Yoruba people, Nigeria. Wood with white paint, 11¼″ high, c. 1960*

121. *General Potowski. By Jan Lameski. Poland. Painted wood, 16¾″ high, c. 1960*

122. *Lady. San Pedro Tlaquepaque, Jalisco, Mexico. Painted earthenware, 7¾″ high, c. 1965*

Overleaf

123. *Parasurama, Narashima, Bali, and Manu. Benares, Uttar Pradesh, India. Painted wood, 8″ high (on average), c. 1960. These figures illustrate characters from tales of the god Vishnu's nine incarnations on earth.*

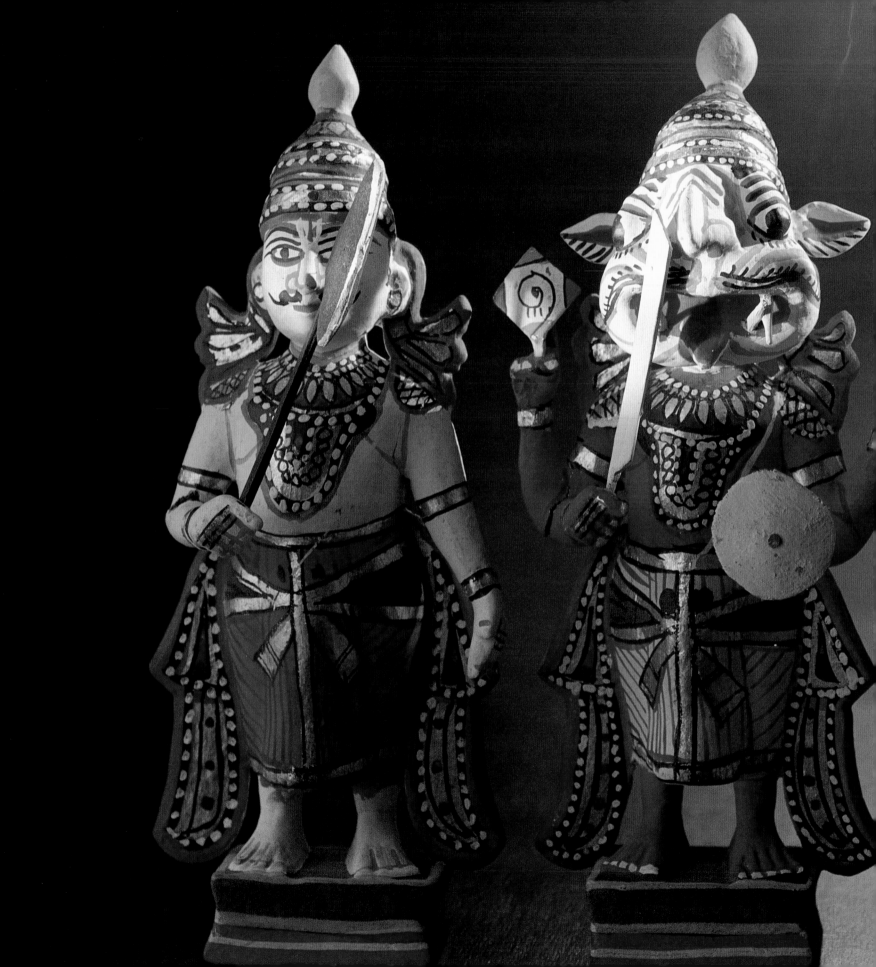

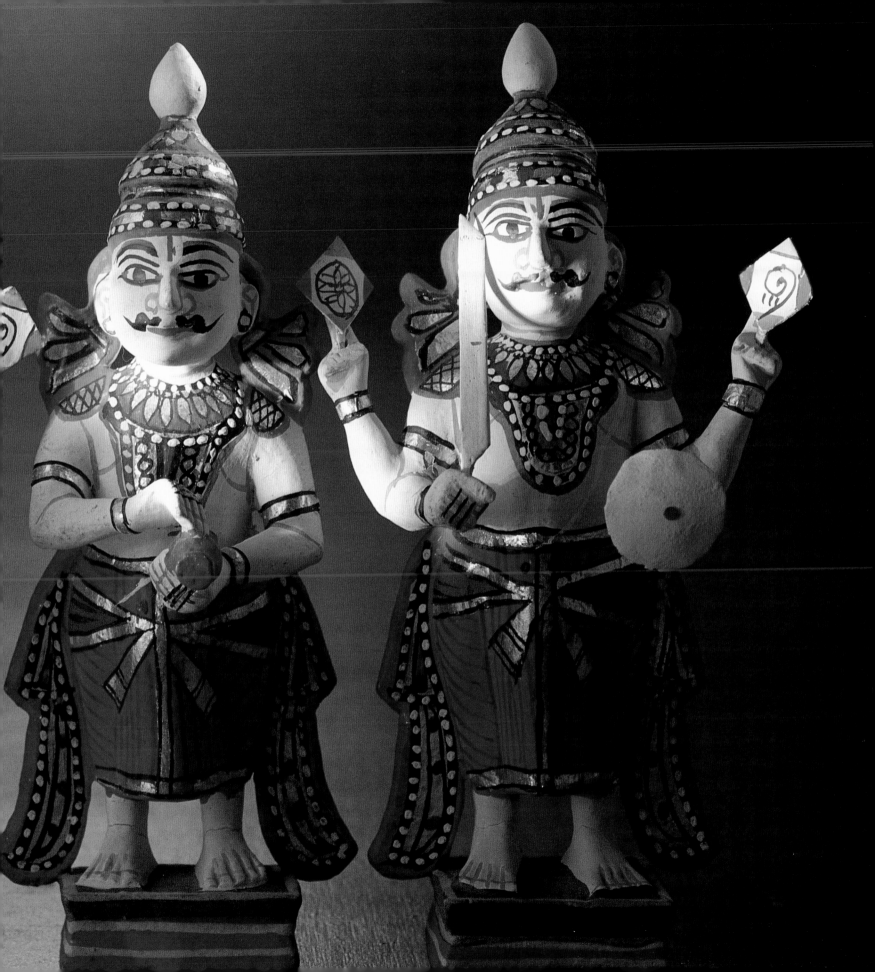

124

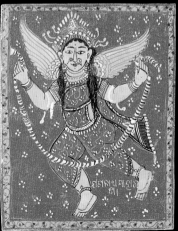

125

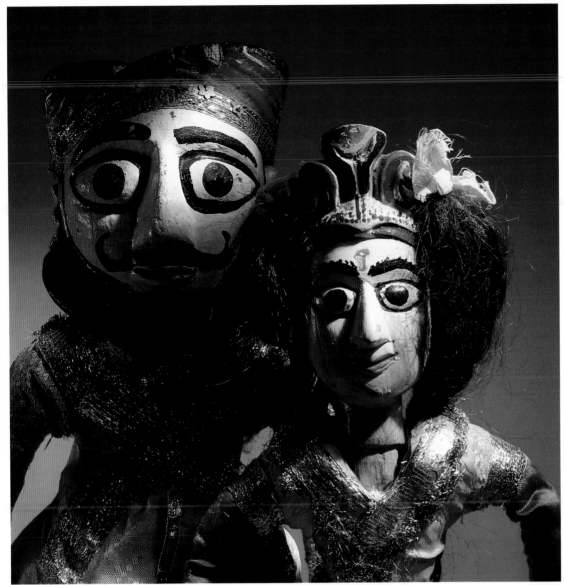

126

124. *Angel:* Angel de la Guarda. *Kuna people, San Blas Islands, Panama. Appliquéd, embroidered cotton, 16³/₄ x 19¹/₂", c. 1960. This is a mola, a panel for a blouse.*

125. *Angel:* Apsara. *Puri, Orissa, India. Painted, sized cloth, 5¹/₄ x 4¹/₄", c. 1960. This* pat *of a celestial nymph* (apsara) *is a pilgrimage memento from Puri.*

126. *Marionettes: Sword fighter and dancer (details). State of Rajasthan, India. Painted wood and cloth, 22" high, c. 1900*

127. *Talismans. Probably Iran. Repoussé silver alloy, 2¹/₂" high, c. 1950*

128. *Votive Offering. Italy. Stamped silver plate, 6¹/₈" high, twentieth century*

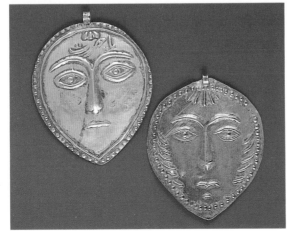

127 128

the meadows. His affectionately rendered buds and tendrils and swaying saints at once spiritualized the material and materialized the spiritual. In different moods, artists in India can range from the profound geometry of the *yantra* to the amusing illusion of ceramic fruit, but their elephants and horses, gods and people—stylized, abstracted, insistently symbolic—mark the center of their tradition.

It is a particular orientation to the world and to the spirit that most profoundly directs an artist's education. More than anything, conventional mixtures of the spiritual and the materialistic, realized in great models, shape the traditions within which artists rise to maturity. The Indian worker in brass, the African worker in wood, the Peruvian worker in clay all locate themselves in the vibrant middle place made beautiful and terrifying by the release of power through the world—power that is trapped by demons and witches and saints, by enchanted stones, wayside shrines, and figures of gods. Others in more materialistic societies display their love of the world through their concentration on illusion.

Still others drive in the opposite direction. Turning away from the world in quest of the spirit, they abandon imagery in favor of the word. Memorizing ancient texts or reading scripture over and over again, letting phrases burn into the brain, the person of faith answers the call to art by repetition of the received word. The hafiz who possesses the Koran in his heart chants it. The preacher's sermon rises to the repetition of the Bible's verses or lines out of hymns that gather the congregation into songs, swelling with power, rolling with voices joined in unison.

The people of the book—Jews, Protestants, and Muslims—make art of the word. In song, on samplers, and in illuminated manuscripts, their art derives from God's word etched on sacred pages. In Islam, calligraphy might be ornamented, but those who decorate the texts are lesser men. Calligraphic excellence lies in the impeccable formation of the letters through which God's word is revealed.

In Istanbul's book market, the men at tea amid piles of old books and calligraphic works often told me a story. A master calligrapher—he was given different names—was

Allah: the name of God written on the façade of the Old Mosque, Edirne, Turkey

ferried from one part of the city to another. Having no money, he paid the boatman by drawing quickly on a piece of paper a single *vav*. The boatman's annoyance left him when he learned the value of the seemingly simple stroke, and the next time he ferried the master, he refused coins and asked for another black mark on white paper. Value lay in the suave perfection of the master's gesture (something like Giotto's circle), and value lay in the shape itself. *Vav* means "and"; it symbolizes the connecting, totalizing force of the world. The *vav*, single or mirrored into a symmetrical double form, is drawn enormous on the walls of great mosques. Meditating upon it, the faithful are pulled toward comprehension of the power of the All. More directly, the calligrapher writes the holy names or the one word, God. It is enough to display his talent, enough to move the soul of the viewer. More is unnecessary.

In some religious traditions the spirit is made flesh. In others the spirit is made word. When people of the word step toward the world to make images, they create geometrically.

Consider the flower, lifting out of the seed, leaving seeds behind so that identical flowers will follow. The sequence of flowers, marked by repetitive blossoms, is one with the

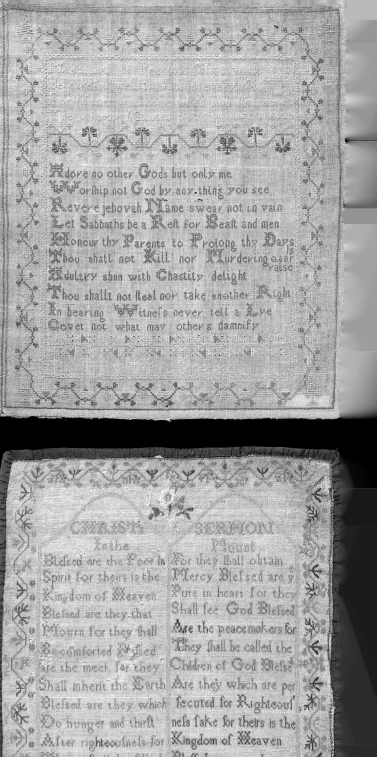

Adore no other Gods but only me
Worship not God by any thing you see
Revere jehovah Name swear not in vain
Let Sabbaths be a Rest for Beast and men
Honour thy Parents to Prolong thy Days
Thou shall not Kill nor Murdering ever praise
Adultry shun with Chastity delight
Thou shallt not steal nor take another Right
In bearing Witnefs never tell a Lye
Covet not what may others damnify

CHRIST'S SERMON

In the Mount
Blefsed are the Poor in For they shall obtain
Spirit for theirs is the Mercy Blefsed are y
Kingdom of Heaven Pure in heart for they
Blefsed are they that Shall see God Blefsed
Mourn for they shall Are the peacemakers for
Be comforted Blefsed They shall be called the
are the meek for they Children of God Blefse
Shall inherit the Earth Are they which are per
Blefsed are they which secuted for Righteous
Do hunger and thirst nefs sake for theirs is the
After righteousnefs for Kingdom of Heaven
They shall be filled Blefsed are ye when
Blefsed are the mercifu Men shall revile you &

Clarifsa Betty This Piec
Seventh Year Age

131

132

132. Panel. Morocco.
Painted wood,
22³/₈ x 23³/₈", c. 1930

133. Panel. Cairo, Egypt.
Appliquéd cotton,
67¹/₂ x 35", c. 1960.
Such panels are parts of
tents or cloth dividers for
rooms; they are still made
exquisitely in central Cairo.

repetitive rebirth of light. Day succeeds day, seasons turn. Year after year, orderly cycles contain life. Then observe the flower in bloom. Its symmetry, like the symmetries of our bodies, is a figure of simultaneous repetition. Around the rose or sunflower, petals repeat to effect a symmetrical unity. The artist's depiction of flowers or faces will contain some part of their simultaneous repetitivity, their symmetry, and it may imply the sequential repetition of their growth, something of their existence as examples of their types. The artist might work to emphasize repetition, to make the flower into a reference to the principles of its being. If the principles and their causes move the artist more than the flower itself, the flower will be drawn away from its momentary appearance toward its repetitive essence. Intensified symmetrically, it will be both a likeness and a diagram of its creation. The artist whose love is not for flowers, but only for the principles they embody, and who thinks of those principles as manifestations of divine design, will eliminate the flower entirely. What remains is symmetry and color. Then, placing the fragment of symmetry into a larger symmetry, making it one repetitive element in a repetitive unity, and reusing color to emphasize the wholeness that results from repetition, the artist creates a geometrical design that is a picture not of things but of the process that causes things to be: the orderly, unifying force of the universe. That eternal force is obscured by the moment. Artists fascinated by shifting, variable complexities will fix upon them and strive to entrap them in illusionistic portraits of interesting facts. Their opponents—and these are the people of the word—scrape away the transitory surface to reveal a pure and infinite geometry.

Interior portal of the Seljuk caravansary, Ağzıkarahan, Turkey

Şukran Öztürk and Sebahat Yüksel with a rug they have just completed, Karagömlek, Çanakkale, Turkey

Medieval Christian art and the art of Islam, arts of great faith, body forth consonant imagery. The medieval icon takes our attention, but it lives among geometric emblems, arches that march and rise and point in repetition, perfect circles that swirl and contain mazes, ribbons that interlace, knotting into infinity. The arts of medieval Christianity blend with the arts of Islam in repetitive geometric images of the unifying, totalizing process that created the cosmos.

In later days, we find the quilts of the Protestant and the carpets of the Muslim sharing one grammar of form. They repeat motifs in bands that unify the whole field through alternating colors or staggered rows. Or they arrange a design that radiates from the center making each quarter a repetition of another. Like the repetition of words, the repetition of geometric units brings the artist out of herself into harmony. For convenience, her motifs are named for objects, but it is not the motif that bears meaning, it is the overall order of her work. Her geometry depicts the universe, not its appearance but the force behind its appearance. Repetitive motion reiterates the process of unification, and the encompassing geometric result is a diagram of unity itself. Like the calligrapher's *vav*, the geometric image is a portrait, not of God's face but of God's power.

Mr. and Mrs. U. T. Pierce with a quilt made by Mrs. Pierce, Oxford, Mississippi

Shifting closer to the world, the people of the word fasten to different aspects of the geometric image to guide them through dangerous engagement. Since geometry portrays a force and not a thing, it directs people toward perfection of objects in terms of their functions.

In England a man came to a maker of wagons and ordered a wagon with no "postles" on it. The maker pondered. His wagons were carved and painted, but they never had sculpted images of the apostles on them. His customer associated all decoration with idolatry. He wanted his wagon plain, an unconfused incarnation of wagonness. The thing plain in style is dramatically functional. Its beauty is not additive but intrinsic to its utility. It represents in reality the dynamic depicted abstractly in geometric images. In one culture, the abstracted human figure is a small god. In another culture, within which the representation of people is vain or blasphemous, the tool is a small image of God's power. The plain wagon and the perfectly balanced hammer are shadows on earth of divine goodness.

Old country people tell me that God has placed into everything, every leaf and rock and worm, a utility that it is our job to discover and employ during our shaping of a life bound by God's rule. It is all as God intended. Our duty is to pray, search, work, adjust. Hope is not vain, for the world was made to be useful to humankind. It contains the cure to every disease, the answer to every earthly need. The goodness of God made the world a tool for our use.

Forming a geometric image, the artist depicts God's power. Making a tool, the artisan uses God's power to create a simulacrum of God's power. We have nearly come to understand this—the representational dimension of utility—among the Shakers. We can almost see the stark Shaker chair as a workaday emblem of sacred force. The Shakers' idea, however, is a general one. Beauty, the first perfection of things, argued Saint Thomas Aquinas, is regulated by the second perfection: utility. To work is to pray, the monks said. To restrain the self, to give, to create usefully, is the charge of the rural artisan in the United States. That is why any chair made in an old-time Protestant community can be mistaken for Shaker work, and it is no accident that the Shakers found a wide market for their products.

The plain tool hides delight behind its form, within its technology. John O. Livingston discusses his baskets in terms of utility and strength. "Them babies are strong," he says, dropkicking one the length of his shop. But his baskets are unnecessarily beautiful. He chooses their wood carefully and arranges it by color. He finishes them fastidiously, burning off all the fine splinters that disrupt their smooth, clean appearance. More important, he takes delight in the elaborate process of their creation, felling young oak trees, splitting them into long strips, shaving the strips round in a machine of his own invention, then weaving baskets that match perfectly the models in his mind. "From a Tree to a Basket," a sign in his shop proclaims, telling you directly where his joy lies: in the wonder of technological manip-

Chair at Ike Hall's House, Jackson County, Indiana

John O. Livingston, Mount Pleasant, York County, Pennsylvania

ulation through which he masters both the nature that lies beyond and the nature that rises within himself. Ask Shannon York in Tennessee why he builds harrows, old-time A-drags, and he will tell you it is because his neighbors need them. Then with a twinkly little smile he adds, "Besides, I pleasure in shop work." There is pleasure in dropping a tree and making it submit to your plans, pleasure in action as tools glide gracefully through materials. But that pleasure is consumed by technology, and it appears but shyly in the final product, which seems the opposite of art for art's sake. Pure art and pure tools are the gentle lies of different cultures. As fine artists ignore the utility in paintings (the tools by which they win their bread), so the maker of tools pretends that all was necessary labor. Delight enough ran in the process. The tool can stand as a sign of the maker's restraint, as a gift to the needs of the other, as a little repetition of God's goodness.

The plain style of the immanently sacred tool is not solely a Protestant achievement. Though Westerners are most attracted to Islamic works through which geometry elaborates, within Islamic society plainness is a virtue. The abstemious ideals of the fundamentalist

Shannon York, Moss, Tennessee

Christian and the modest costume of the Amish both have their analogs in Islamic towns. The artisans, my friends in Turkey, approve of intricate exhibitions of mastery, and they approve of works that are *sade*. "Plain," as the Puritans meant plain, stripped down to utility, would be an apt translation. The work that is *sade* is not *basit*, simple; it is called honest, direct, straight. Its joints are tight, its form is true. It tolerates none of the slack workmanship that in other places, or here at different times, signals loose, happy play. The bowl of beaten copper or turned hornbeam needs no ornament to be considered a work of high art. Its form is, like the cow made by God, there to be used. In use, in service, the tool, like the cow, recalls the goodness out of which the universe was created. The undyed white carpet of the Muslim weaver and the whitewashed, foursquare church of the Protestant builder—plain tools from which all signs of human whim have been erased—parallel in the sphere of earthly action the loving process that made the world.

One aspect of the geometric image is the universal power it represents, the power echoed in plain tools. The other aspect is its mode of representing. When the geometric spirit is pressed into the service of the will to depict, the result is an object removed from the world and perfected through enhancement of its inherent symmetries. The object is a vehicle for the fusion of the ordering force of the universe and the ordering force of the human mind.

Let us follow the course among the Pueblo people of New Mexico. The initiate memorizes the sacred word. Lifted by song, driven by drumming, the word blends into the stately dance drawn in lines, merging and dividing, circling and coiling, transcribing geometric figures. All media—poetry, music, motion, costume, sculpture—blend to shape a sacred performance that is the community in its instant of harmonic connection with itself and the universe. Then, alone with clay, the artist gathers this energy into her work. The coils out of which she builds her pot circle like the dance, like the sun. The genius of the potter's design is that it works in the round; it fits a spherical form through repetitive movements that encircle the whole. She may paint parallel lines like the dance, circles like the dance, or a

terraced sequence that echoes the steps of the dance, the melodic contours of the old songs, the profile of the pueblo and the mountainous horizon and the clouds that pile above, bearing life-giving water. Water is the goal of the dance. "When we make our potteries," says Lilly Salvador at Acoma, "our mind is on moisture." Her land, she says, is dry, and her thoughts and hopes and prayers must concentrate on water. The red and broken floor of an ancient sea that in withdrawing sucked all dampness with it surrounds the rock of Acoma, atop which Mrs. Salvador and her family dance, lifting their knees, shaking evergreen boughs downward, down toward the pink dust, calling the rain down. The pot she builds out of earth will hold water, and as she circles it, identifying the motifs she has painted, Lilly calls them rain and snow, rainbows, lightning, and, most often, clouds.

More important than decoration is the process, accompanied by song, through which people break into the world, taking hard gray clay from Mother Earth, mixing it with water, and shaping it, burning it into usefulness. The surface of the vessel may be left plain, unornamented, as in the golden bowls of Picuris and Taos, the smooth black jars of Santa Clara and San Ildefonso. Beauty glows within useful form. Painted, the pots whirl with a stream of geometric motifs, occasionally, as in the fine-line decoration of Acoma, stilling into a geometric totality composed of geometric elements. All are glossed for dampness—hatchings for rain, dots for snow, arcs for rainbows—but they stop short of representation. If the potter reaches to represent things, then the things she portrays connect her in two ways with artists from widely different cultures. First, they are conventionalized and drawn toward the geometric. Second, she chooses out of nature but a few things. Recent expansion of the production of figurines, of Nativities and storytellers, obscures the center of the tradition. Holding to the spiritual center, Pueblo artists have moved tentatively toward the world, largely avoiding human imagery and selecting, especially at Zia and Acoma, birds and flowers. They are interpreted to fit the deep themes of the Pueblo. Lilly Salvador names the bird a parrot and calls it "the bringer of water." For her, the flower is the result of the existence of moisture. The pair of bird and flower both fit this dry locality and carry us away to other places.

Parrot pot by Wanda Aragon, Acoma, New Mexico

Traditions that shun the depiction of people and orient toward spiritual geometry typically venture into representation through birds and flowers. Searching the world for signs of sacred power, the mind is pulled into fascination with orderly cycles that can be suggested through geometrical designs. The mind will rejoice, too, in the world's decoration: the flowers that flicker over the hillsides, the birds that sing unbidden to ornament the air. Deciding to decorate a chest or pot, an object that carries in its form the world's implicit utility, people repetitively select the natural forms that decorate the world. Their works—among the greatest and most common of folk art—repeat the order of the world: fundamentally useful, yet ornamented with birds and flowers.

The significance of God's ornamentation of creation has not utterly vanished within our secular scene. We say a little bird told us when we have come by a fact mysteriously. More directly, country people tell me birds are God's messengers. My grandmother learned of a brother's death from a small bird that came to her window, and I have found such experiences to be usual among people from widely different cultures whose view of the world

remains open. We might not say, as Ellen Cutler did, that flowers are signs of God's goodness, but we persist in giving flowers to sick people, to brides, to new mothers, to the dead, to people poised perilously at life's seams. The flowers beside the hospital bed, the flowers around the casket, the flowers on the grave, may only indicate connections between people for us, but they contain hints of wider connections, of vitality in the ambit of danger and fear, of protective potency—hints that should help us imaginatively enter worlds more alive with symbol than our own.

Birds and flowers are the two things from nature we customarily welcome into domestic settings. Making this exception to our definition of nature as dirty and wild, we do not surrender to nature; we incorporate it on our terms, confining birds in cages, arranging flowers in vases. Pulling nature into control, we act like folk artists who, expanding toward representation, shape their birds and flowers conventionally, arranging them geometrically.

Mihrab of the village mosque, Mısvak, Çanakkale, Turkey

Orthodox Islamic tradition does not avoid representation. There may be few people, but there are birds aplenty and a bounty of flowers. From Mughal India to the western marches of the Ottoman Empire, birds flutter through art, and geometric motifs permute into flowers, flowers that repeat across open fields and, most typically, that stand stiffly in symmetrical arrangements. Their unnatural perfection of form gains emphasis when flowers rise from a vase to fill an architectural niche. In Islamic art the niche is a representation of a piece of architecture, the mihrab in the mosque's wall oriented toward Mecca, the gateway through which the soul aspires toward God. In the Koran, God's light is likened to a niche within which a lamp burns like a star. The flowers in the niche are worldly incarnations of light. They stand in transcendental perfection as a foretaste of paradise. Look again, and the flowers are so arranged as to suggest a body, with one flower centered at the top, a pair springing on stems like arms spread wide, other pairs below—all rising from a vase, an artificial form out of which they push upward to fill the niche like a person being lifted out of the world toward bliss. Do the flowers depict the act of prayer, the soul in ascent? Are they a

Plates painted by Ibrahim Erdeyer, Kütahya, Turkey

self-portrait of the artist's spirit? Then look again, and the flowers are but the blossoms that delight us with their beauty and disappoint us with the brevity of their lives.

Why worry about particular meanings, the Muslim mystics ask, when everything means the same thing? Flowers grow and know an instant of glory before they wither and decay into earth. They remind us of ourselves. Flowers are the logical art of the farmer, the product of the application of practical agricultural knowledge about seeds and soil to the creation of beauty. They teach the limits of our creative energy. We operate in a world that lies beyond our control, using things we did not make to create things that, like us, will not last. Our creativity is but participation in creation. Flowers embody our limitations, dying as we must, and yet the flower portrayed eternally at its peak of fullness symbolizes that which does not die. How different from symmetrical arrangements is a jumbled floral still life trapped in three-

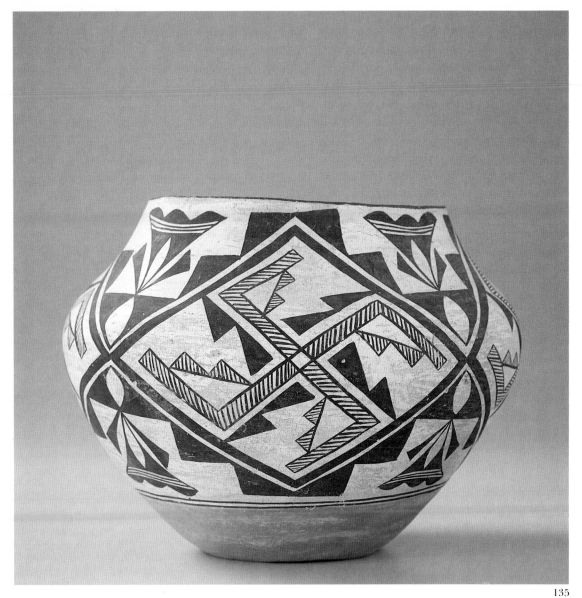

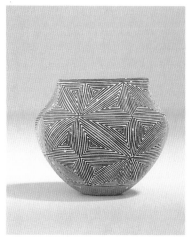

136

135 137

135. *Jar. Acoma Pueblo, New Mexico. Slipped and painted earthenware, 6⁷/₈" high, c. 1940*

136. *Jar. By Lucy M. Lewis. Acoma Pueblo, New Mexico. Slipped and painted earthenware, 4" high, c. 1960. Lucy Lewis is the great master of fine-line decoration at Acoma.*

137. *Jar. Picuris Pueblo, New Mexico. Micaceous earthenware, 5³/₄" high, c. 1960*

138. *Plate. Zia Pueblo, New Mexico. Slipped and painted earthenware, 4³/₄" diameter, c. 1960*

139. *Bowl. Santo Domingo Pueblo, New Mexico. Slipped and painted earthenware, 16¹/₂" diameter, c. 1920*

138 139

dimensional space, shaded to capture the fleeting moment, a petal fallen to the table. Here are flowers set outside of time against an empty background, standing impossibly on thin stems, facing forward, staring or turned to present sharp profiles, perpetually erect in a light without source, as though glowing from within. An emblem of the soul free of the earth or of the undying bloom of paradise, ablaze in the niche, the flower is all that is perfect.

Mosaic niche,
Kashaitully Mosque,
Dhaka, Bangladesh

The flower of Islam was so filled with meaning that it escaped through Europe during the Reformation. Reading their book, shaken by prohibitions against graven images, wishing to clear their path to God of intercessors, Protestants turned to the flower. They found it in the decoration of medieval churches, and they found it fully developed on textiles imported from the East. It fit their needs and they made the geometrical flower the prime motif of their folk art. Their old tradition, directed by the concept of spiritual flesh, dominated by the icon, prevented many of them from reaching the extreme position of Islam, and it drove others farther, into the radical rejection of ornament of any kind, but at the center of their art the flower grew in the place of the saint. In the Catholic work, flowers surround the saint. In the Protestant work, the saint vanishes and flowers rush to fill the void. Painted in the Central European tradition of the Old World and the New, carved in England and New England, the cryptically human, symmetrical arrangement of undying flowers rises out of a vase to fill a niche.

The Protestant niche is, like the mihrab in Islamic art, a picture of architecture. At the simplest level, it represents consciousness, the intending and creating capacity of humankind. The depiction of architecture in both Islamic and Christian tradition is a way to avoid the human body while recognizing the human presence.

Architecture rises out of the human will to order. When architecture elaborates symmetrically within a religious tradition, gathering eternal geometries, then it represents both human power and the divine source of human power. All power fused in the wondrous symmetries of the medieval cathedral, through which human order celebrated divine order. Symmetrical architecture signifies order. Religious symmetrical architecture symbolizes the hierarchy of power within order. The human is contained by the universe.

Nasima with a prayer rug
she wove, Gillande,
Manikganj, Bangladesh

The meaning inhering in architecture inspires people in religious societies to build—and to create representations of buildings. In Lithuania and Poland, in Mexico and Peru, artists make models of churches. In Japan and India, artists make models of temples. In Islam, stylized, realistic, and even photographic images of Mecca are placed on the walls of mosques. The mihrab, the niche that orients faith, is realized on the wall facing Mecca and it is represented repeatedly on ceramics and textiles. The mihrab of the prayer rug—in old examples from central Anatolia and new ones from Afghanistan and Bangladesh—may elaborate architecturally, gathering columns and domes, to become visually, as it is conceptually, the center of the mosque.

140

141

142

140. *Pillowcase Fragment (detail). Bavaria, Germany. Embroidered silk on cotton, 15³/₄ x 31", dated 1841*

141. *Towel (detail). Hungary. Embroidered cotton on linen, 34¹/₄ x 11¹/₂", c. 1810. Stitched in a style originating in Turkey, such towels decorated the interiors of European homes on the fringe of the Ottoman Empire.*

142. *Sampler (detail). Signed M. Diaz. Mexico. Embroidered wool on cotton canvas, 22⁷/₈ x 7¹/₂", dated 1880*

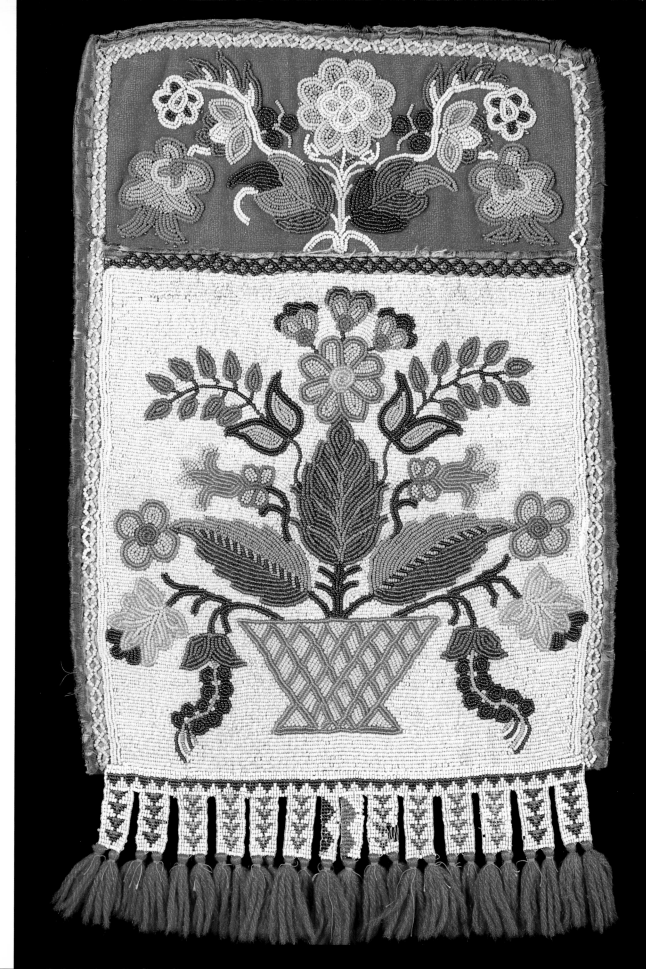

143. *Bandolier Bag. Métis people, Red River area, Manitoba or North Dakota. Beaded wool, 19⁷/₈ x 11¹/₁₆", c. 1900*

The niche is an architectural fragment, and it is the frame of epiphany, the portal of sacred exchange and transformation. Hindu gods and Catholic saints often appear in architectural niches. They are protected by the buildings men erect; they emerge out of the universal architecture. In the niches of Islamic and Protestant tradition, flowers replace gods. The Islamic niche, the mihrab, is the central symbol of the religion, the point at which all becomes one. The niche surrounding the flowers in Protestant tradition connects less obviously to religion, but like the cathedral (its facade, a triumphal series of arches), it sets human power in context. The shape of the niche on the German or English chest repeats that of the gravestone. The gravestone's form is one segment of an arcade, a pair of columns from which a round arch springs. The arcade is a conventional medieval representation of the entrance to Heaven. The form of the niche, one element out of the endless sequence of the arcade of glory, the shape of the stone above the grave, orients the mind toward death, beyond which the righteous shall find eternal life among the flowers. Islamic tradition embraces the same associations. The mihrab depicted on the prayer rug often intensifies its meaning by taking on the shape of the gravestone, which, in turn, abstracts the contours of the human body. Shaped like a head and shoulders, like a gravestone, like an arch, the niche containing a floral display (or a lamp, a scatter of amulets, or a sublime emptiness) gestures past the vanity of architecture toward the architecture of the universe.

Left
Carved cupboard panel, England, 1673
Right
Painted chest panel, Switzerland, 1739

Johnnie and Winnie Brendel, Reinholds, Pennsylvania

Present or implied by the overall form of the hieratic bouquet, the niche is the ordering force that at once surrounds the flowers and lifts through them to make them recall the gratuitous loveliness of nature, the art of agriculture, the original and ultimate garden, the goodness of God that scatters the sand with flecks of beauty.

The rosette on the pottery of Zuni and Acoma might have come from Spain. It might have entered Spain from Islam. But the natural forms that dominate the art of the people of the word are not to be explained by historical connections. There is a consistency deeper than history. The geometric flower shared by Christianity and Islam beckons us into the logic that spreads the surface of art with a master set of images.

Flowers decorate the natural world. It is natural that flowers should dominate the decoration of useful things, as in Norwegian *rosemaling*, and that the flower can expand to mean all ornament. We term fancy speech "flowery." Painters of china in England were called "flowerers." Irish lace makers and Scottish embroiderers spoke of all their decorative work as "flowering."

As points of bright color sprinkled over the dull landscape, flowers match the stars sparkling in the night sky. People who glitter away from their drab backgrounds are called stars. Often flowers and stars merge indistinguishably into a single image and then blend with geometric motifs. Johnnie Brendel, whose grandfather was a barn painter in rural Pennsylvania, told me that the wheels of abstract design that outsiders call "hex signs" are called both "barn flowers" and "barn stars" by his neighbors. Stars and flowers share brightness.

144. Wycincanka. *By Helena Selenda. Chaśno, Łowicz, Poland. Cut paper, 10¹⁄₈ x 17³⁄₄", c. 1962*

145. Chuang Hua. *Shanxi Province, China. Cut paper, 8¹⁄₂ x 4¹⁄₂", c. 1950. Such chuang hua ("window flowers") decorate windows at New Year's.*

Opposite
146. *Big Star:* Gwiazda Duża. *By Stanisława Dawid. Kadzidło, Poland. Cut paper, 11³⁄₄" diameter, c. 1962*

Opposite

148. *Jewelry Box. Northern India. Painted wood, 10³/4" high, c. 1900. The decoration derives from the Mughal style, based in Islam and influenced by illustrations from European herbals.*

[*156*]

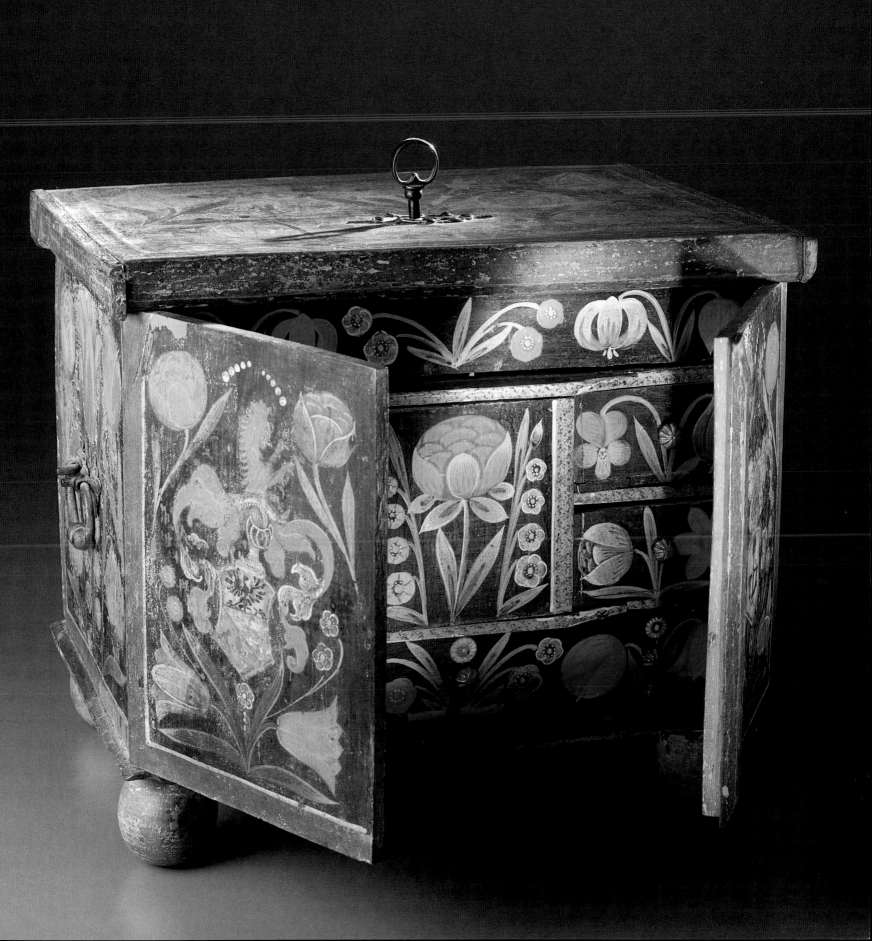

149

149. *Parrot. Kondapalli,
Andhra Pradesh, India.
Painted wood, 5" high,
c. 1960*

150. *Bird and Peonies.
Hebei or Shanxi Province,
China. Painted cut paper,
3³/₄ x 2³/₄", c. 1950*

151. *Plate. Rio Balsas
area, Guerrero, Mexico.
Painted earthenware,
7¹/₈" diameter, c. 1950*

Opposite
152. *Bag (detail). Sierra de
Puebla, Puebla, Mexico.
Embroidered wool on cotton,
24¹/₄ x 12¹/₄", c. 1940*

150 151

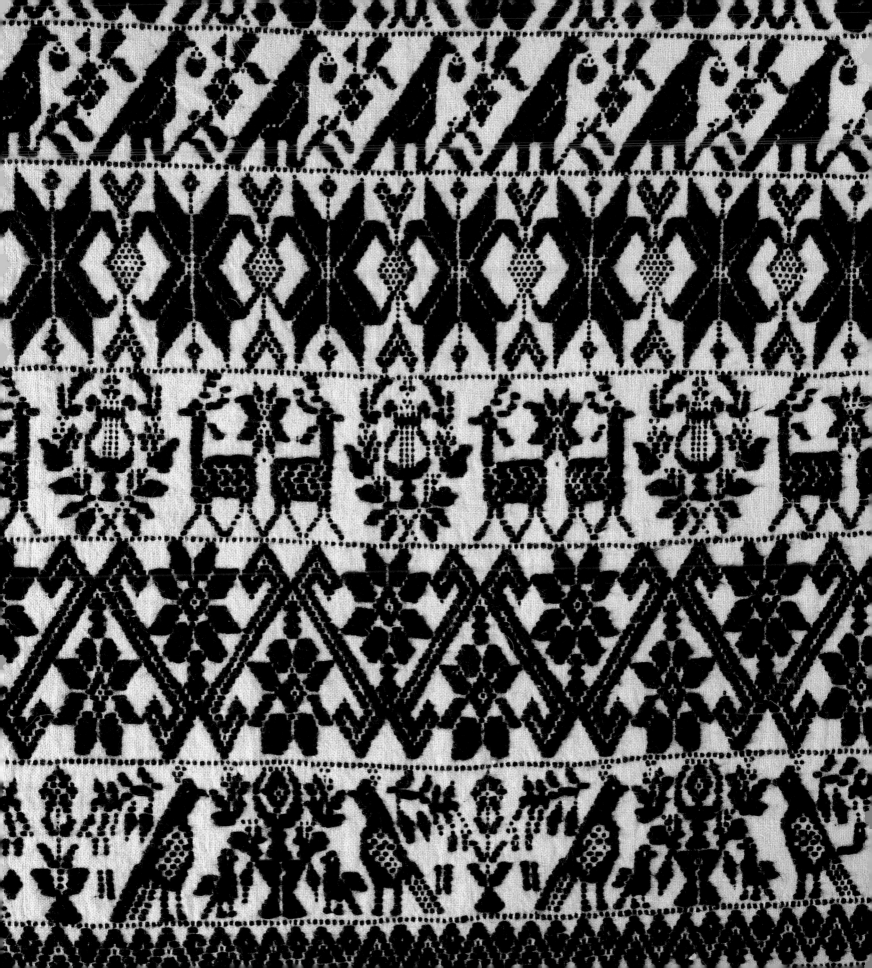

153. *Pendant. Morocco.*
Chased silver alloy,
4³/₈ x 2⁷/₈", c. 1950.
The khamsa, *or hand*
of Fatima, is worn by
North African women
as a protective talisman
against the evil eye.

154. *Pendant. Morocco.*
Chased silver alloy,
3 x 1¹/₂", c. 1950. This
talisman presents an
image of the mihrab,
the prime architectural
feature of the mosque.

155. *Pendant. Morocco.*
Chased brass, 9⁵/₈ x 6⁵/₈",
c. 1950. Jewish citizens of
Morocco have adopted the
khamsa; *this one, designed*
to hang from a lamp in a
synagogue, features the
Star of David.

154

153

155

Opposite
156. *The Ka'ba. Mecca,*
Saudi Arabia.
Chromolithographed paper,
15¹/₂ x 21¹/₈", c. 1950.
Such prints are made for
sale to pilgrims and this one
was purchased in Egypt.

157. *The Holy Virgin of Copacabana:* La Santísima Virgen de Copacabana. *Copacabana, Bolivia. Painted wood, plaster, paper, 11¼" high, c. 1900. This* retablo *replicates a carved cactus-wood statue enshrined in a seventeenth-century Spanish colonial church in Copacabana; the original is attributed to an Indian named Tito Yupanqui.*

Opposite
158. *Jagannatha Temple. Puri, Orissa, India. Painted wood, 19½" high, c. 1950. Lord Jagannatha (a form of Krishna, himself a manifestation of Vishnu) stands with his brother Balarama and sister Subhadra.*

The gay floral colors of folk art, applied to objects in Latin America or India without reference to natural appearance, are signs of contention with conditions. They tell of victories won with nature's inspiration over nature's norms. The high color of the flower joins the bright plumage of birds, providing one reason for the repetition of parrots on Acoma pottery, in Swedish tapestries, and on Pennsylvania German *fraktur*. In the art of India, parrots meet preening peacocks. Like flames of feather, peacocks appear in Byzantium, Iran, and China, where birds join butterflies that call us back to the pottery of Acoma.

Flowers that soar from the earth, birds are bright and they are vital. Their light motion through the sky makes them apt symbols in disparate cultures for the soul in its flight. Their earthly potency is trapped in repetitive images of cocks striding. Their containment of nature's life force links them with the beautiful leaping beasts of the earth. The fish of China and England, the deer of Zuni and Switzerland, and the antelope of Africa join in their possession of the free energy of the world, captured most often in the bird on the wing. Flowers and birds bring into awareness the bright and vital force of nature.

Life in its potent moment of joy is symbolized diversely, but its images are limited in number, and then limited further by conventions of depiction. Birds and deer and fish, tulips and lilies and carnations, appear in stylized profile. Sunflowers face us directly, aligning with the rose of England, the lotus of India, and the Japanese chrysanthemum, so that they might be suns or stars or geometric emblems of unity: perfect circles divided into equal parts by lines radiating from the center.

Draw a circle to symbolize completion and oneness. Place over it a cross to divide the circle into quarters, and you have a design used in cultures as separated as Central Asia, Central Africa, and the northern plains of Native America to represent the cosmos, its parts and directions. Place a second cross at an angle, halving each quarter, and you have at once the universe and the inner structure of both stars and flowers as they are conventionally depicted by artists scattered across the globe. The flower's symmetry, perfected geometrically, elaborates in the floral medallions of Persian carpets, in the *yantras* of India, and in architectural facades; think of the rose windows filtering colored light toward the altars in great cathedrals.

Natural and artificial symmetries fuse to produce the conventionalizing capacity of the artist, who reaches through the world to discover in its ornament (its birds and flowers) and in its deep order (its abstract geometries) the immanent power that is echoed, employed, and represented in art. Cultures differ, topics vary, but folk art repeatedly displays a style that favors the strong, clear colors of flowers and the strong, clear forms of geometry. It is not muddy, sketchy, vague. It is bright and firm.

Philosophers in medieval Europe concentrated upon two aspects of the art of their time. Their quantitative interest in proportion, in the harmonic relation of parts to whole, caused them to emphasize geometry. Their qualitative interest fixed upon luminosity, the descent and diffusion of the heavenly light that was transformed through objects into pure,

Opposite

159. *Church. Quinua, Ayacucho, Peru. Painted earthenware, 38½" high, c. 1958. Originally made to be placed on the rooftop to protect the home, pottery churches like this one are now made for sale to outsiders.*

160. *Church. By Rosendo Rodriguez. San Pedro Tlaquepaque, Jalisco, Mexico. Painted cardboard, 20¾" high, c. 1965*

O'Craian Tomb, Sligo Abbey, Sligo, Ireland

House front, Ortahisar, Cappadocia, Turkey

bright color. Nature's symmetries—the blessed form of the body, the orderly whirl of the spheres—manifested God's design. Nature's color contained the light of God. Repeated in art, geometry and gemlike color signaled the artist's active participation in divine movement. The medieval thinkers provide one articulate matrix for the abstracted geometric patterning and high color that characterize folk art.

Now we can let pent-up power flow into human images. All the force abiding in tools and geometry, in birds and flowers and architecture, in symbols of order despite confusion, of life despite death, of brightness despite darkness, of power despite weakness—all floods into folk artistic depictions of people. I have slowed our course and risked repetition and digression for important cause. If we commence with an illusionistic ideal, and then come upon the static, symmetrical personages of folk art, we can misread them as impoverished, as naive attempts to capture appearances. So I started at the other end, at prayer, and led us through tools and geometry to the birds and flowers that are more common in world art than people. My hope was that, when confronting human images in folk art, you would carry with you—as the artist carries—ideas of order and utility and ornament that bear within them connections to a spiritual, rather than a materialist, ideal.

I ask you to move toward the human image at the center of folk art, not from the direction of the Victorian portrait, but from the direction of the geometric flower. Our first discovery is a mood of ambivalence surrounding the portrayal of the human body. The people we meet are skeletons, representations of Death as an antigod or of the body in its decayed state: skulls on Puritan gravestones, in Puritan portraits, skeletons frolicking on the Mexican Day of the Dead, happily mocking, grimly rebuking love for the world.

Along with people abstracted to pure mortality, to bundles of bones, come images of the undying—angels and devils—the good and evil spirits that drop out of eternity to protect or endanger the immortal soul. Devils dance and grin with Death. Angels lift out of life in placid geometry, pointing the way away from the earth and its bones. On the eighteenth-century gravestones of England, New England, or German Pennsylvania, the angel takes on architectural shape: a head centered between a pair of wings. Architectural symmetry perfects that of the body. The facade with windows flanking a portal matches the face with an eye on either side of a nose above a mouth. Each is a unity divisible by two and three. A line imagined down its center yields equal halves, but there is a middle section, of nose and mouth or of door, that differs from the two side sections, of eye or window, that repeat each other. There are three parts, two parts, and unity. So it is in a host of symmetrical designs. The bilaterally symmetrical, yet tripartite, facades of cathedrals with towers flanking a portal are repeated by lions flanking a shield, or stags flanking a flower, or birds flanking a fountain, or wings flanking a head. Head and wings constitute the essence of angelness, a mortal in flight. The winged head found throughout the European tradition is an

effigy of the soul, the bright and vital, birdlike, aspect of the human being.

In the old Hindu tradition the depiction of angels was important; portraits of people

were not. In medieval Christian tradition, the great chain of being was linked within the human being. People were both angels and beasts. With their bestial mortality stripped away, people became angels. Envision an angel, a face staring from a gravestone, the eyes wide open, eternally awake. Remove the wings, and you have the central image of folk art, weak in illusionistic reference because powerful in spirit.

Facing front to create a bilaterally symmetrical form, shorn of cluttering detail, staring ahead as though stunned by wonder, the columnar, architectural people of folk art stand before you. Worldwide, people make people like that, and, facing us, they make themselves like that. We like candid photographs and tell our subjects to smile, look natural. The country people before me do not smile. They stand stiffly without expression so that my camera will not record a random instant. Their photos, like the oldest pictures in our albums, hold them beyond time, outside of the moment, liberated from the world. People make art of themselves in photographs. Some emulate casual portraiture. Others compose themselves into emblems of selves. I have met in my travels nobody who thought the camera would steal the soul, but I have met many who arranged themselves before the lens as much like souls as possible.

The peasant composing his body for the camera and the carver freeing a body from a block of wood shape images that blend geometry and appearance. The result is not a simplified picture of reality; it is a picture of spirit in the world. It is a capturing of the very idea of art, simultaneously conceptual and sensual, spiritual and material.

Artists since the Renaissance, struggling to purify the sensual tendencies in art, have abandoned the center of art and helped create our island of secularity, where we satisfactorily describe the universe by science and explain human behavior by economic motivation. Like all people, we think ours is the central place. Art alone will teach us of our marginality. The arts of medieval Europe and European folk art, the arts of Native America and Latin America, of Africa, Asia, and the Pacific Islands, are one in their blending of geometric spirituality with worldly appearance. They isolate us in a tiny, strange place. Here, all is orderly and complete. But should we venture into the larger world, our ingenious concepts, though we apply them courageously, will net us only confusion.

The folk art in our midst, stolidly standing, provides us an entry into the big world we left during our experiment in secular order. To protect our culture, bravely working to preserve our sense of centrality and superiority, we willfully misread folk art as a fanciful mauling of our ideals, as naive illusionism, as mere craft, as anachronism. Graciously, folk art offers us a way to retrieve connection with the central experience of humanity.

The artist's education, I repeat, is guided by a tradition that relates the spiritual and the material. Folk and fine art range equally wide, but folk art centers its energy near the midpoint of the spectrum running between the abstract and the realistic. There folk art expresses art's simultaneous attraction to the geometric and to the illusionistic through works in which the spiritual and the conceptual dominate, but the material and the sensual form a strong counterweight. When traditions that are predominantly spiritual meet traditions that are dominantly materialistic, the resultant works are those that perplex us most.

One result of contact is recoil and purification. Islam has developed its position in reaction to the pictorial traditions on its borders in Asia, Africa, and Europe. The Koran does not explicitly prohibit representation. The Prophet Muhammad is said to have trea-

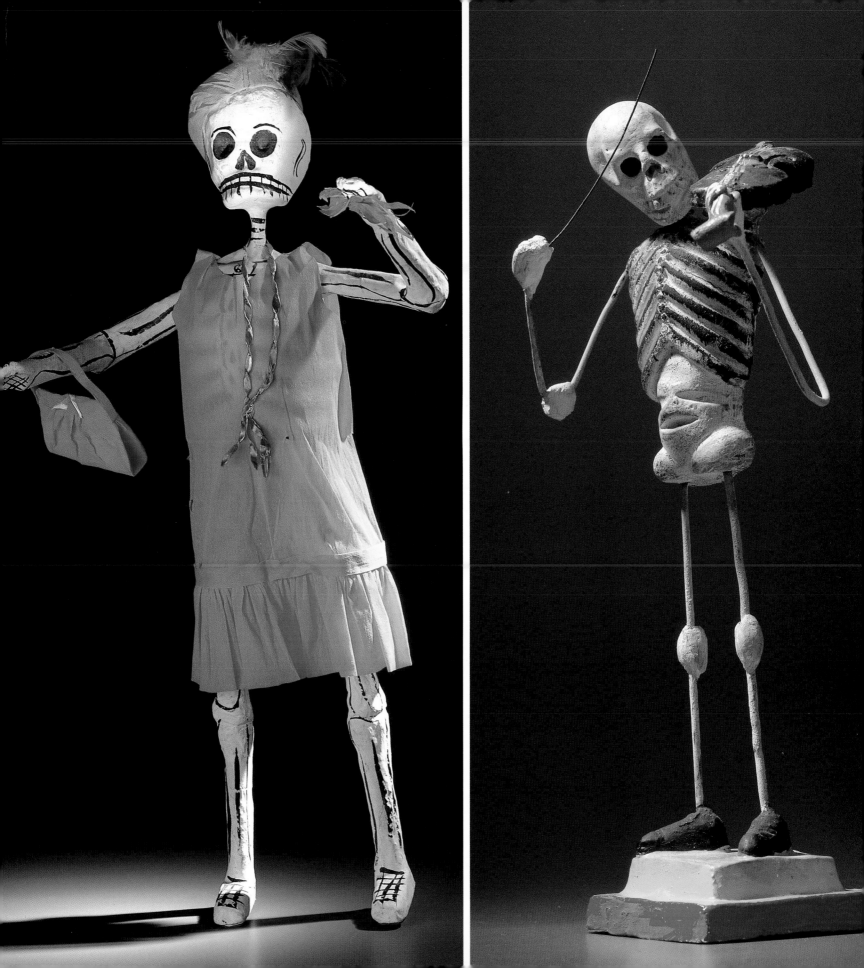

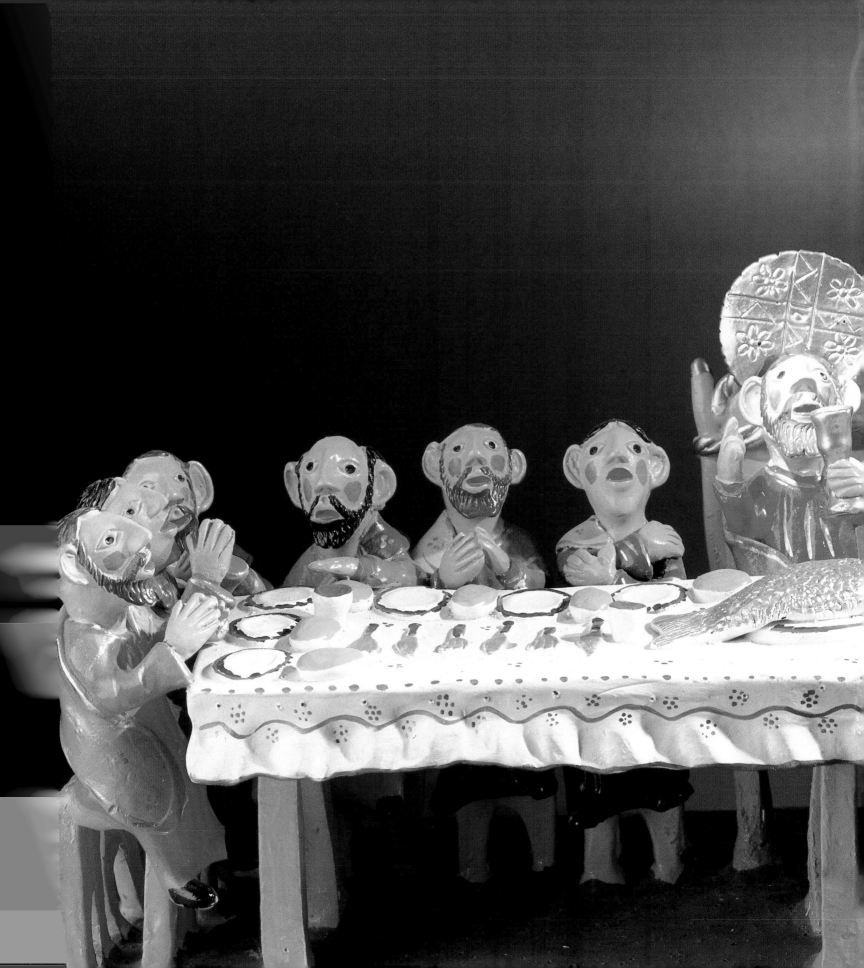

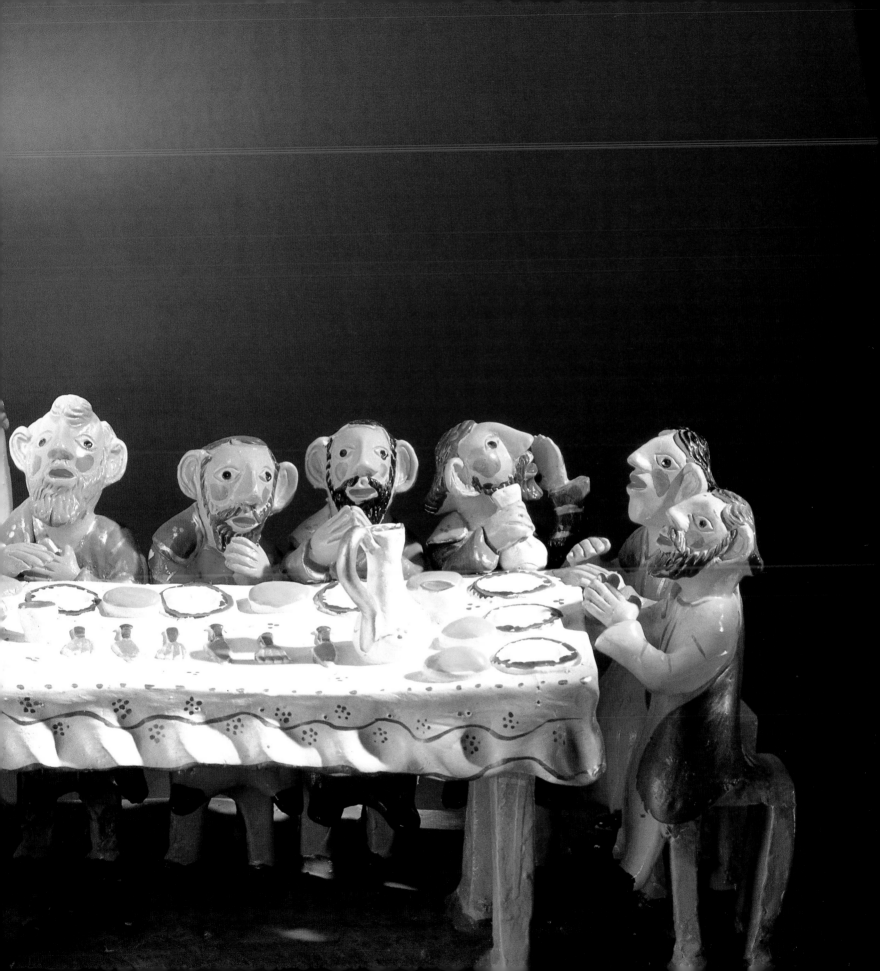

sured an image of the Virgin Mary, celebrated in the Koran as a perfect woman. As Islamic art developed, it purified its tradition through negation, especially of Christian norms. Within Christianity, the Puritans comparably clarified their vision by a rejection of icons. They began by smashing the faces of the saints and whitewashing over the paintings in churches—acts paralleling the Muslim conversion of churches into mosques during their expansion. As Western fine art sought illusion, the Puritan tradition moved in the opposite direction, replacing saints with flowers, then replacing flowers with tools. By the nineteenth century, the flowers were nearly gone and the creative energy flowing out of the Puritan tradition found its delight in technology, in baskets woven out of broken trees, in machines that served man as man served God.

Naturally we think that people who learn our ways will acculturate, aping until they assimilate. But many do not like all of what they see. They turn away and intensify their tradition to clarify its difference. That is the mood in many ethnic communities trapped in big nations. In this frame, I interpret the genius of José Dolores López of Córdova. Interacting with outsiders, with tourists and collectors, he did not emphasize the illusionism implicit

Rafael Córdova with his carving of San Rafael, Córdova, New Mexico

in the Hispanic tradition. He stripped it away to create figures less naturalistic than those on the altars of his childhood. His saints, unpainted and stilled into symmetry, bore subtle messages of rebellion through the channels that connected him to the outside world. Commercial products, they defied their commercial context by embodying spirituality, and they embodied it so perfectly that, while others in New Mexico struggle to reproduce the art of a past day, José's great-grandson Rafael, the son of Gloria, can carve saints that stand still at the vital center of the world folk art tradition. Because extreme in its location, both in space and time, the art of the López family forms an intense instance of the reaction of carvers in the Philippines and Puerto Rico, in Mexico, Bolivia, and Peru, who found sacred images dangerously interacting with materialism and reshaped them so they could reclaim spiritual power.

Irene Aguilar with her image of Our Lady of Guadalupe, Ocotlán de Morelos, Oaxaca, Mexico

One reaction to the artistic alternative of realism is to step back, to return to a more abstract mode. Much of the strength of modern art, folk or fine, is to be understood as a recoil from illusionism. Another reaction is to step toward materialism and create synthetic works.

Art since the Renaissance has accustomed us to synthetic works that are sacred in content but materialist in style. Folk artists often reverse that formula. Mexican artists, like the brilliant Aguilar family of Oaxaca, at work between a baroque past and a present shaped by magazines and customers fond of illusion, create sacred images in the purest folk style, glorious and graceful Madonnas, and they make little people and goad them into action. Tellingly, these are often religious actions, weddings or baptisms or wakes, but any event lies open to depiction, and Latin American art is filled with genre scenes, with people going to the doctor, going to market, going to church, dancing in the plaza. From one perspective, the clay figures seem like dolls. From another, they resemble gods. The topic is secular, but the style is sacred.

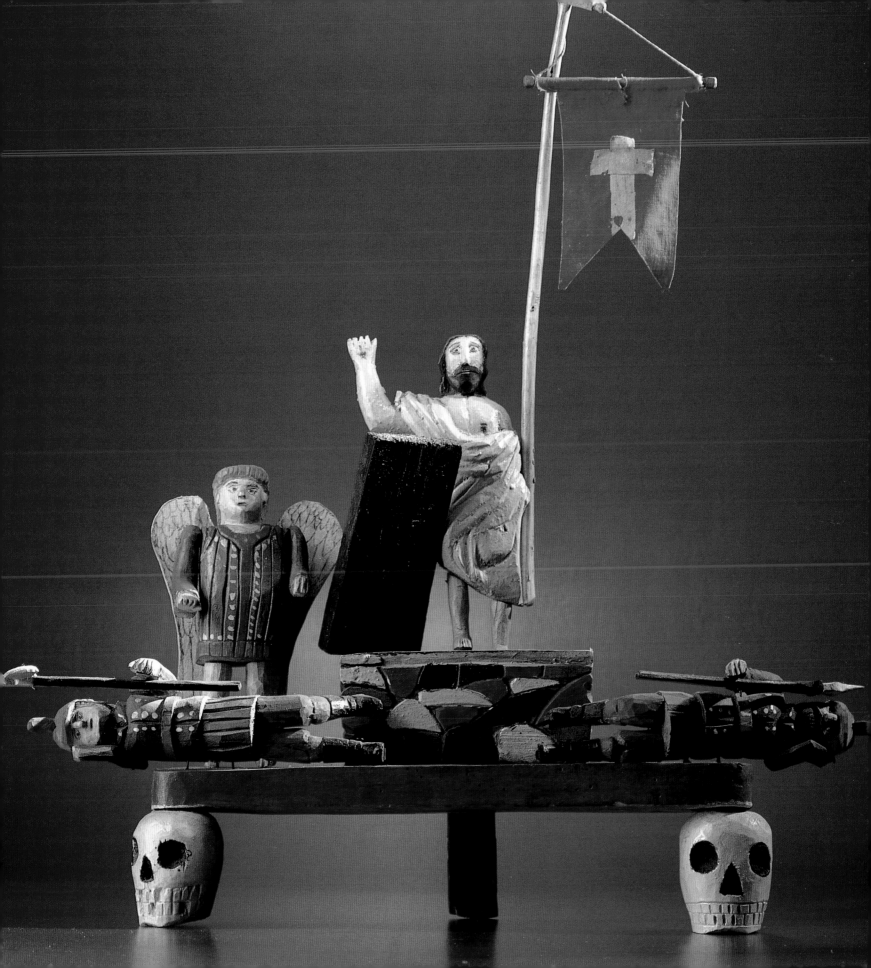

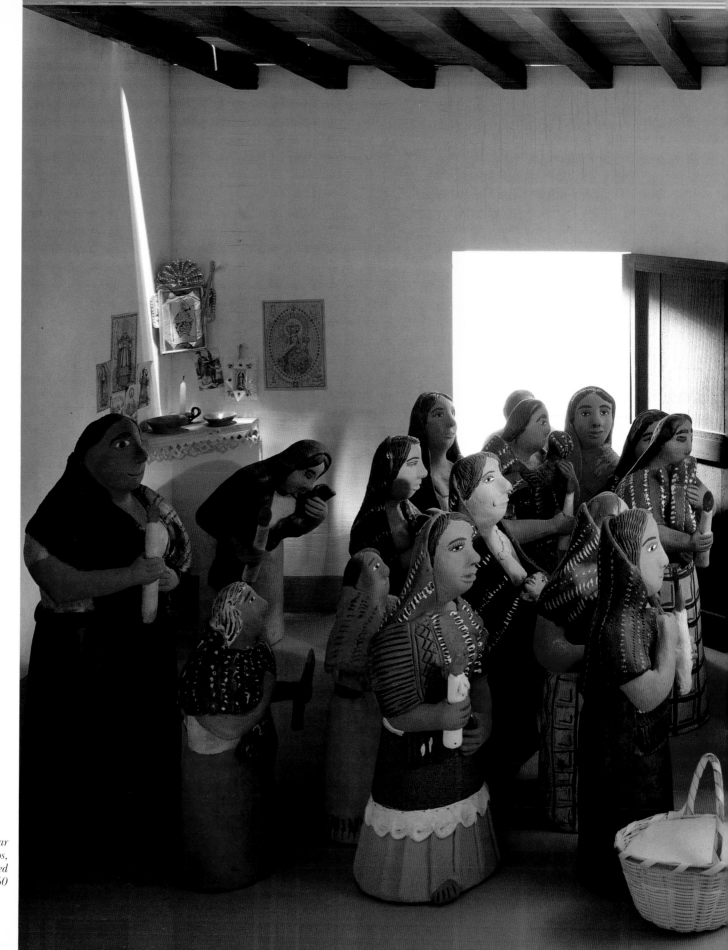

170. Wake. By the Aguilar family. Ocotlán de Morelos, Oaxaca, Mexico. Painted earthenware, c. 1960

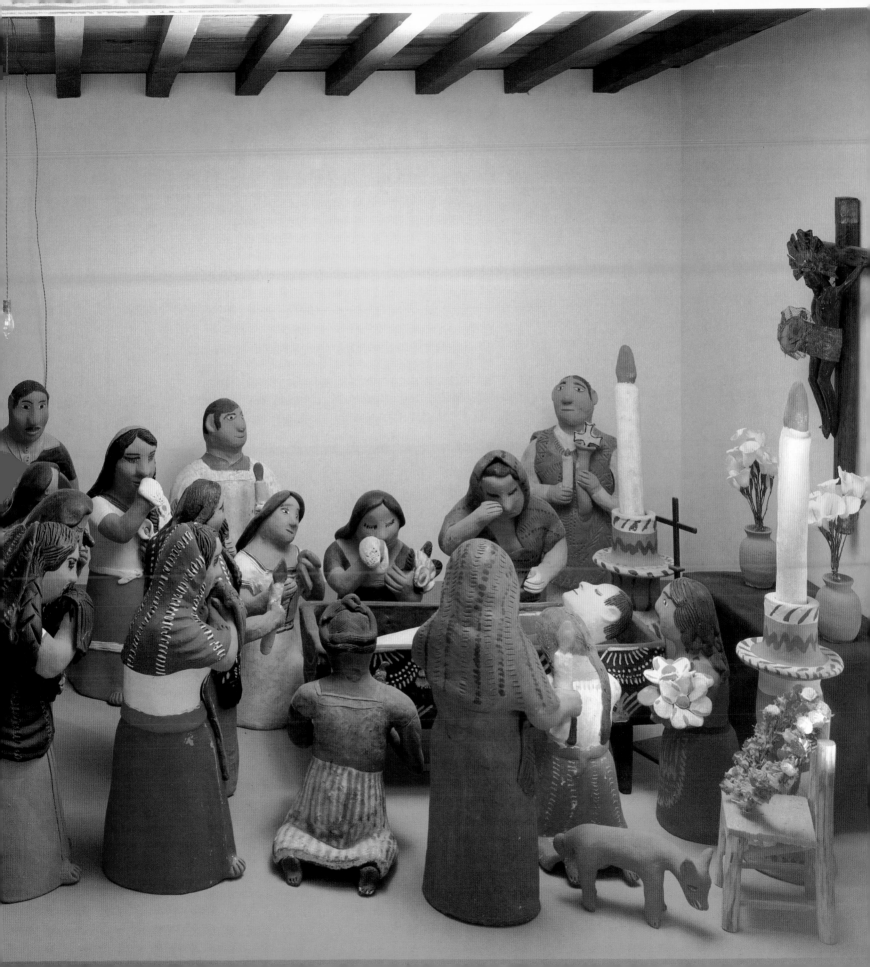

Suspended between one culture and another, genre figures send a mixed message. Rendered like saints, the little people contain a spirituality that makes them strangely moving. Busy in the scenes of their lives, they are like people. Stylized in their smallness, they are like dolls. Gazing out of rigidly composed bodies, they stand within life like souls amid glory.

The blend of secular topic and spiritual style is commercially savvy. People who have been prepared by modern art to appreciate the abstract qualities of folk art, but who do not like its religious subject matter, are attracted to genre scenes. Wandering out of a Nativity, country folk leave the Holy Family to find new life in secular contexts. The blend perfected by the Aguilars, by Helen Cordero and the makers of Pueblo storytellers, has not meant the surrender of the old style, yet it suits the contemporary scene.

The same blend fit an earlier day in Europe, when people shifting between sacred and secular orientations purchased pottery figures, notably the chimney ornaments of nineteenth-century Staffordshire. Stylistically the figures bore memories of sacred images, but topically they were secular. The Staffordshire potteries offered holy icons and portraits of religious leaders (especially of the preachers of Methodism, the dominant persuasion of the potters), but they concentrated on theater stars, celebrities like murderers, and great authors, such as Shakespeare, Milton, and Burns. Significantly, they featured images of temporal more than religious authority, monarchs and statesmen—Queen Victoria, Gladstone, Parnell, Garibaldi, Napoleon III—and, as in folksongs and tales, negations of legal authority like the highwayman and rare hero, Dick Turpin. Robber or king, knight or general, the man on horseback is a potent secular symbol. The equestrian officer from Staffordshire joins the military horsemen of European folk art and the noble riders of India and Africa in a cavalcade of worldly might.

The mixture of secular subject and spiritual style is especially conspicuous in portraiture. The portrait is topically secular in the extreme. Yet artists in Japan, China, and India, the miniaturists of Islam, the sculptors of the late Roman Empire and Benin, the painters of rural Europe and Latin America all learned to pull their subjects toward the spirit through abstraction, without eliminating their worldly identity.

The case seems especially perplexing in early nineteenth-century New England. Imagine an artist raised in a hard Protestant community encountering the vain concept of the portrait. His ancestors had dampened the arrogance of personal images by locating them in the context of death. Now, in a secular mood inspired by prints of academic portraits and trying to capture his sitter's likeness, he struggles and fails. He disrupts anatomy, limning arms that will not join shoulders and heads that float away from pillowy necks. He smudges dough-white faces with stains supposed to be shadows. He fails, but another succeeds. Through practice he learns and enters the academic tradition by portraying people seated heavily in real space, lit by real light, accurate in proportion and detail. Yet a third artist succeeds differently. He lifts and flattens his sitter into a geometric composition. He avoids distracting perspective and modeling. He streamlines form and erases expression to pull the soul out of his subject and set it on the canvas as a timeless emblem of an individual. The eye should have little trouble distinguishing between these efforts, one naive, one traditional in the academic manner, the third a conjunction of worldly topic and spiritual style that exists, like the clay figures of Mexico, as a sign of a shift toward materialism that has not demanded the abandonment of love and fear for the spirit.

171. *Angels. By the Aguilar family. Ocotlán de Morelos, Oaxaca, Mexico. Painted earthenware, 10 1/8" high, c. 1960*

172. *Women. By the Aguilar family. Ocotlán de Morelos, Oaxaca, Mexico. Painted earthenware, 9 1/2" high, c. 1960*

173. *Lawyer:* Dr. Advogado. *By Vitalino. Caruaru, Pernambuco, Brazil. Earthenware, 5 3/4" high, c. 1960. Vitalino was a pioneer of north Brazilian figurative art. Since his death in 1963, his works have commanded great prices.*

174. *William Shakespeare and John Milton. Staffordshire, England. Glazed earthenware, 8 1/2" high, c. 1848*

171

172

173

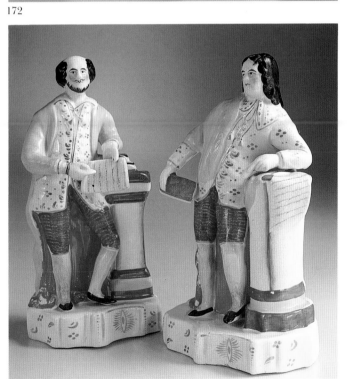

174

175. *Horseman. Ecuador. Painted wood, 9¼" high, c. 1910*

176. *Louis Napoleon. Staffordshire, England. Glazed earthenware, 12¾" high, c. 1854.*

177. *Dick Turpin. Staffordshire, England. Glazed earthenware, 9½" high, c. 1865*

178. *Horseman. Bastar District, Madhya Pradesh, India. Cast brass, 14½" high, early twentieth century*

179. *Horseman. State of Bihar, India. Cast brass, 6½" high, c. 1950*

180. *Horseman. Spain. Glazed earthenware, 7⅝" high, c. 1950*

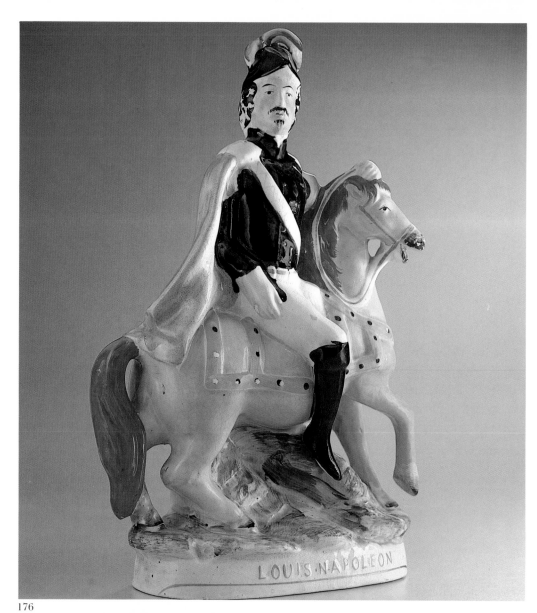

176

175

177

178

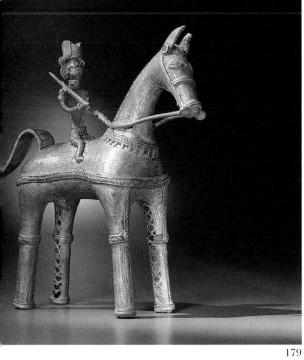

179

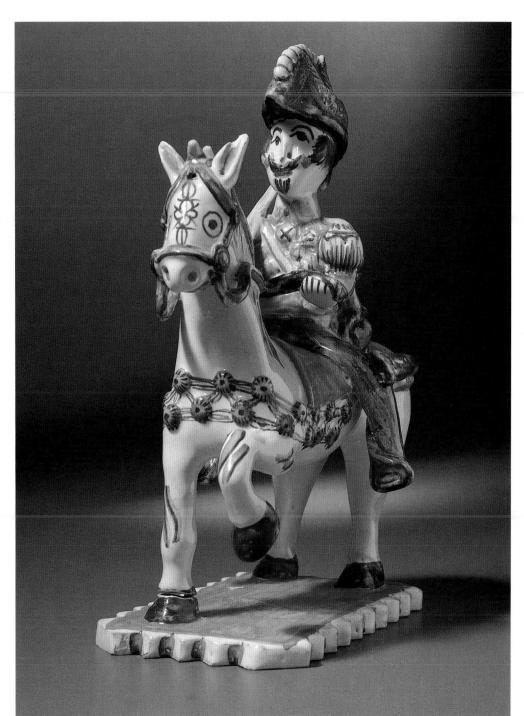

180

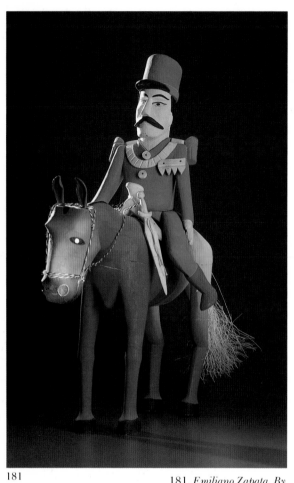

181

181. *Emiliano Zapata. By David Villafañez. Oaxaca, Oaxaca, Mexico. Painted wood, 22⁷/₈" high, c. 1970*

182. *Horseman. Lisbon, Portugal. Glazed earthenware, 10³/₈" high, c. 1960*

Opposite

183. *Horseman. Yoruba people, Nigeria. Painted wood, 27¹/₄" high, c. 1960. Among the Yoruba, the horseman may depict a warrior or the devotee of a warrior-deity in the guise of the god.*

182

As folk artists follow secular topics with an increasingly illusionistic style (as tends to happen among creators of genre scenes), or as they are inspired to edge their style toward realism in an effort to express sacred subjects more professionally, the spectrum from abstraction to illusion fills in, but the deep pattern of cultural exchange is not more complicated than this. Artists raised in one culture who encounter the art of another might continue to perform within their old tradition, perhaps exaggerating it in contradistinction to the alien style. Or they might jettison their old style to adopt the new one, in which case they become accomplished or not. If not, their works remain immature. Or they might pluck ideas out of the new style—subjects or media or approaches to representation—which they succeed in amalgamating with their native style. These different patterns can produce things that resemble each other superficially, but only one results in the naive. The others yield the works we call folk art or fine art.

Folk art and fine art can be separated by characteristic tendencies, but in this they are the same: both are created by people who have mastered traditions. Both, then, are expressions of people who interact to form social associations governed by certain values. So both manifest the deep ideas of rightness that rise diversely through things to typify particular cultures.

Cultures differ because groups of people shape their lives around different values. Some are more secular, others more sacred. But all art is alike in that it expresses culture. All art, too, expresses the individual. The idea of the naive can distract us from art's universal capacity to express culture. The idea of anonymity—another of the notions often raised amid talk about folk art—can comparably distract us from art's universal power to express individuality.

If all we mean by anonymity is that we do not know the names of the people who made the things before us, then most art, folk or not, is anonymous. The cathedral of Our Lady at Chartres is one of the world's greatest works of art. No one knows the names of the men who built it. That does not mean they were not individuals. The architect John James has so loved the great building that, during diligent study, he has been able to discover in its fabric the hands of nine masters, whose theological orientations and modes of design, whose handling of forms and materials, were so distinct that, though nameless, they emerge in his writings as rich personalities.

Within communities of workers it is always so. People who know a community's tradition can separate the general properties of a style from its handling by an individual. Facing a group of landscape paintings or useful pitchers that look the same to the outsider, the insider will attribute particular works to specific individuals on the basis of characteristic tendencies. The insider sees the individual styles that, clumped together, make the collective style. Works of art are never anonymous inside the community; they become anonymous when they wander. Within the community there is no need for signature. Why sign works, James Joyce asks in *Finnegans Wake*, when the whole work is a signature? It follows that most of the world's art, folk or fine, is not signed.

When signatures appear in an artistic tradition, it is tempting to read them as signs of the arrival of individualism, as a step on the road of progress at the end of which we stand. Artists in our day, painters in the lofts of New York or carvers in the hills of New Mexico, sign their pieces. After years of fine work at Jugtown in North Carolina, the master potter Vernon Owens began signing those pitchers and jugs he wished others to identify with him.

Opposite
184. *Sign of the Watchmaker:* Enseigne de l'Horloger. *West Africa. Oil and watercolor on wood, 30 x 39¾", c. 1970*

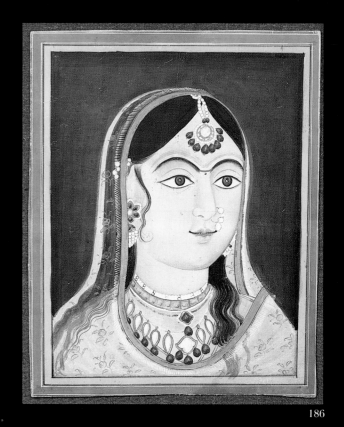

186

185. *Empress Josephine.*
Eastern United States.
Chalkware (cast, painted
plaster), 14¹/8" high,
mid-nineteenth century

186. *Rajput Lady.*
Northern India. Painted
paper, 9¹/4 x 7¹/2", late
nineteenth century

187. *Portrait of a Rajput*
Ruler. State of Rajasthan,
India. Painted paper,
11⁷/8 x 9³/4", late
nineteenth century

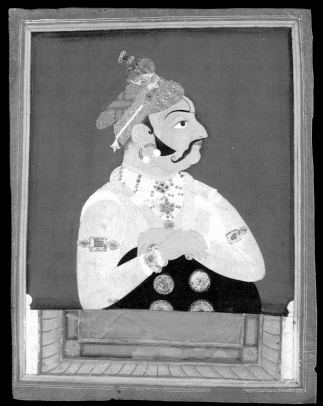

187

Within traditional communities, signatures can bring negative reaction. When Hungarian potters started signing their ornate brandy flasks, others mocked their pride, inscribing the sides of superior pieces, "Made by Anybody at Nowhere." The great Lucy Lewis was the first at Acoma to sign her pots, and the artists around her were critical. Signatures run counter to the folk cultural norm. Painters of icons in eastern Finland today refuse to sign their masterpieces. In the past, the Millennial Laws of the Shakers forbade the signing of craftworks.

Contrasting cultures in which works are customarily signed with those in which they are not, we might conclude that fine arts are the products of individualistic cultures, while folk arts are the products of communitarian cultures. It might feel strange to surrender all elder anonymous masterworks to the realm of folk art, but doing so—once again connecting the medieval art of Europe through folk art to the world artistic norm—we would strengthen the conventional association of individualism with secular cultures and communalism with sacred cultures.

The contrast of the individualistic with the communal helps in our search for the spirit of folk art. Folk arts are often literally group products. Though identified with one artist, the work absorbs the efforts of others. Gloria López Córdova's husband, Herminio, laughs that he gets no credit for the dirty, tedious task of sanding her pieces. The twenty people who labor in an atelier in Kütahya are lost within the final product credited to the atelier's master, who might not have touched it. Recognizing this reality, folk artists often speak in the first person plural. Turkish weavers always say, *yaptık*, "We made it." At the same time, during patient questioning, they always ascribe the rug to one woman. Her father followed the sheep over the rocks and sheared them. Her mother spun the wool. Her aunt helped dye it. Her neighbors gathered to warp the loom. Her younger sister sat beside her weaving fully half of the rug. Friends stopped by and knotted a few rows while chatting. But the rug at last is Aysel's. She selected the design, directed its making, controlled its harmonies of color. It is hers to keep for her dowry or sell for cash. It is hers, but she says, "We made it."

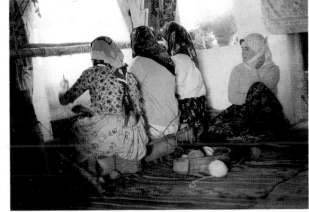

Aysel Öztürk, Hanife Öztürk, and Şukran Öztürk weaving together, Karagömlek, Çanakkale, Turkey

The artist acts within a group and at the end of a sequence. The ideas descended from others. It was José Dolores López and not Gloria who codified the concept she enacts. But the sensitive eye would not confuse her carvings with those of the people from whom she learned or with those of her contemporaries who share her tradition. Her son's carvings now follow hers closely and they could be mistaken for hers—as excellent student work often perplexes connoisseurs trying to attribute a piece to the master—but that only strengthens the distinctiveness of her achievement. Her style is her own. Yet she does not work alone; she is helped by the family around her and guided by her familial tradition. From multitudes of such examples, we can generalize that art simultaneously expresses an individual and a group—this family, that community.

Folk art insists upon this truth: no artist learns or works in isolation. That is less obvious but no less true for fine art. The most luxuriously solitary painter in a cold New York loft built his style upon received models and relies on others to weave his canvas, to fabricate his brushes and paint. And there are others, perhaps only built out of the imagination, who

will receive and appreciate the artist's effort.

These connections are the point of the word "tradition," the reason for its constant use and frequent misuse. Tradition constructs the future out of the past; its force is the individual who makes through a single action—carving a saint, singing a song—a double connection. The first connection is backward to the sources of inspiration. The traditional artist keeps faith with the past, honoring the work of the dead through vitalizing acts of preservation and reconstruction. The second connection is outward. The traditional artist uses the energy of others—suppliers of materials, members of the audience—to shape a communication capable of gathering and consolidating the collective. It can be said that all art is traditional: it has sources, and so recreates the past; it communicates, and so creates the future. But, especially when artists struggle to break free of the native tradition or reach to embrace an alien tradition, connections can be obscured. In folk art, connections are emphasized. They enhance, rather than diminish, the folk artist's power.

During personally satisfying creative acts, folk artists take responsibility for both the preservation of history and the construction of society. Real connections and deep debts do not embarrass the folk artist, and the collective experience of education and creation undergirds an ideology that characterizes the communities from which the greatest of the folk arts flow. Publicly, ritually, the position is communal.

This formal advocation of a communal ideal can mislead the analyst into describing traditional communities as though they lacked individualism. All I can say after a quarter of a century of study is that nothing could be further from the truth. The people I know in farming communities in the mountains of North Carolina or the hills of Ireland, in the villages of England or Turkey, delight in individualism. Their stories celebrate colorful characters. Their gossip focuses upon eccentrics whose excesses they excuse as natural to the human variety. Individuals evolve intensely distinct styles and tastes, and they spend hours describing them in detail. They seem indeed obsessed with the development of personal opinions on every matter, from the most profound to the most petty.

If artists, they tell first about their debts and connections. That is the decent thing to do. But, warming to the topic, they expand in accounts of their personal struggles, stressing the bright particularity of their accomplishment. They are as frank about their qualities as they are about their debts. In a matter-of-fact manner, Ahmet Şahin will tell you—correctly—that he is the most important of all the thousands of potters in Turkey. "Of course," he said, when I told him I wanted to know the story of his life. Then he told me to write a book and make him its *kahraman*, its hero.

The little artists lavish redundant attention upon their minor innovations. The big ones see themselves as giants who have risen above their dreary neighbors and become free by virtue of their genius to do as they please. Repeatedly, I have found they disregard normal responsibilities. They create and usually they teach, for those are the artist's special obligations, but the rest of the way is theirs alone. Believe me, Peter Flanagan, Ballymenone's great musician, is as richly and complexly developed as ever artist was. His neighbor, the great storyteller Michael Boyle, says all great storytellers are mad, brilliant in their originality, failures at life's little jobs.

My point is not that all folk artists are unusual people, but some are. Cultures account for the wild artistic temperament differently. It may be attributed to genetic makeup or psychological disposition, to social conditions, to visits from the muse, to dreams or posses-

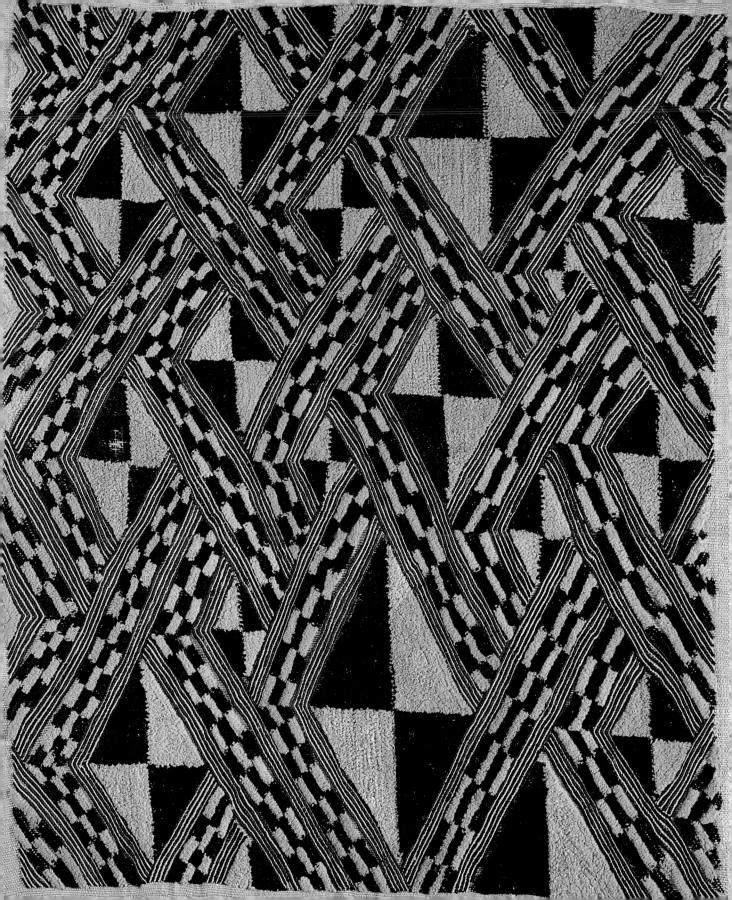

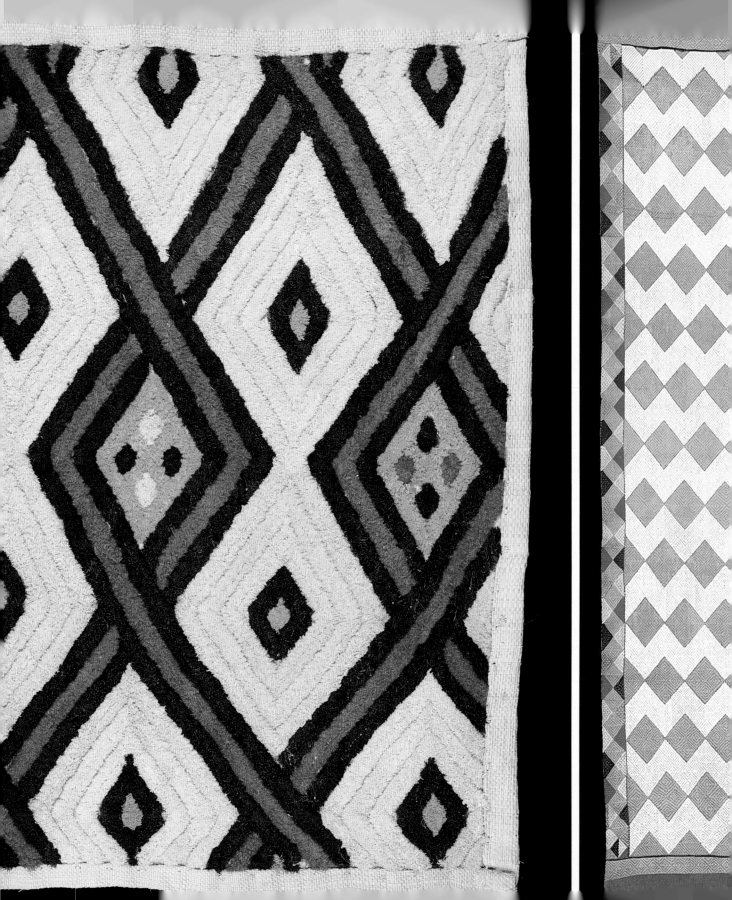

sion by spirits or experiences out of the body. In the folk artist's world, as in our own, there must be some explanation for those who carry the general drift to individualism to its greatest extremes. The explanation provides them a role in normal social exchange.

If anything, I would say that people in traditional communities are more concerned with the development of distinct personalities and more tolerant of deviation than the people I live among in a modern metropolis. They must be. Their existence requires diversity and it requires cooperation.

The six men who go "a-drudging" aboard a skipjack on the Chesapeake Bay are bound by an egalitarian compact. They sleep together in the cramped forward cuddy, and they share equally in the day's catch. On the *Geneva May*, out of Wenona, two are black, four are white. From dawn to dusk through the mean winter season, four of them, "the middle

deck men," will throw the cold iron dredges over the side and bend to cull the oysters they scrape off the bottom. The two youngest, Gerald and Steve, work hardest. The eldest, Lloyd, will take his time, for he is an expert waterman. He knows the sky, the sea, the machines. He prepared the dredges on the way out to the oyster rock, smoking a cigar and singing hymns beneath his breath, and he will take charge quickly and completely in times of trouble. One man's job is easy, but necessary. He cleans the fish the dredges bring up and prepares a hot dinner of boiled beans, fried fish, and sweet black coffee to restore the chilled workers at noon. Paul Benton is the captain. Though I knew, once I had learned to ride the boat's pitch and anticipate the swing of the boom, exactly when the dredges would leave and return, exactly when the sail needed to be shaken out or reefed in, and I knew the men knew better than I, still they waited for Captain Benton to give every command. He controlled the motor that powered the dredges and the lines that held the sail and the gaff that gauged the weight of the dredges bumping below. They jumped at his word.

Aboard the *Geneva May*, the egalitarian unit is not built out of simple equality. It is compounded of varying talents and responsibilities arranged into a hierarchical order that dissolves after work, when the men share the profit and a toast to a successful day, but snaps into place during work, when all willingly and efficiently submit to the man best at the task at hand. Death lies one slippery step away. The men do not swim, the water is cold, and the boat, a graceful thing of wood and canvas, maneuvers too slowly to save them. "We come back for the body," they say. Their fortunes depend upon cooperation. There are babies to feed at home on the Eastern Shore. So they shape a unity that is at once egalitarian and hierarchical, that creates oneness out of recognized differences.

When the storm clouds roll and the hay lies in peril, Irish country people cannot let negative evaluations of the failures and foibles of their neighbors get in the way. They assemble behind the man best at the work and move as one across the meadows to win the hay that will carry the cows over the winter. And when black night yawns with dreadful boredom, they are glad the fiddler neglected his garden to perfect his talent. They forgive his oddity. It is necessary to their happiness.

The people who create the greatest folk art are accustomed to cooperation, and they relish personal quirks as the spice of life. Though attracted to both individualism and

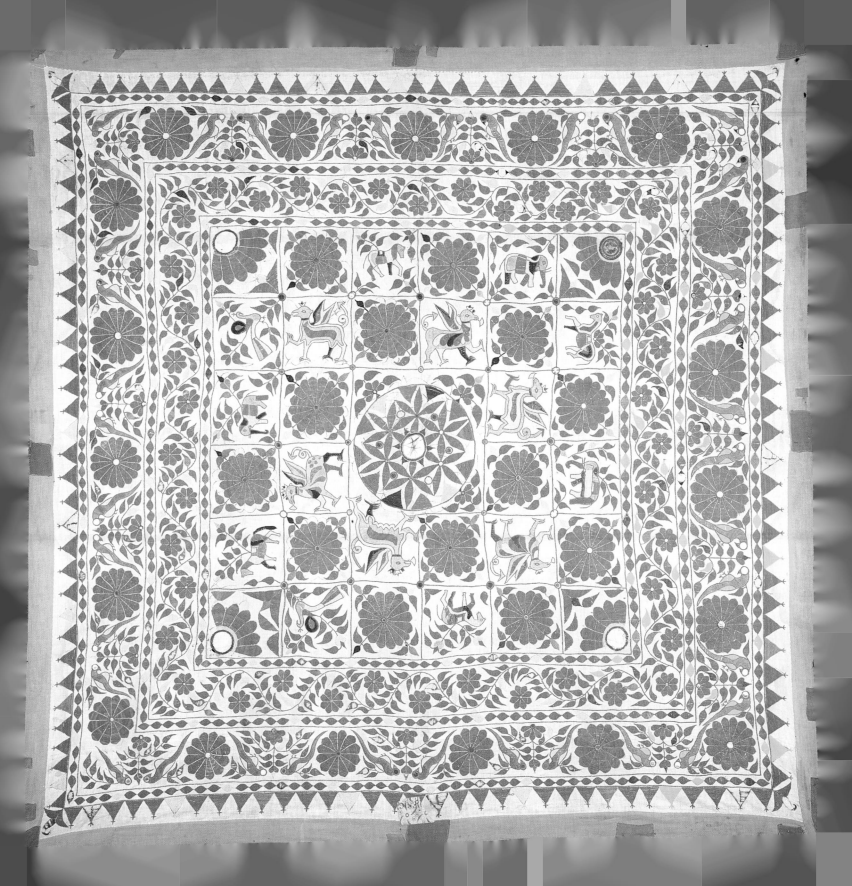

193. *Embroidery Pattern. Northern China. Cut paper, 4³/₄ x 4³/₄", c. 1960. On this stencil to guide embroidery, flowers and a butterfly surround a double* xi, *the character for happiness, positioned above the swastika-like* wan, *literally meaning "ten thousand" and serving as a wish for longevity.*

194. Askı. *Kütahya, Turkey.* Çini *(underglaze painted composite ceramic), 4¹/₂" high, early nineteenth century. Shaped like the ornaments suspended in mosques, these were made as votive offerings to hang in churches throughout the Ottoman Empire, from Greece to Jerusalem.*

193 194

195 196

195. Tama. *Greece. Stamped silver alloy, 7" high, c. 1950. The* tama *is offered to a saint in request for a favor or in thanks for a favor granted.*

196. *Brooch. China. Kingfisher feathers on brass, 2 x 2", c. 1920. Five bats—*wu fu, *a homonym for five blessings—encircle* shou, *the character for long life.*

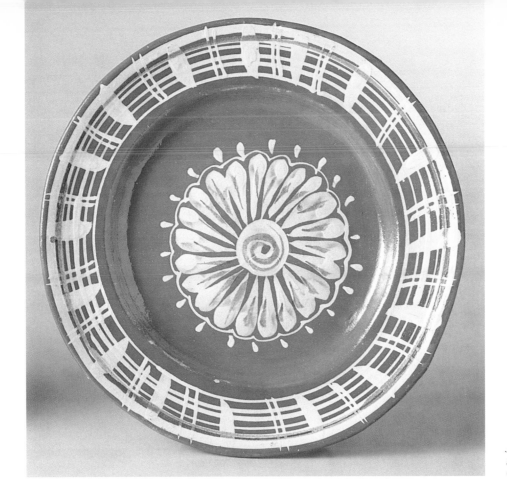

197. *Plate. Tonalá,*
Jalisco, Mexico. Painted,
glazed earthenware,
8³⁄₄" diameter, c. 1960

198. *Plate. Tonalá,*
Jalisco, Mexico. Painted,
glazed earthenware,
8⁷⁄₈" diameter, c. 1960

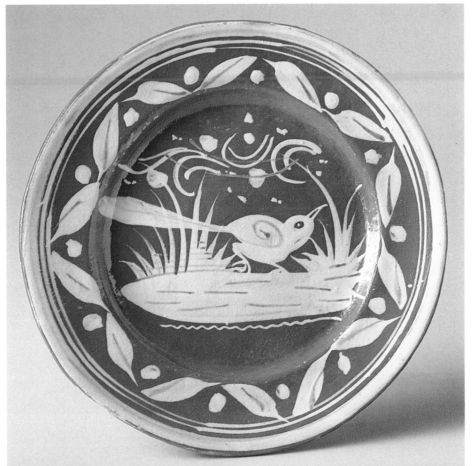

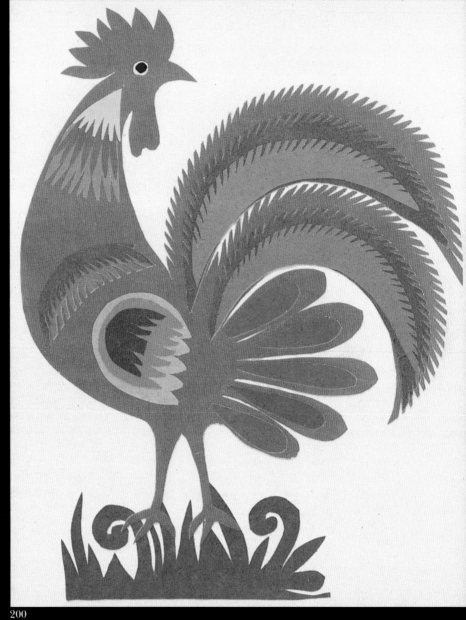

199

200

201

202

communalism, they typically arrange them so that individualism will be contained by a public ideology of the common good, so that natural diversity will interlock into a complex and stable whole. The daily routine may flare with egoism and factionalism, contention and mean gossip (they know what their neighbors do, and they care what they do, and they know the rules that enable harsh judgments). But the ideal is communal.

The deep force of order in traditional communities is religion. Religion isolates individuals, charging them with responsibility for their souls or their ritual roles, and religion calls them into unity. Standing, kneeling, falling in prayer, they surrender themselves. Dancing all day in the plaza to the beat of one drum, then following their saint into the church and receiving together the body and blood of Christ, they know a sensation of mystical oneness.

Folk art is the materialization of that experience. It depicts the absorption of real individuals into oneness. That is what folklorists tried to describe when they defined folklore as simultaneously variable and traditional. Folklore holds to the center of a tradition within which variability is realized and contained, as individuals are realized and contained in communities. Folk art does not represent an archaic order lacking in individualism. It represents the willing submission of fully realized human beings to a communal ideal.

It is the overt commitment to the collective that causes resistance to signatures. Within the group, the work is already, clearly and adamantly, a sign of the individual. Signing works with names, artists break out of the group within which they are already known to claim the attention of outsiders. Achieving stature beyond the community, the artist is drawn away from participation among those who share the tradition, and that disrupts the communal ethic on which the collective depends. The farmer who gracefully tolerates a neighbor's strangeness will attack viciously those who rise through pride to separate themselves from normal neighborly interaction. Of course, folk art is normally unsigned, and when signed it is usually with a collective name, a place or atelier—and when the individual signature appears, the reaction is initially negative.

The signature means that the individual no longer finds recognition within the group sufficient, perhaps for psychological reasons, more likely for economic reasons. To sell a work to people incapable of reading it alone as a signature, the piece is signed. Things with signatures fetch higher prices in the art market. Despite the fitness of the notion to crude theories of modernization, the signature does not mark the arrival of individualism. People were always individuals. Rather it indicates a disruption in the communal ethic that abides eccentricity in order to perpetuate the collective.

Signatures are small rebellions. As the impulse in the signature expands, and artists push farther and farther away from the group within which individuality is naturally recognized, works are refined, elaborated, shaped increasingly to bear the individual presence until the old hierarchy is overturned, and the individualistic comes to dominate the communal. Now oriented away from the community, artists create new things. These might be bad pictures of traditional art, mere commodities, tools to dig cash. Or they might be exciting innovations that reflect the old tradition but at last express the individual soaring free of communal engagement. Often these novelties call others after them and become the models around which a school gathers. The process is one, but motives differ. People may break beyond communal confines to improve their economic position or to answer deep personal needs that the old tradition cannot meet. The process is one, but we evaluate it differently in folk art and fine art.

[*197*]

199. *Phoenix Shadow Puppet. China. Cut, painted leather, 21¹/₄" high, nineteenth century. The phoenix appears—in shadow plays as in life—in times of peace, prosperity, and reason.*

200. *Rooster. By Marianna Pietrzak. Błędów, Łowicz, Poland. Cut paper, 8³/₄ x 6³/₄", dated 1962*

201. *Rooster. Northern China. Cut paper, 4¹/₄ x 4", c. 1960. Like the sun, the rooster is an embodiment of* yang, *the bright, generative principle of the Chinese cosmos. His crowing disperses the evil lurking in the night.*

202. *Butterfly. Northern China. Cut paper, 8¹/₂ x 15¹/₈", c. 1950. A butterfly, the emblem of joy, in red, the color of joy.*

In folk art, the process of communal disengagement leads to a welter of curios and souvenirs among which occasional works of excellence appear. We doubt their validity and describe their creation as aberrant. In fine art, the same process yields heaps of mediocre commercial art, and it produces the very works we use to define greatness. In folk art, the authenticity of the deviant work is questioned. In fine art, we proclaim the work authentic precisely because it is deviant. We view its creation as normal.

Apparently the process that is abnormal in folk art is normal in fine art. In folk art, the communal contains the individual. In fine art, the individual contains the communal.

Characteristically, the folk artist accepts the communal ideal, then works within the tradition that gathers the group, finding inside it sufficient space for individual expressiveness. Tradition is not an enemy, but a tool used to realize the self. Aided by old solutions summarized in tradition, the folk artist bears down on the job at hand, melting into the rhythmic flow, loving action for itself, then gaining satisfaction from completion. The Turkish weaver calls work at the loom good. While weaving, she loses track of time, yet wastes no time, for every second was trapped in a knot. It feels good, she says, to complete a motif, and the finished rug, cut ceremonially from the loom, is great proof of her existence as a capable

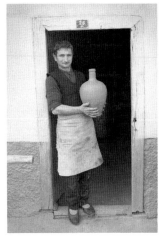

Osman Kaya, master potter, Kınık, Bilecik, Turkey

human being. "I think, therefore I am" is abstract, unconvincing. "I make, therefore I am" satisfies, and the project completed is a source of delight. It may closely resemble earlier projects, but it is distinct. This is mine. I made it despite these conditions. It tells me of the command I have over myself and my environment. It is a picture of my being.

There is joy galore in effective repetition, in the old song sung perfectly, in the pot through which clay danced again to the potter's tune. Finding pleasure in work and pleasure in using the work to connect to others, folk artists do not take novelty for their goal. They strive for perfection. By contrast, it would seem, the fine artist finds tradition numbing or abrasive and sacrifices perfection to novelty.

This is the heart of the matter, the essence of the contrast between folk and fine art. It abides in an attitude toward tradition. Being the use of the past to create the future, tradition is the force that shapes and perpetuates communities. Among those who live beyond community, tradition is the way they make community-like connections between themselves, the sources of their learning, and others who share their worries and opinions. Folk artists collapse into tradition, merge with it, and bring it alive in works that grip and contain its energy. Fine artists pull away and battle with the past to create works that aggrandize the self and drive tradition onto a new course.

That is the contrast, but is it the answer? I mean, if we say that folk art is an individual's perfection of tradition and fine art is a rebellion against tradition that generates novelty, would that contrast split into groups the things we call folk art and fine art? The answer, simply, is no. The great majority of fine landscapes and portraits would be folk art—individual versions of a received tradition. Yet we persist in calling some novelties folk art and many traditional performances fine art. My question is why we do.

Maybe social class is the answer. We associate fine art with wealthy people, for only they can buy it, and folk art with poor people, for they often make it. If we call fine art "high

art," thereby making folk art into "low art," and then similarly—and with similar crudity—divide people into high and low, we might casually begin to associate kinds of art with classes of people. Vague assumptions about class lie behind many decisions to classify objects as folk or fine. Let us bring them into the open.

It is not easy. We are no more comfortable with talk about class than the Victorians were with talk about sex. It is embarrassing, it is titillating, and the unequal distribution of wealth is a fact of life. The author of a modern Nigerian chapbook, titled *Money Hard to Get But Easy to Spend,* begins teaching the way to riches by reminding us, "Life is hard and sugary. But the number of those who suffer its hardship exceeds those who enjoy its sugary." Cultural relations between the many who have it hard and the few who have it sugary are differently described. From the right, we are told that the poor receive their culture from the wealthy and live lives of diminished emulation. From the left, we are told the poor shape life out of protest and resistance. Either way, passive or active, poorer people are seen to exist only in relation to the wealthy. If we sophisticate the concept by describing the reaction as creative synthesis, a kind of social provincialism, and then sophisticate it further by inquiring into the origins of the culture of wealth and discovering that it often rises out of the common resource, and then reformulate the relations of rich and poor into a continuous circle of influence, we might still hold to the notion that differences in art express differences in access to wealth. That idea is not altogether false, but it is too neat. It is incomplete. Social parochialism has escaped us. Historians confined by method to marks made on paper remain confounded by lives guided by spoken arrangements, by cultures shaped into pots and houses rather than books. Scandalous as it might seem to us during our scramble to associate ourselves with the power money brings, most people do not care what we do. They are off on their own course, guided by different powers. Their social status is derived from within the small circle of their neighbors. Their art perfects their own world view. If they are poor by comparison with others, then poverty is among their conditions, but it does not follow that their art will be about their wants, their envy, their relations with wealthy people about whom they may not care. They must deal with the climate and with material deprivation, but their history is not reducible to an account of the weather or the misdeeds of those who conspire to keep wealth from them. Their history, like all history, is the tale of their creative adaptation. No one exists unconditioned, without limits, and even slaves in chains, as Afro-Americans have proved, construct in the small place left to them an art that is more than a reaction to evil.

I wish you could come with me once on a walk up a long, rocky lane to a mountain village. Among the stone houses, there are signs of places beyond: a blue plastic basin by the spring, a spinning wheel cobbled out of parts salvaged from a bicycle, an empty cigarette package crumpled, gleaming in the mud. This place is not isolated, but its way is its own. In winter, in the one warm room, a young woman sits in the slanted light by the window, tracing a flowering vine in minuscule stitches along the edge of a pillowcase. In spring, she passes beneath an explosion of white blossoms in the nut trees to join her sisters pressing seeds into the pungent earth. In summer, young men grip one another by the shoulder and stomp in a circle, dancing in the heavy, monstrous manner of bears to celebrate her wedding. In the autumn, she will thresh beans with her new husband at the village edge. Here life unfolds out of the local rhythm, art rises out of such control as people can manage, and little has to do with the slim flow of what we call history.

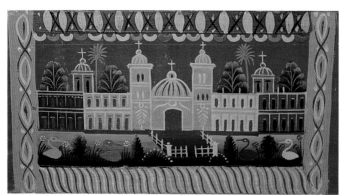

203

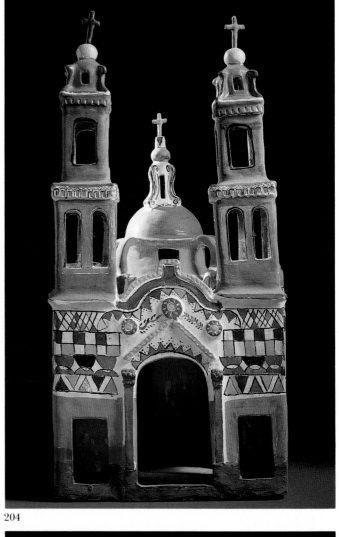

204

203. *Chest. Olinalá,*
Guerrero, Mexico. Painted
wood, 5¹/2" high, c. 1950

204. *Church. By the*
workshop of Herón
Martínez. Acatlán de
Osorio, Puebla, Mexico.
Painted earthenware,
24" high, c. 1960

205. *Miniature Shrine.*
Aksum, Tigre, Ethiopia.
Carved slate, 6³/8" high,
c. 1950

206. *Miniature Shrine.*
Aksum, Tigre, Ethiopia.
Carved slate, 3³/4" high,
c. 1950. Tiny iconic shrines
are made as votive offerings
for churches and home
altars in the Aksum area.

205 206

207. *The Crucifixion. By Domingos Goncalves Lima, called "Misterio." Barcelos, Braga, Portugal. Painted earthenware, 19¹/₄″ high, c. 1960*

208. *The Crucifixion. Signed "J.R." Barcelos, Braga, Portugal. Glazed earthenware, 7¹/₈″ high, c. 1960. "J.R." may be a member of the family of Rosa Ramalho, who, like "Misterio," works in the figurative ceramic tradition of Barcelos.*

207

208

Since places like the one I evoke are rare today in the United States, we let ourselves think of them as unreal, forgetting not only our own past, but the size of the world. Remember that you would have to add the populations of Canada, Great Britain, East Germany, and West Germany to that of the United States to arrive at a number half the size of India. If you added the population of the United States to India, you would still have to add the Netherlands to reach the population of China.

Our view of the world is confused by our tendency to generalize from the smallness of our own experience and by our trust in bad metaphors. We may conceive of society stratigraphically, putting rich people like ourselves at the top, putting the poor below, and letting gravity do the work of cultural construction as money and ideas trickle down. But that is not how it is. Everyone exists at the same human level, and we would make progress by ceasing to study people from the top down or the bottom up. Everyone should be understood from the inside out, from the centers where they have power to the edges where power dies, from the center where they create to the edges where others create for them: the edges where the poor are thwarted by a lack of cash and the rich are thwarted by a lack of skill. Then, knowing all people as able and limited, we could know them as artists and as elements in the big systems we attempt to describe by metaphors of layering.

All people are limited in what they can do. Poverty sets dreadful limits. But the differences of limit experienced by the rich and poor do not alone make classes. Classes arise when recognition of the gulf between the hard and the sugary stiffens into general animosity, into oppression and resistance.

Looking upon the makers of art and thinking about their social class, we must first face the possibility of the irrelevance of class to the artist hard at work on matters of importance to those gathered around, and second we must face the inappropriateness of the concept of class—so fit to nineteenth-century England, so embarrassingly vital in twentieth-century America—in our own past and in the present of much of the world.

Class is more than the possession of wealth. It is a matter of orientation. In the traditional community, some people are wealthier than others, but all are oriented toward the same values, so wealthier people have grander, more expensive versions of the things everyone has. The materials are finer, the ornament more lavish, but the basic concept is the same. If wealthier people break away and orient themselves to the outside, connecting to people in other places, then we might call them members of an upper class. The less wealthy hold to the native tradition, while the wealthiest disengage and associate themselves with others they may not know, using alien traditions as signs of their separation from those "below." That is the situation in which the nationalistic definition of folklore arose and made heroes of the common people.

The common people, though, were not all ground down by penury. They included rich farmers as well as poor, and crucially they included artisans. Today people who work with their hands might be classed low—despite the money they make—by scholars whose wages are similar but who wish to identify themselves with the upper class and so stress education as a criterion for class. But extending that notion backward or outward falsifies reality. In ancient days craftsmen like smiths belonged to the elite, and in the more recent past of Europe artisans of the middling sort made the things we call both folk and fine art.

The great folk art of Europe is not the product of poverty. Quite the reverse. In the history of every Western nation there is a great moment for folk art. It is marked by the same

211

212

211. *Our Lady of Solitude:*
Nuestra Señora de
Soledad. *San Antonio,
Oaxaca, Mexico. Dried
flowers on paper, with
bamboo frame, 55" high,
c. 1970*

212. *The Tree of Life. By
Herón Martínez. Acatlán
de Osorio, Puebla, Mexico.
Painted earthenware,
42 1/2" high, c. 1960.
Martínez has been a great
innovator in Acatlán,
inventing forms that others
have copied.*

213. *Shrine to Our Lady of
Guadalupe:* Nuestra
Señora de Guadalupe.
*Guaymas, Sonora, Mexico.
Painted plaster with
shells, glitter, and paper,
25 1/2" high, c. 1965*

213

215

216

214. *Two Crucifixes. Chile. Painted wood, figure on the right 6" high, c. 1960*

215. *Retablo. By Jesús Urbano. Ayacucho, Ayacucho, Peru. Painted potato-paste figures, painted wood niche, 35½" high, c. 1958*

216. *Altar for the Day of the Dead. By David Villafañez. Oaxaca, Oaxaca, Mexico. Painted wood, 31" high, c. 1960*

214

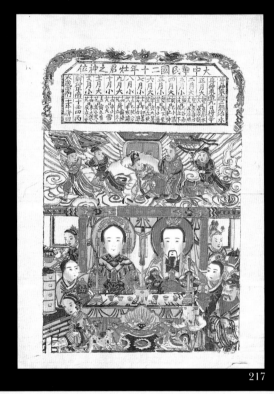

217

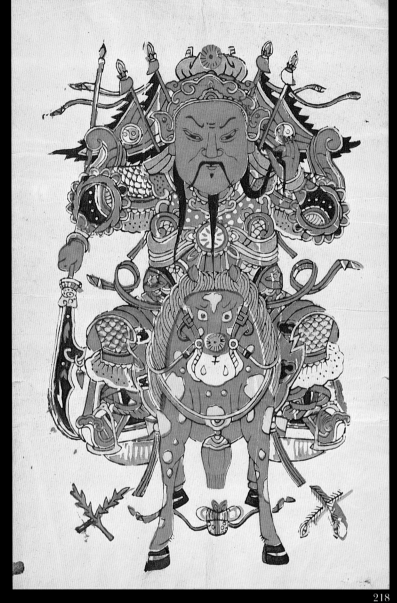

218

219

dynamic tension that generates the greatest fine art. When people are attracted both to the material and the spiritual, when their love for the world challenges their love for God, when individualistic urges swell and threaten to overwhelm the communal ethic, old traditions absorb new influences and they expand and stabilize in a style that represents the great flowering of folk art. It is not a moment of poverty but of sudden new prosperity for farmers and artisans. This is the era of flowered chests: England from 1580 to 1730, Central Europe from 1710 to 1840, Eastern Europe from 1820 to 1890.

For a case beyond Europe, consider Turkey today. Some wealthy people are oriented Westward. Their homes, art, and life-styles are patterned after those of the European elite. Other wealthy people are oriented conservatively, internally. Their homes, art, and life-styles refine and elaborate the general norm. The rich man's calligraphy is inlaid with mother-of-pearl. The poor man's is carved in wood. But they say the same thing. The rich man's prayer rug has minuscule knots of silk, the poor man's has big knots of wool, but they bear the same mihrab. Artists serve a diverse clientele.

Who makes art? Among famous fine artists there are a few, like Edgar Degas, who came from the upper class, and a few, like Jean François Millet, who were born poor. But the great stars of fine art in modern times—James Joyce has been our example—came from the middle class, and in an earlier day they came from among the middling artisans. Folk artists might be poor today, but many are not, and in the past they, too, were of the middling sort, strong farmers, steady artisans.

If the difference between folk and fine art does not arise from the artist's estate, perhaps it derives from the class of the consumer. We are back where we began. Being expensive, fine art is bought by rich people, but less wealthy people consume it in museums and books and create the market for art with their writing. Further, much folk art today is too expensive for any but the wealthy. If consumers pull artists into their class, then many folk artists are of the upper class.

The social class of artists and consumers cannot be used as a shortcut to the separation of folk from fine art. Still, we think of folk art as rising out of hard lives, and we use folk art as a sign of the virtue and humanity of people who chance to be poor. Their art proves they are as capable, as creative and intelligent, as rich people. They are merely less wealthy. It is not false to see folk art as a victory over poverty.

In our past, systems of creation and patronage unified people of varying means. Though different in their possession of worldly goods, they were one in basic values. Within such systems, artists created for people richer and poorer than themselves. That situation, once normal in Europe and still vital in Turkey, is the healthiest state for folk art. In their wealthy patrons, artists have customers for their most exquisite creations. Poorer people provide them with a wide and stable market, founded upon serious needs. Since they are not alienated from their customers, rich or poor, their grandest works do not become facile performances and their simpler works do not become hollow and shoddy; both embrace the essence of cultural power.

Then, as wealthier people abandon the religious tradition that unified them with the artisans and join into an upper class, and as they are followed by others who form the middle class, the people of communities bound by sacred tradition become poor. They may be poor because they are religious and find evil the materialistic values necessary to becoming rich. Or they may be religious because they are poor and dream of justice in another life. More to

217. *Zao Wan Ye. Probably Hebei Province, China. Block-printed paper, 13 3/8 x 9 7/8", dated 1931. Below a ritual calendar appear Zao Wan Ye and his wife, gods who preside over the kitchen.*

218. *Hu Jingde. Hebei or Shanxi Province, China. Block-printed paper, 15 x 9 7/8", c. 1960. Hu Jingde is one of a pair of door gods whose pictures are pasted on either side of the door at New Year's to drive away the demons who wander as the year changes.*

219. *Decoration for the Kitchen. Northern China. Painted cut paper, 4 x 20 5/8", c. 1950. The motifs call for luck, marital happiness, and prosperity.*

220

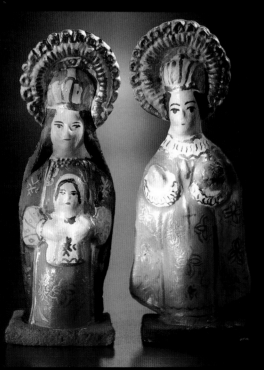

221

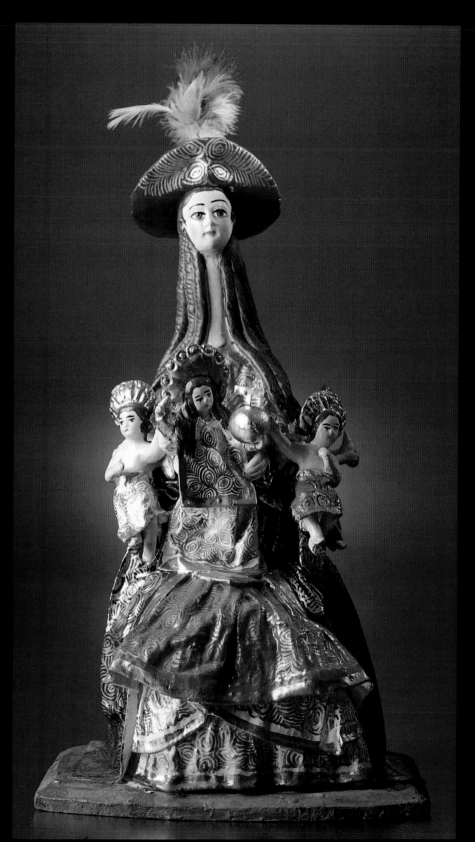

222

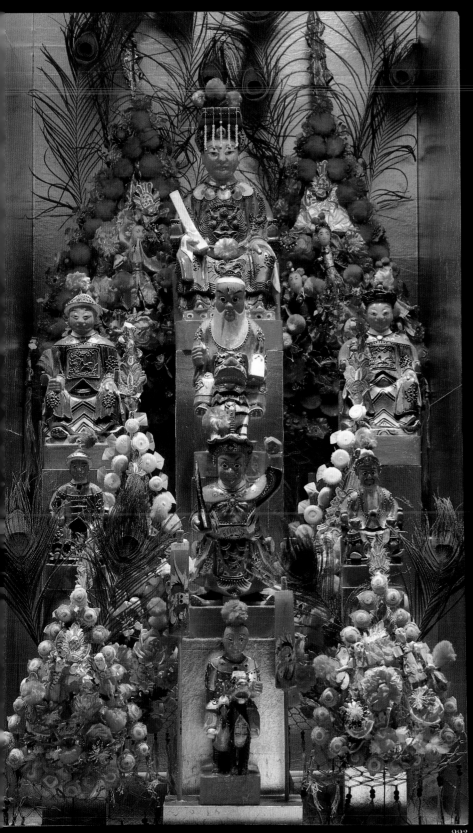

223

220. *Saint Martin:* San Martín de Porres. *Ayacucho, Ayacucho, Peru. Painted stone, 5⁵/₈″ high, c. 1958*

221. *The Virgin Mary and the Holy Infant of Prague. Cuzco, Cuzco, Peru. Painted plaster, 8¹/₂″ high, c. 1958*

222. *Madonna. By Hilario Mendivel. Cuzco, Cuzco, Peru. Painted, gessoed fabric, wood, 17¹/₂″ high, c. 1958*

223. *Household Deities. China. Painted wood, c. 1920. Alexander Girard purchased these statues in San Francisco's Chinatown when the shop in which they had served as a shrine was torn down. The arrangement is his.*

the point, they are poor because they were not born rich, and religious because the work they must do drives them hard up against life and into an awareness that cries out for explanation. Whatever the cause, it has become true in our times that people organized by religious tradition, among whom folk art flourishes, are often poor. As they pass through life, working down in black old holes, digging in the muck, chasing after the damned old cows, struggling toward eternal rest, art is their worldly consolation and the emblem of their unbeaten humanity.

But we must not be confused. It is not natural for life to be bad. Even today folk art is not necessarily the product of poor people. The Amish, who have built a traditional community among us, whose quilts are among the great folk arts of our day, are prosperous people. In our past the greatest folk art flowered out of a wealth in which farmers and artisans shared, and in much of the world today, as in Turkey, folk art is made and consumed by rich as well as poor people.

In this late stage of our civilization, folk art is often made by poor people, but that is not how it was or must be, and no general rule abides in that observation. The key to the division of folk art from fine art is not class but the attitude of the artist I have been discussing all along. If artists continue to work within the communal frame, then, no matter how we classify them, high or low, they are not members of classes but of communities that may be as diverse in wealth as they are diverse in personality. If artists break out of community, perhaps in a wish to be classed with the wealthy, they do not shift from tradition to alienation. They shift from one tradition to another.

All art is an individual's expression of a culture. Cultures differ, so art looks different. Whether spiritual or materialist at base (and so geometric or illusionistic at the surface), most art subordinates the individual to the tradition. However, differences in experience breed differences in values, causing like things to be described differently.

The individuals in traditional communities stress the communal ethic. We stress individualism. Think of daily experience. Living in a tight little community, people exist in a state of regular exchange. The ones they meet at work are the ones they meet in church are the ones they meet on the road again. Connections repeat, overlap, multiply, and force them into an awareness of interdependence that guides them into acceptance of a communal ideal. Living as part of a loose, diverse population, broken for scholarly convenience into classes, constrained by law but governed by no single ethical tradition, we choose friends, meet others at work, others at the theater, pass many on the street. We live among people we do not know, and we do not know who grows our food or sends our electricity or makes our paints and brushes. We forget our debts to others and, supported by a massive, hidden system, begin to drift into a state that is not independence but ignorance of dependence, that is not individualism but aloneness. A communal ideal would be inappropriate, impossible. Reaching for a collective vision, we might become patriotic or lovers of the universal human spirit. Those ideals can shape noble, selfless actions. But they are abstract by comparison to the communal concept that presses in upon the individual whose life passes in one small place among neighbors and kin. Our grand ideals leave us alone. It is not easy. Things happen, but we are not sure how. We are responsible, yet we ourselves create almost none of the social order or material bounty on which our lives depend. Knowing the sensations of powerlessness and anonymity that we project improperly onto people poorer than ourselves, we pity victims and make heroes of those who take charge and gain celebrity. Our operative ideal is individualistic.

Opposite
224. *The Three Kings:
Los Tres Reyes Magos.
By Manuel Jiménez.
Arrazola, Oaxaca, Mexico.
Painted wood, figure on the
left 9¹/₄" high, c. 1960*

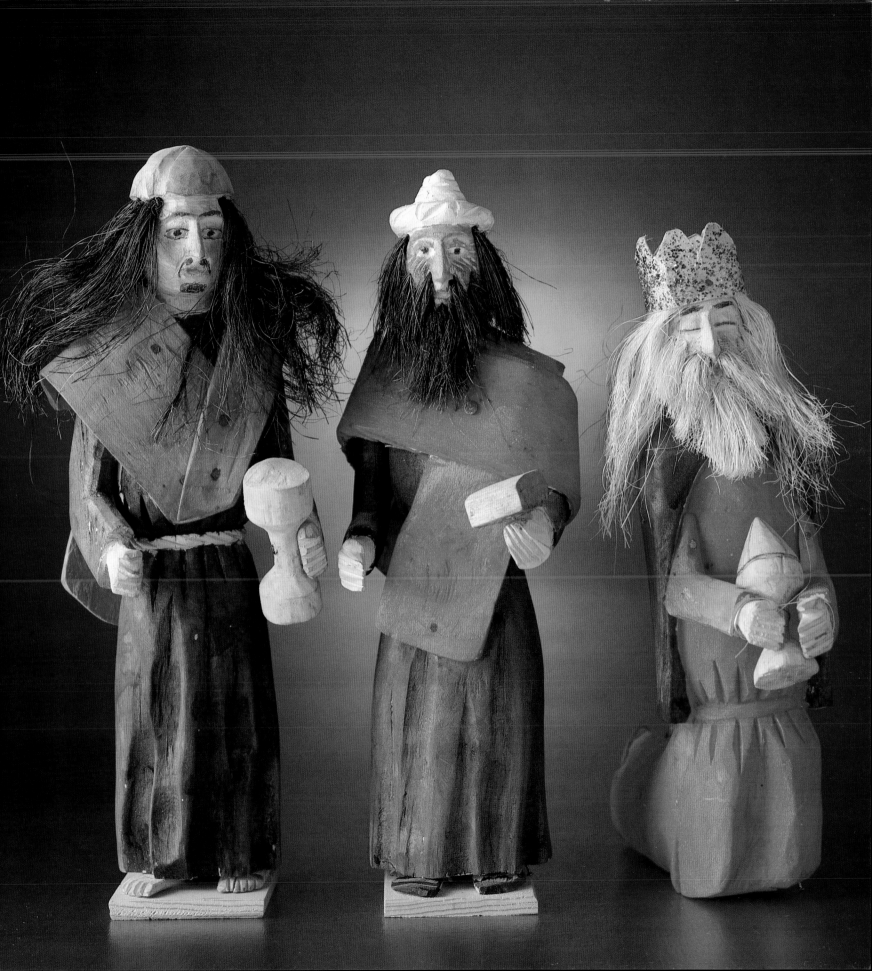

225. *Hanuman. Bastar District, Madhya Pradesh, India. Cast aluminum alloy, 7³/₄" high, c. 1950. Hanuman is the loyal monkey servant of the god Rama.*

226. *Oni. Aomori, Aomori Prefecture, Japan. Painted earthenware, 5¹/₈" high, c. 1960. Oni are demons; this one may represent the namahage of the Oga Peninsula, who enters farmhouses on New Year's Eve in search of naughty children and lazy brides.*

227. *Woman. By Teodora Blanco. Santa María Atzompa, Oaxaca, Mexico. Earthenware, 27¹/₄" high, c. 1965. The Atzompa pottery tradition included small figures for fertility rituals; from that seed in the heat of Teodora Blanco's genius grew fantastic sculpture.*

225

226

227

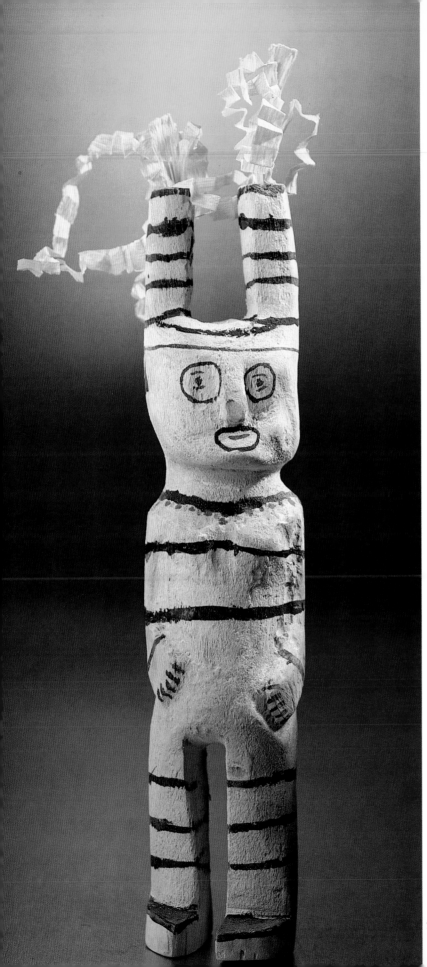

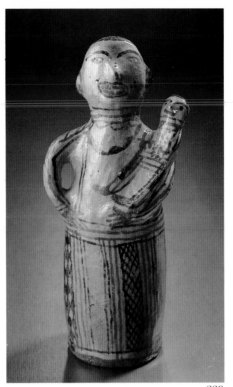

228. **Koshare.** *Probably by Lorenzo Aguino. San Juan Pueblo, New Mexico. Painted wood, 14¹⁄₂" high, c. 1960. The koshare is a ritual clown who appears in Pueblo feast day ceremonies.*

229. **Mother and Child.** *Berber people, Morocco. Painted earthenware, 11⁷⁄₈" high, c. 1960. Having long made utilitarian pottery, Berber women have turned recently to figurative works.*

230. **Koshare.** *By Felipa Trujillo. Cochiti Pueblo, New Mexico. Slipped and painted earthenware, 11¹⁄₂" high, c. 1960*

229

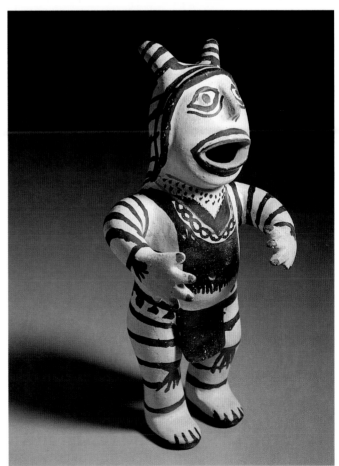

230

228

In a traditional community, small acts are enough to secure a sense of individuality. Old ideas perfectly repeated or gently reshaped speak clearly to others of one's excellence. Art is an emblem of the social order, of minor variation within a stable whole. But in a vast, heterogeneous mass, it takes a big act to claim attention; the artist who wants recognition must make a grand gesture. Our attraction to power and celebrity, our anxiety over anonymity, lead us to identify great art with novelty. We want it original and we want it autographed. Art is an emblem of the social order, of the rare excellence that spires out of the mass of mediocrity.

To gain notice, to realize the self in a scene scaled beyond face-to-face knowing, the artist rebels against tradition. A total rebellion would escape notice, so the rebellion must be tempered. It must love what it pretends to hate, subtly incorporating what it seems to deny. While subordinate to the personal, the traditional must be conspicuously present.

Further, rebellion against tradition does not mean social rebellion too. It means a shift of allegiance from one group to another. To clarify, let me use the idea of community with precision. A community is a social unit, like Peter Flanagan's Ballymenone, composed of people who live and work together, managing their own affairs in accord with shared values that embrace all of life. The groups we know are but metaphorically communities. We are born into families tied through a complex overlap of networks into a variety of social institutions. As we move from place to place, job to job, we ally ourselves to a variety of different groups bound together, not by a total lifeway, but by special interests.

One such group that folklorists study is that united by occupation. Taking a job in a factory, a man may do more than labor. He may participate in a tradition of the workplace that partially shapes his identity. Factory workers have folklore, characteristic expressions of their group's unity. So do secretaries and cowboys and artists. Since artists by virtue of dress, conduct, and work are not bankers—artists are specifically set outside the rules of etiquette —they might be envisioned as rebelling against society. But their rebellion is a request to be accepted as a member of a small group within which outrageous paintings are artistic communications—that is to say, folk art. It is a matter of perspective. From the angle of the artist's mother, the act is strange and painful. From the angle of the artist's group, the act is splendid affirmation. James Joyce among his friends at Paris and Wassily Kandinsky within the Blue Rider were members of groups whose values they shaped into art.

Classically, folk art is an individual's expression of the values of the community into which the artist was born, while fine art is an individual's expression of the values of a group the artist has chosen to join. The shift in experience from community to elective association is one profound change in our social history, but art weathered that change just as people did: shaken, confused, thrilled by hope. So, taken alone, the contrast of community and group helps us none in separating folk art from fine art, for fine art is, like the cowboy's braided rawhide or the whaleman's scrimshaw or the professor's lecture, an expression of the traditions of an occupational group. But let us isolate the artist's orientation away from the culture of birth and toward a special group of peers, then connect it with the artist's rebellion within tradition that creates novelties as signs of personal achievement, and we are ready to enter art history.

Tempered rebellion is the dynamic of art history. To tell their tale, art historians require artifacts that display patterns of change so that they can be arranged into narrative order. Change needs cause, and the agent of the art historian's story is the exceptional

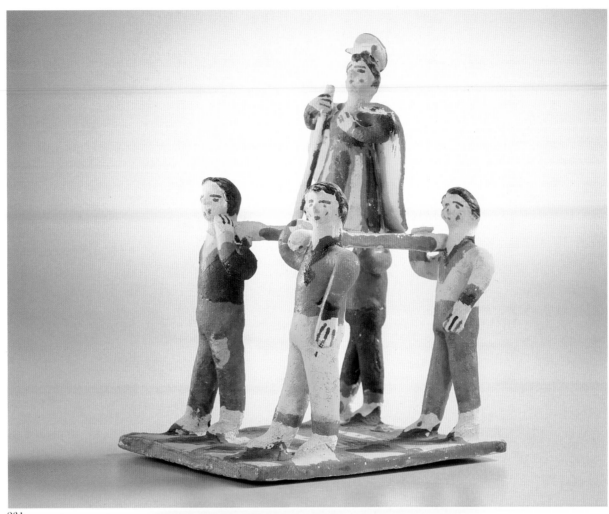

231

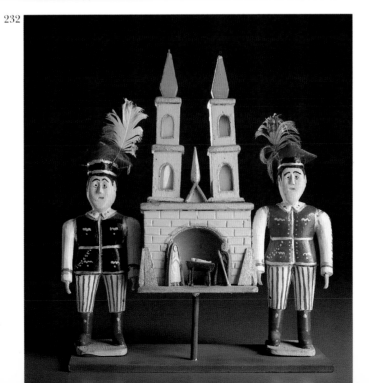

232

231. *Men Carrying a
Saint. Rabinal, Baja
Verapaz, Guatemala.
Painted earthenware,
7" high, c. 1965*

232. *Carolers with
Szopka. By Feliz
Czajowski. Kraków,
Poland. Painted wood,
10¼" high, c. 1960.
Bearing a szopka, a model
church, carolers go from
house to house at Christmas,
singing and offering best
wishes for the new year.*

233. Qolla *Dancers. By Santiago Rojas. Cuzco, Cuzco, Peru. Painted cactus wood, 8¹/2″ high, c. 1958. During the festival at Paucartambo, men dress as* qollas, *ancient traders. With them comes Emilia the shepherdess, played by a boy.*

234. *Dancing Couple and Musicians. Poland. Wood, 11¹/2″ high, c. 1960*

235. *Festival Scene. Ocumicho, Michoacán, Mexico. Painted earthenware, 9¹/4″ high, c. 1970. The Tarascan Indian village of Ocumicho has become famous for its figurative ceramics; this scene depicts a celebration featuring masked* negrito *dancers.*

236. *Dancing Couple. By Lauro Ezequiel. Caruaru, Pernambuco, Brazil. Earthenware, 5¹/4″ high, c. 1959*

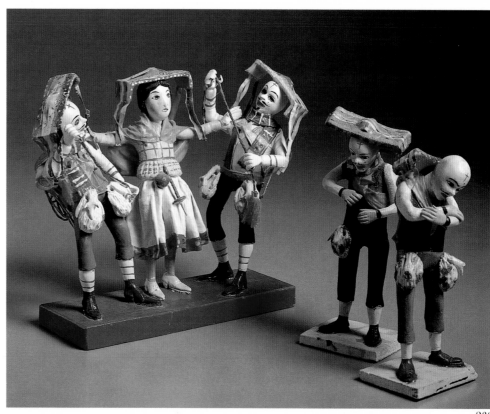

233

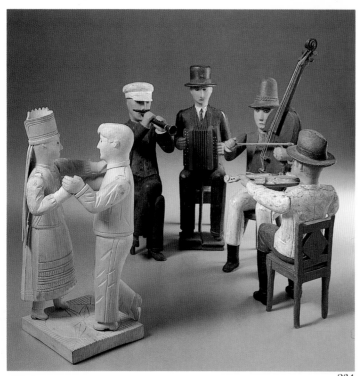

234

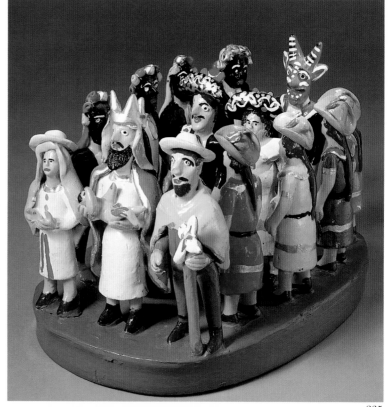

235

individual who generates novelties that bear clear relations to past artistic practice. The novelty inspires imitators who understand how their tradition has been stretched, who assemble around it and begin confecting the objects out of which a progressive sequence can be constructed.

History is not the past. It is a story told about the past that is useful in the present. To tell the story of art, we project our values upon the past and gather out of it the works that are useful to us, works that talk to us about our interest in personal power (as opposed, say, to communal power or sacred power). They help us think about our development and our conditions and our potential. Our acts of appropriation and narration guide our understanding and undergird the art market, with which art history exists in a productive, interdependent relation. But acting responsibly to serve our little group, we act irresponsibly toward history. The truly global history we need in these times eludes us. Our fascination with celebrities and novelties distorts the tale of what happened in history, especially as we press earlier than the Renaissance or farther than Europe. More shamefully, our history leaves most art out of account.

We close in upon folk art by noting that it is art left out of the story. An early motive of folklorists was to compensate for neglect. They went into the field to gather examples of literature that had been left out of the anthologies: the ballads and wonder tales of Europe, the myths of Africa and Native America. Not all neglected literature was thought to be folklore. Only the virtuous drew the collector, and folklore's virtue was tradition. Tradition swallowed the individual, embraced the collective, and stood courageously outside of time. In literary history and art history, the emphasis is on exceptional individuals and patterns of change. Folklore and folk art assimilate but poorly to history, being marked by the communal and the unchanging.

That contrast, which directed the scholars of the last century into their definition of folklore, contains some truth and much difficulty. One problem is that most of what we call fine art is not the novel product of exceptional individuals. It is the workman-like product of the multitudes of followers who, exactly like artists in traditional communities, organize themselves in groups around models and find room for personal expression within fundamentally repetitive performances. Most fine art is more traditional than individual, more stabilizing than progressive.

The second problem is that folk art also follows lines of historical development. One historical pattern is progressive, even if its motion is distinctly more gradual than the motion described by art historians. Slowly Mexican artists absorb more secular subjects, more illusionistic detail, and press their clay figures gently through stylistic changes. More often, the developmental pattern in folk art is unlike that used by art historians to tell their tale. In one common pattern, long periods of near stability are followed by a violent reordering during which the tradition is recentered. Another long period of stability follows. In this, folk art does not conform to the pattern of constant reorganization, borrowed out of political history for use in art history. It approximates the pattern of economic history described by Fernand Braudel.

Vernacular architecture studies offer good models to students of folk art. For long stretches, builders in traditional communities adhere to one basic house form, varying it constantly to suit individual needs, but leaving its fundamental order unaltered. Then social changes, following upon economic changes, cause builders to rethink their concept com-

Opposite
237. *Skeleton Orchestra. State of Mexico, Mexico. Painted plaster, wire, 8¼" high (on average), c. 1956*

[*218*]

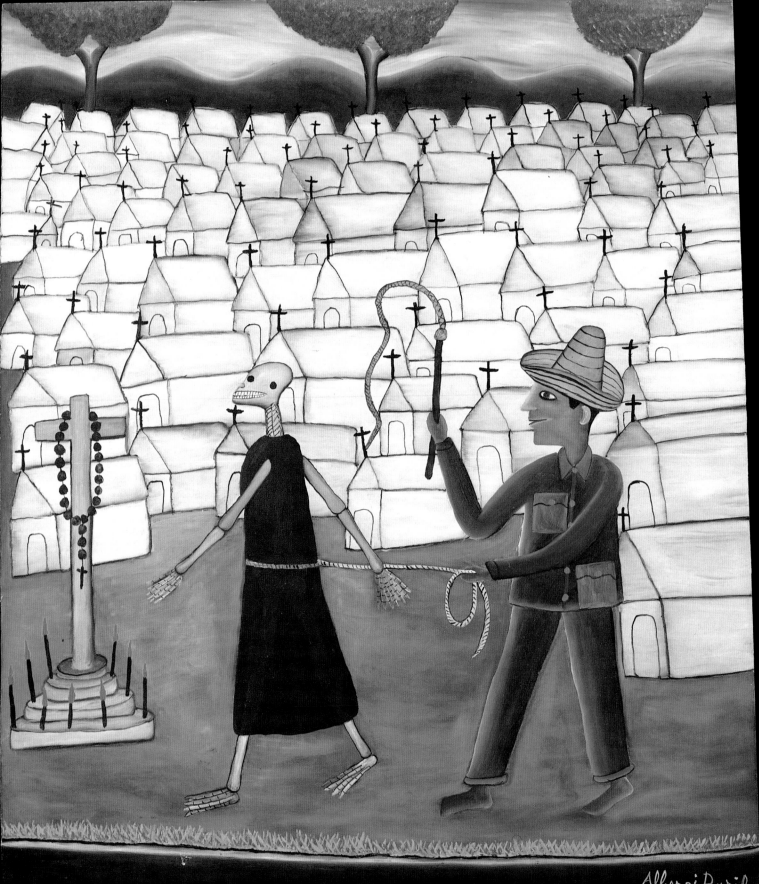

Alberoi Bazile
le 29/5/67

239

240

pletely. They invent a radically new form which then holds for another long period.

Other arts in the same communities often follow the same course. Germans in Pennsylvania shaped their tradition initially by selecting and developing certain Old World ideas. They chose a house out of their architectural repertory and they came to decorate their plates and chests with lilies and tulips, birds and prancing deer. Three generations pass.

Nineteenth-century Pennsylvania German house, Schaefferstown, Pennsylvania

Suddenly their house is reshaped, flowers and birds disappear. Thinking that folk culture lacks history, we might ignore that change and characterize the Pennsylvania Germans of all times by the art of the later eighteenth and earlier nineteenth century. Or we might call the change death. In reality, what people did was reorder their culture to meet a new age with a new form of house and a new kind of unornamented tool-like art. Artifacts tell us plainly that about 1830 the Pennsylvania Germans endured a convulsive change, analogous to that of the Danes at the same time, the English a century earlier, the Irish seventy years later.

Another distinct historical pattern in folk art is recursive. The potters of Acoma and the potters of Kütahya have returned again and again during their history to antique models, readjusting their tradition through revivals. What looks from a distance like simple continuity appears close up to be a series of revolutions fought and won in the name of tradition. Since we know most about the most recent revival, we are tempted to describe a recursive historical pattern as though it amounted to a long period of slow decline followed by a bright moment of revitalization. In fact, the history of folk art is less a matter of stability than it is of constant revival. Today the ceramic tradition of Kütahya exists in an excited state. The young masters are battling the decay of the recent past by learning from the works of the far past. But the old men will tell you there was a comparable revival in the 1920s and one in the 1890s. Artifacts will tell you there was one in the 1730s. Lacking knowledge of early revivals, we are led to describe as continuous a pattern that is, in reality, recursive.

The ahistorical view of folk art is a selective and distanced one. If we knew as little about the history of fine art as we do about the history of folk art, and if we adopted the same long view of it, things would seem less different. We would concentrate on the remarkable continuity of certain genres like the landscape. It is not a longer step from Constable to Welliver than it is from the saints carved in New Mexico in Constable's time to the saints carved there in Welliver's time. We would see the gradual rise to illusionism, from Giotto to Estes, as the slow development of a tradition. We would be no more able to distinguish among the French Impressionists than we would among the painters of Mexican retablos. We would see modern art as a sequence of revivals.

Looking at folk art from afar, we lose its delicate development into its stability. Assuming all history conforms to the ancient Greek theory of progress, we miss the historical patterns that typify conservative traditions. Folk art displays long periods of stability punctuated by instants of massive creative activity. Focusing on the times of stability, ignoring the times of change, we come to feel folk art lacks history. Calling continuous a pattern of tortured recursion, we miss the major dynamic of folk artistic history.

The tendencies we have isolated during our search for its spirit tell us why folk art is

241. *The Jagannatha Deities. Puri, Orissa, India. Painted cloth, 17 x 20¾", c. 1960. One of the many mementos made for pilgrims to the Hindu temple at Puri, this* pat *is a diagram of the temple; it shows Jagannatha, Balarama, Subhadra, and associated myths and rituals.*

242. *Crucifixion* Mola. *Kuna people, San Blas Islands, Panama. Appliquéd, embroidered cotton, 15 x 18¾", c. 1960*

241

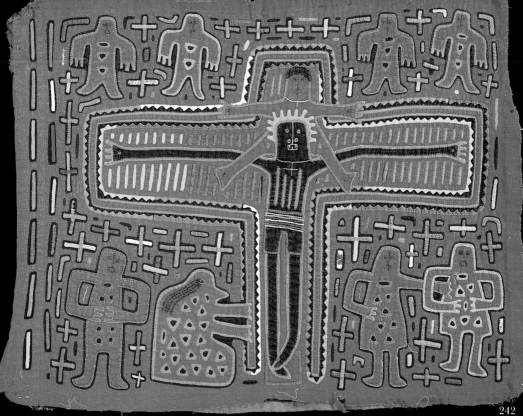

242

243. *Bag (detail). Probably Macedonia. Embroidered silk on cotton, 10 x 12",* c. 1920

Right
244. Toran. *Saurashtra, Gujarat, India. Embroidered mirrorwork, silk on silk and cotton, 28¹/₄ x 52¹/₂", late nineteenth century. The* toran *is hung above the door on ceremonial occasions as a sign of welcome. The top panel of this* toran *is the work of the Mahajan people, while the lower tabs were embroidered by Mochi leatherworkers.*

243

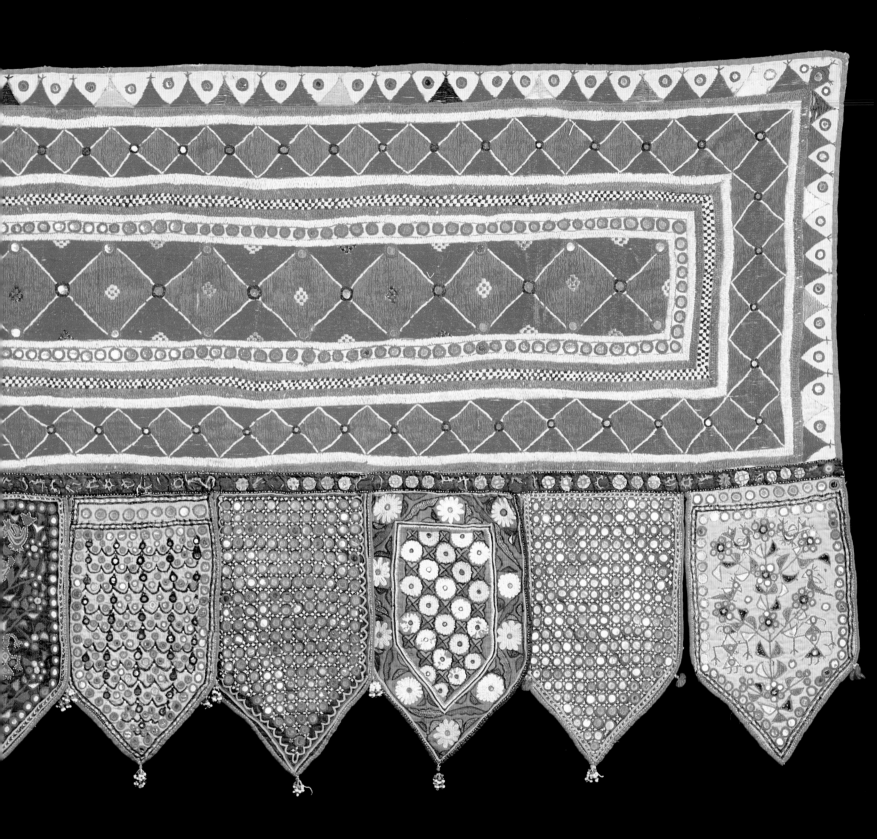

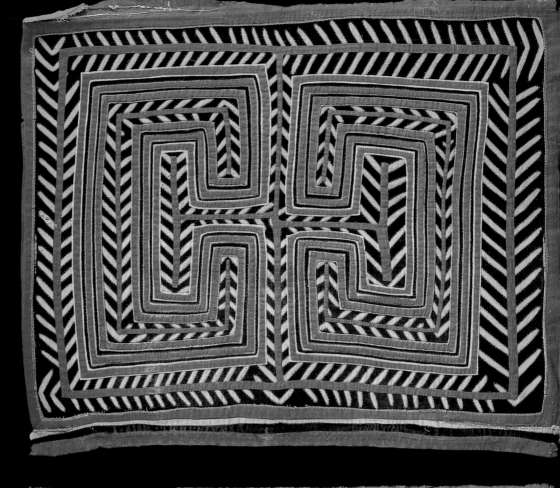

245. Mola. *Kuna people, San Blas Islands, Panama. Appliquéd cotton, 18 x 22 1/2", c. 1960. A pair of molas are sewn into a single blouse—one on the front, one on the back— which, with a headscarf and wraparound skirt, forms the distinctive dress of Kuna women.*

246. Mola. *Kuna people, San Blas Islands, Panama. Appliquéd cotton, 17 x 22 1/8", c. 1960. At once, the mola is an expression of artistry and, being made mostly now for export, an economic asset.*

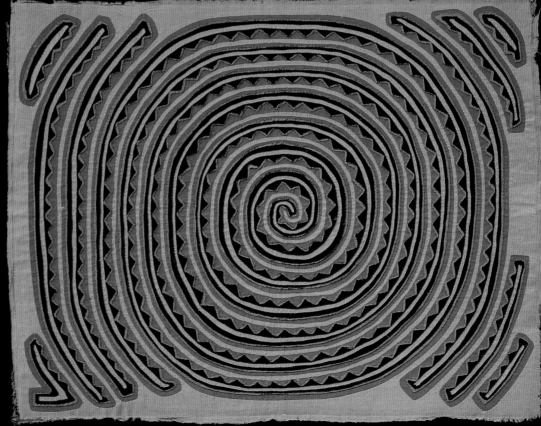

not part of art history. It does not fit. Rather than interrupting the story and beginning to make additions that would lead to scrapping the whole and starting anew, art historians leave folk art to other scholars. I summarize: by contrast to fine art, folk art is less formal in education; in appearance it is more abstract, in essence more spiritual, in orientation more communal. As a consequence, its practitioners are less wealthy, its history is more recursive than progressive. The ideal context for folk art is the agricultural village, prosperous enough to have material reserves, large enough to contain craft specialization, small enough to be experienced directly and to be governed by religious tradition.

This set of dichotomies might help us make sense of our customary distinction between folk art and fine art: rural, urban; communal, individualistic; homogeneous, heterogeneous; poor, rich; stable, changing; recursive, progressive; sacred, secular; spiritual, materialist; abstract, realistic; conceptual, sensual; informal, formal. However, these are but slight tendencies in mixed realities. If you try to shape them into definitions, you will find the generalizations becoming swamped by exceptions. Folk art is rural, but it is also urban. It is communal, but it is also individualistic. It enfolds richly all the traits that counter the traits with which it is identified. If you ignore the exceptions and hold to a definition derived from those contrastive pairs, your rigorous work will not return to you the distinction you assume between folk and fine art. Most fine art will be folk art. More important, you would be doing violence to art's reality. It is the purpose of art to be impure, to blend categories, to overturn them and erase distinctions, to disturb simple thought and move the mind behind the senses into a totalizing experience.

That does not mean that folk art cannot be defined. But all definitions of folk art overlap with fine art. Fine art, like folk art, comprises the key media of groups bound by identity; it is at once traditional and variable; and it arises as artistic communication in small groups. Maybe the greatest hindrance to understanding folk art is the assumption that it must be something other than fine art. But there is no definition of fine art. It consists of a historical accumulation of objects diverse in kind. Defining something that must be defined as different from something that has not been defined—that is a task out of a nightmare: impossible. If a definition of art were derived from the objects customarily included in the art historian's narrative, it would apply to folk art, just as all carefully constructed definitions of folk art apply to fine art.

How, then, do we distinguish so easily between them? In this way. Surveying the vast expanse of art, we claim some of it as ours. Out of that which appeals to us because it helps us understand ourselves (as opposed to that which helps us understand other people), we create a genealogy for ourselves and teach it in art history books and art appreciation classes. Simply, fine art is our art. Folk art is their art.

To keep fine art and folk art separate, we look at them from different points of view. We look at our art from the inside, so it is the product of human beings like ourselves, of individuals who intend their actions and create history. We look at folk art from the outside as though it were the product of less-than-human beings, of animals compelled by forces beyond their control into unintended, instinctual behaviors that yield no proper history.

The traits customarily used to characterize folk art—the absence of education, individuality, sophistication, and will—all derive from the adoption of an external point of view. We begin by assuming our way to be normal. Other people, those in the past and those in other places, are viewed as though they were struggling to become us, sometimes succeeding

—anticipating or echoing precociously—usually failing. From that firm position, we look over at folk art and describe it as a poor version of our accomplishment. We say folk art is the product of uneducated people, when it is the product of people educated differently from the way we are. We say folk art is naive, assuming folk artists are trying to meet our standards, and particularly our ideal of illusionism, when they are trying to meet standards of their own. We say folk art is anonymous, meaning only that we are so distanced from the people who make it that we do not know their names. We say folk art has no history because its historical patterns are unlike those we expect.

The difference between folk and fine art is more a matter of academic convention, of differences in scholarly traditions of discourse and approach, than it is a difference in phenomena. Thinking positively about our culture, positioning ourselves firmly within it and knowing little about folk artists and their worlds, we demean folk art as the dull result of inertia or as the happy innocence of unimportant people. Thinking negatively about our culture, positioning ourselves outside of it and knowing little about fine artists and their worlds, we demean fine art as adolescent extravagance or snobbish decadence. If scholars could strip away their prejudices and learn to approach all art in the same mood of disciplined compassion, they would learn that it is all competent, that it all blends the individualistic and the traditional, the sensual and the conceptual, that it is all historical, the product of human beings who live in societies beset by problems conquered by fun and serious work.

Come to folk art in the same inquisitive, respectful spirit you adopt before fine art. You will discover in it distinct tendencies that rise deeply from within cultures unlike our own. Art differs as cultures differ, but as for definitions, you will be left with this and not more. Folk art is the fine art of other people. Fine art is our folk art.

Folk Art and Popular Art

Art's deep unity is what makes it so valuable to the historian or the folklorist. Because all art contains and so bodies forth the individual and collective, feeling and idea, because it is historical, it teaches us directly of the cultures of different times and places. As the incarnation of the excellence of particular cultures, art is the ideal resource for the person who would understand human unity and diversity.

During our comparison of folk and fine art, art pulled toward unity, but the cultures that give rise to art moved apart. They did not separate perfectly because cultures are impure. There is no such thing precisely as a folk culture. The culture that contains the sacred and communal impulses that we associate with folk art will contain as well the secular and individualistic impulses that we associate with fine art. Still, all cultures develop characteristic mixtures of universal traits, emphasizing some, de-emphasizing others, and as our culture has consolidated increasingly around a secular and individualistic set of values, we have been fortunate that folk art exists to teach us about cultures unlike ours, to remind us of alternatives. Through folk art we can move toward knowledge of the dominant experience of humankind, which is, despite our natural feelings to the contrary, not our own.

Two comparisons remain to be made. Our understanding will be further refined by comparing folk art with "primitive art" and "popular art."

Until recently in our history (as is still the case among many of the world's nations that are culturally more coherent than our own) popular art and folk art were synonyms. In the

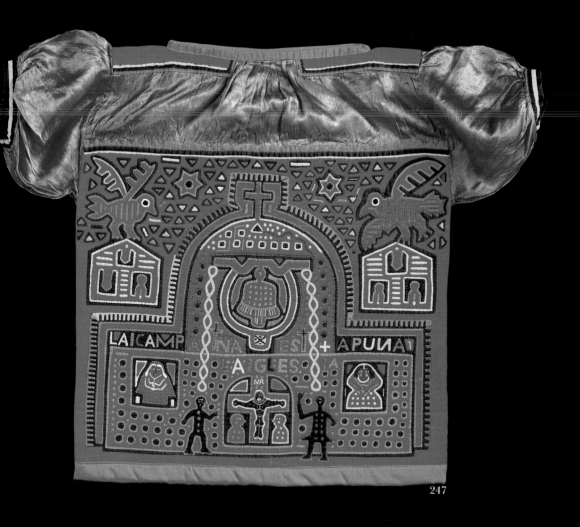

247

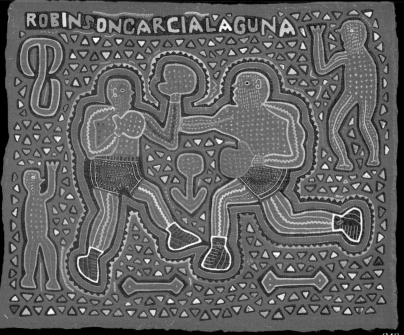

248

247. Mola: *The Bell Is Placed in the Church. Kuna people, San Blas Islands, Panama. Appliquéd, embroidered cotton and synthetic fabrics 20¹/₄ x 27⁷/₈", c. 1960. This commemorative* mola *illustrates the way the* mola *appears as a blouse panel and the way old techniques are adapted to figurative ends.*

248. Mola: *Robinson Garcia Laguna. Kuna people, San Blas Islands, Panama. Appliquéd, embroidered cotton, 15¹/₄ x 19¹/₄", c. 1955. This* mola *seems to reinterpret a news clipping about Sugar Ray Robinson in order to depict the Panamanian boxer Laguna and his opponent, Garcia.*

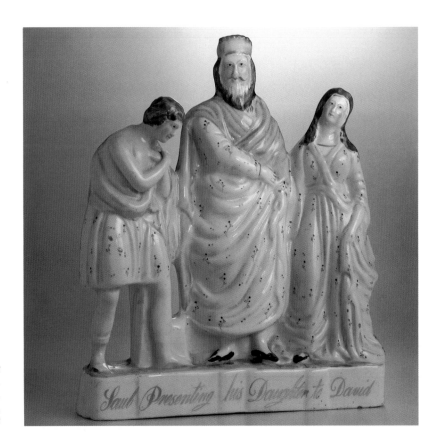

249. *Saul Presenting His Daughter to David. Staffordshire, England. Glazed earthenware, 10¼" high, c. 1860*

250. *Turkey England France. Staffordshire, England. Glazed earthenware, 10⅞" high, c. 1854. Derived from a medal struck at Paris to commemorate the alliance of Abdülmecid, Victoria, and Louis Napoleon, this is one of many figures from the Crimean War.*

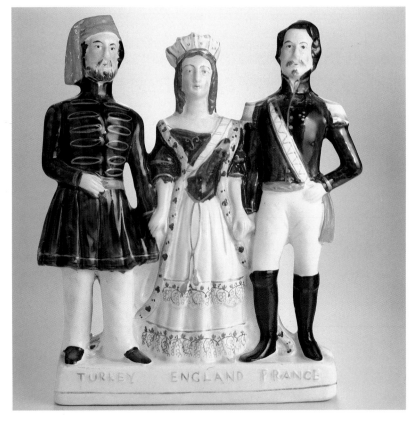

United States, the term "popular art" has been used increasingly to designate phenomena that contrast with folk art, phenomena typical of an age of mass production, mass communication, and alienation. Let us begin with a real scene in which the folk artistic ideal is met.

An evening soft as rose petals descends on the village of Kagajee Para beside the Bangshai River in Bangladesh. Children returning from school wait on the riverbank for the ferryman to steer his boat from the other side. Fields of rice in every shade of green fan away from the village and fade with the day. Smoke from big kilns filters through the village, where women sit among thousands of round water jars stacked like cannonballs. They mold clay over forms for the bottoms, then build the tops and coil the rims of the big jars, turning them by hand on plates placed upon the cool clay at their feet. There are 61,000 villages in Bangladesh, and this is one of the 680 given to the manufacture of pottery.

Shadowed by smoke, the pink sky dims and darkens until the lone light is a fire in front of a house of bamboo and cane at the edge of the village. There the master Ananta Pal is seated on the earth painting small figures of the goddess Saraswati. Around him squat men waiting to buy the statues they will place tomorrow on altars for Saraswatipuja, the festival of the goddess. It is full dark. The men do not talk, but watch closely as the master swiftly, deftly adds color and glitter to the images he has molded out of potter's clay. In the house behind him crowd large statues, dressed resplendently in cloth, made for groups who will build public altars. The small ones he finishes by the fire's flicker will command the center of domestic worship.

Tomorrow at dusk, having been ritually invested with breath and welcomed as a revered guest with food and flowers, Saraswati will stand, garlanded, amid green plants and piles of books, on an altar sheltered by pale cloth. She is the daughter of the great goddess Durga, slayer of the buffalo demon, and she is the goddess of the intellect. Saraswati rises from a lotus, bearing a musical instrument, symbol of intellectual attainment. Her sister Lakshmi is the goddess of earthly bounty and success. They are rivals, venerated by different people, which is why, I am told, the intelligent are always poor, the rich are always stupid. Those who want Saraswati's blessing tomorrow will enter her tent at the temple, or they will come to her canopied altar in the house yard, strung with red lights, and receive the sweet cakes prepared for her. Eating with the divine guest, they will consume materially as they hope to consume spiritually. In a place prepared for the union of the world and the cosmos, isolated by drumming and sweet incense and the presence of the goddess in clay, her devotees will exchange veneration for blessing. Later her image will be placed in running water to be washed back into the universe.

Saraswati on a domestic altar for Saraswatipuja, Dhakeshwari, Dhaka, Bangladesh

Ananta Pal's image of Saraswati unifies completely these aspects of all artifacts: design, making, and use. That is the folk artistic ideal. Its disruption raises the need for a term to cover situations in which design separates from making or making separates from use.

Though design and manufacture ideally unify in folk art, division of labor is not unusual. Today the traditional potter in the United States, a man like Burlon Craig, might dig and wedge his own clay, turn his own ware, burn and sell it. That was not the case in Mr. Craig's youth, when things were more like they are in other places. In Wales or Turkey,

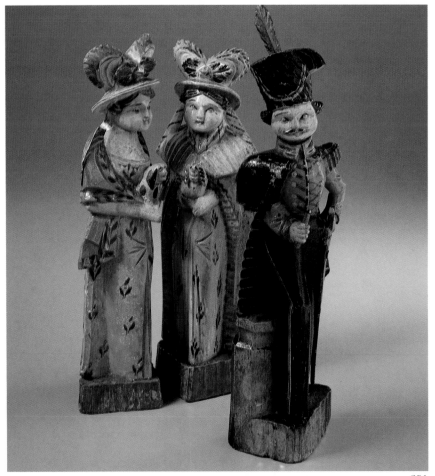

251

251. Dury. *Noginsk, U.S.S.R. Painted wood, male 16½" high, late nineteenth century. Dury lampooned the Russian aristocracy.*

252. *Cardinal Rising from Fruit. San Pedro Tlaquepaque, Jalisco, Mexico. Painted earthenware, 2⅞" high, c. 1970. This was probably made in the Panduro family atelier, though such "fruits with elves" were also made by Maximillano Anguiano in Tlaquepaque.*

Far right

253. *Hand Puppets. Western Europe. Painted wood, 16" high (on average), late nineteenth–early twentieth century*

252

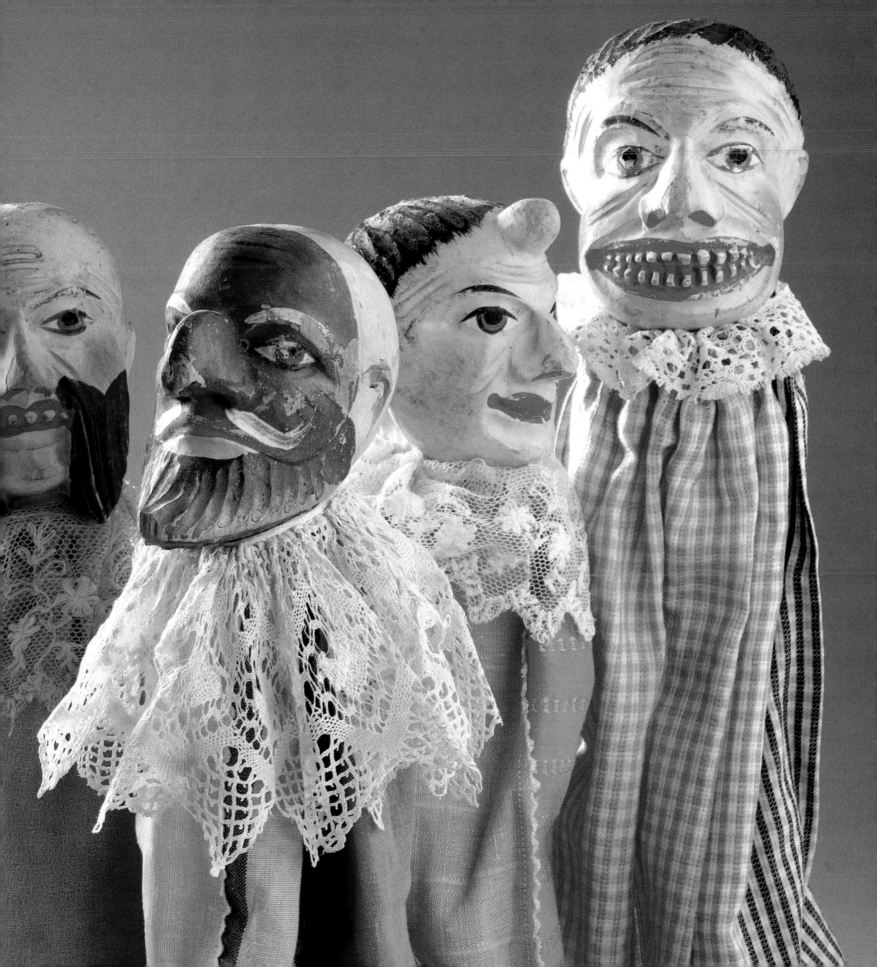

Australia or Japan, the potter works in a team. There is one person to process materials, another to shape vessels, others perhaps to paint and glaze, to load and fire the kiln. One person does not control the whole procedure, but the master controls the key step in which design and manufacture blend: the shaping of vessels. In large ateliers, such as those of Kütahya, the master designs and executes the exceptional piece, but common ware is designed by the master and made by another. They remain in close contact, so the result will meet the master's standards for normal work, but space has opened in the process that can lead, as the Kütahya masters will tell you, to a decline in quality, to things less than art.

In the potteries of nineteenth-century Staffordshire, the designer—the "modeller" —created the prototype, but others, often children at hard labor, molded, joined, and painted the figures. The potential for individual creativity was not eliminated from manufacture; different versions of the same figure vary in vitality. But the individual was tightly confined by designs, as painters of tiles in Kütahya are. If we take this process farther and imagine the master's design repetitively stamped out by a machine, we watch the maker's individuality vanish. The worker need not become embittered as a result. Some industrial laborers enjoy making the machine run smoothly and take pride in their contribution to the final product. But the industrial artifact is a new thing. Having lost art from its making, the thing itself is not art, but it can be to art as a photograph of a painting is to a painting. Being a representation of its design, the industrial object can be a vehicle for communication about art between designers and those they wish to contact.

The designer of Staffordshire figures drew his concept out of his education in the potteries and his experience as a member of a society shifting between sacred and secular orientations in a time of expanding prosperity. Since his customers shared his culture, he could reach them in chimney ornaments that bore traces of spiritual style within secular topics, that were his in design but not manufacture. Connections were made despite the worker.

Workers aid the art of the industrial object by their absence, by the suppression of their innate creative spirit. The industrial ideal is met as the worker's presence is erased, as mechanization increases, as the original design is more and more perfectly realized in replication. Making disappears from consideration, except as it appears negatively in "human error" (as though there were some other kind), and an object becomes excellent insofar as it expresses its design. It follows that design as a concept would become, as it has in our day, more and more important, and that the makers of things would lose significance, descending in status and esteem, to be left with wages for consolation.

Stripped of the workmanship that signals individual excellence among craftsmen, most industrial artifacts bear no relation to art. But if their designers and users find them aesthetic and if they read out of them ideas of importance, then, even if their makers hate them, they can be media for communication, much as phonograph recordings are vehicles for musical performances.

Such objects might be called popular art. But the recording is not art. The maker of the record is good to the degree that as a technician he has become an invisible conduit for the art of the symphony or the fiddle tune. The record is a representation of the art that the audience receives despite the record. Popular art is not art. It is a channel through which fine art or folk art flows from designers to consumers. The process has become complicated. Instead of a chisel or a brush, the designer uses people who use machines to draw out of a

massive public a small group who understand his effort. Others might buy it without understanding completely. For them, it may be popular, but it is not art. Within the knowing group, the industrial artifact is a message from the designer.

Offered directly to no one, searching through the world (like a poem by a dead author) for people who will understand it and use it well, the mass-produced artifact leads us into the more crucial realm of disruption in the folk artistic ideal: the separation of art from use.

Art is developed to use. The icon is to venerate, the amulet is to thwart witchcraft, the jug is to carry water. Art unifies its creators and possessors in assumptions about function. Marcel Duchamp commented on those assumptions by bringing a urinal into a gallery, by suggesting the *Mona Lisa* be used as an ironing board.

Normally the artist at work is guided by notions of use, but changes can leave artists without others who know how to use their works. When that happens, when art is no longer shaped by active exchange between creators and patrons, it becomes dependent entirely upon the artist's personal integrity.

Willie Seaweed, great artist of the Kwakiutl, carved and painted masks for his neighbors to use in profound ceremonial dances. He made, too, a few pieces for tourists. He could have cut corners, producing things less than art, but he did not. His masks and miniature totem poles made for outsiders were as fine and full as those he made for use in his community, though presumably the outsiders would use them for mere decoration. Mr. Seaweed avoided the great danger faced by artists who produce for the unknowing: the descent to prettiness. Realizing that others will not understand completely, that they will not use the piece in accord with the norms built into its fabric, artists can be tempted to deliver less, meeting a reduction in function with a reduction in quality, creating things that are pretty but insignificant.

Hispanic carvers in New Mexico tell me that few of their customers are Hispanic. Their carved saints will become bits of decor in the homes of wealthy infidels. It is a tribute to the integrity of the best carvers that, despite their customers, they continue to shape figures of implicit power which, like Ananta Pal's images of Saraswati, could be brought into real power through blessing and adoration.

When the need for utilitarian pottery in the North Carolina Piedmont had neared its end and a tradition stretching back through the colonial period to Staffordshire and the Rhineland lay in peril, outsiders intruded and built a new market for the noble old ware. Jugtown became a center of regional revitalization. The master there, Vernon Owens, does not ask whether or not his customers will use his pitchers and jugs. He will not sell handsome but unsound pieces. He offers only those that could be used, that continue to bear the power of utility abiding in the plain style of the people of the word—the utility that is to usefulness as beauty is to prettiness.

Vernon Owens, Jugtown, North Carolina

A lack of deep connection between makers and users will drive artists into reliance upon a personal set of standards, making them into isolated and heroic custodians of tradition. It will inspire others to produce diminished objects that are not art but devices for the extraction of cash. In the extreme case there is not even a distanced user.

Lou Sesher spent a lifetime on the rivers of the Ohio and Mississippi system, rising from deckhand to engineer. When he retired he kept in touch by going down to Chuck McCarthy's bar by the Monongahela River, swapping lies with the other old rivermen and greeting the boats that passed in the night with tiny flares made out of matches. During his days he recalled his life by painting river scenes on the insides of window blinds and building boat models. His father had designed riverboats, and Mr. Sesher found his old tools— knives, a rasp, and a drawshave—and began making models of his father's boats and the boats he remembered from his youth: *The Queen City, Vulcan, The Bostona.* For his father, models were necessary. He used them to sell financiers on the idea of manufacture, and he shaped their hulls so precisely that lines could be drawn off them while the boat was being built. But for Mr. Sesher there was no practical need. He made them for his own pleasure.

Lou Sesher's models won blue ribbons in Golden Age Club competitions. In that context, they were some old guy's hobby. Their excellence attracted his neighbor, Walt Hudson, and Walt learned Lou's style, making boats of his own. Together they shaped a two-man school of art. From Mr. Sesher's father in Kentucky to his neighbor in Lock Four, Pennsylvania, Mr. Sesher's boats carry the story of a little tradition. But we have not yet met their significance.

Lou Sesher,
North Charleroi,
Pennsylvania

Once Mr. Sesher and I were together in Washington and we went to the Smithsonian, where we saw impeccable scale models of riverboats. "Hell," he said, "anybody can make a boat that looks like a boat." He pointed at the rails along the deck on the museum's models. They were really that small, he said, but if you were in a storm on the river, you wanted them thick, so he made them thick. The boats carried livestock in quantity, but why make many small horses, he asked, when a couple of enormous ones gets the idea better? The museum's models looked like riverboats, but he made things that felt like boats, that captured the truth experienced by men whose lives passed aboard them.

Building his boats, not boat models but boat sculpture, Lou Sesher made connections. The connections were not those of the world, made among real people, the connections effected by his father's models. They were abstract connections built in the mind. Like the art of painters whose works link less to live others than to the heroes of art history, like the soaring tune of the aged fiddler playing his heart out for his dead daddy, Lou Sesher's wonderful boats confronted the reality of an age of aloneness and beat aloneness through the construction of an inner world of association.

Mr. Sesher's boats were communications with himself about himself. Their power lay in that tight circle, but as palpable memories, dreams realized in materials, they bore the potential for making connections with others.

At one extreme, we find Lou Sesher's boats, private and meditative creations. At the other extreme stand Ananta Pal's figures of Saraswati, contributions to public ritual. Between lies the norm of contemporary production in nations like the United States where artifacts are characterized by their double nature. This doubleness has been shaped into an ideology among creators of "popular art," such as the postmodern architects. Through a single work they communicate with two groups. One is a small group of cognoscenti who

254. Musicians. By Zofia
Wiankowska. Niespusza
Nowa, Łowicz, Poland.
Cut paper, 9³/₄ x 19⁷/₈",
dated 1962

255. Domestic Scene. By
Jadwiga Łukawska.
Łowicz, Poland. Cut paper,
9³/₄ x 19³/₄", c. 1962

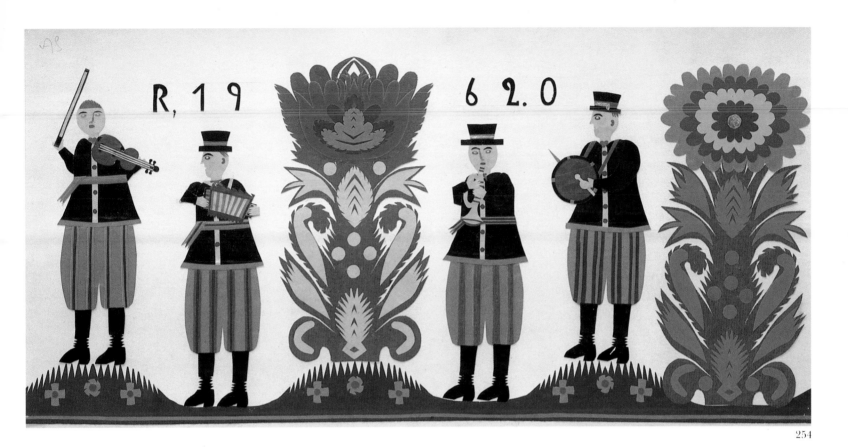

254

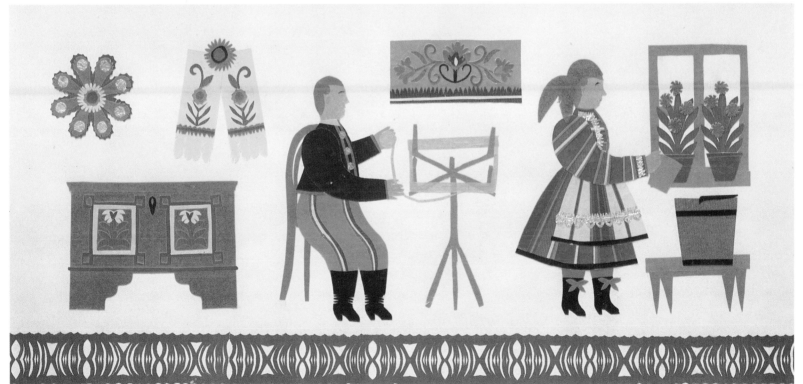

255

understand their wit, their irony, their references, and take the work as fine art. The other is larger. Its members miss the density and subtlety of the work. For them, it is not art but fashion. The same thing is true for folk artists. They create one thing that stimulates two responses. Some understand its utility, its significance and power. For them, it is folk art. For others it is not art; it is a fetching, whimsical thing, pretty but not disturbingly important.

Artifacts double in nature typify our age. They seem new, in need of a special name, but what is new is the increased complexity in the field of response. The thing that is art to some people is not art to others. What has changed is the proportion of these two groups.

The norm for art, folk or fine, is a small group within which the artist's intentions and the patron's reactions mesh coherently. But there are always grades of knowledge and response. There are some who know more, some who understand less, even in the tightest traditional community. And, being material—lasting and transportable—every work of art is potentially double; it might fall in among outsiders.

Ordinarily insiders outnumber outsiders. In the United States now, that is reversed. Outsiders outnumber insiders. Mass production, mass communication, and vast systems of quick transport get things to people who do not fully understand them. The majority of the folk artist's customers, like the majority of the consumers of the artifactual projections of the designer's idea, do not belong to the artist's small group.

The shift in patronage from insider to outsider might be interpreted as marking the birth of wicked commercial motives. But only the rich can afford to hold to the ideal of an amateur, profit-free art. Folk art, the serious and resplendent work of people mired in the world, has always been commercial. Where tribal societies met, tribes often specialized in certain products that they exchanged with others. Villages also specialize, producing things to sell to other villages and to people in cities. A kind of splashily, happily decorated pottery is made in the village of Kınık in northwestern Anatolia, then shipped out for sale in urban markets throughout Turkey. There is nothing new in this. Rugs have been woven for commercial purposes in western Turkey for centuries. They came off the looms in 1500 and ended up on the floors of the mosques of great cities and on the tables of aristocrats in Italy and England. Today rugs in the same designs and techniques come off looms of the same kind to be offered for sale in shops in Izmir, Brussels, and Philadelphia. As cities swell in size and increase in number, we allow ourselves to associate cities with modernity, but the city is an ancient institution. For thousands of years cities have included, as Istanbul still does, districts where craftsmen jostle and compete, selling their traditional art to any and all who come. And they come not only from the city's neighborhoods and the surrounding countryside; they come great distances, from far foreign nations. It has been like that for time past history.

Ibrahim Erdeyer and Mehmet Gürsoy, master potters, Kütahya, Turkey

People make things for themselves, especially on the wild mountainside and the far frontiers, but the best artists, folk or fine, have been professionals who made things for economic exchange. If that is not quite so for folk musicians in the West, it is true for folk musicians in much of the world, and it is generally true for folk sculptors and potters and weavers. The Kütahya masters, like Mehmet Gürsoy, say the main reason for their art is their inner passion, but their secondary goal is making a comfortable living. That arrangement of values, essential to

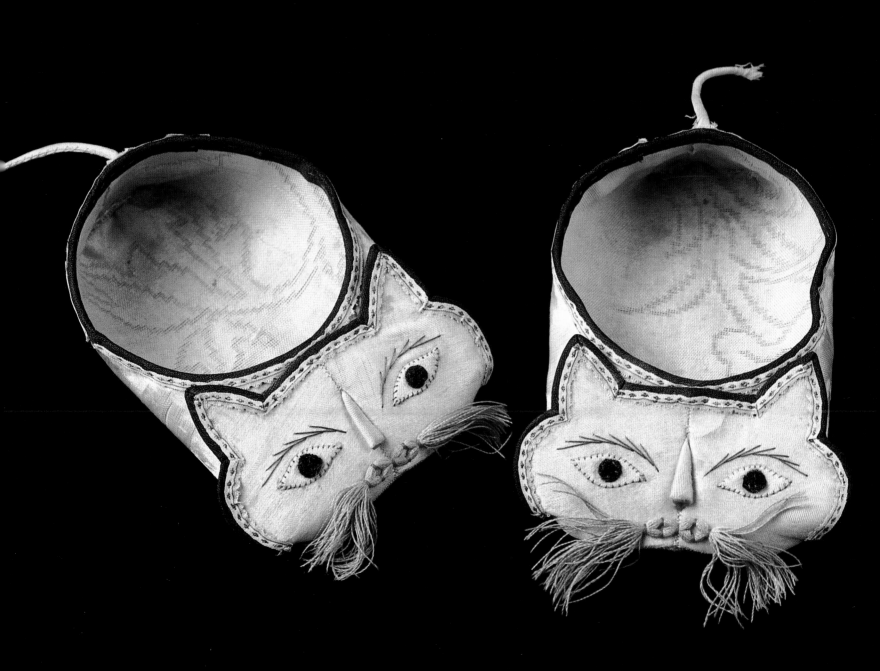

the preservation of art, is easily upset, especially when makers sell to customers unable to recognize the qualities of an artistic tradition. But, as Willie Seaweed and Vernon Owens teach, that is not inevitable. Rather than descending into commercial prettiness, artists bravely hold to tradition. Then having met their personal standards, having suffused their work with love, they can release it into the world—as the industrial designer does—hoping it will find someone who can appreciate it, but having satisfied themselves enough during the act of creation.

Helen Cordero of Cochiti speaks for the artist in modern times when, wondering at the popularity of her storytellers, she says that maybe people like them because they "aren't just pretty things that I make for money." Her work, she says, comes out of her heart.

In a few big industrial nations, the norm has ceased being a community within which artist and patron meet as they do by the fire in Ananta Pal's Kagajee Para. Now art is an offering into the world through which the artist may or may not touch others. If many of those others are but buyers of curios and commodities, there are some who, though no part of the artist's native community, can be so moved by the inherent excellence of a work that they are called into personal association with the artist, as Walt Hudson was called by Lou Sesher's boats, as Alexander Girard was called by Helen Cordero's clay figures.

The old country fiddler whose young neighbors have become excited by rock and roll gathers, if he is lucky, a new audience of city kids who love his music and may even learn to understand and perform it. Similarly, the folk artist might assemble out of a wide public a new ring of patronage. Though spread across space, customers can move through appreciation into a direct relation with the artist. The old community is replaced by a dispersed market composed of individuals who can provide the artist with hints, commissions, and critical guidance. At last, though, the artist is left alone, charged by an inner demon with personal responsibility for the maintenance of tradition. The situation seems different today, but it is as it always was. Bearing down on the work at hand, the artist exists in communication with the self, answering personal needs that need no response to be excellent.

I have stood on the porch and listened to the old man inside raising his ballad beautifully for himself alone. I have watched the potter forget me in the miracle of whirling clay. I understand how our theories need audiences more than artists do.

We have considered one aspect of the separation of making from using: artists without audiences. As we swing to the opposite possibility—audiences without artists—the locus of integrity shifts from the creator to the consumer.

Come again into the kitchen of Ellen Cutler's thatched home in Ballymenone. Passing her dresser of delph and taking a seat at the corner of her hearth, you find yourself inside her great work of art. Around you spins a scatter of goods: plates gleaming in rows, a chromo of a thatched cottage, a shelf bristling with glass animals, tea tins with the Queen's portrait, brass candlesticks, china dogs, a calendar with a scotch whiskey ad, a teapot shaped like a house, a creamer shaped like a cow, a framed photo of her grandchildren, a plate with a donkey bearing creels of turf, another with a poem, an embroidered "Lead Me and Guide Me," and in the window, next to the Bible, a glass dippy duck.

Most of the things around you are neither folk nor art. They were tossed out by manufacturers who, stretching for customers beyond the limits of a particular culture, eliminated complicated meanings and reduced things to usefulness or prettiness. Mrs.

Cutler waded into the tide of commodities and selected the things that appealed to her. But the act of selection tells little about her because her choice was terribly constrained by economic realities. Further, most of the things in her kitchen were selected for her; they were gifts. But as she arranged them around her, she created a new and personal ensemble that tells much. The elements of her kitchen's decor may or may not be art, but their arrangement yielded a single great piece of folk art. It expresses her being. She is a "house proud" woman. She keeps things tidy and neat and arrays them carefully. Her kitchen is a hosting of memories, a bank of private history like Lou Sesher's boats. All those gifts surround her with silent voices chatting gently, endlessly, of loved ones who are absent, of happy days agone. To create her great work, she employed her community's old rules of order, its tropes to symmetry and clarity, its classification of things into low, dark, and useful or high, bright, and lovely. "Lovely" is her word. She has arranged things worthy of love into a conventional pattern through which her personal star shines, with which she welcomes the visitor into her own special place. All this is the spark of her heart and her gift to you. Come in, sit down, have a cup of sweet, creamy tea and a slice of buttered bread. Relax in the glittery delight of her kitchen. Take heart, gain strength. Soon you will return to the world of cold rain and wind and bombs that rattle the black trees on the dead hills.

Ellen Cutler, Ballymenone, County Fermanagh, Northern Ireland

Ellen Cutler's creation suits our age. No longer makers of things, we have not surrendered creativity: we make things out of things. The old folk artist intrudes upon nature, disrupting its continuity, separating fragments out of the world and shaping them into works of art. We break into the world of goods, separating bits out of it and arranging them into new works. The most conspicuous new work is the domestic environment. Despite the qualities of the things themselves, the rooms we build out of the things that others make are our works of art. Our homes are our mirrors. We see ourselves in them. They are expressions. Others read us through them.

The dynamic of intervention, selection, and arrangement that makes pots out of clay can make domestic environments out of commercial goods. The act that creates interiors is purified in collecting.

It is easy to look negatively upon collecting. Collectors know sadness as well as joy. Is this any way to spend a life? I speak for no one but myself when I admit the melancholy that always follows my purchases. Buying is a wan substitute for real experience. When I feel happy, when I have time enough to explore the world's glory, I feel no need to possess objects. But feeling pressured, agitated, distracted, I buy rather than surrendering life altogether. The works of folk art that I gather around me delight and teach me. They remind me of people and places. They rebuke me for the shallowness of my life. All collectors must wonder sometimes, and we make easy targets. We seem like people with more money than sense, desperately concocting little realms of irrelevance. We seem transported by greed, personifications of the decadence of late capitalistic civilization. Not quite feeling that way, I am encouraged that the impulse to collecting is not confined to people of questionable mental health or to cultures of wealth. It lives richly among the mostly impecunious and adamantly sane country people I know. Let me tell you about their motives.

Here is the first. All people are born creative. They are driven from the deepest place

257

258

259

into creative activity. If they do not topple trees and chop their bodies into sculpture, then like Mrs. Cutler they go shopping. They buy things and receive gifts, heirlooms and remembrances. Then they arrange them into new units. Displayed or not, the units are creative entities. As the artist improves upon nature through its destruction and reorganization, the collector bravely faces the chaos of artifacts and rings out of it a small place of order within which the self can learn about the self.

Collecting is more than a variety of creativity suitable to people whose lives pass amid commodities and far from nature. The collectors I meet in traditional communities are generally artists themselves. They answer their need to create by weaving their own rugs or turning their own pots. Yet, Turkish weavers collect rugs and many of the potters I know collect pottery. Understanding their own artistry, they are drawn to the artistry trapped in artifacts. They save examples of their own work. Sometimes these are early pieces by which they gauge their progress. Sometimes they are especially excellent, and sometimes they are failures which they love as only a mother can love her own child. At Burlon Craig's pottery, old One-Eyed Pete, an ugly jug that misfired, stands as a little shop spirit. Artists save works by their family and friends: the lone bowl surviving from a grandmother, the first little effort of a grown daughter, the gifts from their colleagues—reminders of people they like and love. Their interest expands beyond known others. They preserve the old pieces they find, and they battle dealers at auctions to own the antique masterworks of their tradition. Like Mrs. Cutler's kitchen, the collection teaches artists about their own history and the society to which they belong. The collection floods with sentiment and story. Since the collection is potentially a narrative within which the collector is an actor, its items are both meaningful and useful. They embody materially the tradition that will inspire future success.

In the village of Karagömlek, Şardiye Taşkın pulls back the curtain and exposes her collection piled neatly atop a chest. Within the pile are old and new rugs she has woven, rugs she has bought, weavings from her mother and from women who were dead before she was born—more rugs than necessary. Her floors are already full. Her collection includes samples of various techniques, naturally interesting to her as a weaver, and it is a repository of designs from which she has already innovated, out of which she will create again and again.

At home in Acoma, Wanda Aragon stands in a room full of pottery and says her greatest treasures are the big jars made by her mother, her teacher, Frances Torivio. She lifts her own latest piece and displays it with justifiable pride. It represents in technique and decoration a refinement of the excellence abiding in her mother's old work. In his atelier at Kütahya, in a room filled with new and old samples from many ceramic traditions, the master Sıtkı Olçar pulls out a box of sherds unearthed at Iznik. At once they are his heritage and his models for future work.

These motives unify the folk artists who are collectors. They wish to preserve artifacts that teach history, especially a vital, personal history. They gather and save things that can inspire future work. Describing his reasons for collecting, Alexander Girard says nearly the same thing. We accumulate souvenirs, he writes, to relive the past, treasuring artifacts that remind us of people we knew and loved, collecting things we associate with ways of life we would like to see perpetuated, things that can be sources of nourishment for the creative

257. *Blanket. Possibly Songhai people, Niger. Strip-woven plain weave with supplementary-weft pattern, cotton on cotton, 59³/₄ x 83¹/₂", c. 1960*

258. *Bull. Puri, Orissa, India. Painted cloth, 4¹/₂ x 5¹/₄", c. 1960*

259. *Brahma Bull. Chihuahua, Chihuahua, Mexico. Painted wood, 5¹/₈" high, c. 1960*

Wanda Aragon, Acoma, New Mexico

Opposite
260. *Pouch. Eskimo people,
Alaska. Embroidered
silk on seal parchment and
sealskin, seed beads,
tradecloth lining, 12¹/₂ x 9¹/₂"
(unfolded), c. 1930*

spirit in a new age. His clear statement joins him at once to country potters and the builders of great museums. The serious collection is not a cabinet of curiosity. It is a way to preserve the past for use in the future. The artifacts massed in Burlon Craig's shed or the Girard Collection or the Victoria and Albert provide artists with a reservoir of fresh ideas. They provide thinkers with tools to use in contemplating life. Are we on the right track? Folk art challenges us at every turn, forcing us into confrontation with sturdy alternatives.

The collection moves one step further in importance when—in the home or the museum—it is shaped into a display. Then it becomes an artistic communication, arranged for the pleasure and enlightenment of others. Like Mrs. Cutler's kitchen, Mr. Girard's exhibition is one person's artful reordering of the past, designed to be delightful in the present, useful in the future.

Collecting is one of the means people use to confront and overcome a world lacking in direct, intimate connections. When the ideal represented by Ananta Pal's figure of the goddess stretches and disassembles, when design separates from making, when artists separate from users and users separate from artists, when things threaten to fall apart, what lies in peril is not folk art but art itself. Industrial artifacts become at best pictures of art, and workers become tools. Fine artists create mere fashion. Folk artists create anemic souvenirs. The result is not popular art. It is not art.

Art lives because designers continue to shape concepts that can be perceived as artlike, as aesthetic and meaningful. Art lives because artists who no longer know their patrons bring into themselves the response of the absent other. Attending to what William Faulkner called the policeman in the head, they create to meet standards now dependent on one lone brave soul. Art lives because consumers, though ill served by manufacturers, remain creative, because children can turn an idiotic jingle from a television commercial into a snappy jump rope rhyme, because sincere singers can breathe life into a hack's cheap lyrics, because poor old ladies can arrange trivial commodities into lovely, significant environments.

Key among contemporary efforts to make connections despite disconnection is the collection that gathers the past into new vitality. The collector joins the architect newly committed to historical preservation, renovation, and vernacular revival; and the fine artist exploring historical models, collage, assembly, and construction; and the folk artist in the midst of an exhilarating global revitalization movement. By dint of personal integrity, all are at work creating the kinds of connections that were once easy and natural, the connections upon which art—call it folk, call it fine—depends for existence.

Folk Art and Primitive Art

If folk art is the fine art of the other, then "primitive art" is a special class of folk art. It is special by virtue of the clarity of disconnection we grant it.

"Primitive" is not a good word. Primitive art is distinguished on the basis of negative traits—usually the absence of writing—that are of little relevance to the creation of art. Other traits are more confusing. It is called "non-Western," yet it does not embrace much of Eastern art. It is called "tribal," though it includes the art of great states with complex governments. Still, the clarity of its difference, founded mostly upon its irrelevance to European history, has been productive in the study of primitive art.

The idea of folk art has been developed to encompass arts that exist in relation to the idea of fine art. Viewed positively, folk art represents noble resistance, the preservation of sacred and communal values in a world decaying into secular individualism. Viewed negatively, folk art is the naive imitation of fine art, the barbarization of civilized achievement. Despite the irrelevance of the idea to the artist's reality, folk art has been conceived as existing in interaction, perhaps antagonistic interaction, with fine art. Primitive art has been fortunate. It has been studied as though it existed outside of connection with us.

Archaeological evidence of primitive art survives from times before contact. But, of course, as soon as we gain direct knowledge of primitive artists, they exist, like folk artists, in interaction with the outside world represented by the anthropologist, a world that had probably been represented earlier by travelers, missionaries, and traders. So primitive art, with the exception of its archaeological residue, is a variety of folk art, a kind of creativity that follows its own course despite contact with us. But scholars differ. Studies of folk art customarily emphasize the contact that studies of primitive art customarily ignore.

That has been good for primitive art. As a result of the stress placed upon its apartness, primitive art has been favored as the recipient of the application of anthropological principles to the study of art. Primitive art, though badly named, though isolated by false premises, offers models that should be adopted in the study of all art. If we are ever going to achieve a democratic and global—realistic—vision of art, our first step will be to treat every artistic tradition as though it were governed by its own rules.

Even if all of their ideas were imported from without, our first task is to understand artists in terms of their own norms of creativity. We do that for fine artists. We do it for primitive artists.

Evaristo Medina, Cochas Chico, Huancayo, Junín, Peru

We should do it for the vast majority of the world's artists who are folk artists. Until we do, until we cease seeing folk art as a good or bad version of some other art, we will not merely misunderstand the objects in folk art galleries, we will misunderstand the world.

Confronting every artistic tradition within its own cultural system, after the manner of anthropological studies of primitive art, we make a necessary first step in the serious study of art. It will mean abandoning the whole baroque structure of art history and starting all over again, but that is a small price to pay for understanding. We begin by granting the right of true otherness to all artists, to those in the European academies as well as to those in Indian villages and New Guinea tribes. What makes a good beginning, however, would make a bad conclusion. Once we have understood all artistic traditions from the inside, on their own ground, we would be fools to leave them without interaction or history. Knowing a tradition's spirit, we can watch it touch and recoil, reach and blend and change over time.

Having taken firmly an anthropological first step, as art historians often do without benefit of anthropology in their studies of schools and movements, we need to take a second and historical step. Doing so, we will see first that, even if we imagine primitive art to have been at some past moment the product of a people wrenched into isolation by the hermetic system of their culture, people of primitive societies existed in communication with others, shaping and refining their art through contact and contrast. And if we look upon the more recent past, we will find that formerly isolated primitive cultures exist now in some relation to

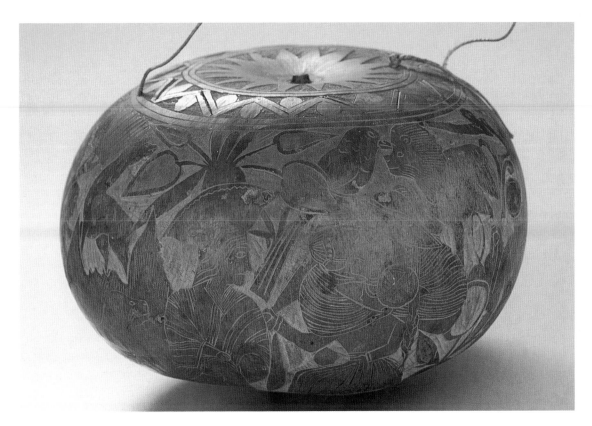

261. *Engraved Gourd:*
Maté. By Evaristo Medina.
Cochas Chico, Huancayo,
Junín, Peru. 4³/₄" high,
c. 1968. Gourd carving is
an ancient tradition
recently revived into
commercial success.

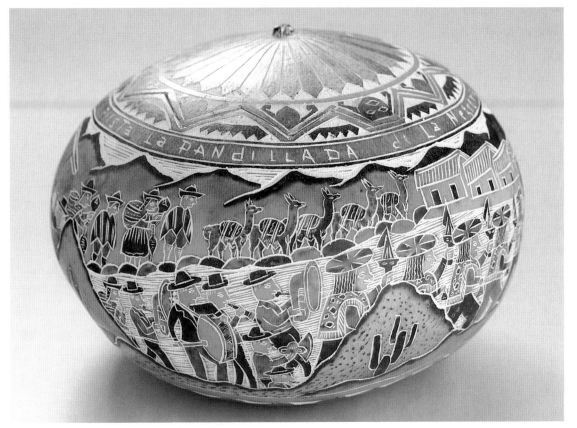

262. *Engraved Gourd:*
Maté. By Leoncio Veli.
Cochas Chico, Huancayo,
Junín, Peru. 5³/₈" high,
c. 1979. The picture shows
a fiesta, the procession of
"a group of Blacks going
toward the town."

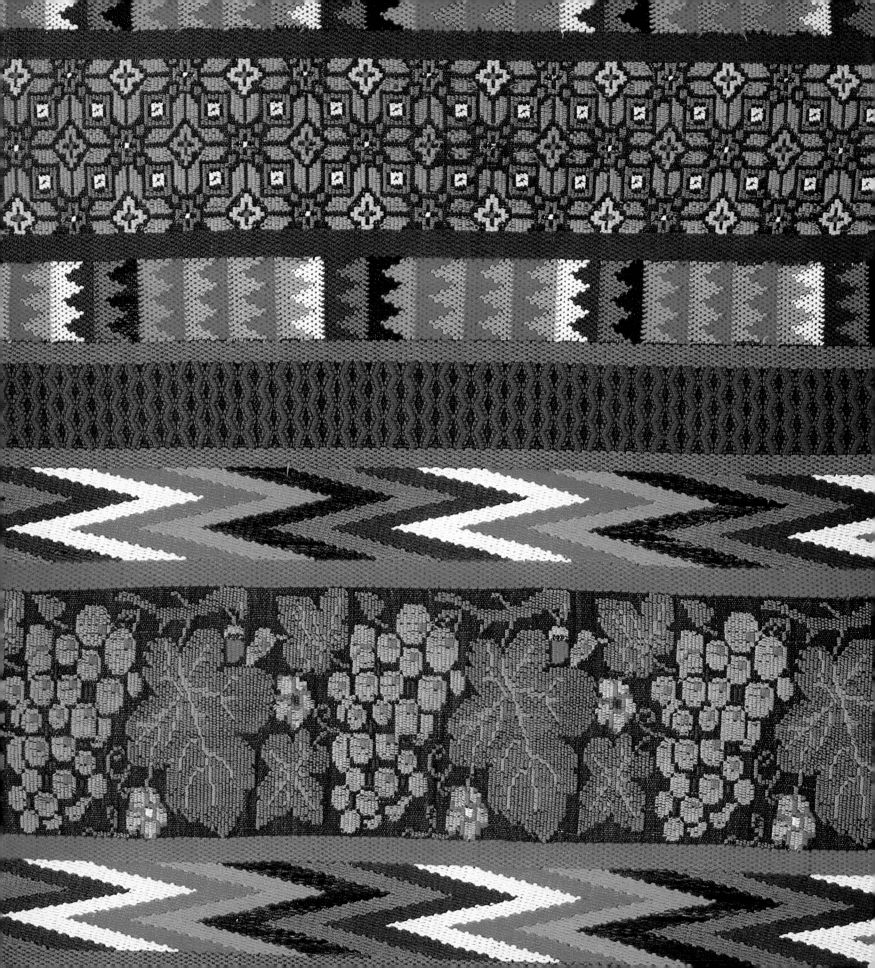

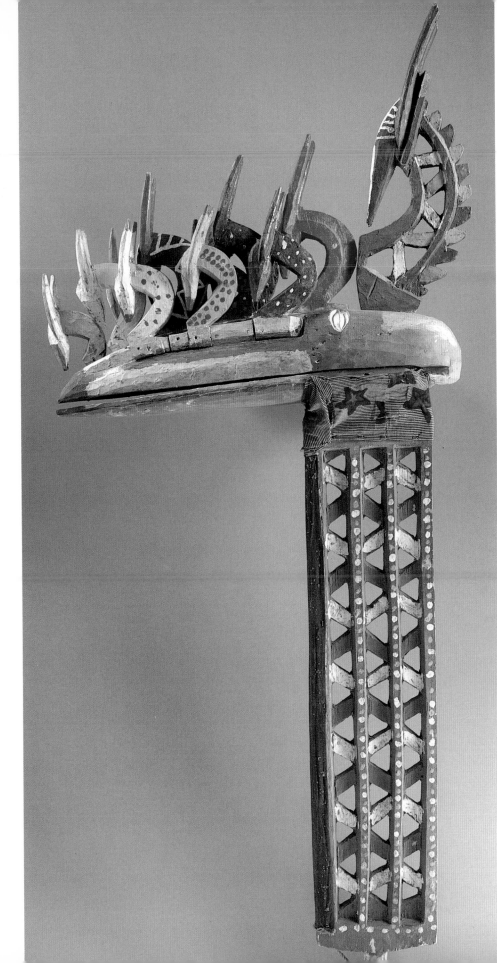

265 266

Opposite

263. Huipil *(detail).*
Cakchiquel Maya people,
San Antonio Aguas
Calientes, Sacatepéquez,
Guatemala. Backstrap-
woven plain weave with
supplementary-weft
pattern, silk on cotton,
50 x 14½", c. 1950. This
is a section of half of the
indigenous women's upper
garment, exhibiting
European influence in the
floral elements.

This page

264. Pelican Puppet. *Bozo*
people, Mali. Painted wood,
cloth, 58" high, c. 1960.
Elements drawn from the
famed antelope headdresses
of their neighbors, the
Bamana, enrich this puppet
from the Pelican dance of
the Bozo people.

265. Votive Horse.
Bankura District, West
Bengal, India. Earthenware,
29" high, c. 1960

266. Boy. *Baule people,*
Ivory Coast. Blackened
wood with white paint,
13½" high, c. 1970

264

cultures like our own. Their art is folk, their own despite us.

"Primitive art" shares with "folk art" all the traits we use to separate "folk art" from "fine art." Primitive art unifies with folk art in expressing the distinct, more sacred and communal, cultures that occupy the same world we do.

Surely we do not continue to separate primitive art from folk and fine art on the basis of race. That would be even cruder and more distasteful than separating folk art from fine art on the basis of class. It cannot be that we think fine art is the art of pale wealthy people, folk art is the art of pale poor people, and primitive art is the art of dark people. The world may be a mess, but it is too good to be approached from the angles of racism and class prejudice. It is too grand to be splintered into bits for scholastic convenience.

In Gujarat, in western India, Hindu potters shape figures, especially of horses, that are purchased by tribal people who use them as votive offerings. Works by Hindus are clustered in isolated sanctuaries to invoke the blessings of tribal deities. Around Bondoukou in West Africa, Muslim artists carve masks for their pagan neighbors to use in rituals, and on great Islamic holidays, Muslims don Do masks and dance in front of their mosques. The mask seems the perfect negation of Islamic tradition. It is representational; Do masks portray not only thrushes, baboons, and warthogs, but men and women, even Muslim elders. Worn, the mask is danced into life, making it more vital and illusionistic than the most realistic painting. Yet, since the fourteenth century, the Muslim people of West Africa have coexisted with masking traditions, occasionally embracing them and bringing them, as in the Do dance, within Islam.

Then consider the Navajo rug. The ancient people came from the north and learned weaving from the Pueblo people. Weaving became a great Navajo art, an emblem of the tribal nation. From the beginning Navajo weaving has energetically absorbed various influences. Early weavings flowed in horizontal bands of undyed wool, often incorporating indigo blue from the Spanish. Late in the eighteenth century, color increased. Red was raveled from trade cloth. During the nineteenth century, European yarns widened the palette, and the horizontal stripes elaborated through the adoption of ideas from basketry and Hispanic serapes. Late in the nineteenth century, the weavers became dependent on yarns and synthetic dyes manufactured in the eastern United States. At the end of the century, traders encouraged a return to hand-spun wool and older colors; they supplied bordered designs from oriental carpets and inspired a shift from blankets to floor covering. In our century, Navajo weavers have attended to suggestions from outsiders that they should return to natural tones, vegetal dyes, and native designs, that they should weave tapestries for the wall as well as rugs for the floor. Now their work is technically diverse, embracing vegetal and synthetic dyes, hand-spun and mechanically processed wool, and it has come to encompass a wide artistic scope. They weave designs from sand paintings, once a sacrilege. They have expanded an old but minor tendency to the pictorial into woven pictures of the things and scenes of life, including—as early as a century ago, but especially during the era of pop art—American flags. Their masterpieces are based on designs derived from oriental rugs, Caucasian especially but also Turkish and Persian. But they are rendered in a stricter and more angular symmetry, in a weave and palette distinctly their own. Little in Navajo weaving rose from the root among the Navajo people, but the synthesis is wholly and perfectly their own. Navajo weavings are the apt artistic markers of Navajo presence in a deliciously complicated world.

267. Blanket: The American Flag. Navajo people, Arizona. Tapestry-woven wool, 30¹/₈ x 31¹/₄", c. 1960

268. Blanket. Navajo people, Arizona. Tapestry-woven wool, 56¹/₂ x 41", c. 1920. This piece represents the revival of older designs and natural colors under influence from the trading post at Chinlee.

269. Blanket: Map of the Four Corners Area. Navajo people, Arizona. Tapestry-woven wool, 38 x 29¹/₄", c. 1960

267

268

269

Realizing that Navajo weaving, a folk art, a commercial art, represents the state today of "primitive art," we might still hold to the hope that somewhere in the highlands of New Guinea or the interior of Brazil lives and breathes the pure, unadulterated other. The great anthropologist Claude Lévi-Strauss supplies our myth. In his study of Northwest Coast Indian masks, he taught beautifully of the interaction between native cultures. Years before, in *Tristes Tropiques*, he wrote an antitravelogue, one of our century's essential books.

Our search for the other, Lévi-Strauss tells us at the beginning, only leads us into confrontation with our own bad history. Traveling, we find but the filth of our own civilization; later, withdrawing from reality, we replace experience with stereotypes. Without hope, then, he sets himself off on a quest for the primitive. Struggling into the Brazilian interior, he was disappointed by the first Indians he met; they were "less pure" than he had hoped. Pressing on, he spied half a dozen naked men painted red. They led him into a stunning aesthetic experience in which his training and hopes meshed at last with reality. In a "relatively untouched" village, among the Bororo, Lévi-Strauss felt the thrill of fulfillment. It was like Wassily Kandinsky stepping out of the twentieth century into the radiant home of a Russian peasant where all was art. A few times, I have been so moved. After years of chasing down the last singers in the Southern Mountains and cajoling them into surrendering half-forgotten ballads to my tape, I found myself in Ireland in a public house, surrounded by men in black, moving in the smoke. Then one stood forth, unbidden, and staring into nowhere began to sing to himself, to all the world, a noble ancient poem. My heart leapt: for the first time I heard a folksong like those I had imagined out of my training. After years of isolating the fragments of handmade excellence that survived in a world built of miserable shoddy and trying to wrest an understanding of material culture from them, I stood in a Turkish village where everything around me, the houses, the textiles, the ceramics, was locally made and vital with quality. It was as I had dreamed: women dressed like flowers, weaving on handhewn looms, bringing bread hot from the domed clay oven. We sat on the floor and consumed a feast, arranged bravely out of the land, then sat back satisfied as the little fire splashed pink light over the whitewashed walls of the home built by Mehmet, my host, with his own hands. Quietly the neighbors came up through the dark. Their courteous greetings, their chat about earth and beasts and God's goodness, became the hum of the environment. A shelf above us bore bowls of tinned copper, glowing like a row of little moons. Mehmet's sheepskin prayer rug, hanging on the wall, thickened into a mound of shadow. Streams of diamonds on the brocaded rug beneath us ebbed and flowed with the fire. The company increased and the last man among them brought us a treasure wrapped in an old army coat, a small television that we would use to watch the night's episode of *Dallas*.

In Brazil, Claude Lévi-Strauss pushed on, abandoning the Bororo, a materially simple, spiritually complex people of the kind that populate anthropology books. Again by a river, naked men beckoned him further, into an unexplored area the size of France, roamed by nomads, "among the most primitive" in the world. In the wilderness he met the Nambikwara. They were individuals like us, though their social order was rudimentary, primitive in the sense of basic, primal. Their chief was an intellectual. His tale was melancholy. His people had been devastated by disease, and the old customs were dying for want of participants. It was a thrill for the anthropologist to be the first white man to enter a native community, but the man had been preceded by his civilization in the form of exotic diseases

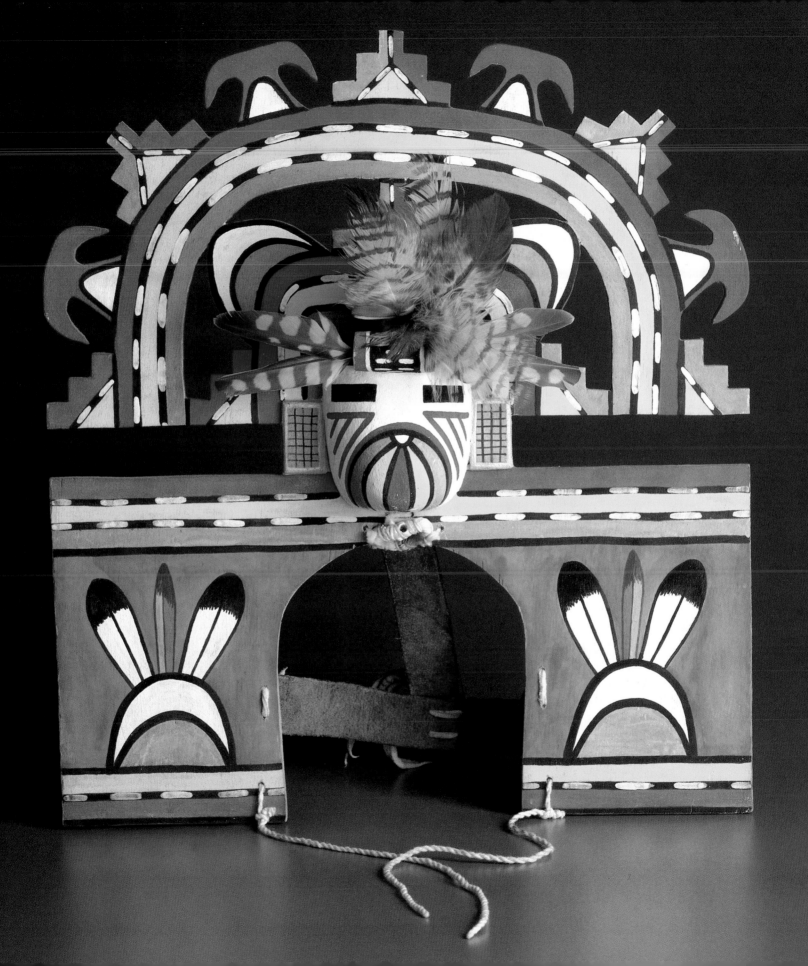

that had mutilated the community. Claude Lévi-Strauss' enthusiasm soured, evaporated.

Those who seemed to be the people of the origin, alive in the state of nature, were but the straggling survivors of the horrors of Western civilization. On his return, Lévi-Strauss huddled under a mosquito net to fill the backs of the pages of his field notes with the words of a play. In it, Augustus is taught by an eagle the ways of the gods. The god Augustus will come to tolerate stench and excrement. The ground aswarm with insects, crawling with infection, will seem to him good. In the drama's next act, Cinna the traveler tells Augustus that he has been everywhere, known pain and eaten disgust, but it was to no end, for the real experience escaped, and only reflections and lies seemed convincing. The trip is circular. The world is but the world.

The anthropologist bids farewell to travel. No primitive men squat awaiting discovery. And if they did, no story would capture their essence, and if it did, no one would believe or understand.

Yet, reason remains for travel. Serious tourists venture into the world out of hatred for home. There is purpose in the act of dislocation. Searching for facts to support an ideal against which their own places are adjudged failures, travelers become critics. Inspired by Rousseau, seeing truly how others live, the anthropologist describes alternative social orders to criticize the order that entraps him at home. If folk art is the traveler's quest, then evidence accumulates out of the world, and folk art becomes a weapon in the hands of the critic.

The modern student of folk art stands with William Morris, who used a dream of popular art a century ago to attack those who attacked art. Against those who reduce art to something that brings pleasure, to a savory soup or hot bath, against those who reduce art to self-expression, to something no nobler than the belch of a drunk, scholars of folk art stress the useful and intellectual dimensions of art. Folk art is a critical weapon; it is a corrective concept, balancing the personal with the social, the progressive with the traditional, the novel with the perfect, the material with the spiritual. Folk art calls goodness and reason, the smell of the earth and the glory of God, back into art.

Folk art is a reaction to simplification and error. It is one way we battle with our own culture, retarding its drive toward consolidation around falsehood.

It is only an idea. There is no folk art out there in the world. We speak of folk art to attack facile concepts, to prevent the easy identification of art with that done by people in our society who call themselves artists. If we come to believe that folk art is something real, if we reify our ideals and hold people to them, we will end up not only criticizing our own tradition: we will fault them all. Judged against the ideal we construct, all changes in folk art will seem decadent. Provincial creativity will seem a surrender of authenticity. Sincere revivals will be viewed with snide suspicion. The reasonable wish of people to live well and do as they wish will seem like commercial fraud.

As a concept, folk art is a by-product of progress, just as primitive art is an artifact of colonialism. While our culture has closed down around its own virtues and defined progress as the rise to the rational, the secular, and the individualistic, it has followed that the integrated, sacred, and communal virtues abounding domestically among "the folk" and abroad among "primitive people" would come to seem like survivals from a past we are struggling to escape, like anachronisms, abominations, no part of reality. Art has convulsed, constricted. Our studies of folk and primitive art are attempts to save art, to push it open and release it from servitude to only one among the many ideas of excellence; they are steps toward the

Opposite
271. *Hunter's Shirt.*
Mande people, West Africa.
Monkey skull, shell,
leopard skin on woven
cotton, 26¹/₂ x 43³/₈",
c. 1960. The hunter's shirt
displays power: the amulet
cases hold Koranic
inscriptions; the spots, shell,
and skull signify the world
beyond the village. This is
an orderly representation of
a hunter's shirt made for
sale to outsiders.

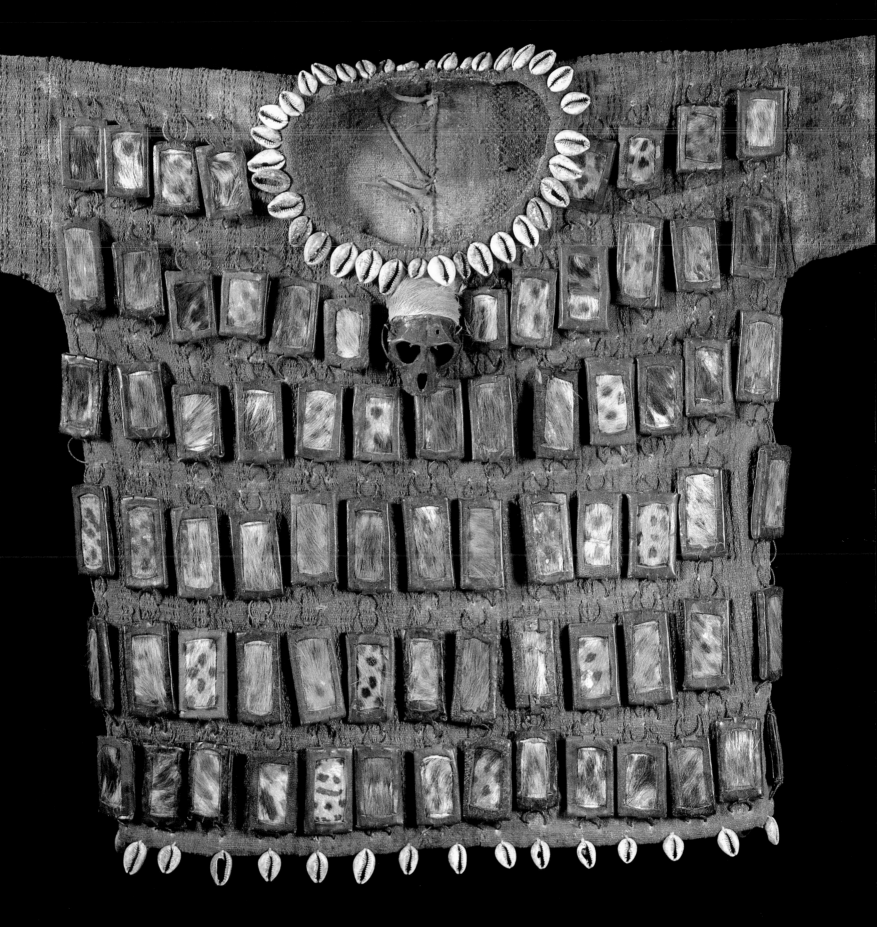

272. San Acacio. *By José Mondragón. Córdova, New Mexico. Wood, 12¹/₂" high, c. 1965*

Opposite
273. San Acacio *(detail). By Manuel Vigil. Tesuque Pueblo, New Mexico. Painted earthenware, 13³/₈" high, c. 1960. Saint Achatius, a Roman soldier, chose martyrdom over service in Hadrian's heathen army.*

development of a concept of art free from convenient prejudice. That ideal is far from met, but if we treat the arts of dark and poor people seriously, the idea of art will be rid of its racism and class bias, and if our studies deepen and art broadens, we will be at least moving in the right direction. The goal is Wassily Kandinsky's: to see art as art.

First we must intentionally compensate, balancing, learning to value what our culture devalues. That is the purpose of the concepts of primitive art and folk art. Once we have absorbed their lessons, things will take on an intricate inevitability. All art will seem appropriate, a necessary consequence of its conditions. At that point the anthropologist stands, like the god Augustus, unable to do more than approve of what is. Sensing the anthropologist's distress, critics condemn social scientific relativism, the ability to understand the values of others, as lacking in value, as preventing us from making the judgments necessary to progressive action. But relativism is only a stage. Once we have used the idea of folk art to compensate for the failures of fine art, then we will be free to abandon conventional distinctions and shift toward understanding every art in terms of its own predicament. Then perhaps we will go so far as to understand art for itself.

When our knowledge of art is picked clean of our culture's prejudices, we will be able

to judge without relying on false support. Among the arts customarily called fine and folk, we will find some to be excellent, some to be merely the pitiful spawn of bad conditions. More important, we will be able to separate art from what is not art.

Art is real. "Folk" art exists only because "fine" art does. But art exists because we do. We are, all of us, individuals, and all of us are members of societies, and all societies occupy a world rolling beyond control. Those are truths, and art is their simultaneous recognition: it is that which at once pleases us as individuals, situates us among our fellows, and mutters of the enormity that enfolds us. Now judge. Set art against reality and say that it should bear witness to the individual, the society, the world. The best art does that insistently, courageously: think of the Sistine Chapel, the Book of Kells, the Green Mosque at Bursa, the Acoma pot of blossoms and parrots. Such are the best. If "folk art" stresses the group at the expense of the individual, it is to that degree a failure; call it noble, coercive. If "fine art" stresses the individual at the expense of the group, it too fails; call it expressive, arrogant. If any "art" should shy away from acknowledgment, whether framed as scientific or religious, of the powers beyond us, it betrays us; call it frivolous, cowardly.

That is a beginning, but there is more. Art is our birthright. We are stuck here. Alone, one by one, we are born and die. We are members of groups without which we would not survive our first day. From them we learn. To them we return our learning. And all the time beyond us flows and cracks, without question, a power not ours that we can bend but not master. Art is the way we come to grips with all this and make it visible, comprehensible. Born into this mumbo jumbo world, we have a right to make art, and I call conditions good that enable us to be artists, and I condemn conditions that steal art from us.

Art is the way we achieve our humanity. The enemies of art are the enemies of humankind. If they say art is the privilege of a rare talented few or the possession of prosperous white men, I say they act criminally toward their kind.

I feel that, say it, then recoil, knowing that perfect judgments lie beyond our science. But that is no reason to surrender, crumbling into acceptance of the worst in our tradition. I am sad standing in Chartres, sad looking at old photographs of the villages of the Northwest Coast Indians. Where is art now to match that? Why is it that theorists of art today fall so far short of Saint Thomas? But we have our task, and if our trip only returns us to the beginning, we must take it. So we leave in quest of tests for our ideals. The concepts of primitive and folk art have been sufficiently developed to redress the failings of fine art. We are ready to meet every culture on its own terms, knowing that there is no reason why a man, though born into comfort and trained in an academy, should not be able to make art as grand as the peasant girl on the mountainside or the naked man in the bush.

We begin our study of art by understanding each tradition in the purity of its own system. But our search will carry us, as it did Claude Lévi-Strauss, beyond the ideals with which we began into awareness of the messy reality of things. Knowing the world, knowing its superiority to our schemes, we will come to know art as mixed, as a message about the wonders of impurity, as real. Not fine, nor folk, nor primitive, not sensual nor conceptual, useless nor useful, traditional nor original, art is.

Art is the joy we find in work, surely; it is the record of our bodies bumping through the world, our wits at war with the unknowable. It is the story of our fumbling toward collaboration and our union with the power that moves the universe.

Art is the best that can be done.

Notes

This book is based on my research in the field, but I have bene-fited greatly from the works of others. To acknowledge my debts and to lead you to other reading, I offer these notes, and at the end I append a bibliography. Some of its entries appear for his-torical reasons, others come out of a small gesture toward breadth, but most are there because they exemplify the descrip-tive precision or interpretive courage I admire. Though arbitrar-ily limited to works in English (as those in the notes are not), they are not restricted to writings explicitly on folk art. The bibliogra-phy assembles a basic set of texts that I recommend as necessary to the serious study of folk art. It allows me shorthand reference to many of the writings cited in the notes that follow, divided as my text is divided.

Folk Art in the Girard Collection

My brief analysis of Alexander Girard's exhibition at the Museum of International Folk Art is founded upon interviews he kindly granted me in the summer of 1987. Quotations come from those conversations, except for the one about our living in aesthetic squalor, which comes from Charlene Cerny's fascinating "An Interview with Alexander Girard," *El Palacio*, 88:4 (Winter 1982–83): 7–9, 20, reprinted in the brief introduction to the exhibition *Multiple Visions: A Common Bond: The Girard Foundation Collection* (Santa Fe: Museum of International Folk Art, 1982), which includes an enlightening history by Yvonne Lange of the acquisi-tion of the collection. Earlier presentations of parts of the Girard Collection from different areas appear in Girard, *Magic of a Peo-ple*, and Monroe Wheeler, ed., *Textiles and Ornaments of India* (New York: Museum of Modern Art, 1956). The current contentious debate over the definition of folk art in the United States is con-fused by a view restricted to American objects and texts. Serious work on folk art was underway in Germany early in the nine-teenth century. During the late 1870s and early 1880s William Morris developed a modern and comprehensive view of folk art, presented in his key essays "The Lesser Arts," "The Art of the People," "The Aims of Art," "Useful Work *versus* Useless Toil" and gathered with others into his volumes *Hopes and Fears for Art* and *Signs of Change*. Reading those books would have forestalled much of the current confusion. The problems are only that Mor-ris discussed the topic but did not define it, and, as was appropri-ate in his day, he used the term "popular art." William Butler Yeats, whom Morris treated as a son and who called Morris "my chief of men," adopted the Morrisian view of popular art and, in the last section of *The Celtic Twilight*, dated 1901, renamed it "folk art." At the beginning of our century, then, in writings in English by great thinkers, the territory had been mapped, the province named. Thirty years later in America the struggle for under-standing began all over again. In his introduction to *American Folk Art*, pp. XI–XXVII, Simon Bronner provides a clear historical summary of American folk art study and sketches the current debate. Key texts for the argument are: Cahill, *American Folk Art* (1932); the symposium in *Antiques*, edited by Alice Winchester, reprinted in Jack T. Ericson, ed., *Folk Art in America: Painting and Sculpture* (New York: Mayflower Books, 1979), pp. 14–21; Glassie, "Folk Art" in Dorson's *Folklore and Folklife* (1972), reprinted in Thomas J. Schlereth, ed., *Material Culture Studies in America* (Nash-ville: AASLH, 1982), pp. 124–40, and "Folk Art," *Encyclopedia Americana* (New York: Americana Corporation, 1976), vol. 11, pp.

486–92; Michael Owen Jones, "The Study of Folk Art Study: Reflections on Images," in Linda Dégh, Henry Glassie, and Felix Oinas, eds., *Folklore Today: A Festschrift for Richard M. Dorson* (Bloomington: Indiana University, 1976), pp. 291–303; Ames, *Beyond Necessity*; Scott Swank's Introduction to Quimby and Swank, *Perspectives on American Folk Art*, pp. 1–12; John Michael Vlach, "American Folk Art: Questions and Quandaries," *Winter-thur Portfolio*, 15:4 (1980): 345–55; John R. Porter's essay, "Défini-tion de l'Art Populaire ou Analyse de la Construction d'un Con-cept," in his *Questions d'Art Populaire* (Quebec: CELAT, 1984), pp. 5–19; the Foreword by Alan Jabbour, the Introduction by Vlach and Bronner, the papers by Vlach, Metcalf, Bergengren, and Glassie, in Vlach and Bronner, eds., *Folk Art and Art Worlds*; Charlene Cerny's review of *Young America* in *The New York Times Book Review* (Feb. 22, 1987), pp. 15–16; Robert T. Teske, "State Folk Art Exhibitions: Review and Preview," in Burt Feintuch, ed., *The Conservation of Culture* (Lexington: University Press of Ken-tucky, 1988), pp. 109–17; David Park Curry, "Rose-Colored Glasses: Looking for 'Good Design' in American Folk Art," in *An American Sampler: Folk Art from the Shelburne Museum* (Washington, D.C.: National Gallery of Art, 1987), pp. 24–41.

Folk

Folklore was named in 1846 by William J. Thoms in a paper reprinted in Alan Dundes, ed., *The Study of Folklore* (Englewood Cliffs, N.J.: Prentice-Hall, 1965), pp. 4–6. The twenty-one defini-tions printed in Maria Leach, ed., *Funk and Wagnalls Standard Dictionary of Folklore, Mythology and Legend* (New York: Funk and Wagnalls, 1949), vol. I, pp. 398–403, are often cited as an excuse for avoiding the search for a unified concept of folklore. My earlier, more elaborate, less coherent attempt to reduce folklore's many definitions to three and then to one (the dynamic relation of individual creativity to collective order) appears in the paper "The Moral Core of Folklore," *Folklore Forum*, XVI:2 (1983): 123–53. Dan Ben-Amos offered the definition of artistic communica-tion in small groups in his landmark paper "Toward a Definition of Folklore in Context," reprinted from the *Journal of American Folklore* in Américo Paredes and Richard Bauman, eds., *Toward New Perspectives in Folklore* (Austin: University of Texas Press, 1972), pp. 3–15. For the pottery of Acoma, history and prehistory are sketched in Alfred E. Dittert, Jr., and Fred Plog, *Generations in Clay: Pueblo Pottery of the American Southwest* (Flagstaff: Northland Press, 1980), pp. 43–47, 119–35; and Jonathan Batkin, *Pottery of the Pueblos of New Mexico: 1700–1940* (Colorado Springs: Taylor Museum, 1987), pp. 136–47. Ruth Bunzel's *Pueblo Potter*, one of the best books ever written on folk art, describes Acoma pottery in the period of her research, 1924–25, as the finest and most serviceable Pueblo ware, and she dates the rise of the contempo-rary styles to the period 1870–1905; see pp. 7, 29–38, 81–83. The Chino and Lewis families and examples of their work are pre-sented in the small catalog *Seven Families in Pueblo Pottery: Maxwell Museum of Anthropology* (Albuquerque: University of New Mexico Press, 1974), pp. 2–16. Susan Peterson has composed a fine book on Lucy M. Lewis. Stephen Trimble provides a nice sketch of the current scene in *Talking with the Clay: The Art of Pueblo Pottery* (Santa Fe: School of American Research Press, 1987); chapter 5 includes Acoma; he quotes Frances Torivio on p. 76 and features a pot by her daughter, Lillian Salvador, on p. 103. Frances Torivio [Pino] is credited correctly as the first to make storytellers at Acoma in Babcock and Monthan, *The Pueblo Storyteller*, p. 52; Frances' work

is presented in plate 12; a figure by her daughter, Wanda Aragon, is pictured in fig. 28; and see pp. 135–38.

Art

I follow Bascom, *African Art*, pp. 8, 184–87, in saying sculpture is the prime artistic genre of Africa, though I am mindful that the emphasis on sculpture reduces "Africa" to West Africa and Central Africa; see Vansina, *Art History in Africa*, pp. 1, 20. I report my Irish experience in *Passing the Time in Ballymenone*; see especially pp. 11–34, 306–26, 575–80. The key work in sociolinguistics is Dell Hymes, *Foundations in Sociolinguistics: An Ethnographic Approach* (Philadelphia: University of Pennsylvania Press, 1974). Historical meanings of the word "art" are sketched usefully by Raymond Williams in *Keywords: A Vocabulary of Culture and Society* (New York: Oxford University Press, 1976), pp. 32–35. Art as skill, as a means rather than an end, is discussed by Ananda K. Coomaraswamy in *The Dance of Śiva: Essays on Indian Art and Culture* (New York: Dover, 1985; first pub. 1924), pp. 18–29. Coomaraswamy relates the Indian concept to that of medieval Europe, which is excellently set forth by Eco in *Art and Beauty in the Middle Ages*, especially pp. 93–94. In *The Life of Forms in Art*, Focillon calls attention to hands and techniques as central to art; see particularly pp. 36, 65–78. In this chapter I use Emerson's ideas on art from his great early essay *Nature*, published in 1836 and often reprinted; see in particular the Introduction and the section on Beauty. If you were to read only one thing on folk art, it should be William Morris' essay "The Lesser Arts," his first public lecture, given in 1877 under the title "The Decorative Arts," printed in 1878, included in *Hopes and Fears for Art* (1882) and in volume XXII of his collected works, and available in modern anthologies: Holbrook Jackson, ed., *On Art and Socialism* (London: John Lehmann, 1947), pp. 17–37; A. L. Morton, ed., *Political Writings of William Morris* (London: Lawrence and Wishart, 1973), pp. 31–56; Asa Briggs, ed., *William Morris: Selected Writings and Designs* (Harmondsworth: Penguin Books, 1962), pp. 84–105. All the ideas attributed to Morris in this section come from that one grand paper with the exception of his definition of "real art" as the "expression by man of his pleasure in labour," to be found in "The Art of the People," delivered in 1879, printed in *Hopes and Fears for Art;* the quotation is on p. 58. He repeated that definition in his important essay, "Art under Plutocracy" (1884), in which he gave John Ruskin as its source, a point he underscores in his Preface to Ruskin's chapter from *The Stones of Venice*, "one of the very few necessary and inevitable utterances of the century," *The Nature of Gothic* (Hammersmith: Kelmscott Press, 1892). Among William Morris' less frequently cited and reprinted essays I would like to refer you especially to his paper "The Lesser Arts of Life," Lecture VI in *Lectures on Art Delivered in Support of the Society for the Protection of Ancient Buildings* (London: Macmillan, 1882), pp. 174–232 (not to be confused with "The Lesser Arts"). I quote Kandinsky's cry for ending false divisions in the field of art from Klaus Lankheit's Introduction to Kandinsky and Marc, *Blaue Reiter Almanac*, p. 37. Bertram Frauenknecht's books on Turkish kilims provide a clear instance of the absorption of folk art into the process of modern appreciation: *Anatolische Gebetskelims*, written with Klaus Frantz (Nuremberg: Nomad-Press, 1978); *Anatolische Kelims* (Nuremberg: Galerie Frauenknecht, 1982); *Frühe Türkische Tapisserien* (Nuremberg: Frauenknecht, 1984). I report a little chat with Burlon Craig, but to meet him you will want to read Terry Zug's masterful *Turners*

and Burners, anticipated by Zug's *The Traditional Pottery of North Carolina* (Chapel Hill: Ackland Art Museum, 1981). The Meaders family of Georgia potters have been presented in two fine books, the pioneering study by Rinzler and Sayers, and John Burrison's superb *Brothers in Clay*. Those books, along with Nancy Sweezy's excellent *Raised in Clay* (she treats Burlon Craig, pp. 87–92, and Lanier Meaders, pp. 107–11), make the pottery of North Carolina and Georgia the most completely understood and best documented Anglo-American folk artistic tradition. In Graburn's *Ethnic and Tourist Arts*, pp. 200–201, Donald W. Lathrap tells of the development of face vessels among the Shipibo, and in his admirably clear essay, William Bascom generalizes about the rise of naturalism in current African art, pp. 313–14. I retell the story of the storyteller from the fine book *The Pueblo Storyteller*, by Barbara Babcock and Guy and Doris Monthan, pp. 3–27. For *kente* cloth I follow Thompson's truly important book *Flash of the Spirit*, pp. 197, 207–22; see, too, Sieber's lovely *African Textiles and Decorative Arts*, pp. 155–205, and Peggy Stoltz Gilfoy, *Patterns of Life: West African Strip-Weaving Traditions* (Washington, D.C.: Smithsonian Institution Press, National Museum of African Art, 1987). The richness of High Ottoman art is well represented by Esin Atıl's glorious catalog *The Age of Sultan Süleyman the Magnificent*. Godfrey Goodwin, *A History of Ottoman Architecture* (New York: Thames and Hudson, 1987), chapters 5–7, introduces the architectures of the period, focusing upon the great Sinan. Of the many works on Turkish calligraphy, my favorite is Şevket Rado, *Türk Hattatları* (Istanbul: Yayın Matbaacılık, n.d. [1984]). Generalizations on the significance of particular media are not common, but Ricardo Muratorio, writing in Panyella's *Folk Art of the Americas*, p. 220, is willing to state that pottery and textiles are the most important folk arts in the Americas, and Munsterberg writes in *The Folk Arts of Japan*, pp. 107, 121, that pottery and textiles are most important in Japan. By asserting that architecture is the third great global artistic genre, I break with conventions that restrict "art" to the portable and the permanent (that is, to objects that fit the needs of the art market). A wider, more reasonable view would bring impermanent material culture—cuisine, grooming, gardening, fireworks—and immovable artifacts, not only architecture but whole landscapes, into the study of art. Let me refer you to a small clutch of landscape studies that should be read by students of folk art: Hoskins, *Making of the English Landscape*; E. Estyn Evans, *The Personality of Ireland: Habitat, Heritage and History* (Cambridge: Cambridge University Press, 1973); Richard Weiss, *Haüser und Landschaften der Schweiz* (Zurich: Eugen Rentsch, 1959). Then I will return to the small, hard, saleable objects that dominate talk about art; we have trouble enough with them. For one example out of the many in which folk art is identified with decoration, see Jean Palardy's fine study *Les Meubles Anciens du Canada Français* (Montreal: Pierre Tisseyre, 1971), in which most of the hundreds of pieces of furniture he illustrates could be called folk art, but the few specifically called folk art—nos. 560, 565, 574—are embellished with abstractly representational ornament. In *Ethnic and Tourist Arts*, p. 15 (see also pp. 108–9, 203), Graburn describes the miniature as a response to the tourist market. The miniature is portable and economical of materials; it can be used decoratively, collected in small places, and its baby-like smallness suits the possessor's affectionate wish to control experience. But the miniature is not restricted to new markets; it is useful in education (children learn by trying their hands at small works), and I have repeatedly found that

masters make miniatures as tests of talent, to delight themselves, with no commercial motive; indeed, they will not sell them but keep them or make them gifts. George Kubler defines art as that which is not a tool in his important essay *The Shape of Time*, pp. 11–16, 80. Though he states correctly that artifacts mix the qualities of art and tools (p. 14), he persists with the division of art from tool as though it were real, and without examining the nature of tools, he at last defines art simply by medium, identifying it with painting, sculpture, and architecture (p. 31) and "tools" with things that are not "art," a circular conclusion that does not aid his admirable attempt to move toward a universal concept of the history of things. I was inspired to use the example of the silver teapot by Jules Prown's lovely paper "On the 'Art' in Artifacts," delivered at the North American Material Culture Research conference, St. John's, Newfoundland, in 1986. I treat Ellen Cutler's dresser as a masterwork of folk art in *Passing the Time in Ballymenone*, pp. 361–65. The useful object made useless by decoration and made useful again through ceremony and social association is described richly by Hofer and Fél in *Hungarian Folk Art*, pp. 10–16. I use the Mexican mask as example because the Girard Collection is rich in masks from Mexico and because there is a fine new book on the topic with a valuable bibliography: Janet Brody Esser, ed., *Behind the Mask in Mexico* (Santa Fe: Museum of New Mexico Press, Museum of International Folk Art, 1988). In *The Transformation of Art in Nature*, Coomaraswamy describes the development of artistic conventions in a way that bears intriguing connection to the dynamic of bricolage, the science of the concrete, set forth by Claude Lévi-Strauss in his book, essential to our understanding, *The Savage Mind*, and I was aware of influence from both of them as I worked through the problems of conventions and beauty. Community standards are a natural interest of the folklorist. Community was a powerful concern in the days of the discipline's formation; see, for example, George Laurence Gomme, *The Village Community: With Special Reference to the Origin and Form of Its Survivals in Britain* (New York: Scribner and Welford, 1890). Robert Redfield's clear statements in later times consolidated the idea; see *The Little Community: Viewpoints for the Study of the Human Whole* (Chicago: University of Chicago Press, 1955). Community has become a feature of folkloristic rhetoric. Yet students of American folk art, while they talk about community, rarely study it. Generally they do not even study the small groups of friends and customers that surround artists (though writings by Michael Owen Jones and Charles Briggs offer good models for such work); instead, they study folk artists as individuals who have internalized collective norms. This makes sense in the contemporary American scene. The individual, not the community, is the logical unit of study, for American folk artists are less actors in a community setting than they are individuals whose work expresses a tradition learned from others. In this, folk artists are little different from fine artists. Both are individuals whose works gather small groups through their containment of shared concepts. If we try to differentiate between them, saying that those concepts are traditional for folk artists and nontraditional for fine artists, we misunderstand fine art. As T. S. Eliot reminds us, no art rises in pure originality; it is all a flowering of tradition; see *Notes Toward the Definition of Culture* (New York: Harcourt Brace, 1949), pp. 117–18. Scholars confused by the notion of originality should read H. G. Barnett's *Innovation: The Basis of Cultural Change* (New York: McGraw-Hill, 1953). I describe the historical process of innovation as a dynamic of recentering in *Folk Housing in Middle Virginia*, chapter 6. Afro-American quilts provide an excellent example of a tradition recentered; see Vlach, *Afro-American Tradition in Decorative Arts*, chapter 4; Thompson, *Flash of the Spirit*, pp. 218–22; Maude Southwell Wahlman and John Scully, "Aesthetic Principles in Afro-American Quilts," in William Ferris, ed., *Afro-American Folk Art and Crafts* (Boston: G. K. Hall, 1983), pp. 78–97; Gladys Marie Fry, "Harriet Powers: Portrait of a Black Quilter," in Wadsworth, ed., *Missing Pieces*, pp. 16–23; Mary Anne McDonald, "Jennie Burnett: Afro-American Quilter," in Charles G. Zug III, ed., *Five North Carolina Folk Artists* (Chapel Hill: Ackland Art Museum, 1986), pp. 27–39; Eli Leon, *Who'd a Thought It: Improvisation in African-American Quiltmaking* (San Francisco: San Francisco Craft and Folk Art Museum, 1988). For every student of art, Robert Plant Armstrong's trilogy—*Affecting Presence, Wellspring, Powers of Presence*—is required reading. I described Armstrong's project in progress in "Source for a New Anthropology," *Book Forum*, II: 1 (1976): 70–77. There is a fine book on the *kantha*: Zaman's *Art of Kantha Embroidery*. Stella Kramrisch dealt with the *kantha* early and well: *Unknown India*, pp. 66–69, reprinted in Barbara Stoller Miller, ed., *Exploring India's Sacred Art: Selected Writings of Stella Kramrisch* (Philadelphia: University of Pennsylvania Press, 1983), pp. 108–12. Jasim Uddin's poem has been translated into English by E. M. Milford as *The Field of the Embroidered Quilt* (Dhaka: Poet Jasim Uddin Academy, 1986; first pub. 1939). In "Folkloristic Study of the American Artifact: Objects and Objectives," in Richard M. Dorson, ed., *Handbook of American Folklore* (Bloomington: Indiana University Press, 1983), pp. 376–83, I described the concentrations on materialization and conceptualization as distinct foci within material culture studies.

Folk Art and Fine Art

Peter Flanagan is a hero of my writings on Ireland. He stars especially in *All Silver and No Brass: An Irish Christmas Mumming* (Bloomington: Indiana University Press, 1975), chapter 3, and *Passing the Time in Ballymenone*, chapters 3 and 32. Stories told by Mr. Flanagan appear in my collections *Irish Folk History* (Philadelphia: University of Pennsylvania Press, 1982) and *Irish Folktales* (New York: Pantheon Books, 1985). My paper "William Houck" from 1967 was reprinted in *Studies in Traditional American Crafts*, 3 (1980): 3–34. Charles Briggs has written an outstanding book on the wood carvers of Córdova, New Mexico. Eluid Levi Martinez, grandson of José Dolores López and a carver himself, provides a view from within the family in *What Is a New Mexican Santo?* (Santa Fe: Sunstone Press, 1978). These books present the older tradition well: Espinosa, *Saints in the Valleys*, and Wroth, *Christian Images in Hispanic New Mexico*. Considering its vitality and quality, there is amazingly little writing on modern Kütahya ceramics, though my little paper, "Traditional Crafts," describes things briefly, and Faruk Şahin's dictionary, *Seramik Sözlüğü* (Istanbul: Anadolu Sanat Yayınları, 1982), contains much information of value. Earlier Kütahya ceramics are described by Oktay Aslanapa in *Osmanlılar Devrinde Kütahya Çinileri* (Istanbul: Sanat Tarihi Enstitüsü, 1949). The Kütahya tradition is continuous with the classic Turkish work of the sixteenth century, centered at Iznik, which is described well by Lane in *Later Islamic Pottery*, pp. 45–60, and updated by Oktay Aslanapa, *Türk Sanatı* (Istanbul: Remzi Kitabevi, 1984), pp. 322–32; by John Carswell in his chapter, "Ceramics," in Petsopoulos, ed., *Tulips, Arabesques, and Turbans*, pp. 54–116; and by Atıl in *The Age of Sultan Süleyman*, pp. 235–85.

Walter B. Denny's study of one monument, *The Ceramics of the Mosque of Rustem Pasha and the Environment of Change* (New York: Garland, 1977), is a fine account of Iznik at its peak. W. David Kingery and Pamela B. Vandiver provide fascinating technical analysis in *Ceramic Masterpieces: Art, Structure, and Technology* (New York: The Free Press, 1986), chapter 6. Further detail is added by Tahsin Öz, *Turkish Ceramics* (Ankara: Turkish Press, Broadcasting and Tourist Department, 1957), pp. 20–42, and by Gönül Öney, *Türk Çini Sanatı* (Istanbul: Yapı ve Kredi Bankası, 1976), pp. 65–120. Most of these works (say, Lane, pp. 60–65, Öney, pp. 127–29) would lead you to believe that Kütahya ceramics, though vital after the failure of Iznik in the eighteenth century, barely survived into the nineteenth century, and that late work is a matter of debased reproduction rather than the robust revival it is. In *French Folk Art*, pp. 97–99, Cuisenier takes a different route to the correct conclusion: there may be art that is naive, but it is wrong to call folk art naive. The provincial issue appears within studies of regionalism. My book *Pattern in the Material Folk Culture of the Eastern United States* treats American regions. For fine studies, I refer you to Kirk's *American Chairs* and Fred Kniffen's important paper "Folk Housing: Key to Diffusion," reprinted from *Annals of the Association of American Geographers* (1965) in Upton and Vlach, *Common Places*, pp. 3–26. William Carleton makes the parochial idea explicit in *Traits and Stories of the Irish Peasantry* (London: William Tegg, 1866), I, p. 182. Patrick Kavanagh raises the idea anew in his essay "The Parish and the Universe," *Collected Pruse* (London: Martin Brian and O'Keefe, 1973), pp. 281–83. All students of rural life should know Kavanagh's autobiography, *The Green Fool* (London: Martin Brian and O'Keefe, 1971; first pub. 1938), his novel *Tarry Flynn* (London: The Pilot Press, 1948), and his poem *The Great Hunger* (Dublin: Cuala Press, 1942)—hard statements from within. I build my little treatment of the folktale on the structural analysis of Vladimir Propp, *Morphology of the Folktale* (Austin: University of Texas Press, 1968), refined by Claude Brémond, "Morphology of the French Folktale," *Semiotica*, II: 3 (1970): 247–76. The structure of the ballad follows if you attend to the ballads most often sung and collected. For more on structural analysis of oral literature and material culture, I refer you to my paper "Structure and Function, Folklore and the Artifact," prelude to *Folk Housing in Middle Virginia*. I was inspired to use Ganesha as an example by Paul B. Courtwright's study *Ganeśa: Lord of Obstacles, Lord of Beginnings* (New York: Oxford University Press, 1985). A pair of recent pictorial treatments of Indian traditional art by a father and daughter present a variety of images of Ganesha, some in rich context: Ajit Mookerjee, *Ritual Art of India* (London: Thames and Hudson, 1985), figs. 102, 107; Priya Mookerjee, *Pathway Icons: The Wayside Art of India* (London: Thames and Hudson, 1987), figs. 16–18, 67, 68. To tell about Wassily Kandinsky, I drew from his "Reminiscences," in Robert L. Herbert, ed., *Modern Artists on Art* (Englewood Cliffs, N.J.: Prentice-Hall, 1964), pp. 19–44, especially pp. 31, 39–42. I repeat Kandinsky's words and opinions from his great essay *Concerning the Spiritual in Art*, especially pp. 24, 30, 50, 52, 75 (his wife's remembrances begin that volume); and from his essay "On the Question of Form," *Blaue Reiter Almanac*, especially pp. 147–53. I retell the tale of Farmer Tupp who wanted no "postles" on his wagon from Sturt's grand *Wheelwright's Shop*, p. 79. Saint Thomas' theory of art, and the integrated medieval vision that unified beauty and utility, are described well by Eco in *Art and Beauty in the Middle Ages*, especially pp. 15–16, 19, 78–81. In

the Introduction to his *Tulips, Arabesques, and Turbans*, p. 9, Yanni Petsopoulos aptly isolates a "plain tradition" in Ottoman art, exemplified effectively in James Allan and Julian Raby's chapter in the book, "Metalwork," especially pp. 27–29. I use the example of the cow as a sign for the goodness of God because it is the example used in the Koran. From Francis H. Harlow's pamphlet *Historic Pueblo Indian Pottery* (Santa Fe: Museum of New Mexico Press, 1970), where characteristic samples from each of the pueblos are illustrated, it will be seen that the objects represented are all birds, flowers, or ritual items. In *The Pueblo Potter*, p. 70, Bunzel comments that the motifs on the pottery are all associated with the weather or ceremonial apparatus, though they are not properly symbols. She found even such associations to be weak at Acoma (p. 71), though that is not the case today. She describes a special instance of sacred representation in which the artistic dimension was undercut—and so the sacred content was stressed—by loose handling: pp. 23–24. A similar stepping away from art in the act of representation is described by Jonaitis, *Art of the Northern Tlingit*, pp. 122–24. (Our concern for illusionism doubly distorts our vision, causing us to undervalue nonrepresentational art and to consider nonartistic works art because they are representational.) Bunzel notes, p. 60, that Pueblo women valued pottery more for its technical excellence than its decoration. (Technology more than decoration relates to sacred significance among the people of the word.) Bunzel notes, too (p. 65), that Pueblo potters can always tell who made a work in question. Oleg Grabar in *The Formation of Islamic Art* (New Haven: Yale University Press, 1974), chapter 4, relates the history of Muslim attitudes against representation, pointing out that the Koran is less specific than the Bible in its prohibition of graven images; and he describes the history and meaning of the mihrab, especially pp. 120–22. The catalog *Prayer Rugs* (Washington, D.C.: Textile Museum, 1974) offers a sampling of rugs from different times and places that depict mihrabs, and it begins with Richard Ettinghausen's essay, pp. 10–25, in which he discusses the history and meaning of prayer rugs. In his superb book *Sacred Art in East and West*, pp. 77–78, Burckhardt characterizes the niche, the mihrab, as the location of the holy of holies, the place of epiphany, of the showing forth of the divine; throughout his work, Burckhardt clearly presents the difference between religious content and religious style (see pp. 7–13, 44, 67–71, 150–54), and, pp. 18–33, he describes the circle overlain with the cross of the four directions as basic to sacred architecture. Émile Mâle, *Religious Art: From the Twelfth to the Eighteenth Century* (New York: Pantheon Books, 1949), p. 162, describes the arcade as the door to paradise, and, p. 82, he tells of winged skulls that mock our faith in life. John James, *Chartres*, is one of the very best books you will read on the topic of material culture. The medieval philosophers' interest in geometry and color is excellently set forth in chapters 3 and 4 of Eco's *Art and Beauty in the Middle Ages*. "So why, pray, sign anything as long as every word, letter, penstroke, paperspace is a perfect signature of its own?" asks James Joyce in *Finnegans Wake* (New York: Viking, 1939), p. 115, a book that is one long signature. The mock signatures of Hungarian potters are mentioned by Fél, Hofer, and K.-Csilléry, *Hungarian Peasant Art*, p. 32, where they comment as well that women always recognize individual artists from their embroideries. Peterson tells in *Lucy M. Lewis*, p. 40, that Mrs. Lewis was the first at Acoma to sign her work, when she entered a competition in 1950. For more on signatures, see Marriott's *María*, chapter 26. The Shakers' prohibition against

signatures is mentioned in the Andrewses' *Religion in Wood*, p. 102, where they comment that the craftsmen did not always abide by the proscription. In my chapter of Glassie, Edward D. Ives, and John F. Szwed, *Folksongs and Their Makers* (Bowling Green: Bowling Green Popular Press, 1970), I noted a biographical pattern for especially creative folk artists: many avoided normal social and economic responsibilities. Edward Ives treated the idea seriously in the last chapter of *Lawrence Doyle, The Farmer Poet of Prince Edward Island: A Study in Local Songmaking* (Orono: University of Maine Press, 1971), and Michael Owen Jones reworked the notion in his fine study, one of the best books we have on folk art, *The Hand Made Object and Its Maker*, pp. 164–67. I was reminded of the validity of my idea in composing chapter 32 of *Passing the Time in Ballymenone*; see especially pp. 679–81. If commercialization often brings folk art into decay, it also offers creative individuals exciting new options; for examples: Hans Himmelheber, "The Present Status of Sculptural Art Among the Tribes of the Ivory Coast," in June Helm, ed., *Essays on the Verbal and Visual Arts* (Seattle: American Ethnological Society, University of Washington Press, 1967), pp. 196, 199; Jerold L. Collings, "Basketry: From Foundations Past," in Patrick Houlihan, ed., *Harmony by Hand: Art of the Southwestern Indians* (San Francisco: Chronicle Books, 1987), p. 25. In Europe, folk art is normally identified with a particular phase of historical development, lying between the medieval and the modern and characterized by a sudden rise in prosperity for country people. The authors of the chapters on Norway, p. 15, and France, p. 117, in Hansen's survey, *European Folk Art*, both stress prosperity as the cause for folk artistic flowering. In *Hungarian Folk Art*, pp. 37–39, 58–59, Hofer and Fél correlate the rise of folk art with prosperity and discuss the matter with characteristic precision and intelligence. As a result of writings in English by Tamás Hofer and Edit Fél and the fine publications of the Corvina Press, Americans who read only English can learn deeply about the folk art of one foreign nation: Hungary. There is no excuse for the isolationism of American folk art scholarship. In a way consonant with my description of Turkey and reminiscent of Yeats' view of Ireland, Coomaraswamy in *Christian and Oriental Philosophy of Art*, chapter 8, says that in traditional India aristocratic and peasant views of art converge. The modern Western idea of art, founded upon individualism (and so emphasizing expression and the reception of pleasure), is a bourgeois concept, less attributable to the existence of wealth than to the rise of a middle class that based its claim, not on land and blood, but on trade and wit. Coomaraswamy's idea of portraiture, set forth in chapter 7, might help those confused by early portraits and their connection to folk artistic ideals. The nature of history, essential to understanding the structure of art history, is clarified by considering folk history, just as the nature of art is clarified by meditating upon the concept of folk art. My paper "Folklore and History," *Minnesota History*, 50:5 (1987): 188–92, lays out the issues. The history of folk art—I mean the big history of folk art and not the little history of its collection—connects intriguingly with the history of the long duration, brilliantly presented by Fernand Braudel in *On History* (Chicago: University of Chicago Press, 1980). The first reason for students of folk art to attend to vernacular architecture is that it is a variety of folk art, as implied by my paper "Vernacular Architecture and Society," *Material Culture*, 16:1 (1984): 4–24, reprinted in Simon J. Bronner, ed., *American Material Culture and Folklife: A Prologue and Dialogue* (Ann Arbor: UMI Research Press, 1985), pp. 47–62. The second rea-

son follows from the first. Vernacular architecture is the one area of folk art that has been accorded careful historical study and so supplies useful inspiration for the whole of the field. The anthology by Upton and Vlach, *Common Places*, provides a fine introduction. For two works providing fuller examples of the historical study of vernacular architecture, both treating the same region, see my book *Folk Housing in Middle Virginia* (its point sharpened in chapter 13 of *Passing the Time in Ballymenone*) and Dell Upton's *Holy Things and Profane: Anglican Parish Churches in Colonial Virginia* (New York and Cambridge: Architectural History Foundation, MIT Press, 1986). Most complete of the historical stories is that of the development of the English house; see: S. O. Addy, *The Evolution of the English House* (London: Swan Sonnenschein, 1898); M. W. Barley, *The English Farmhouse and Cottage* (London: Routledge and Kegan Paul, 1961); R. W. Brunskill, *Illustrated Handbook of Vernacular Architecture* (New York: Universe Books, 1970); Eric Mercer, *English Vernacular Houses* (London: Royal Commission on Historical Monuments, Her Majesty's Stationery Office, 1975); with the key argument articulated by W. G. Hoskins in his great paper "The Rebuilding of Rural England, 1570–1640," *Provincial England: Essays in Social and Economic History* (London: Macmillan, 1965), pp. 131–48.

Folk Art and Popular Art

The report of a survey conducted in 1986, Mohammad Shah Jalal, *The Present State of the Traditional Pottery Craft in Bangladesh* (Dhaka: International Voluntary Services, 1986), provides statistical evidence of the great richness of the tradition. I chose the examples of division of labor in the manufacture of pottery because of particular studies that offer you more information: Lewis' *Ewenny Potteries*, pp. 9–17, for Wales; my "Traditional Crafts" for Turkey; Ioannou's comprehensive *Ceramics in South Australia*, pp. 28–32, 38–39, 77–80, 86, 149–54, 182–86, 308–9; Cort's excellent *Shigaraki*, pp. 252–67, 272–94, for Japan. The development of the pottery of Staffordshire is well known because, as early as 1829, Simeon Shaw wrote *History of the Staffordshire Potteries*, drawing information from oral history and old examples. His book is an amazing harbinger of modern material culture studies; from it, for instance, we learn the names of individual innovators from as early as the seventeenth century, so that the tradition can be seen as a series of creations rather than as a vague continuous force, shrouded—as they say—in the mists of time; see his book, pp. 65, 102, 108, 118–19, 150, 172, 187, 204, 211, 214, 223. On p. 104 he describes the pattern of work. A later but far less modern book, which is critical of that in Shaw which the modern scholar admires, but which like Shaw's is useful in being the product of local men in direct touch with the ceramic tradition, is the Rheads' *Staffordshire Pots and Potters*, published in 1907. They give chapter 19 over to figures and provide, in chapters 21 and 22, information on nineteenth-century factories, but they emphasize the early and the fine (the Staffordshire tradition flowered in the Tofts and in Josiah Wedgwood), largely skirting the usual Victorian figures. That lack is redressed in modern guides for collectors, some of which are highly intelligent and contain valuable historical and technical summaries; for examples: H. A. B. Turner, *A Collector's Guide to Staffordshire Pottery Figures* (London: MacGibbon and Kee, 1971); Anthony Oliver, *The Victorian Staffordshire Figure: A Guide for Collectors* (London: Heinemann, 1971); and Pugh's *Staffordshire Portrait Figures*. Labor conditions are described by Turner, pp. 145–51, and Oliver, pp.

11–28. In his fine study of Willie Seaweed, *Smoky-Top*, Bill Holm describes Seaweed's excellent "tourist art" on pp. 29–30, 40, 153. See, too, Peter L. Macnair, *The Legacy: Tradition and Innovation in Northwest Coast Indian Art* (Seattle: University of Washington Press, Royal British Columbia Museum, 1984), pp. 75–80. On p. 35, Holm asserts, correctly I am sure, that though Seaweed did not sign his work, it can be identified by its distinctive form and handling. The story of the Jugtown revival is told by Jean Crawford in *Jugtown Pottery: History and Design* (Winston-Salem: John F. Blair, 1964); Nancy Sweezy carries the story forward, from the days of Ben Owen to the days of Vernon Owens, in *Raised in Clay*, pp. 211–17. Lou Sesher, painter and sculptor, was also a marvelous teller of tales. Dave Walton published the corpus of Mr. Sesher's stories in *Keystone Folklore Quarterly*, XI: 4 (1966): 215–37; XII: 1 (1967): 81–93; XII: 3 (1967): 177–86; XII: 4 (1967): 229–32; XIII: 1 (1968): 3–17 (which includes Mr. Sesher's autobiography); and XIII: 2 (1968): 167. The multiple talents of traditional artists provide one of the many reasons why studies of folk art must ultimately break free of conventional generic categories. The architect Charles Jencks presents the idea of "double coding" as fundamental to contemporary creativity in *What Is Post-Modernism?* (New York: St. Martin's Press, 1986), pp. 7, 18, 22, 43. I quote Helen Cordero from Babcock and Monthan, *The Pueblo Storyteller*, p. 97. Mrs. Cutler's kitchen is the key text of chapter 13, *Passing the Time in Ballymenone*. Always in advance, Austin E. Fife considered domestic environments built out of disparate elements as items of folklife in "Folklore of Material Culture on the Rocky Mountain Frontier," *Arizona Quarterly*, 13:2 (1957), especially pp. 108–9. I follow closely Alexander Girard's words about collecting from his Introduction to *Magic of a People*.

Folk Art and Primitive Art

My examples of the blending of tribal tradition with the traditions of the great religions come from Haku Shah, *Votive Terracottas of Gujarat*; and René A. Bravmann, *Islam and Tribal Art in West Africa* (Cambridge: Cambridge University Press, 1974), pp. 43, 47–58, 116–17, 125, 156–57, 166–70. For Navajo rugs, I relied on these clear new books: Kent, *Navajo Weaving*; Kaufman and Selser, *Navajo Weaving Tradition*. Lest it seem a departure to embrace primitive art within folk art: I argued for the inclusion of Native American arts within folklife in 1968 in *Pattern in the Material Folk Culture of the Eastern United States*, pp. 212–16, and in 1972, though still confused by my training and not yet emboldened by enough experience in the field, I wrote in "Folk Art," p. 259, that most of what is called primitive art is—and Navajo rugs provided one of my examples—folk art. Claude Lévi-Strauss' *The Way of the Masks*, a defense against critics who have not bothered to read his works with care, is both a fine explanation of structuralism and a superb study of art. It is summarized suggestively in his *Anthropology and Myth: Lectures, 1951–1982* (Oxford: Basil Blackwell, 1987), pp. 89–95. Lévi-Strauss' book *The Savage Mind* is a crucial text in the debate over our destiny, and a forceful apology for art. His *Tristes Tropiques* provides a good introduction to his work; I build my story out of words on pp. 38–39, 57–58, 86–87, 123, 154, 214–16, 271–72, 305, 316–17, 326, 332–33, 346, 376–92. Academic fashions change but Claude Lévi-Strauss remains a hero of our age.

BIBLIOGRAPHY

Ames, Kenneth L. *Beyond Necessity: Art in the Folk Tradition*. New York: W. W. Norton, Winterthur Museum, 1977.

Andrews, Edward Deming and Faith. *Religion in Wood: A Book of Shaker Furniture*. Bloomington: Indiana University Press, 1966.

Apted, M. R. *The Painted Ceilings of Scotland, 1550–1650*. Edinburgh: Her Majesty's Stationery Office, 1966.

Armstrong, Robert Plant. *The Affecting Presence: An Essay in Humanistic Anthropology*. Urbana: University of Illinois Press, 1971.

———. *Wellspring: On the Myth and Source of Culture*. Berkeley: University of California Press, 1975.

———. *The Powers of Presence: Consciousness, Myth, and Affecting Presence*. Philadelphia: University of Pennsylvania, 1981.

Atıl, Esin. *The Age of Sultan Süleyman the Magnificent*. Washington, D.C., and New York: National Gallery of Art, Harry N. Abrams, 1987.

Babcock, Barbara A., and Monthan, Guy and Doris. *The Pueblo Storyteller: Development of a Figurative Ceramic Tradition*. Tucson: University of Arizona Press, 1986.

Bakurdjiev, Georgi. *Bulgarian Ceramics*. Sofia: Bulgarski Hudozhnik, 1955.

Barber, Edwin Atlee. *Tulip Ware of the Pennsylvania-German Potters: An Historical Sketch of the Art of Slip-Decoration in the United States*. Philadelphia: Pennsylvania Museum and School of Industrial Art, 1926; first pub. 1903.

Bascom, William. *African Art in Cultural Perspective*. New York: W. W. Norton, 1973.

Baud-Bovy, Daniel. *Peasant Art in Switzerland*. London: The Studio, 1924.

Baxandall, Michael. *Painting and Experience in Fifteenth-Century Italy: A Primer in the Social History of Pictorial Style*. Oxford: Oxford University Press, 1972.

Beck, Jane C. *Always in Season: Folk Art and Traditional Culture in Vermont*. Montpelier: Vermont Council on the Arts, 1982.

Becker, Howard S. *Art Worlds*. Berkeley: University of California Press, 1982.

Benes, Peter. *The Masks of Orthodoxy: Folk Gravestone Carving in Plymouth County, Massachusetts, 1689–1805*. Amherst: University of Massachusetts Press, 1977.

Berliner, Nancy Zeng. *Chinese Folk Art*. Boston: Little, Brown and Company, 1986.

Biebuyck, Daniel P., ed. *Tradition and Creativity in Tribal Art*. Berkeley: University of California Press, 1969.

Bishop, Robert, and Safanda, Elizabeth. *A Gallery of Amish Quilts: Design and Diversity from a Plain People*. New York: E. P. Dutton, 1976.

Bivins, John, Jr. *The Moravian Potters in North Carolina*. Chapel Hill: University of North Carolina Press, 1972.

Bizley, Alice C. *The Slate Figures of Cornwall*. Marazion: Worden Printers, 1965.

Black, Mary, and Lipman, Jean. *American Folk Painting*. New York: Clarkson N. Potter, 1966.

Boas, Franz. *Primitive Art.* New York: Dover, 1955; first pub. 1927.

Bogatyrev, Petr. *The Functions of Folk Costume in Moravian Slovakia.* The Hague: Mouton, 1971; first pub. 1937.

Boyd, E. *Popular Arts of Spanish New Mexico.* Santa Fe: Museum of New Mexico Press, 1974.

Boyle, Elizabeth. *The Irish Flowerers.* Belfast: Ulster Folk Museum, Institute of Irish Studies, Queen's University, 1971.

Briggs, Charles L. *The Wood Carvers of Córdova, New Mexico: Social Dimensions of an Artistic "Revival."* Knoxville: University of Tennessee Press, 1980.

———. *Chain Carvers: Old Men Crafting Meaning.* Lexington: University Press of Kentucky, 1984.

Brüggemann, W., and Böhmer, H. *Rugs of the Peasants and Nomads of Anatolia.* Munich: Kunst und Antiquitäten, 1983.

Bunzel, Ruth. *The Pueblo Potter: A Study of Creative Imagination in Primitive Art.* New York: Dover, 1972; first pub. 1929.

Burckhardt, Titus. *Sacred Art in East and West: Its Principles and Methods.* London: Perennial Books, 1967.

———. *Art of Islam: Language and Meaning.* Westerham: World of Islam, 1976.

Burrison, John A. *Brothers in Clay: The Story of Georgia Folk Pottery.* Athens: University of Georgia Press, 1983.

Cahill, Holger. *American Folk Art: The Art of the Common Man in America, 1750–1900.* New York: Museum of Modern Art, W. W. Norton, 1932.

Chinnery, Victor. *Oak Furniture: The British Tradition.* Woodbridge: Antique Collectors' Club, 1979.

Christensen, Erwin O. *Early American Wood Carving.* Cleveland: World, 1952.

Clarke, Mary Washington. *Kentucky Quilts and Their Makers.* Lexington: University Press of Kentucky, 1976.

Coe, Ralph T. *Lost and Found Traditions: Native American Art, 1965–1985.* New York: American Federation of Arts, 1986.

Coomaraswamy, Ananda K. *The Transformation of Nature in Art.* Cambridge: Harvard University Press, 1935.

———. *Christian and Oriental Philosophy of Art.* New York: Dover, 1956; first pub. 1943.

Cooper, Patricia, and Buferd, Norma Bradley. *The Quilters: Women and Domestic Art.* Garden City, N.Y.: Doubleday, Anchor Press, 1978.

Cort, Louise Allison. *Shigaraki, Potters' Valley.* Tokyo: Kodansha International, 1979.

Csikszentmihalyi, Mihaly, and Rochberg-Halton, Eugene. *The Meaning of Things: Domestic Symbols and the Self.* Cambridge: Cambridge University Press, 1981.

Cuisenier, Jean. *French Folk Art.* Tokyo: Kodansha, 1977.

Dancu, Juliana, and Dancu, Dumitru. *Folk Glass-painting in Romania.* Bucharest: Meridane, 1982.

d'Azevedo, Warren L., ed. *The Traditional Artist in African Societies.* Bloomington: Indiana University Press, 1973.

Deetz, James. *In Small Things Forgotten: The Archeology of Early American Life.* Garden City, N.Y.: Anchor Press, 1977.

Dewhurst, C. Kurt; MacDowell, Betty; and MacDowell, Marsha. *Religious Folk Art in America: Reflections of Faith.* New York: E. P. Dutton, Museum of American Folk Art, 1983.

Dewhurst, C. Kurt, and MacDowell, Marsha. *Rainbows in the Sky: The Folk Art of Michigan in the Twentieth Century.* East Lansing: Michigan State University, 1978.

Dewhurst, C. Kurt, and MacDowell, Marsha, eds. *Michigan Hmong Arts: Textiles in Transition.* East Lansing: Michigan State University, 1983.

Domanovszky, György. *Hungarian Pottery.* Budapest: Corvina, 1968.

Eaton, Allen H. *Handicrafts of the Southern Highlands.* New York: Russell Sage Foundation, 1937.

Eck, Diana L. *Darśan: Seeing the Divine Image in India.* Chambersburg, Pa.: Anima Books, 1985.

Eco, Umberto. *Art and Beauty in the Middle Ages.* New Haven: Yale University Press, 1986; first pub. 1959.

Emerson, Ralph Waldo. *Nature.* East Aurora, N.Y.: Roycrofters, 1905; first pub. 1836.

Espejel, Carlos. *Mexican Folk Ceramics.* Barcelona: Editorial Blume, 1975.

Espinosa, José E. *Saints in the Valleys: Christian Sacred Images in the History, Life and Folk Art of Spanish New Mexico.* Albuquerque: University of New Mexico Press, 1967.

Evans, E. Estyn. *Irish Folk Ways.* New York: Devin-Adair, 1957.

Fabian, Monroe F. *The Pennsylvania-German Decorated Chest.* New York: Universe Books, 1978.

Fairbanks, Jonathan, and Trent, Robert F., eds. *New England Begins: The Seventeenth Century.* 3 vols. Boston: Museum of Fine Arts, 1982.

Fél, Edit; Hofer, Tamás; and K.-Csilléry, Klára. *Hungarian Peasant Art.* Budapest: Corvina, 1958.

Ferris, William. *Local Color: A Sense of Place in Folk Art.* New York: McGraw-Hill, 1982.

Finley, Ruth E. *Old Patchwork Quilts and the Women Who Made Them.* Philadelphia: J. B. Lippincott, 1929.

Fischer, J. L. "Art Styles as Cultural Cognitive Maps." *American Anthropologist* 63 (1961):71–93.

Fleming, E. McClung. "Artifact Study: A Proposed Model." *Winterthur Portfolio* 9 (1974):153–73.

Fleming, John, and Honour, Hugh. *The Penguin Dictionary of Decorative Arts.* Harmondsworth: Penguin Books, 1979.

Focillon, Henri. *The Life of Forms in Art.* New York: George Wittenborn, 1948.

Fontana, Bernard L.; Robinson, William J.; Cormack, Charles W.; and Leavitt, Ernest E., Jr. *Papago Indian Pottery.* Seattle: University of Washington Press, 1962.

Forman, Benno M. *American Seating Furniture: 1630–1730.* New York: W. W. Norton, 1988.

Giffords, Gloria Kay. *Mexican Folk Retablos: Masterpieces on Tin.* Tucson: University of Arizona Press, 1974.

Girard, Alexander. *The Magic of a People.* New York: Viking, 1968.

Glassie, Henry. "William Houck, Maker of Pounded Ash Adirondack Pack-Baskets." *Keystone Folklore Quarterly* XII (1967):25–54.

———. *Pattern in the Material Folk Culture of the Eastern United States.* Philadelphia: University of Pennsylvania Press, 1968.

———. "Folk Art." In Richard M. Dorson, ed., *Folklore and Folklife: An Introduction.* Chicago: University of Chicago Press, 1972, pp. 253–80.

———. "Structure and Function, Folklore and the Artifact." *Semiotica* VII (1973):313–51.

———. *Folk Housing in Middle Virginia: A Structural Analysis of Historical Artifacts.* Knoxville: University of Tennessee Press, 1975.

———. "Meaningful Things and Appropriate Myths: The Artifact's Place in American Studies." *Prospects* 3 (1977):1–49.

———. *Passing the Time in Ballymenone: Culture and History of an Ulster Community.* Philadelphia: University of Pennsylvania Press, 1982.

———. "Traditional Crafts: A Lesson from Turkish Ceramics." In Thomas Vennum, Jr., ed., *Festival of American Folklife Program Book.* Washington, D.C.: Smithsonian Institution, 1986, pp. 68–73.

Goldstein, Kenneth S. "William Robbie: Folk Artist of the Buchan District, Aberdeenshire." In Horace P. Beck, ed., *Folklore in Action: Essays for Discussion in Honor of MacEdward Leach.* Philadelphia: American Folklore Society, 1962, pp. 101–11.

Gowans, Alan. *Images of American Living: Four Centuries of Architecture and Furniture as Cultural Expression.* Philadelphia: Lippincott, 1964.

Graburn, Nelson H. H., ed. *Ethnic and Tourist Arts: Cultural Expressions of the Fourth World.* Berkeley: University of California Press, 1979.

Grancsay, Stephen V. *American Engraved Powder Horns.* Philadelphia: Ray Riling Arms Books, 1965.

Hansen, H. J., ed. *European Folk Art in Europe and the Americas.* New York: McGraw-Hill, 1968.

Harper, Douglas. *Working Knowledge: Skill and Community in a Small Shop.* Chicago: University of Chicago Press, 1987.

Henning, Darrell D.; Nelson, Marion J.; and Welsch, Roger L. *Norwegian-American Wood Carving of the Upper Midwest.* Decorah, Iowa: Vesterheim, 1978.

Hofer, Tamás, and Fél, Edit. *Hungarian Folk Art.* Oxford: Oxford University Press, 1979.

Holm, Bill. *Smoky-Top: The Art and Times of Willie Seaweed.* Seattle: University of Washington Press, 1983.

Hoskins, W. G. *The Making of the English Landscape.* London: Hodder and Stoughton, 1955.

Inverarity, Robert Bruce. *Art of the Northwest Coast Indians.* Berkeley: University of California Press, 1950.

Ioannou, Noris. *Ceramics in South Australia, 1836–1986: From Folk to Studio Pottery.* Netley: Wakefield Press, 1986.

James, John. *Chartres: The Masons Who Built a Legend.* London: Routledge & Kegan Paul, 1982.

Jenkins, J. Geraint. *Traditional Country Craftsmen.* London: Routledge & Kegan Paul, 1965.

Jonaitis, Aldona. *Art of the Northern Tlingit.* Seattle: University of Washington Press, 1986.

Jones, Agnes Halsey, and Jones, Louis C. *New-Found Folk Art of the Young Republic.* Cooperstown: New York Historical Association, 1960.

Jones, Michael Owen. *The Hand Made Object and Its Maker.* Berkeley: University of California Press, 1975.

Jones, Suzi, ed. *Webfoots and Bunchgrassers: Folk Art of the Oregon Country.* Eugene: Oregon Arts Council, 1980.

Kandinsky, Wassily. *Concerning the Spiritual in Art.* New York: George Wittenborn, 1964; first pub. 1912.

Kandinsky, Wassily, and Marc, Franz. *The Blaue Reiter Almanac.* New York: Viking Press, 1974; first pub. 1912.

Kaufman, Alice, and Selser, Christopher. *The Navajo Weaving Tradition: 1650 to the Present.* New York: E. P. Dutton, 1985.

K.-Csilléry, Klára. *Hungarian Village Furniture.* Budapest: Corvina, 1972.

Kent, Kate Peck. *Pueblo Indian Textiles: A Living Tradition.* Santa Fe: School of American Research Press, 1983.

———. *Navajo Weaving: Three Centuries of Change.* Santa Fe: School of American Research Press, 1985.

King, Donald. *Samplers.* London: Victoria and Albert, 1960.

Kirk, John T. *American Chairs: Queen Anne and Chippendale.* New York: Alfred A. Knopf, 1972.

———. *American Furniture and the British Tradition to 1830.* New York: Alfred A. Knopf, 1982.

Kluckhohn, Clyde; Hill, W. W.; and Kluckhohn, Lucy Wales. *Navaho Material Culture.* Cambridge: Harvard University Press, 1971.

Kramrisch, Stella. *Unknown India: Ritual Art in Tribe and Village.* Philadelphia: Philadelphia Museum of Art, 1968.

Kubler, George. *The Shape of Time: Remarks on the History of Things.* New Haven: Yale University Press, 1962.

Lambert, M., and Marx, Enid. *English Popular Art.* London: B. T. Batsford, 1951.

Lane, Arthur. *Early Islamic Pottery: Mesopotamia, Egypt and Persia.* New York: D. Van Nostrand, 1948.

———. *Later Islamic Pottery: Persia, Syria, Egypt, Turkey.* London: Faber and Faber, 1957.

Lasansky, Jeannette. *Willow, Oak and Rye: Basket Traditions in Pennsylvania.* Lewisburg, Pa.: Union County Oral Traditions Projects, 1978.

Leask, Ada K. Longfield. *Some Irish Churchyard Sculpture.* Ballycotton: Gifford and Craven, 1974.

Lévi-Strauss, Claude. *Tristes Tropiques.* New York: Atheneum, 1975; first pub. 1955.

———. *The Savage Mind.* Chicago: University of Chicago Press, 1966.

———. *The Way of the Masks.* Seattle: University of Washington Press, 1982.

Lewis, J. M. *The Ewenny Potteries*. Cardiff: National Museum of Wales, 1982.

Lipman, Jean, and Armstrong, Tom, eds. *American Folk Painters of Three Centuries*. New York: Hudson Hills Press, Whitney Museum of American Art, 1980.

Lipman, Jean, and Winchester, Alice. *The Flowering of American Folk Art (1776–1876)*. New York: Viking Press, Whitney Museum of American Art, 1974.

Litto, Gertrude. *South American Folk Pottery*. New York: Watson-Guptill, 1976.

L'Orange, H. P. *Art Forms and Civic Life in the Late Roman Empire*. Princeton: Princeton University Press, 1972.

Ludwig, Allan I. *Graven Images: New England Stonecarving and Its Symbols, 1650–1815*. Middletown, Conn.: Wesleyan University Press, 1966.

Marriott, Alice. *María: The Potter of San Ildefonso*. Norman: University of Oklahoma Press, 1948.

Marshall, Howard W., ed. *Missouri Artist Jesse Howard, With a Contemplation on Idiosyncratic Art*. Columbia: Missouri Cultural Heritage Center, 1983.

Mercer, Eric. *Furniture, 700–1700*. New York: Meredith Press, 1969.

Mercer, Henry C. *The Bible in Iron: Pictured Stoves and Stoveplates of the Pennsylvania Germans*. Doylestown, Pa.: Bucks County Historical Society, 1961; first pub. 1914.

Meurant, Georges. *Shoowa Design: African Textiles from the Kingdom of Kuba*. London: Thames and Hudson, 1986.

Montgomery, Charles F. *A History of American Pewter*. New York: Winterthur, Praeger, 1973.

Morris, William. *Hopes and Fears for Art*. London: Ellis and White, 1882.

————. *Signs of Change*. London: Reeves and Turner, 1888.

Munsterberg, Hugo. *The Folk Arts of Japan*. Rutland, Vt.: Charles E. Tuttle, 1958.

Murck, Christian F., ed. *Artists and Traditions: Uses of the Past in Chinese Culture*. Princeton: Art Museum, Princeton University Press, 1976.

Norberg-Schulz, Christian. *Intentions in Architecture*. Cambridge: M.I.T. Press, 1968.

————. *Genius Loci: Towards a Phenomenology of Architecture*. New York: Rizzoli, 1980.

O'Bannon, George W. *The Turkoman Carpet*. London: Duckworth, 1974.

Ohrn, Steven, ed. *Passing Time and Traditions: Contemporary Iowa Folk Artists*. Ames: Iowa State University Press, 1984.

Paccard, André. *Traditional Islamic Craft in Moroccan Architecture*. 2 vols. Saint-Jorioz: Editions Ateliers 74, 1980.

Panofsky, Erwin. *Meaning in the Visual Arts*. Garden City, N.Y.: Doubleday, 1955.

————. *Gothic Architecture and Scholasticism*. New York: World, 1957.

Panyella, August, ed. *Folk Art of the Americas*. New York: Harry N. Abrams, 1981.

Patterson, Daniel W. *Gift Drawing and Gift Song: A Study of Two Forms of Shaker Inspiration*. Sabbathday Lake, Me.: United Society of Shakers, 1983.

Peddle, Walter W. *The Traditional Furniture of Outport Newfoundland*. St. John's: Harry Cuff, 1983.

Peterson, Susan. *Lucy M. Lewis: American Indian Potter*. Tokyo: Kodansha International, 1984.

Petsopoulos, Yanni. *Kilims: Flat-woven Tapestry Rugs*. New York: Rizzoli, 1979.

————. *Tulips, Arabesques and Turbans: Decorative Arts from the Ottoman Empire*. New York: Abbeville Press, 1982.

Pocius, Gerald L. *Textile Traditions of Eastern Newfoundland*. Ottawa: National Museum of Canada, 1979.

Price, Sally and Richard. *Afro-American Arts of the Suriname Rain Forest*. Los Angeles: Museum of Cultural History, University of California Press, 1980.

Prown, Jules David. "Style as Evidence." *Winterthur Portfolio* 15:3 (1980):197–210.

————. "Mind in Matter: An Introduction to Material Culture Theory and Method." *Winterthur Portfolio* 17:1 (1982):1–19.

Prussin, Labelle. *Hatumere: Islamic Design in West Africa*. Berkeley: University of California Press, 1986.

Pugh, P. D. Gordon. *Staffordshire Portrait Figures and Allied Subjects of the Victorian Era*. London: Barrie and Jenkins, 1970.

Pye, David. *The Nature of Design*. London: Studio Vista, 1964.

————. *The Nature and Art of Workmanship*. Cambridge: Cambridge University Press, 1968.

Pylkkänen, Riitta. *The Use and Traditions of Mediaeval Rugs and Coverlets in Finland*. Helsinki: Archaeological Society of Finland, 1974.

Quimby, Ian M. G., and Swank, Scott T., eds. *Perspectives on American Folk Art*. New York: W. W. Norton, Winterthur Museum, 1980.

Reed, Henry M., and Yoder, Don. *Decorated Furniture of the Mahontongo Valley*. Lewisburg, Pa.: Center Gallery, Bucknell University, 1987.

Reichard, Gladys A. *Navajo Shepherd and Weaver*. New York: J. J. Augustin, 1936.

Reinert, Guy F. *Coverlets of the Pennsylvania Germans*. Allentown: Pennsylvania German Folklore Society, 1949.

Rhead, G. Woolliscroft, and Rhead, Frederick Alfred. *Staffordshire Pots and Potters*. New York: Dodd, Mead, 1907.

Rinzler, Ralph, and Sayers, Robert. *The Meaders Family: North Georgia Potters*. Washington, D.C.: Smithsonian Institution Press, 1980.

Roberts, Warren E. "Turpin Chairs and the Turpin Family: Chairmaking in Southern Indiana." *Midwestern Journal of Language and Folklore* VII (1981):55–106.

————. "Ananias Hensel and His Furniture: Cabinetmaking in Southern Indiana." *Midwestern Journal of Language and Folklore* IX (1983):67–122.

Ruskin, John. *The Stones of Venice*. 3 vols. London: Smith, Elder, 1851–53.

St. Clair, Leonard L., and Govenar, Alan B. *Stoney Knows How: Life as a Tattoo Artist.* Lexington: University Press of Kentucky, 1981.

St. George, Robert Blair. *The Wrought Covenant: Source Material for the Study of Craftsmen and Community in Southeastern New England, 1620–1700.* Brockton, Mass.: Brockton Art Center, 1979.

Salvador, Mari Lyn. *Yer Dailege! Kuna Women's Art.* Albuquerque: University of New Mexico Press, 1978.

Sayers, Robert, and Rinzler, Ralph. *The Korean Onggi Potter.* Washington, D.C.: Smithsonian Institution Press, 1987.

Schiffer, Margaret B. *Historical Needlework of Pennsylvania.* New York: Bonanza, 1968.

Schlee, Ernst. *German Folk Art.* Tokyo: Kodansha International, 1980.

Shah, Haku. *Votive Terracottas of Gujarat.* New York: Mapin International, 1985.

Shaw, Simeon. *History of the Staffordshire Potteries; And the Rise and Progress of the Manufacture of Pottery and Porcelain.* New York: Praeger, 1970; first pub. 1829.

Shelley, Donald A. *The Fraktur-Writings or Illuminated Manuscripts of the Pennsylvania Germans.* Allentown: Pennsylvania German Folklore Society, 1961.

Sieber, Roy. *African Textiles and Decorative Arts.* New York: Museum of Modern Art, 1972.

———. *African Furniture and Household Objects.* Bloomington: American Federation of Arts, Indiana University Press, 1980.

Solon, L. M. *The Art of the Old English Potter.* New York: John Francis, 1906.

Sonobe, Kiyoshi; Sakamato, Kazuya; and Pomeroy, Charles. *Japanese Toys: Playing with History.* Rutland, Vt.: Charles E. Tuttle, 1965.

Spargo, John. *Early American Pottery and China.* Garden City, N.Y.: Garden City Publishing, 1926.

Sprigg, June. *Shaker Design.* New York: W. W. Norton, Whitney Museum of American Art, 1986.

Stackpole, Edouard A. *Scrimshaw at Mystic Seaport.* Mystic, Conn.: Mystic Marine Historical Association, 1958.

Sturt, George. *The Wheelwright's Shop.* Cambridge: Cambridge University Press, 1963; first pub. 1923.

Sutton-Smith, Brian. *Toys as Culture.* New York: Gardner Press, 1986.

Swank, Scott T. *Arts of the Pennsylvania Germans.* New York: W. W. Norton, Winterthur Museum, 1983.

Sweezy, Nancy. *Raised in Clay: The Southern Pottery Tradition.* Washington, D.C.: Smithsonian Institution Press, 1984.

Tashjian, Dickran and Ann. *Memorials for Children of Change: The Art of Early New England Stonecarving.* Middletown, Conn.: Wesleyan University Press, 1974.

Taylor, Lonn, and Warren, David B. *Texas Furniture: The Cabinetmakers and Their Work, 1840–1880.* Austin: University of Texas Press, 1975.

Terry, George D., and Myers, Lynn Robertson. *Carolina Folk: The Cradle of a Southern Tradition.* Columbia: McKissick Museum, University of South Carolina, 1985.

Thompson, Jon. *Carpet Magic: The Art of Carpets from the Tents, Cottages and Workshops of Asia.* Wisbech: Barbican Art Gallery, 1983.

Thompson, Robert Farris. *African Art in Motion: Icon and Act.* Berkeley: University of California Press, 1974.

———. *Black Gods and Kings: Yoruba Art at U.C.L.A.* Bloomington: Indiana University Press, 1976.

———. *Flash of the Spirit: African and Afro-American Art and Philosophy.* New York: Vintage Books, 1984.

Thompson, Robert Farris, and Cornet, Joseph. *The Four Moments of the Sun: Kongo Art in Two Worlds.* Washington, D.C.: National Gallery of Art, 1981.

Trent, Robert F. *Hearts and Crowns: Folk Chairs of the Connecticut Coast, 1720–1840.* New Haven: New Haven Colony Historical Society, 1977.

Ungerleider-Mayerson, Joy. *Jewish Folk Art: From Biblical Days to Modern Times.* New York: Summit Books, 1986.

Upton, Dell, and Vlach, John Michael. *Common Places: Readings in American Vernacular Architecture.* Athens: University of Georgia Press, 1986.

Van Ravenswaay, Charles. *The Arts and Architecture of German Settlements in Missouri.* Columbia: University of Missouri, 1977.

Vansina, Jan. *Art History in Africa: An Introduction to Method.* London: Longman, 1984.

Vlach, John Michael. *The Afro-American Tradition in Decorative Arts.* Cleveland: Cleveland Museum of Art, 1978.

———. *Charleston Blacksmith: The Work of Philip Simmons.* Athens: University of Georgia Press, 1981.

Vlach, John Michael, and Bronner, Simon, eds. *Folk Art and Art Worlds.* Ann Arbor: UMI Press, 1986.

Wadsworth, Anna, ed. *Missing Pieces: Georgia Folk Art, 1770–1976.* Atlanta: Georgia Council for the Arts and Humanities, 1976.

Weiser, Frederick S., and Heaney, Howell J. *The Pennsylvania German Fraktur of The Free Library of Philadelphia.* 2 vols. Breinigsville, Pa.: Pennsylvania German Society, Free Library, 1976.

Wildhaber, Robert, ed. *Swiss Folk Art.* Zurich: Pro Helvetia, 1971.

Winchester, Alice, ed. "What Is American Folk Art? A Symposium." *Antiques* 57 (1950):355–62.

Wroth, William. *Christian Images in Hispanic New Mexico: The Taylor Museum Collection of Santos.* Colorado Springs: Taylor Museum, 1982.

Wulff, Hans E. *The Traditional Crafts of Persia: Their Development, Technology, and Influence on Eastern and Western Civilizations.* Cambridge: M.I.T. Press, 1966.

Yeats, W. B. *The Celtic Twilight.* Dublin: Maunsel, 1902.

Zaman, Niaz. *The Art of Kantha Embroidery.* Dhaka: Shilpakala Academy, 1981.

Zimmer, Heinrich. *Myths and Symbols in Indian Art and Civilization.* Washington, D.C.: Bollingen Foundation, Pantheon Books, 1946.

Zug, Charles G., III. *Turners and Burners: The Folk Potters of North Carolina.* Chapel Hill: University of North Carolina Press, 1986.

INDEX

Pages on which illustrations appear are in *italics*.

CKNOWLEDGMENTS

When I was near the end of this book's first draft in August 1987, my father and Betsy came to visit in Santa Fe. We went out to Acoma and up to Taos and had a grand time arguing over the nature of art. As I was putting the finishing touches on the last draft in December, he lay dying. This book is another token of my love for him, more evidence of his teaching. He awakened my interest in art. Before he died, he had realized himself as the art historian he had always been avocationally, publishing a book on the painters of Washington, D.C., and I carry on. My first thanks are to him. To his memory I dedicate my work.

My love, Kathleen, is my nearest art historian. She read this book carefully at different stages, helping it along, and she talked me over some rough spots. My next thanks are to her.

The book was Charlene Cerny's idea. She told me I should get my thoughts on folk art down on paper. Having listened to many of my talks on the subject, fearing their ideas would escape, Kathy agreed, and Charlene and Steve Becker made it possible for us to spend most of a summer in Santa Fe, where I got it written.

Karen Duffy was my constant friend and competent accomplice. She and I selected the objects from the Girard Collection. She assembled information on them. Together we wrote the captions and organized the illustrations, the superb photographs taken by Michel Monteaux, who, too, proved a delight to work with. Karen and I did not work alone; we were ably, amply assisted by many, most of them on the staff of the Museum of International Folk Art, and we enjoy acknowledging the help of these friends and colleagues: Janet Adams, Monni Adams, Steve Becker, Nancy Zeng Berliner, Marsha Bol, Steven Cohen, Joan Coon, Nora Fisher, Judy Frater, Deborah Garcia-Ortega, Robin Farwell Gavin, Andrea Gillespie, Pat Harlow, Edmund Ladd, Yvonne Lange, Alan Lerner, Lois Livingston, Helen Lucero, Barbara Mauldin, Kristin Mihalas, Donna Pierce, Marion Rinehart, Sherry Sandlin, Judith Sellars, Judy Chiba Smith, Landis Smith, Thelma Walenrod, Peter Weiss, and William Wroth.

Kathy, Charlene, and Karen made it possible for me to get the book done. As I wrote, I was, as always, mindful of multitudinous debts. Out at the edge of my awareness loomed steadily and benignly the shade of William Morris, who understood better than anyone the topic we call folk art. Back at the beginning of my memory, there is a basement with the smell of engine oil, sawdust on the floor, and a screaming table saw. There my grandfather, carpenter by day, cabinetmaker by night, worked wonders. From him I learned about wood and skill and patience. My father returned from the war with a Japanese lacquered box, the first thing I remember recognizing to be beautiful. His idea of a great vacation was to go to Williamsburg again. From him I learned about art and about history. When I was little more than a boy, Fred Kniffen captured me and shaped my interest in material culture into a profession. He remains my great master, and after him come E. Estyn Evans, James Marston Fitch, and Robert Plant Armstrong. They readied me for participation in the movement for the serious study of the artifact. Nurtured by all my colleagues in that movement, I thank them all while naming these few: Jim Deetz, Jules Prown, Ralph Rinzler, Warren Roberts, Wilbur Zelinsky, Simon Bronner, John Burrison, Tom Carter, Bernie Herman, Mike Jones, Suzi Jones,

John Kirk, Rusty Marshall, John Moe, Jerry Pocius, Bob St. George, Tom Schlereth, Dell Upton, John Vlach, Terry Zug. And the future looks bright, for a new generation is rising that includes Jim Abrams, Charles Bergengren, Mike Chiarappa, Salah Hassan, Lee Irwin, Susan Isaacs, Sung-Kyun Kim, Jack Lindsey, Mal O'Connor, Sally Peterson, Caroline Roston, and Emily Socolov.

Being grateful to the entire discipline of folklore, I feel like listing a hundred names for thanks, but I will restrain myself and name a few whose teaching and writing and talking have helped me shape my intellect: Kenny Goldstein, Don Yoder, Roger Abrahams, Ilhan Başgöz, Dick Bauman, Dan Ben-Amos, Bruce Buckley, Linda Dégh, Dick Dorson, Alan Dundes, Lee Haring, Lauri Honko, Dell Hymes, Sandy Ives, John McDowell, and Elliott Oring.

Beyond my discipline, at the heart of my study, are the many who have helped me in the field. At least these names must appear in this acknowledgment: Marvis and Wanda Aragon, Johnnie and Winnie Brendel, William Houck, John O. Livingston, Bud and Ola Belle Reed, Wayne and Lilly Salvador, Lou Sesher, and Tab Ward from the United States; Ellen Cutler, Peter Flanagan, and Hugh Nolan from Northern Ireland; Harald and Marje Jones, Ernie and Vinnie Hartnoll from England; Yadigar and Sebire Aktaş, Sait and Lütfü Bayhan, Ibrahim Erdeyer, Mehmet Gürsoy, Mustafa Kesici, Mehmet Öztürk and family, Ahmet Şahin and family, Ahmet Sefa and family from Turkey; Shamsuzzaman Khan and Mohammad Saidur from Bangladesh.

This book derives from experience accumulated in the field. Not all of my field research has been funded, but some of it has, and for financial support I wish to thank the John Simon Guggenheim Memorial Foundation, the Scotch-Irish Trust of Ulster, the American Council of Learned Societies, the National Endowment for the Humanities, and the University of Pennsylvania. At Harry N. Abrams, I am especially indebted for careful work to Sam Antupit and Margaret Donovan.

I end by thanking the people around me for the friendship that makes my life and work a joy: Roger and Janet Abrahams, Hagop Barın, Tom and Inger Burns, Cece Conway, Karen Duffy, Tom and Ellen Ehrlich, Kenny and Rochelle Goldstein, Bill Hansen, Billy and Elizabeth Lightfoot, John McGuigan, Barry Lee and Missy Pearson, Phil and Pat Peek, John and Beverly Vlach. George and Chris Jevremović must have their own sentence, here next to my family, for whom at last the work is done. While I wrote, Harry—the fourth Henry Glassie in a row—graduated from college. Polly and Lydia came to visit in Santa Fe, where Kathy found time for her own projects, Ellen Adair played at corn dance, and my father and I walked around the town talking about things.

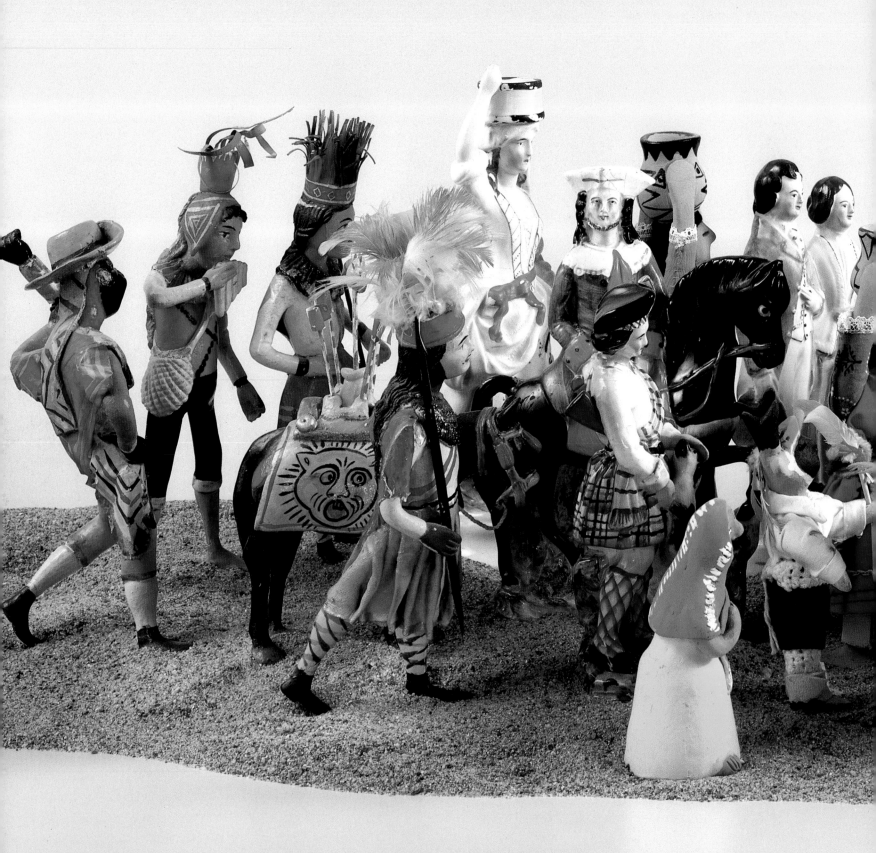

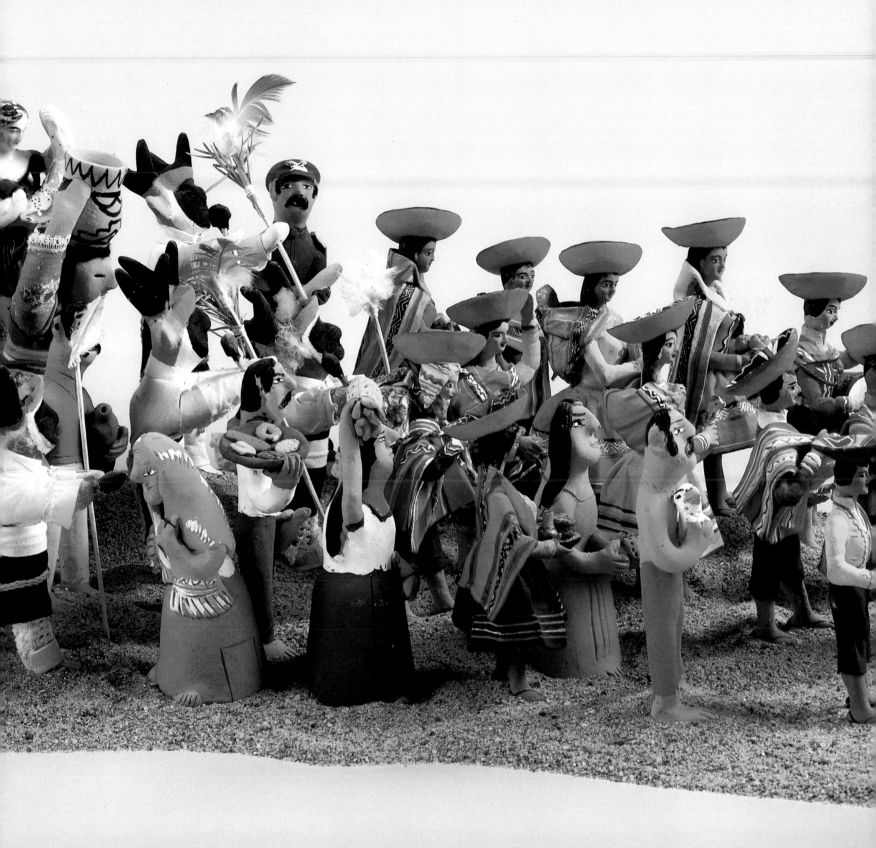